Pablo Picasso
VOLUME I

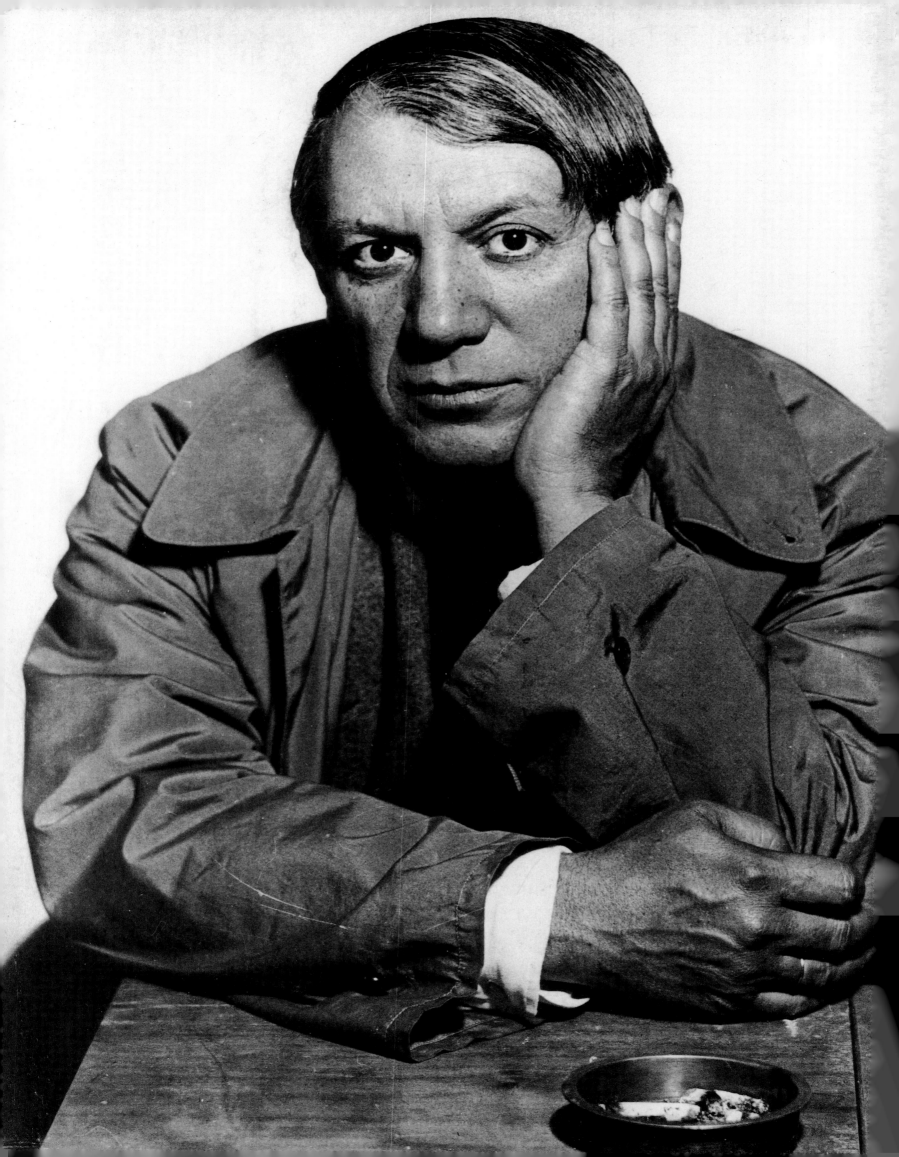

Carsten-Peter Warncke

Pablo Picasso
1881–1973

Edited by
Ingo F. Walther

VOLUME I
The Works 1890–1936

Benedikt Taschen

Frontispiece:
Pablo Picasso. Photograph by Man Ray, c. 1931–1932

Endpapers:
The Crucifixion (after Grünewald)
Paris, Musée Picasso
(cf. p. 337)

© 1992 Benedikt Taschen Verlag GmbH
Hohenzollernring 53, D–5000 Köln 1
© 1991 for the reproductions: VG Bild-Kunst, Bonn
Edited and produced by Ingo F. Walther,
with the assistance of Odo Walther, Karin Warncke,
Herbert Karl Mayer and Marianne Walther
English translation: Michael Hulse, Cologne
Cover design: Angelika Muthesius, Cologne
Printed in Germany
ISBN 3-8228-0562-9
GB

Contents

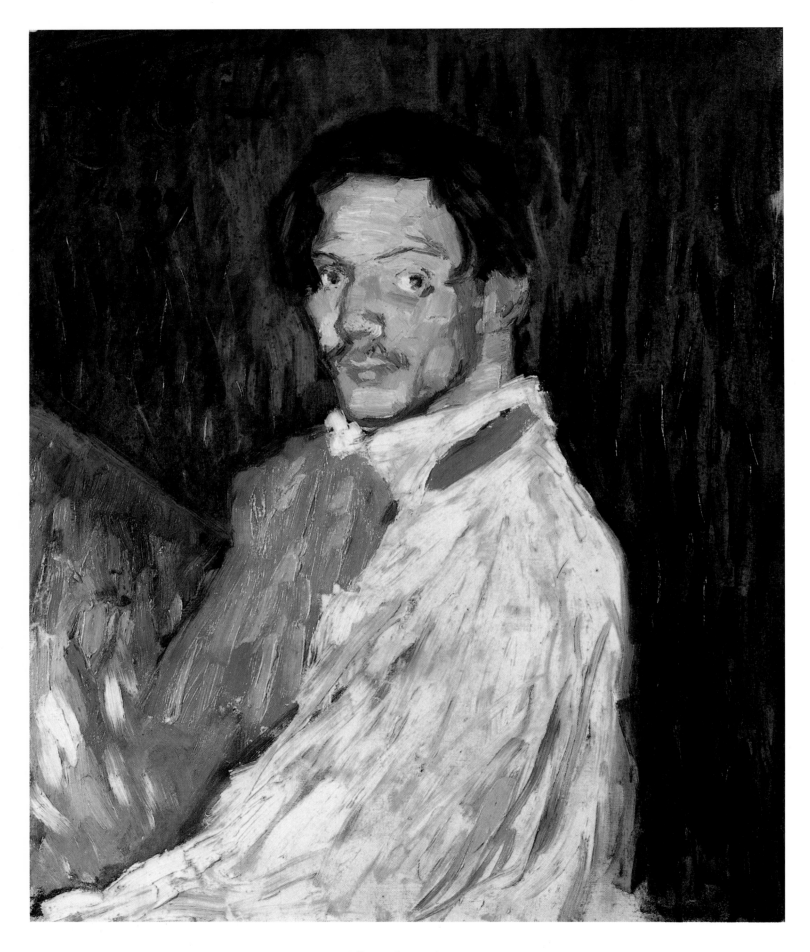

Self-portrait: "Yo Picasso"
Paris, spring 1901. Oil on canvas, 73.5 x 60.5 cm
Zervos XXI, 192; DB V, 2; Palau 570. Private collection

Editor's Preface

In spring 1980, for a highly regarded art publisher, I edited the German edition of the catalogue of the largest Picasso exhibition yet seen, the New York Museum of Modern Art's "Pablo Picasso. A Retrospective". In the process, I took the opportunity to deepen my familiarity with Picasso's work, which is of an extent unparalleled in the history of art, and to study his immense output and creative versatility. It is indeed the work of one of the century's great geniuses.

Some years later I had the good fortune to meet a collector and bookworm whose magnificent library included no less than fifty metres of shelves devoted to Picasso. When I asked if any one of the endless books on Picasso did justice to the universality of his creative genius – as painter and draughtsman, etcher and lithographer, sculptor and potter – he said no. Indeed, he went on, to this day no one has even managed to put an approximate number on the original works Picasso made. There must be over thirty thousand.

Ever since, I have been haunted by the wish to produce a book on Picasso that would be more than merely an addition to that endless shelfload. This book is the result of that wish. With luck it will have succeeded in conveying to the common reader and art lover something of the inventive wealth of Picasso's œuvre, of his seemingly infinite artistic imagination.

Carsten-Peter Warncke's text follows Picasso's evolution as an artist, from the academically trained student to the wild old man of the late work. He places special emphasis on recurring motifs and formal approaches in Picasso's work. His interpretation is on the hermeneutic side, giving less attention to Picasso's personality and private life; the well-illustrated biographical appendix covers this ground. Notes and a detailed bibliography also appear in the appendices.

In selecting the illustrations, I have tried to include both famous, "classical" works that belong in any book on Picasso and others that have been less often exhibited or reproduced. Picasso's late work is still rather too unfamiliar to a wider public, so I have paid particular attention to it. With only a few exceptions, the illustrations are arranged in chronological order. The French titles, and the numbers given in abbreviated form referring to the standard catalogues, are intended to help readers who consult the international literature on Picasso.

I wish to express my personal gratitude and that of the publisher to Pablo Picasso's son Claude for his interest in this project. I am indebted to the Picasso expert Gotthard Klewitz, who died far too soon, and his wife Lieselotte for productive ideas and for loans from their library. Georges Boudaille, the co-author of the œuvre catalogue dealing with the Blue and Rose Periods, was giving me valuable information until only a few weeks before his death.

This book would not have been possible without the support of the many museums and private collectors and the important galleries that made Picasso's work visible and established its importance. My thanks are addressed to all when I single out the two great public collections, the Musée Picasso in Paris and the Museu Picasso in Barcelona, and especially Margarita Ferrer, for special mention. Of the galleries that have so generously and unbureaucratically supported my labours I should particularly like to thank three that have rendered outstanding service to Picasso's work over the decades.

I thank the Galerie Louise Leiris in Paris, and the grand seigneur of Picasso studies, Maurice Jardot, together with Quentin Laurens. Through their good offices it proved possible to reproduce numerous works in the possession of Jacqueline Picasso's daughter Catherine Hutin-Blay, whom I also thank most warmly. I thank the Galerie Beyeler in Basle, which has done so much for Picasso's work through fine exhibitions and catalogues, and particularly Hildy and Ernst Beyeler and their assistant, Pascale Zoller. Without their help it would scarcely have been possible to present such excellent examples of Picasso's ceramic work. And I thank Angela Rosengart of Lucerne, who with her late father, Siegfried, has done so much on behalf of Picasso's work and to whom this book owes numerous invaluable enhancements.

In the final, somewhat pressured stage of production I was particularly assisted by Marianne Walther and by my tried and tested technical assistants, Uwe Steffen, Wolfgang Eibl, Klaus Hanitzsch and Wilhelm Vornehm, whose speed and grasp were exemplary. My father, Odo Walther, helped as always in researching the biographical material.

Ingo F. Walther

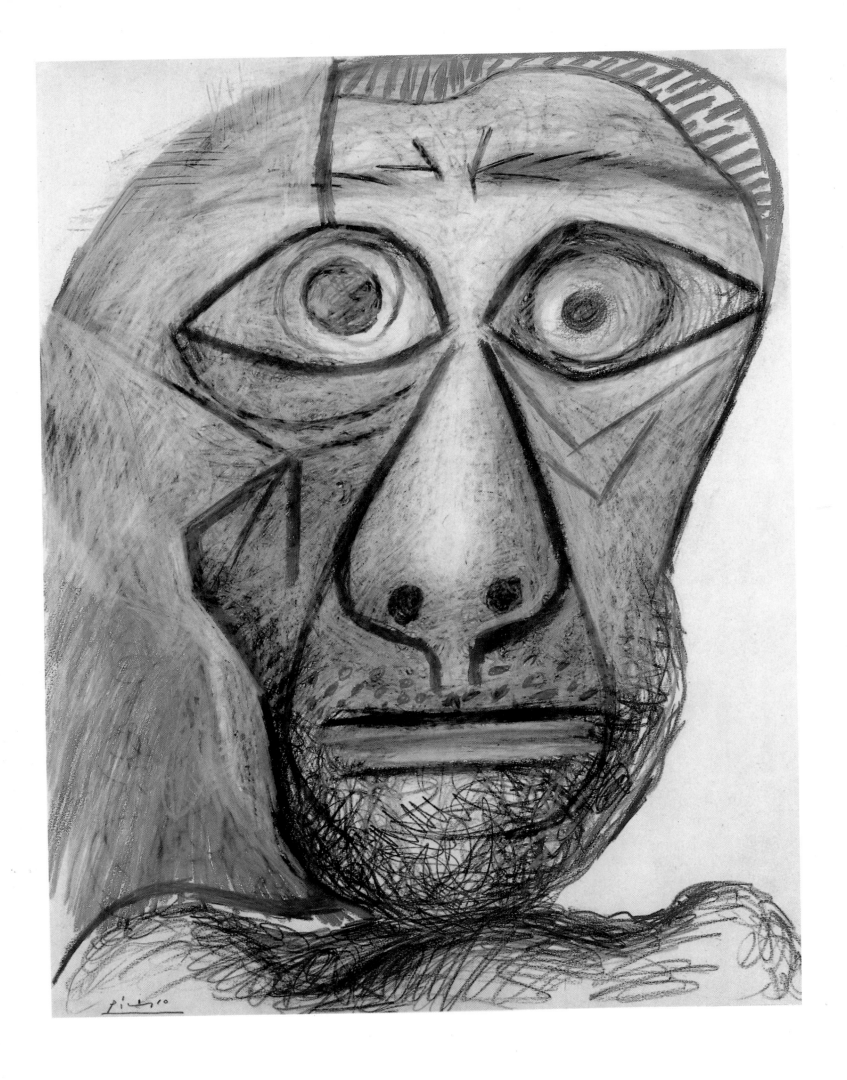

I The Image of the Artist

Picasso was that rare thing in history, an artist of cultic presence, a secular manifestation of the spirit, a genuinely commanding phenomenon. Picasso's name and work are synonymous with 20th-century art. They are the very definition of our era's artistic endeavour. This was already the case in his own lifetime; and by now he has long since become a myth, a legend for the age of mass media. Because this is so, Picasso's image as artist is one of infinite diversity. Many were those who played a part in his life, and many were those who left records. The abundance of documents relating to his life and work, and above all Picasso's own statements, permit us access to his art.[1] And yet the vast quantity of biographical material is a mere drop compared with the ocean of analyses, critiques, studies and theses concerning his work that has been pouring steadily out for decades. As in the case of other artists, commentaries and exhibition notes accompanied his work from the outset. But as awareness of Picasso's distinctive importance grew, so too did the tidal wave of published statements on his work.[2]

Nowadays it is no longer unusual for an entire museum to be devoted to the work of a major artist. But three are devoted to Picasso's: in Antibes, in Barcelona, and in Paris. And the first two of these were created during the artist's lifetime. Picasso was not only significant and famous, he was also popular in the extreme – because his work seemed the very epitome of what people thought was modern in the visual arts. On the one hand, he turned his back on tradition and deconstructed images of natural form. On the other hand, he deliberately and randomly shifted the goalposts of visual creation. In a word, the bizarrely denatured forms that are characteristic of modern art are fully present in Picasso's work.

This has come to mean that Picasso's creations are not merely part of the sum total of 20th-century art, but rather are seen as its icons. "Guernica", for instance (pp. 400/401), is unquestionably the most famous modern painting, worldwide, matched as an art classic only by works such as Leonardo's "Mona Lisa" or Rembrandt's "Night Watch". The bombing of Guernica, thanks to Picasso, came to define the horror of modern war, the inhumanity of man to his fellow man. And, uniquely in modern art, "Guernica"

Self-portrait at the Age of 36
Autoportrait à l'âge de trente-six ans
Montrouge, 1917
Pencil on paper, 34 x 26.8 cm
Zervos III, 75
Maya Ruiz-Picasso Collection

Self-portrait (Head)
Autoportrait (Tête)
Mougins, 30 June 1972
Pencil and crayon on paper,
65.7 x 50.5 cm
Zervos XXXIII, 435
Tokyo, Fuji Television Gallery

has exerted a quite remarkable influence on younger artists such as the American pop artist Peter Saul or the political artists of the Spanish group "Equipo Crónica".[3] Their new versions and reworkings show how a single work can provide the matrix in which a sense of the "Zeitgeist" is popularly expressed. Thus in the early 1950s the portraits Picasso painted of a young girl, Sylvette David, transformed the innocent pony-tail, the teenage girl's hair-style of the day, into the very emblem of an epoch (cf. p. 519).

Not till Andy Warhol did his serigraphs of the famous (Marilyn Monroe, J. F. Kennedy, or Elvis Presley) were artworks again to make such an impact. No other 20th-century artist achieved Picasso's astounding omnipresence, not merely through his art but in his own right. The early painting "Child Holding a Dove" (p. 12) is a two-dimensional, stylized childish pose; but once the image was reproduced in millions it came to stand for naive grace and innocence. Indeed, it became so familiar that it (and its creator) entered the colourful world of comics.[4] And when the French film director François Truffaut made his classic "Jules et Jim" in 1961, it was Picasso's pictures he chose as aptest to signal the cultural habitat of the European intellectual before the Second World War. Significant sequences in the film show Picasso reproductions behind the protagonists.[5]

If Picasso's work acquired this kind of emblematic function, so too did the artist himself, as far as his contemporaries were concerned. It was only to be expected, then, that just a few years after his death he would be made the titular hero of a satirical film about artistic and political trends in the 20th century, "The Adventures of Picasso."[6] Precisely because Picasso was equated with modern art per se, all the extremes of public responses were unloaded upon him, at every stage in his career. When the National Gallery in London organized the first major post-war Picasso show in England, one newspaper described him as a great artist, a poet, a genius whose creations were inspired by the profoundest of dreams, while another damned his art as the work of the devil, dismissed piggy-nosed portraits as the imaginings of a schizophrenic, and declared that such work should not be publicly exhibited in England.[7]

Both extremes are the product of clichés and widely shared preconceptions. Inevitably the dismissal reminds us of the abuse the Nazis heaped on art they considered "degenerate". Equally, though, the praise is nothing but petty phrase-mongering, and tells us nothing of Picasso's success in realizing his intentions, or of his sheer skill. Though these views appear irreconcilable, there is less of a polarity than we might first think; in fact, they share a certain common ground. If the foes of modern art condemn it as the work of lunatics and would ban it if they had a say in the matter, its enthusiastic advocates emphasize what seems inspired and supposedly irrational, inaccessible to cool reason; and in both cases something beyond the everyday experience of the senses is taken to

The Tramp
Le chemineau
Madrid, 3 June 1901
Watercolour and pencil on paper,
20.4 x 12.4 cm
Zervos XXI, 240; DB V, 50; Palau 516
Reims, Musée des Beaux-Arts

Beggar in a Cap
L'homme à la casquette
Corunna, early 1895
Oil on canvas, 72.5 x 50 cm
Zervos I, 4; Palau 64; MPP$_1$
Paris, Musée Picasso

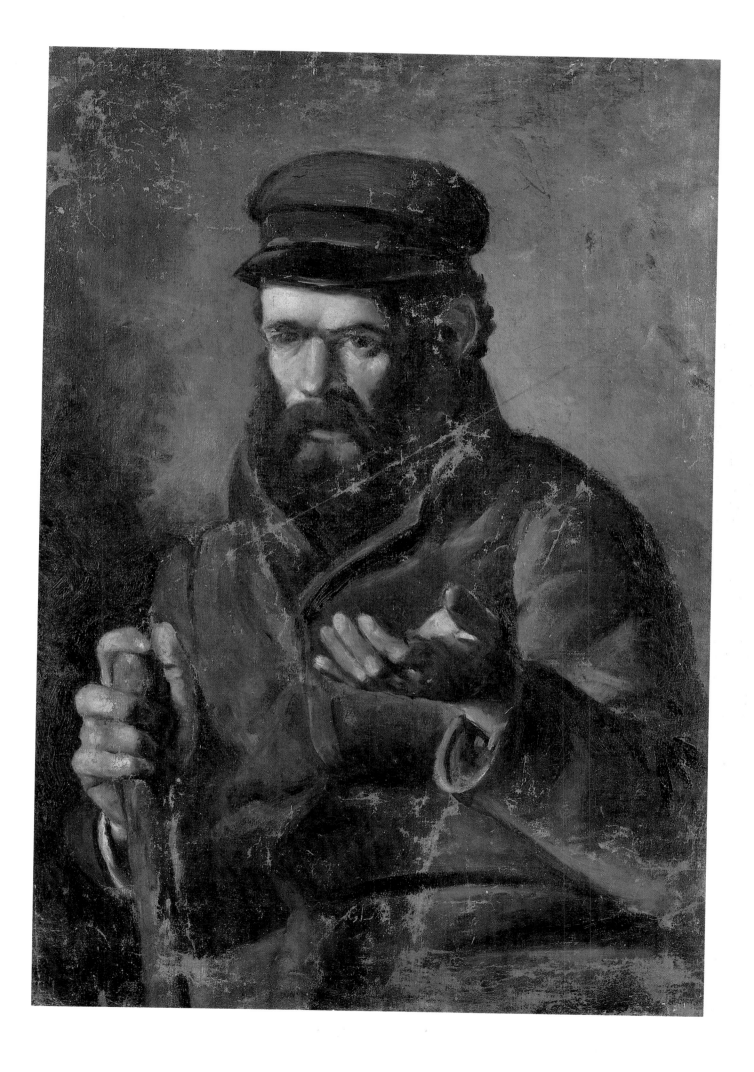

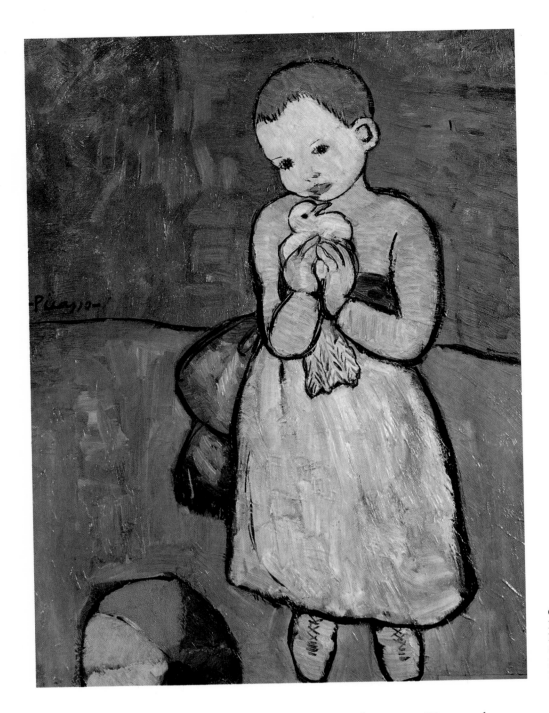

Child Holding a Dove
L'enfant au pigeon
Paris, autumn 1901
Oil on canvas, 73 x 54 cm
Zervos I, 83; DB VI, 14; Palau 669
London, National Gallery (anonymous loan)

be the final source of creativity. At a very early stage, Picasso haters and lovers alike saw his talent as something demonic. One American critic called him the "devil incarnate" in 1910; and the "New York Times", generally a restrained and proper paper, gnashed that he was the very devil and that his audacity was breathtaking, when his first American exhibition was held in Alfred Stieglitz's Photo Secession Gallery in New York in 1911. Not many years later, German critics (and not even the worst) were busy perpetuating the usual equation of visual deconstruction with insanity, viewing Picasso himself as a neurotic and pithily announcing: "People are no longer locked away in asylums. Nowadays they found Cubism."[8]

This is how legends are made; and, to this day, Picasso seems more the stuff of myth than a flesh-and-blood historical person. He himself, of course, must share the blame. Many who knew him in

The Gourmet (The White Child)
Le gourmet (Le gourmand)
Gósol or Paris, 1901
Oil on canvas, 92.8 x 68.3 cm
Zervos I, 51; DB V,53; Palau 617
Washington (DC), National Gallery of Art,
Chester Dale Collection

The Embrace
L'étreinte
Barcelona, 1903
Pastel on cardboard, 98 x 57 cm
Zervos I, 161; DB IX,12; Palau 856
Paris, Musée de l'Orangerie

the early days in Paris were quick to detect the artistic energy, creative depth and autonomous will of his art in the artist too. Picasso was a striking person, a stocky, robust Spaniard who invariably made an impression. He was all charisma and self-confidence. With his hair tumbling across his forehead and his intense gaze, his attitude became a pose. Everyone who photographed Picasso stressed his demonic side,[9] and in doing so, of course, merely repeated what he had proclaimed to be the case: for it was a demonic Picasso who appeared in a number of early self-portraits (cf. pp. 6, 80, 81, 147 and 152). From the outset, fellow-painters and critics and collectors saw Picasso in ways he himself dictated.

This has remained the case to the present day. Picasso's personal appearance, his style of life, his wilfulness, and his relations with women (attesting his vitality in the eyes of many), have provided

13 The Image of the Artist

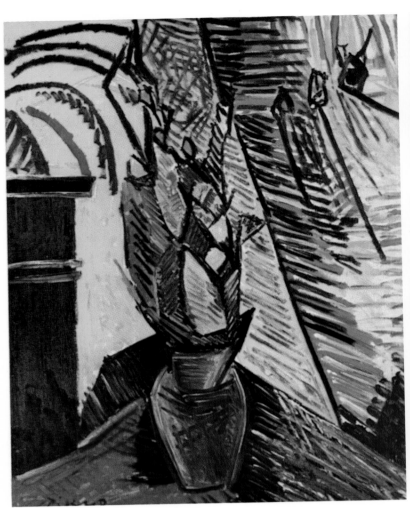 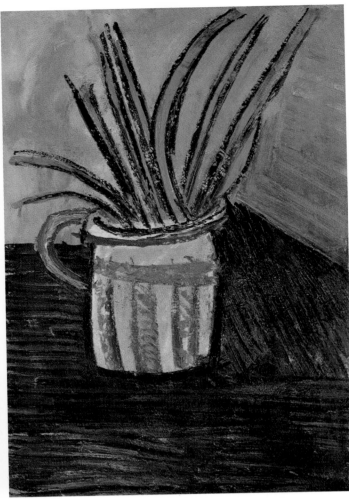

Vase with Flowers
Fleurs sur une table
Paris, autumn 1907
Oil on canvas, 92.1 x 73 cm
Zervos II*, 30; DR 70
New York, The Museum of Modern Art

Exotic Flowers
Fleurs exotiques (Bouquet dans un vase)
Paris, summer 1907
Oil on canvas, 56 x 38 cm
Zervos II*, 37; DR 64
Monte Carlo, Private collection

irresistible media bait. In 1955, Georges Clouzot made a lengthy documentary of the artist at work, and the journalists had a field day celebrating Picasso as a kind of superman: "Summer 1955, and the cameras are rolling in the Victorine studios at Nice . . . Picasso, in shorts and bare to the waist, his torso tanned, his feet in slippers, strides into the bright daylight: a living bronze god come down off his pedestal, mighty, majestic, he belongs to all ages, to primitive cultures and to future times light years away. Depending on how the light falls on his head, his powerful chest or his sturdy legs, he can look like a witch doctor or a Roman emperor."[10] The unintentional humour of comparisons such as these nicely illustrates the image of Picasso that was then widely taken for granted. At a time when most people were glad if they could draw their pensions in peace and quiet, a Picasso rampant wearing a sporty turtle-neck jumper or beach clothes or in pugilist pose, stripped to the waist, was a conspicuous, dynamic exception to the rule.

But none of this would have happened without his art, which to this day resists easy access. The sheer size of his output is daunting. There are over ten thousand paintings alone. Then there are great numbers of sketches and drawings. There are printed graphics. There are ceramics and sculptures.[11] During his own lifetime, Picasso kept for himself a number of his works that he considered im-

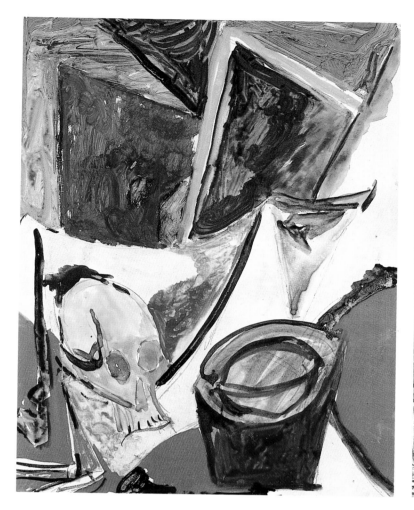

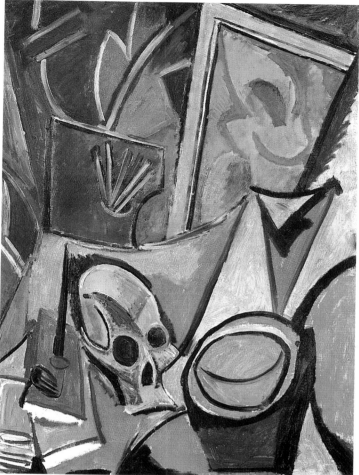

portant, and some of these now constitute the core of the Musée Picasso's collection in Paris. Large quantities of work left at his death have been examined and classified; although no one yet has a full grasp of his entire œuvre, some help is to hand. The 34-volume catalogue of Picasso's work, compiled by Christian Zervos and published between 1942 and 1978, while far from complete reproduces over 16,000 works. Other catalogues document over 600 sculptures and 200-plus ceramic works;[12] they too are incomplete. For decades, major shows throughout the world have not only presented Picasso's work to an amazed public but have also laid the foundation of an understanding of his art.[13]

Born on 20 October 1881 in Málaga, the son of a painter and art teacher, Picasso started to draw and paint at the age of nine. His father guided him, and later he was professionally trained at Corunna, Barcelona and Madrid. At the age of fifteen he was already successfully taking part in exhibitions. In 1898, disappointed by academic teachings, he gave up his studies and set about making a name for himself in artistic circles in Barcelona, and then in Paris. By 1901 he had a Paris show in the Galerie Vollard almost to himself, sharing it with another Basque; he sold 15 of his 65 paintings and drawings before the exhibition had even opened.

The fact that a foreign newcomer could make so rapid an im-

Composition with a Skull (Sketch)
Composition à la tête de mort (Etude)
Paris, late spring 1908
Watercolour, gouache and pencil on paper,
32.5 x 24.2 cm
Zervos II*,49; DR 171
Moscow, Pushkin Museum

Composition with a Skull
Composition à la tête de mort
Paris, late spring 1908
Oil on canvas, 116 x 89 cm
Zervos II*, 50; DR 172
St. Petersburg, Hermitage

pression speaks volumes about the turn-of-the-century art market. But it also implies a great deal about the artist's energy and self-assurance. In both his early periods, Picasso was influenced by 19th-century academic approaches, and characteristically re-worked art that was currently in vogue or had come back into fashion. In 1901/02, three years after taking the plunge into the uncertain life of an artist, Picasso established not so much a style of his own as a style that was identifiably his and thus commercially useful. This marked the outset of the Blue and Rose Periods, which lasted till 1906 and have remained the public's favourites to this day. The year 1906 was both a caesura and a transition. Once again Picasso was trying out new forms; and, just as he was achieving recognition, he abandoned the path he had first chosen to take.

In the Blue and Rose Periods, form and content had seemed to harmonize. Now Picasso tackled form alone, at a radical level. In the Blue and Rose Periods, stylized forms had been given symbolic values fitting the portrayal of the old and lonely, of the poor and hungry, of beggars. In putting the earlier monochrome approach aside, the colourful world of circus artistes and harlequins in the Rose Period betrayed nothing of Picasso's creative emotion at that date. Melancholy lay draped over the unmerry masquerade like a veil.

In 1906 warm reddish-brown tones continued to be emphasized, but now spatial forms became Picasso's dominant concern. The

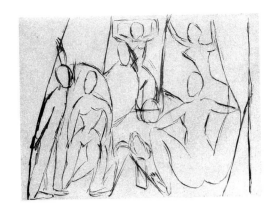

Study for "Les Demoiselles d'Avignon"
Etude pour "Les Demoiselles d'Avignon"
Paris, May 1907
Pencil on paper, 10.5 x 13.6 cm
Zervos II**, 632; Palau 1526; MPP 1862
Paris, Musée Picasso

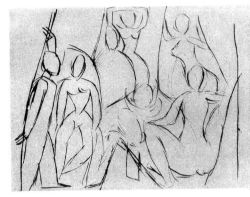

Study for "Les Demoiselles d'Avignon"
Etude pour "Les Demoiselles d'Avignon"
Paris, May 1907
Pencil on paper, 13.5 x 10.5 cm
Zervos II**, 633; Palau 1527; MPP 1862
Paris, Musée Picasso

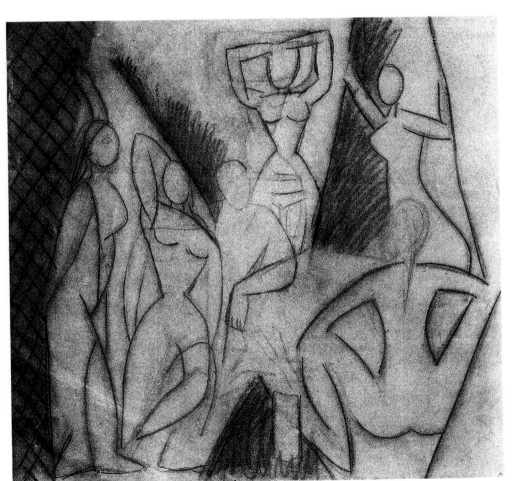

Study for "Les Demoiselles d'Avignon"
Etude pour "Les Demoiselles d'Avignon"
Paris, May 1907
Charcoal on paper, 47.6 x 65 cm
Zervos II**, 644; Palau 1548
Basel, Öffentliche Kunstsammlung Basel,
Kupferstichkabinett, Gift of Douglas Cooper

Guitar, Sheet Music and Glass
Guitare, partition, verre
Paris, after 18 November 1912
Gouache, charcoal and papiers collés,
47.9 x 36.5 cm
Zervos II**, 423; DR 513
San Antonio (TX), Marion Koogler
McNay Art Institute

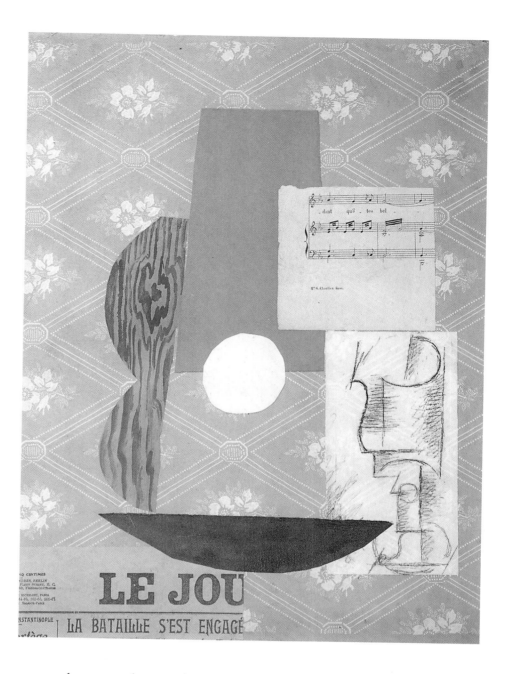

Head of a Man
Tête d'homme
Paris, 1912
Pencil on paper, 62.5 x 47 cm
Zervos II*, 327
Private collection

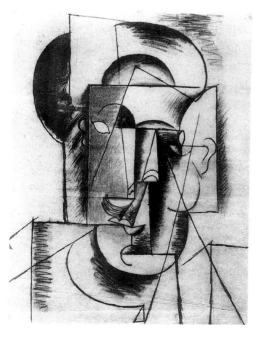

new work centred upon heavy objects rendered geometrically, and must be seen as a preliminary phase leading up to the great experiment of 1907. Picasso made his breakthrough in "Les Demoiselles d'Avignon" (p. 159), achieving a new formal idiom and pointing the way for much of Modernist art. Together with Georges Braque, a younger artist, he established Cubism, the first radically new artistic style of the 20th century. Initially they borrowed the convention of using simplified geometrical forms (hence the name Cubism), arranging them loosely on the surface of the composition without any attempt at unified spatial depth. Around 1910 they moved on to analytical Cubism, in which the spatial and line qualities of the subjects portrayed extend autonomously in parallel and counterpoint across the composition. Pictures thus created look like an agitated juxtaposition of interlocking forms.

In the third and final phase, post–1912, which was known as synthetic Cubism, Picasso and Braque achived compacted and au-

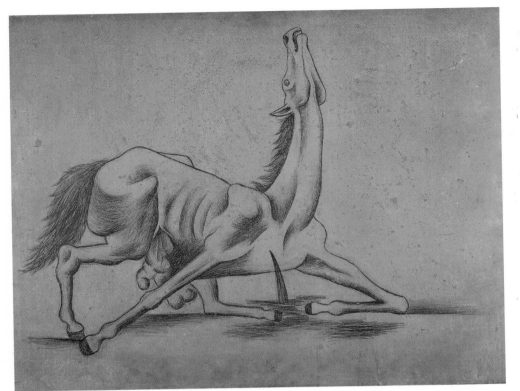

Dying Horse
Cheval éventré
Barcelona, 1917
Black chalk on canvas,
80.2 x 103.3 cm
Zervos III, 70; MPB 110.012
Barcelona, Museu Picasso

tonomous structures. Questions of a material or spatial nature became the subjects of their works: using materials that often lay ready to hand, such as newspaper, wood, sand and so forth, they established a new concept of the visual image. Cubism made Picasso internationally famous and lodged him in the history of art. Though he had changed modern art, Picasso himself did not remain in a rut, much to the admiration of his friends, patrons and advo-

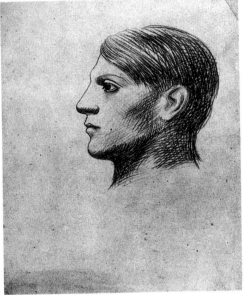

Self-portrait (Profile)
Autoportrait (Profil)
March 1921
Pencil on paper, 27 x 21 cm
Zervos XXX, 149

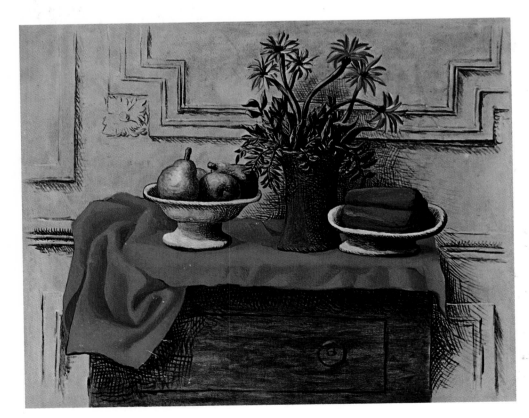

Still Life on a Chest of Drawers
Nature morte sur la commode
Paris, 1919
Oil on canvas, 81 x 100 cm
Zervos III, 443; MPP 63
Paris, Musée Picasso

cates; and in 1916 he surprised everyone by returning to conventional figural and spatial values, painting stylized, monumental, proportionally random figures that made a classical impression.

From about 1924 a lengthy period set in which can best be described as a synthesis of the two formal extremes of his œuvre to date. The Cubist fracturing of the image was married to clearer, more concentrated spatial zones and linear structures. This movement culminated in his most famous work, "Guernica", painted in 1937 for the rightful republican government in Spain, as a protest against totalitarian warmongering.

The formal idiom Picasso had now evolved was to remain at the core of his work till his death. In his later phases he reworked important works by earlier artists, to a greater or lesser extent. He further developed his own methods of three-dimensional work, and branched out into new areas, such as ceramics.

To review Picasso's evolution in this way is to present an essentially familiar view of an unarguably major artist. After the years spent learning the craft come the periods of experiment and of gradually locating a personal style. Following an authoritative period of mature mastery comes a late period which essentially plays variations on familiar themes. But if we look more closely at Picasso's case we begin to have our doubts. In his so-called classical period, Picasso rendered the human image in monumental fashion; but at the same time he was painting works that continued the line of synthetic Cubism, with all its deconstruction and indeed destruction of that selfsame human image. Surely this is an inconsistency?

These different works do still reveal an artist using his own artistic methods with complete assurance. They have that in common. In other cases, though, not even that common ground can be established. If we look at Picasso's early studies, done while he was being taught, they are clearly the work of a talented pupil. At the age of

Bowl of Fruit and Guitar
Compotier et guitare
9 September 1920
Gouache and watercolour on paper,
27.2 x 21 cm
Zervos XXX, 68
Private collection

The Open Book
Le livre ouvert
10 September 1920
Gouache and watercolour on paper,
26.7 x 21 cm
Zervos VI, 1383
Private collection

Candelabrum on Table
Le gueridon
Fontainebleau, 7 July 1920
Gouache and watercolour on paper,
26.7 x 21 cm
Zervos VI, 1384
Private collection

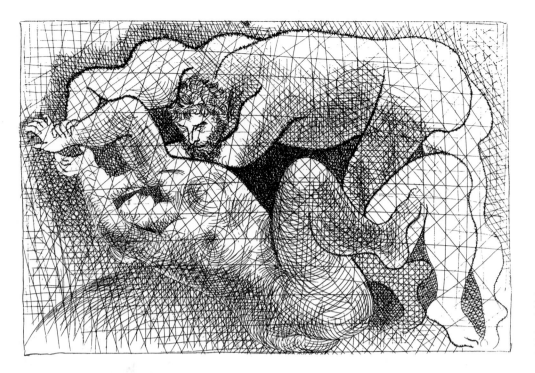

Man and Woman
Homme et femme
1927
Etching, 19.2 x 28 cm
Bloch 77; Geiser 118 b

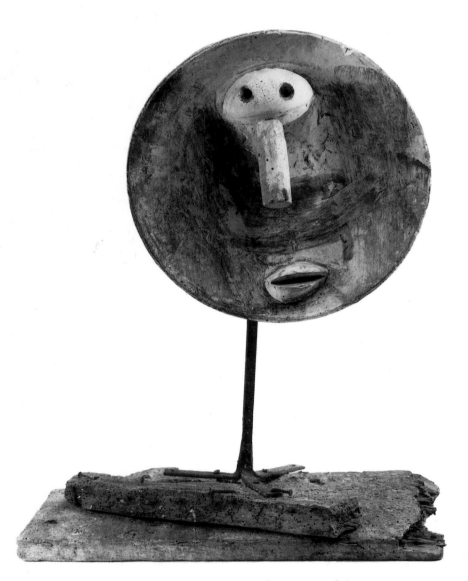

Head
Tête
Boisgeloup (?), 1931
Coloured plaster, wood, iron and nails,
57 x 48 x 23.5 cm
Spies 79; MPP 268
Paris, Musée Picasso

The Image of the Artist **20**

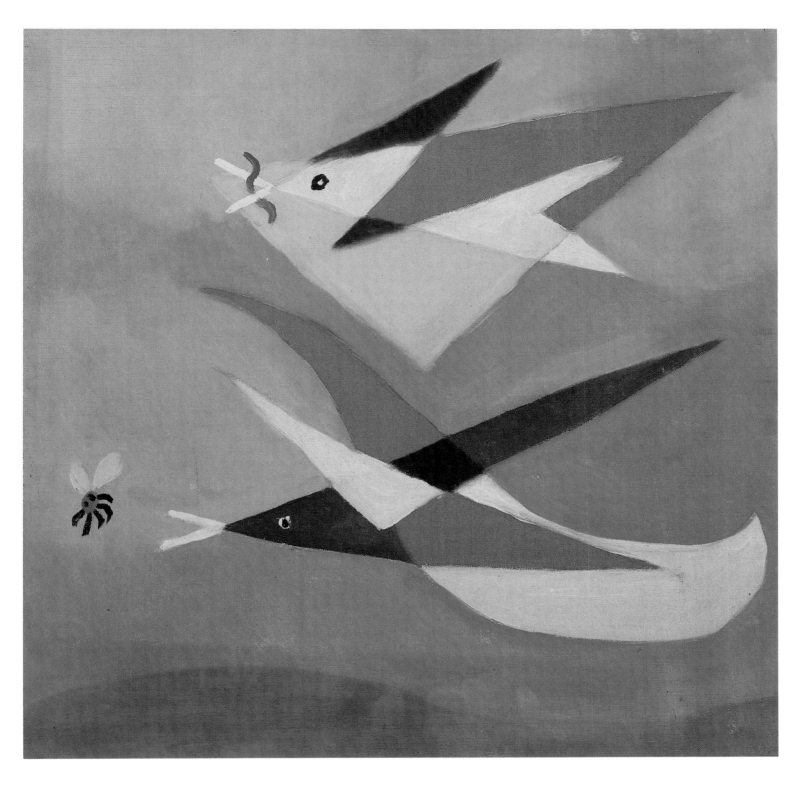

twelve or thirteen his drawings of plaster-cast figures strikingly had the contoured depth and volume that was required (cf. pp. 36 and 37). But the fourth of his sketches done on 1 May 1937 (p. 391) betrays none of this facility. Scrawled outlines sketch an irregular head, neck, rump and legs for the horse. There is little evidence for any well-planned distinction between the essential and unnecessary. All four legs and both eyes, though they would not be visible in a perspective rendering of a side view, are there to be seen. In other words, the drawing seems more a child's drawing than anything else. Yet it would be wrong to draw overhasty conclusions.

The Image of the Artist **21**

The Swallows
Les hirondelles
Paris, 14 May 1932
Oil on canvas, 41 x 41 cm
Zervos VII, 342
Paris, Courtesy Galerie Louise Leiris

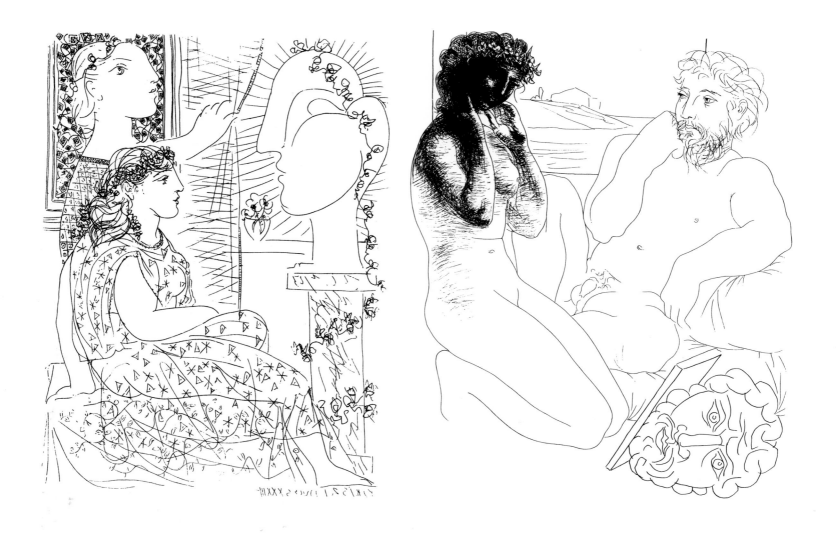

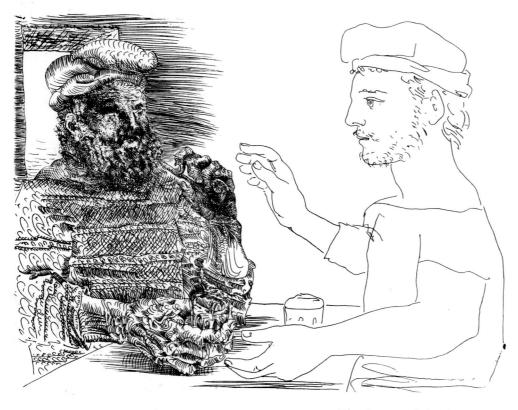

Two Dressed Models and a Sculpture of a Head
("Suite Vollard", plate 42)
Deux modèles vêtus
Paris, 21 March 1933
Etching, 26.7 x 19.3 cm
Bloch 150; Geiser 302 II

Sculptor and Kneeling Model
("Suite Vollard", plate 69)
Sculpteur et modèle agenouillé
Paris, 8 April 1933
Etching, 36.7 x 29.8 cm
Bloch 178; Geiser 331 II c

Two Catalan Drinkers
("Suite Vollard", plate 12)
Deux buveurs catalans
Paris, 29 November 1934
Etching, 23.7 x 29.9 cm
Bloch 228; Geiser 442 II c

Nine Heads
Neuf têtes
7 and 9 November 1934
Mixed media, 31.7 x 22.6 cm
Bloch 285; Geiser 438 Bb

Picasso, then aged 56, was not entering a premature second childhood: the sketch was one of many that served to prepare his great work "Guernica", done when he was at the height of his powers.

This poses a problem. Usual ways of examining an artist's creative characteristics do not allow for the fact that the urge to record a fleeting inspiration may lead him to forget the rules he has long since mastered and to relapse into a pre-training phase. In fact, people generally assume that mastery (and certainly genius) implies absolutely perfect technical command. In Picasso's case there is a discontinuity; indeed, his work is full of discontinuities. For it is far from simple to trace the meaning of his subjects, intentions, and aims.

Picasso's Cubist paintings and sculptures, and the late series of

23 The Image of the Artist

variations on Old Master paintings, alike show him aiming at absolute artistic autonomy of means. References to an objective world outside that of the artwork are subsidiary or indeed entirely immaterial. This, it would seem, is the very core of Picasso's art. It is this that made him so famous – and so controversial.

This may be true, but equally it is at variance with the facts; for Picasso's art was also, and to at least the same degree, an art of traditional pictorial concerns, from start to finish. We might instance his persistent, even stubborn adherence to the historical painting, a form considered superseded in 20th-century art. If the sixteen-year-old painted the allegorical "Science and Charity" (pp. 50/51) in 1897, we need only recall prevailing ideas on art in Spain at the time, and the training the young Picasso was receiving. And in 1903, in the most important painting of his Blue Period, "La Vie (Life)" (p. 105), Picasso transformed the suicide of his friend Carlos Casagemas into an allegorical scene: this, if we choose, we can view as a product of strong emotion, a late expression of his training. But "Guernica" too, much later, treats a real event in the form of a symbolic history painting. Similarly in "The Charnel House" (p. 457) and "Massacre in Korea" (pp. 500/501), specific wars in 1945 and 1951, not war as an abstract universal, prompt attempts to deal with exact historical subjects. And historical painting is by no means the only area in which Picasso pursued verifiable subject matter. His interest in formal games-playing was accompanied by an equally strong lifelong interest in certain subjects: painter and model, circus artistes and harlequins, lovers,

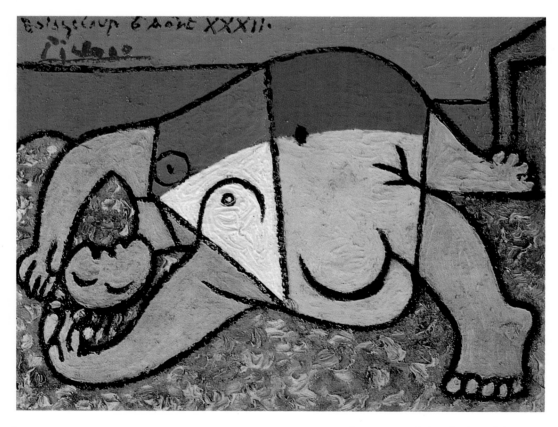

Reclining Woman on the Beach
Femme couchée sur la plage
Boisgeloup, 6 August 1932
Oil on canvas, 27 x 35 cm
Not in Zervos
Paris, Private collection

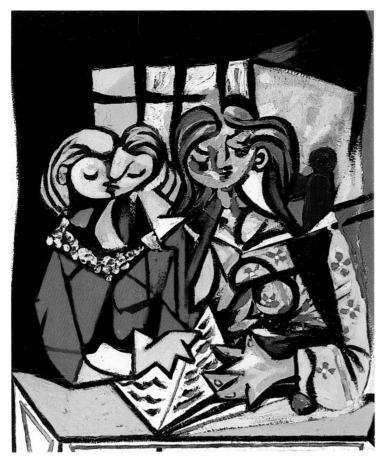

Two Figures
Deux personnages
Boisgeloup, 28 March 1934
Oil on canvas, 81.8 x 65.3 cm
Zervos VIII, 193
Private collection

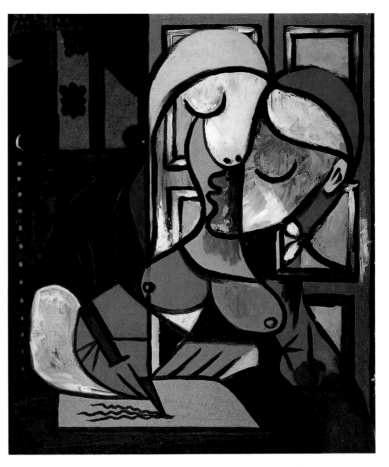

Woman Writing
Femme écrivant
Paris (?), 1934
Oil on canvas, 162 x 130 cm
Zervos VIII, 183
New York, The Museum of Modern Art

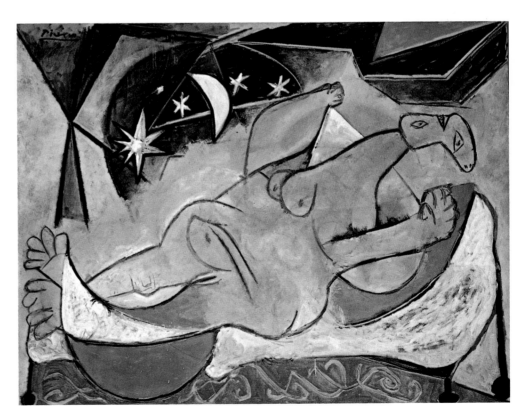

Reclining Female Nude with Starry Sky
Femme nue couchée
Paris, 12 August and 2 October 1936
Oil on canvas, 130.5 x 162 cm
Zervos VIII, 310
Paris, Musée National d'Art Moderne,
Centre Georges Pompidou, Gift of Kahnweiler

25 The Image of the Artist

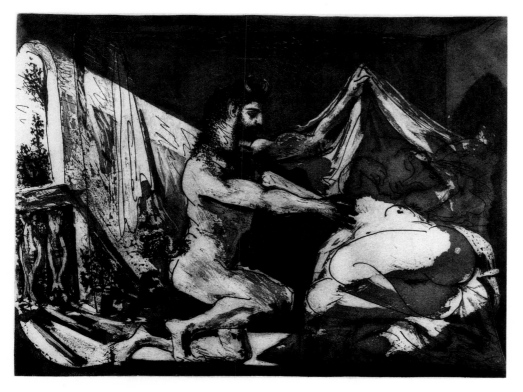

Faun Unveiling a Woman
("Suite Vollard", plate 27)
Faune dévoilant une femme
Paris, 12 June 1936
Etching and aquatint, 31.7 x 41.7 cm
Bloch 230; Baer 609

mother and child, bullfights. His treatment of these subjects persisted as late as the etchings from his final years.

But no single, unified, overall picture emerges. Does this imply that Picasso's art was exclusively centred upon himself? That it had no real concerns?[14] This must be disputed. What is true is that conventional methods of analysis cannot gain a purchase on his art. This explains the widely held and oft repeated claim that Picasso was basically a chameleon personality whose true distinguishing quality was that he had no true distinguishing quality – apart from

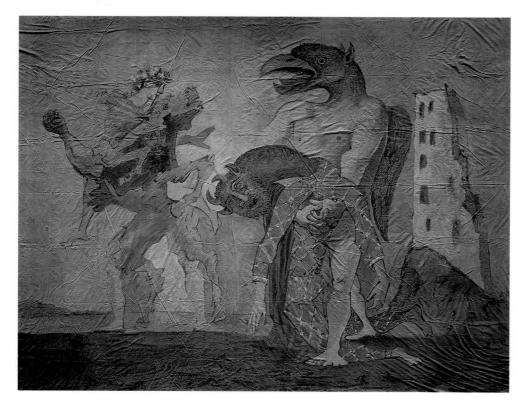

Curtain for "14 juillet" by Romain Rolland
Le rideau pour "14 juillet" de Romain Rolland
Made by Louis Fernandez from a design by Picasso
dated 28 May 1936 and titled "The Hide of the
Minotaur in Harlequin Costume" (cf. p. 378)
Paris, between 28 May and 14 July 1936
Tempera on cloth, approx. 11 x 18 m
Toulouse, Musée des Augustins,
on loan from the artist's estate

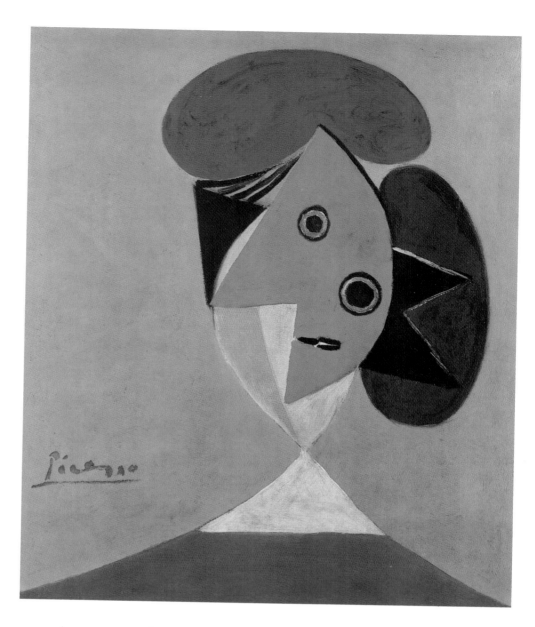

Bust of a Woman
Buste de femme
Paris (?), 1935
Oil on canvas, 65 x 54 cm
Not in Zervos
Basel, Private collection

a perfect grasp of artistic means, a childlike lack of conscious intent, an infinite curiosity and interest in experiment, together with a mulish persistence and unusual energy. Picasso's style, in this view, consists in his command of every available style.

This is too simple. In making Picasso both all and nothing, this interpretation capitulates before any challenge, substitutes anecdotes for analysis, and gives us statistics instead of evaluation.[15] The unusual lifelong devotion implied in Picasso's more-than-lifesize artistic output demands to be taken seriously. This means looking with a critical eye, seeing the weaknesses along with the strengths, and so making Picasso's real greatness comprehensible. Many works of criticism have been devoted to particular areas of Picasso's creative work, and have extended our understanding in important ways. Every age and every generation, however, will seek a new approach of its own to Picasso's art, will want a Picasso of its own. This book has been written for our own time. It is an attempt to trace a life lived in the service of art, to identify what is universal in the sheer copiousness of the unique.

27 The Image of the Artist

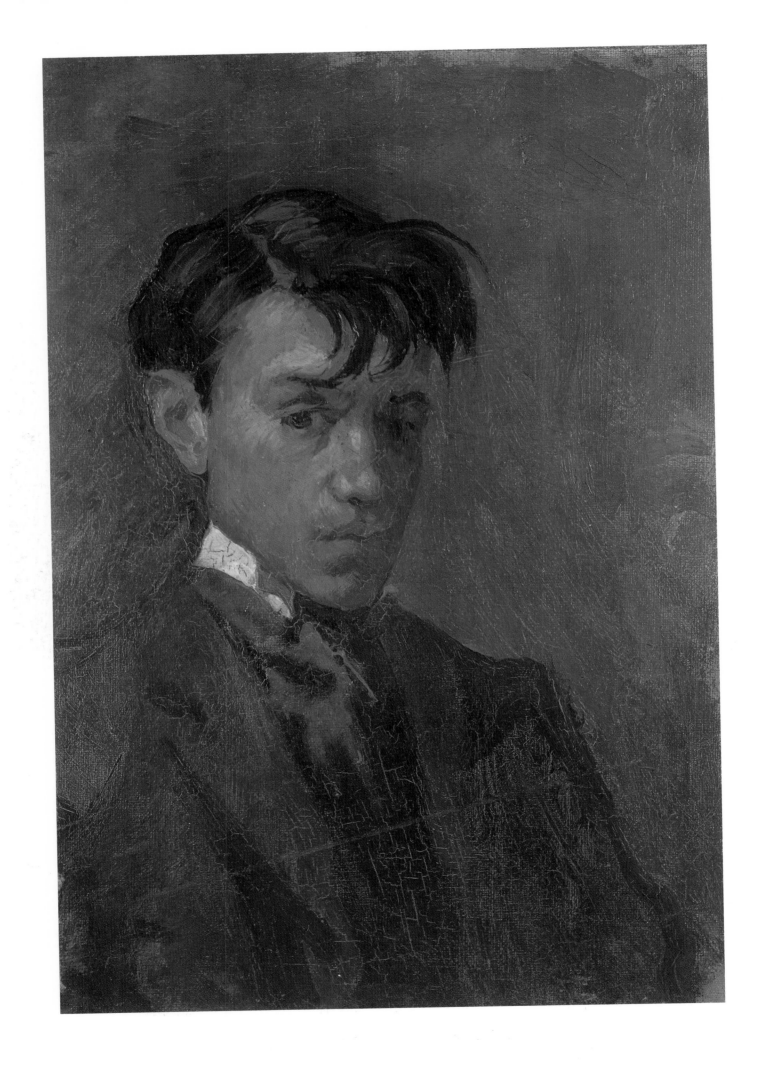

2 The Making of a Genius 1890–1898

One of the earliest surviving drawings by Picasso dates from November 1890. The artist recalled that "Hercules with His Club" (see right) was copied from a painting in the parental home.[16] It is an awkward piece of drawing, of course. The proportions are wrong, the limbs out of scale, the left thigh far thicker than the right, the left arm anatomically incorrect; and the lines are uncertain, the repeated breaking off and resuming sure signs of inexperience. And yet it is also a remarkable drawing. After all, it was done by a nine-year-old. Most drawings by children of that age have the hallmarks of children's indifference to figural fidelity. This is a child's drawing; but it is not childish. It is no wonder that Picasso's painter father recognised his son's talent at an early stage and encouraged the boy accordingly. At eleven, the young Picasso was going to art school at Corunna. In 1895, aged just fourteen, he was admitted to the Academy of Art in Barcelona. A mere year later a large canvas by the young artist, titled "First Communion" (p. 38), was shown in a public exhibition.[17]

There is no need to follow the customary line of seeing Picasso as a miraculous infant prodigy.[18] Still, the sheer wealth and quality of his youthful output are staggering. No other artist has left us so much evidence relating to this early period of life – and of course it is a crucial period. One of the most fascinating sights 20th-century art can offer us is the spectacle of the young Picasso making his steady early advance.

His family realised that he was exceptionally gifted, and preserved the youngster's efforts carefully if they were even only slightly distinctive. The paintings, drawings and sketches Picasso did as a boy remained in his sister's home at Barcelona till the artist donated them to the Museu Picasso there in 1970. The collection is impressive for its sheer size: 213 oil paintings done on canvas, cardboard or other surfaces; 681 drawings, pastels and watercolours on paper; 17 sketchbooks and albums; four books with drawings in the margins; one etching; and various other artefacts. Fourteen of the paintings on wood or canvas, and a full 504 of the sheets with drawings, have been used on both sides (often for studies); and the sketchbooks contain 826 pages of drawings. The juvenilia

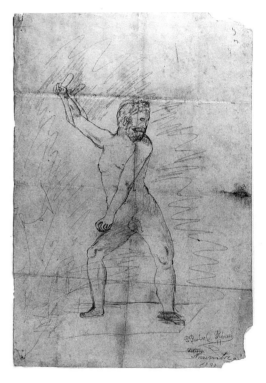

Hercules with His Club
Hercule avec sa massue
Málaga, November 1890
Pencil on paper, 49.6 x 32 cm
Not in Zervos; Palau I; MPB 110.842
Barcelona, Museu Picasso

Self-portrait with Uncombed Hair
Autoportrait mal coiffé
Barcelona, 1896
Oil on canvas, 32.7 x 23.6 cm
Not in Zervos; Palau 154; MPB 110.076
Barcelona, Museu Picasso

Acanthus Leaves (Academic drawing)
Feuilles d'acanthe (Dessin académique)
Corunna, 1892/93
Black chalk and charcoal on paper,
31.5 x 23.8 cm
Not in Zervos; Palau 12; MPB 110.859
Barcelona, Museu Picasso

Sketches in a Schoolbook
Etudes dans un livre d'école
Corunna, 1891
Pencil and ink on paper, 22.2 x 14.5 cm
Not in Zervos; Palau 7; MPB 110.930
Barcelona, Museu Picasso

Bullfight
Course de taureaux
Corunna, 1892
Pencil and gouache, 13 x 21 cm
Zervos XXI, 2
Estate of the artist

that has survived from the years 1890 to 1904, from the boy Picasso's first attempts to the Blue Period, runs to over 2,200 works in various formats and using various techniques.[19]

Different though the works are, they have the same quality, whatever one looks at. An impressive example is the pencil sketch of two cavalrymen done around 1891 to 1893 by the ten- or twelve-year-old Picasso in a schoolbook (p. 32). The horses and riders are done correctly, on the whole, and mistakes in detail do not detract from this. True, the horses' heads ought to be larger, and the officers' chests and arms could be improved; but the portrayal is not at all a child's, and the drawing shows signs of an increasing grasp of line. The boy's talent has noticeably amplified since "Hercules with His Club" and the way is clear to the art pupil's academic studies, done with full assurance. Those studies display the student's technical

Doves and Rabbits
Pigeons et lapins
Corunna, 1892
Pencil on paper, 13 x 21 cm
Zervos XXI, 4; Palau 14
Estate of the artist

Bullfight and Doves
Course de taureaux et pigeons
Corunna, 1892
Pencil on paper, 13.5 x 20.2 cm
Not in Zervos; Palau 5; MPB 110.869
Barcelona, Museu Picasso

Bullfight
Course de taureaux
Corunna, 1892
Pencil and gouache on paper, 13 x 21 cm
Zervos XXI, 5; Palau 13
Estate of the artist

prowess and his command of methods deliberately deployed; the essential visual approach remains the same.

The young Picasso's gift was a striking one, clearly different from normal children's artistic efforts. The artist himself felt as much: "It is quite remarkable that I never did childish drawings. Never. Not even as a very small boy."[20] What Picasso means is the kind of drawings children do unprompted, without any adult suggesting a subject; such drawings, free of influence, are nowadays considered the true sign of a child's creative impulses. The drawings the boy Picasso scribbled in his school books were doubtless the same kind of child's drawing; yet it is these that show us that he always drew like an adult.

But it would be wrong to take this as infallible proof of above-average maturity or even genius. A child's drawing derives its shape

31 The Making of a Genius 1890 – 1898

Double Study of a Bearded Man in Profile
Corunna, 1892/93
Pencil on paper, 23.7 x 31 cm
Zervos VI, 10; Palau 11
Private collection

Two Mounted Soldiers and the Tower of a Fortress
Dos soldados a caballo y un torreón
Corunna, 1894
Ink on paper, 27.1 x 18.5 cm
Not in Zervos; MPB 110.866
Barcelona, Museu Picasso

Double Study of the Left Eye
Corunna, 1892/93
Pencil on paper, 23.7 x 31.5 cm
Zervos VI, 9; Palau 9
Private collection

and imaginative form from a historical process, and bears witness to particular cultural influences.[21] Of course any child who draws is entering into a fundamental act of expression. But the nature of that expression is conditioned. It is only recently that such drawings have come to be valued in their own right, and so very few independently created drawings by children survive from earlier times.[22] And most of those that do betray the educational influence of adults. Just as children were once dressed and brought up as little adults, so too adults' visual preconceptions were once instilled into them. Children's drawings dating from pre–20th century times generally look like less successful adults' drawings. That is to say, they are not fundamentally different from those the young Picasso did. In the Bibliothèque Nationale in Paris, for instance, there is the diary of a 17th-century doctor by the name of Jean Héroard, which contains drawings by an eight-year-old boy. Some of them are on the same subjects as Picasso's schoolbook sketches. And the lad's touch is as sure as Picasso's. But this lad did not come from an artistic family; indeed, in later life he was better known as King Louis XIII.[23]

In a sense, this is typical of children's drawings, in historical terms: painting and drawing had not been part of the European educational curriculum since antiquity, and until the 18th century only two kinds of children were normally given any training in art – those who were meant to become professional artists, and those who were of aristocratic or well-to-do family. There was no such thing as universal drawing tuition.[24] Children were taught the professional rules of the craft. Nor did the introduction of drawing classes in schools change this. Even the great Swiss educational reformer Johann Heinrich Pestalozzi, the most progressive of his

age, was concerned to make children adopt the adult method of pictorial representation as early and as completely as possible. Most educational systems in Europe and North America followed this example in the 19th century. It was not until the end of that century that children's own innate approach to drawing came to be valued and even encouraged; and not till our own day that it properly came into its own.[25]

The drawings done by the young Picasso are not those of a prodigy, then. But this is not to detract from his genius. Quite the contrary. Picasso the artist was moulded by the educational and academic ideas that then prevailed, as we can clearly see from his juvenilia: the education he was given was the making of a genius.

Picasso started school in Málaga in 1886, aged five. None of his drawings of that time survive. But we have a reliable witness to what they were like: Picasso himself. In conversation with Roland Penrose, he recalled drawing spirals at school in those days.[26] This suggests that art instruction at that Málaga primary school was

"La Coruña" (double page of a diary)
Corunna, 16 September 1894
Ink, India ink and pencil on paper, 21 x 26 cm
Zervos XXI, 10; Palau 31; MPP 402(r)
Paris, Musée Picasso

"La Coruña" (double page of a diary)
Corunna, 16 September 1894
Ink, India ink and pencil on paper, 21 x 26 cm
Zervos XXI, 11; MPP 402(v)
Paris, Musée Picasso

"Azul y Blanco" (double page)
Corunna, 28 October 1894
Pencil on paper, 20.5 x 26.5 cm
Zervos XXI, 12; Palau 33; MPP 403(v)
Paris, Musée Picasso

"Azul y blanco" (double page)
Corunna, 28 October 1894
Ink, India ink and pencil on paper, 21 x 26 cm
Zervos XXI, 13; Palau 34; MPP 403(r)
Paris, Musée Picasso

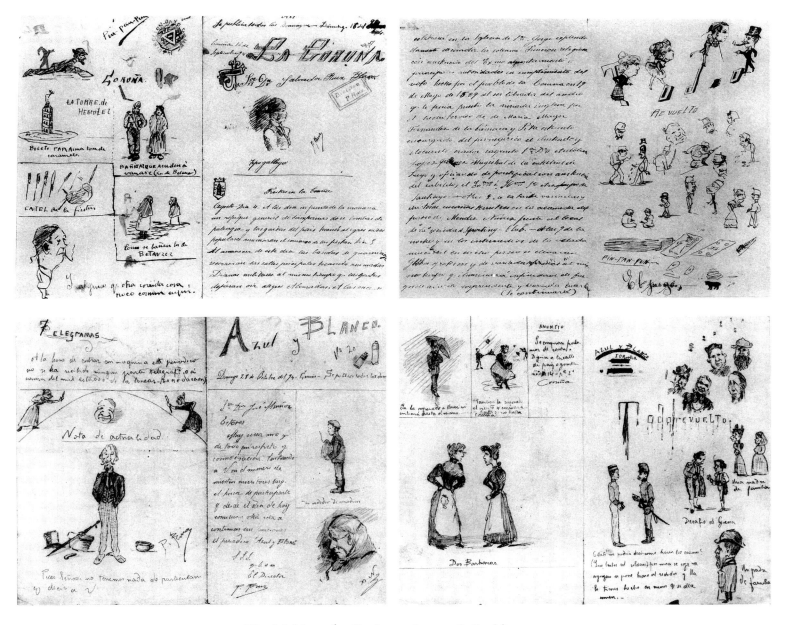

Farmhouse
Maison de campagne
Corunna, 1893
Oil on canvas, 15.8 x 23 cm
Not in Zervos; Palau 20; MPB 110.103
Barcelona, Museu Picasso

designed along lines laid down by Pestalozzi, developed by Friedrich Fröbel, and subsequently adapted by teachers throughout the world. In essence the method was the same one everywhere. Linear drawing was the invariable point of departure: children were encouraged to think and create in geometrical terms. Then they were taught to abstract forms from the world about them. And only then did they move on to the representation of actual things. In this scheme of things, drawing straight or curved lines (such as spirals) was the first, basic step. The children copied lines and linear figures slavishly. Then they had to develop their own motifs by highlighting or omitting lines in what was shown them. Finally they practised free-hand drawing of geometrical figures such as circles, ovals or spirals. It was a way of making even tiny children see schematically. The irregularity and shakiness of children's representation was educated out of them.

Children (such as Picasso) who underwent this process were no longer able to draw in a truly childish way even if they wanted to.[27] In any case, children require something to follow, something they can grasp. Picasso's early drawings copied models; both the cavalrymen in the schoolbook and his numerous attempts to draw bullfights (cf. pp. 30 and 31) were versions done after the bright, colourful world of folksy prints and broadsheets.[28]

One of the ten-year-old Picasso's sheets is of special interest. It is a sheet he used twice, to draw a bullfight and to draw pigeons (p. 31). Plainly the task of depicting Spain's national sport was beyond him, even when he was copying a model. The bearing and movements of the protagonists, and the spatial realization of the overall scene, is most unsatisfactory. But the pigeons are another matter entirely; they are far more convincing. In drawing them, the boy's approach was a geometrical one, using linked ovals for the

The Barefoot Girl
La fillette aux pieds nus
Corunna, early 1895
Oil on canvas, 74.5 x 49.5 cm
Zervos I, 3; Palau 69; MPP 2
Paris, Musée Picasso

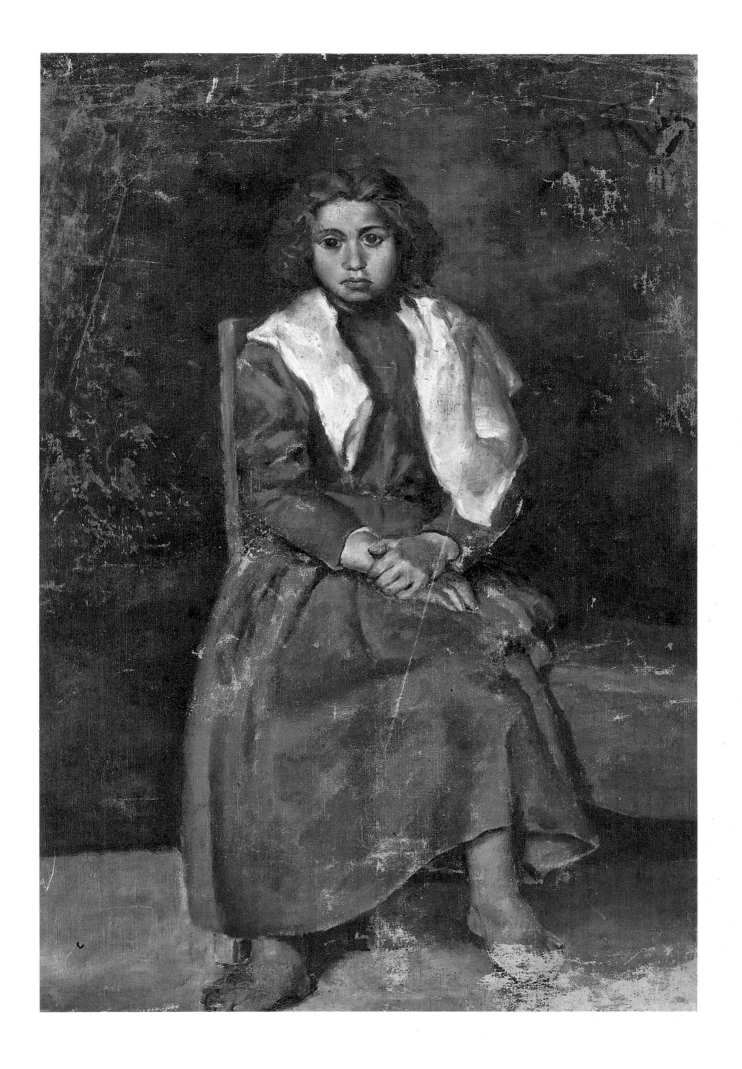

neck, crop and rump and then adding the other parts of the birds'
bodies. His father's work prompted the boy to make these draw-
ings,[29] but did not provide a model. What lies behind the frequent
boyhood drawings of birds, and in particular pigeons, is drawing
instruction at school, with its method of interposing geometrical
schemata between the natural form and its representation. Birds
were a popular subject because they could easily be seen in geome-
trical terms and were thus easy to draw.[30]

Other standard exercises included the perfecting of a leaf out-
line.[31] And so it was that children in the 19th century learnt to
perceive a repertoire of stock shapes in all things, and to reduce
individual forms to variations on geometrical themes. The draw-
backs of this method are plain: individual characteristics are sub-
ordinated to unbending principles of representation. But we must
not overlook a salient advantage. Anyone who had been schooled
in this way, and (of course) had an amount of native talent, had the
lifelong ability to register and reproduce objects and motifs quickly
and precisely. Picasso benefitted from the training of his boyhood
till he was an old man. It was that training that gave him his as-
tounding assurance in his craft. His debt to his school training is

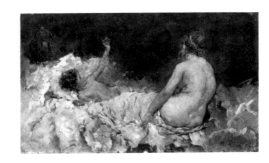

Arcadi Mas i Fontdevilla:
Back Study. Oil on canvas
Barcelona, Museu d'Art Modern de Barcelona
(cf. p. 37 right)

Study of the Left Arm
(after a plaster cast)
Corunna, 1894
Charcoal and pencil on paper, 45 x 34 cm
Palau 25; MPB 110.843
Barcelona, Museu Picasso

Study of the Right Foot
(after a plaster cast)
Corunna, 1893/94
Charcoal and pencil on paper, 52.2 x 36.7 cm
Zervos VI, 7; Palau 21
Estate of the artist

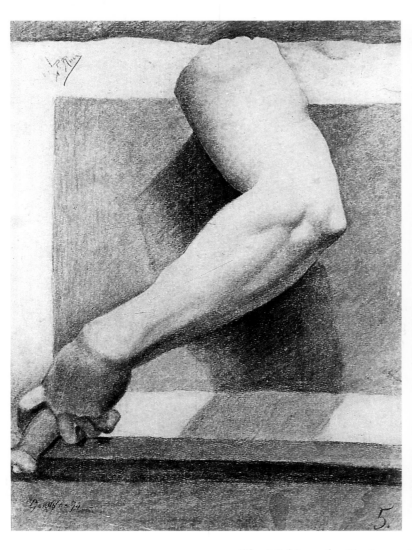

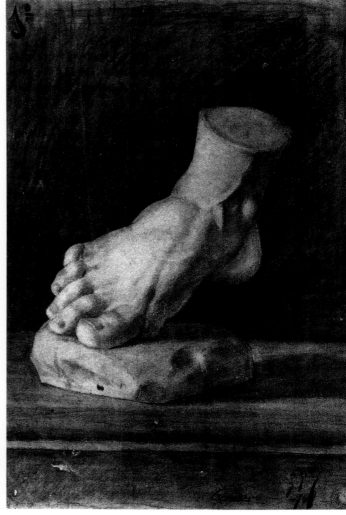

The Making of a Genius 1890 – 1898 **36**

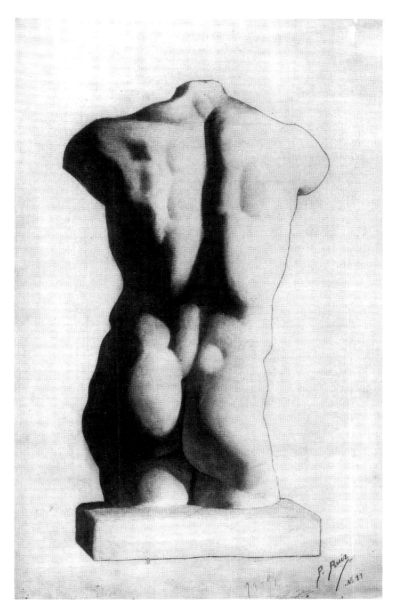

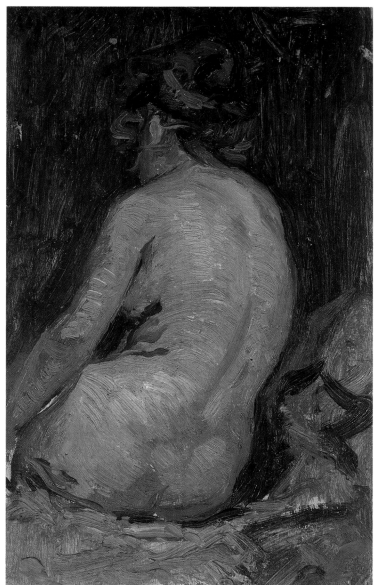

clearly visible in a drawing of boats (p. 46) in which a handful of lines rapidly establish the subject, in accordance with the principle he had learnt of calligraphic construction.[32]

It is small wonder that his school training remained so emphatically with Picasso, since professional tuition followed the same principles. After his family had moved to Corunna when his father took up a new position, the boy first attended general secondary school but then in September 1892 moved to La Guarda art school (where his father was teaching) at the beginning of the new school year. By 1895 he had taken courses in ornamental drawing, figure, copying plaster objects, copying plaster figures, and copying and painting from Nature. It was a strict academic education according to the Madrid Royal College of Art's guidelines.[33] This meant that he once again studied drawing and painting in terms of copying models. His study of an acanthus (p. 30), done in his first year at La Guarda, is a good example of this. It is essentially a line drawing with little interior work, of a kind taught in school art classes.[34]

Study of a Torso
(after a plaster cast)
Etude d'un plâtre (d'après l'antique)
Corunna, 1893/94
Charcoal and pencil on paper, 49 x 31.5 cm
Zervos VI,1; Palau 19; MPP 405
Paris, Musée Picasso

Female Nude from Behind
(after Arcadi Mas i Fontdevilla)
Barcelona, 1895
Oil on panel, 22.3 x 13.7 cm
Not in Zervos; Palau 122; MPB 110.212
Barcelona, Museu Picasso

The Making of a Genius 1890 – 1898 **37**

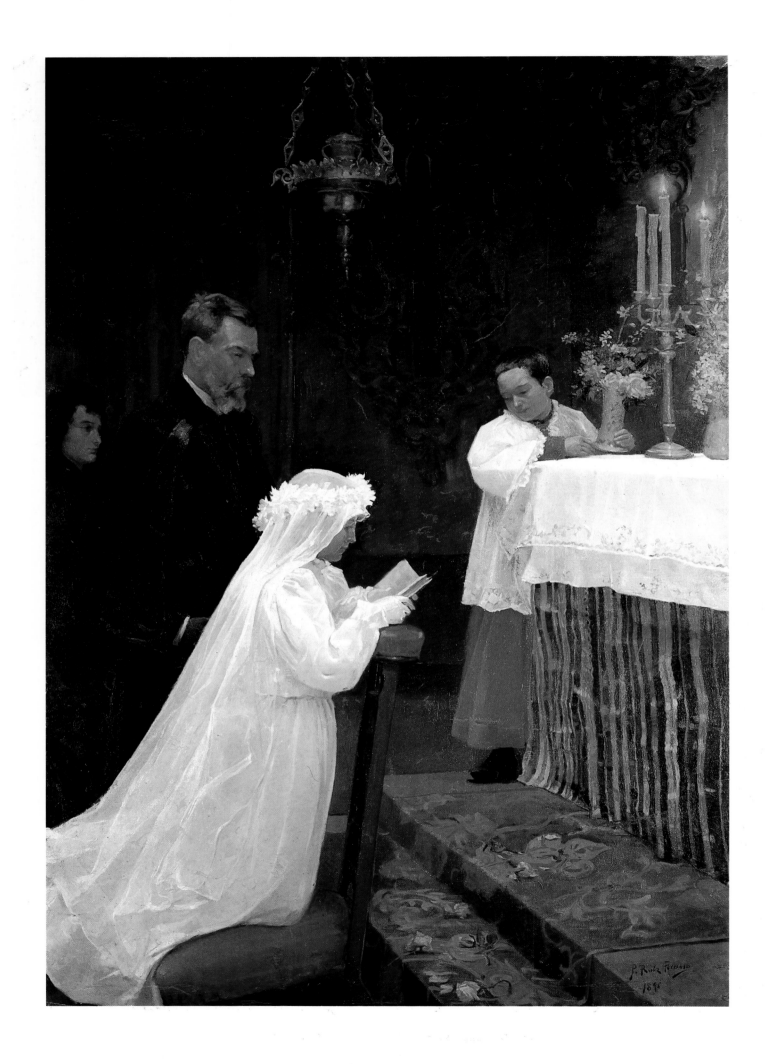

Other basic representational tasks were set for the pupil. We still have a variable-profile study of the left eye which Picasso did at age twelve (p. 32). The drawing was copied from a plaster figure, according to time-honoured custom. The method was well established in 19th-century academies and dated back to the 15th century. Printed originals were used for the drawing of organs, then of larger parts of the body, and finally of whole figures.[35] Once the copying itself no longer posed a problem, the pupil moved on to copying from plaster models. This served a dual purpose: it developed the pupil's eye for a subject, and created the ability to produce three-dimensionally modelled plasticity by means of effective contouring and proper use of light and shadow. This dual purpose was achieved in as linear a manner as everything else in this system, progressing from basic geometrical figures to lightly-modelled line drawings to full three-dimensionality.[36]

Another Picasso study of the same date showing the head of a bearded man in two stages of profile (p. 32), one of them purely linear and the second lightly modelled, is thus not to be taken as proof of any unusual talent on his part where both realistic drawing and abstraction are concerned;[37] rather, it demonstrates that he was copying from one of the many exercise sources.[38] The educational drill was strictly followed in those days, and it was doubtless more of a soulless exercise than a fit encouragement of creative powers. Still, the constant repetition of the same task did provide the art student with an available repertoire of representational methods.

What was more, students were also taught the essentials of art history; the models they followed in their exercises were the masterpieces of ages past. So it was that in his early youth Picasso was familiar with the sculptures of antiquity. He had to copy them over and over, from figures on the frieze of the Parthenon to the Venus of Milo.[39] His lifelong engagement with the art of antiquity was thus as firmly rooted in his early training as his assured technique and his idiosyncratic manner of approaching a subject. In the same way that a pianist has to practise constantly, so Picasso too, throughout his life, kept his eye and hand in top form. His sketchbooks and his many studies contained endlessly repeated versions of the same motif (cf. p. 250), all executed with just a few lines and often with a single, assured stroke.

The single-line drawing was in fact a widely-used teaching method. It brings home the specific form of a subject better than any other technique; only if the drawer has looked very closely and has internalized the essentials of the form he will be able to reproduce it with a single line. A motif set down in this way remains in the artist's memory, always available. And because the technique was so basic, it was of central importance to Picasso. His whole life long, he created new visual worlds by means of representational copying.

The schematic nature of the academic approach to the appropri-

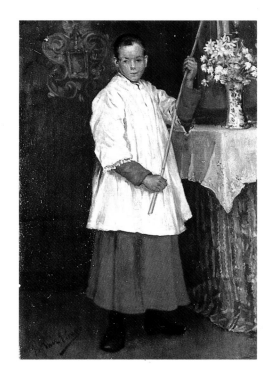

The Altar Boy
L'enfant de chœur
Barcelona, 1896
Oil on canvas, 76 x 50 cm
Zervos I, 2; Palau 140
Barcelona, Museu de Montserrat

First Communion
La première communion
Barcelona, 1896
Oil on canvas, 166 x 118 cm
Zervos XXI, 49; Palau 142; MPB 110.001
Barcelona, Museu Picasso

Portrait of José Ruiz Blasco (The Artist's Father)
Portrait du père de l'artiste
Barcelona, 1896
Watercolour, 18 x 11.8 cm
Not in Zervos; MPB 110.281
Barcelona, Museu Picasso

Portrait of the Artist's Father
Portrait du père de l'artiste
Barcelona, 1896
Oil on canvas on cardboard, 42.3 x 30.8 cm
Not in Zervos; Palau 143; MPB 110.027
Barcelona, Museu Picasso

ation of reality played a similar part in his development. First the subject was envisaged in geometrical terms, then it was rendered in outline, and then it was three-dimensionally modelled. This process was to remain the heart of Picasso's artistic method. For him, drawing always came first, irrespective of whether he was working in oil, printed graphics, sculpture or ceramics. This is why the seemingly rudimentary, often childlike sketches account for such a large body of his output. But the preliminary sketches for "Guernica" (cf. pp. 400/401) or the great sculpture "Man with Sheep" (p. 455) only look childlike at a first, cursory inspection. In fact they are skilful drawings with the precise task of recording the formal principles of new ideas. Only when a notion had acquired contour and recognisable form in this way did Picasso proceed. He worked in ways of such austerely rational, quasi-scientific logic that in this respect he must surely stand alone in modern art. It is only because his tireless labours produced such a superabundance of work that the popular image of his creative methods is a different and unclear one.

It need cause no surprise that Picasso's training struck such deep roots and influenced him for so long. After all, it was an intensive

schooling: he was exposed to it not only in extreme youth, but also repeatedly. The tuition he received at art college in Barcelona (1895 to 1897) was essentially the same again.[40] We do well to remember that the treadmill effect of such repetition must have been a more significant factor than Picasso's tender years.

In point of fact, beginning to study at an early age was by no means so very unusual. Ary Scheffer, famed internationally as a painter in the early 19th century, began systematic training at the age of eleven; and the French academic painter Jean-Jacques Henner, now totally forgotten, began professional training at twelve.[41] At Barcelona, the sculptor Damian Campeny began at fourteen, the earliest possible age there.[42] When Picasso was allowed to sit his entrance exam in advance of the regulation date, in September 1895, his fourteenth birthday was still a month away. For a prospective student only a month off formal entitlement, sterner treatment would have been small-minded.

Picasso's oils of that period treated relatively few subjects over and over, in a fairly uniform style. There are a striking number of human heads, of every age and walk of life and of both sexes. These studies are done in broad, expansive pastose, using monochrome

Portrait of the Artist's Mother
Portrait de la mère de l'artiste
Barcelona, 1896
Pastel on paper, 49.8 x 39 cm
Zervos XXI, 40; Palau 139; MPB 110.016
Barcelona, Museu Picasso

Portrait of the Artist's Mother
Portrait de la mère de l'artiste
Barcelona, 9 June 1896
Watercolour on paper, 19.5 x 12 cm
Not in Zervos; Palau 160; MPB 111.472
Barcelona, Museu Picasso

earthy browns or ochre yellows and sparing local colour to model the light and shadow on faces. Generous as Picasso's brushwork is, the contours remain precise, so that the overall impression tends to be one of draughtsmanlike clarity. We are reminded of great Spanish antecedents such as Diego Velázquez, Francisco de Zurbarán or Bartolomé Estéban Murillo.[43] Once again, however, the more immediate influence was of course Picasso's academic tuition.

Use of brush and paint followed preliminary training in drawing and priming. As with drawing, training proceeded in stages: first copying from existing designs, then from genuine objects, and finally the rendering of living models. In learning how to paint a face, students were also acquiring the basic principles of all painting from life: modelling of light effects, the establishment of a foundation tone using broad strokes, pale colours for the light areas and darker for the shade (with the hair constituting a distinct area in itself) – then a more specific distinction of light and dark through smaller brush strokes, working through to detailed toning. Every kind of painting, not only portraits but also (for example) landscapes, was done in accordance with this basic procedure.[44] Picasso's paintings, whether interiors, studies of heads, or landscapes, followed it precisely. That is to say, he was not yet betraying the influence of any contemporary movements in art – even if remote similarities can at times be identified.[45]

A rear view of a nude woman which he painted in 1895 (p. 37) is interesting in this connection. It is a copy of a work by the contemporary painter Arcadi Mas i Fontdevilla.[46] The latter's painting also uses loose brushwork; but the brush strokes are not as patchy, schematic and indeed almost mosaic in effect as those in Picasso's Corunna head studies or the landscapes he painted on holiday at Málaga (p. 46). These works exemplify the next stage in his academic training. Light and shadow, and colour tonality, were established in contrastively juxtaposed brush strokes that conveyed a mosaic impression. This method was systematic, and well-nigh guaranteed strong impact; a painter who followed it would produce works of persuasive effect. Finally, the tuition programme culminated in the step-by-step rendering in oil studies of a live nude model. Picasso did good work of this kind as a youngster, much like that of any other 19th-century painter who underwent this kind of academic training (cf. p. 44).[47]

This training was rigorously formal and designed to drive out the spontaneity in an artist, and inevitably had considerable disadvantages. Autonomous values of colour, so important to new movements such as Impressionism, were played down. The expressive potential that is in the manner in which an artist applies the paint to the surface, important to great 17th-century artists and much later to Impressionists and Expressionists alike, was altogether out. Academic painting aimed to produce a final work in which the preliminaries were absorbed into a smooth overall finish.

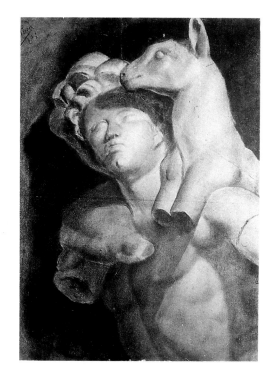

Man with Sheep
(after a plaster cast)
L'homme au mouton (d'après l'antique)
Barcelona, 1895/96
Charcoal on paper, 63 x 47.5 cm
Not in Zervos; MPB 110.598
Barcelona, Museu Picasso

Academic Nude
Etude académique
Barcelona, about 1895–1897
Oil on canvas, 82 x 61 cm
Not in Zervos; Palau 180; MPB 110.047
Barcelona, Museu Picasso

Caricatures. Barcelona, 1898
Pencil on paper, 23.1 x 17 cm
Zervos VI, 153; Palau 328. Private collection

Head of a Boy (Academic Study)
Barcelona, 1896. Oil on canvas on cardboard,
29.8 x 26.1 cm. Palau 177; MPB 110.077
Barcelona, Museu Picasso

Bust of a Young Man (Academic Study)
Barcelona, 1895–1897. Oil on canvas,
43 x 39.3 cm. Palau 178; MPB 110.056
Barcelona, Museu Picasso

But the disadvantages were worth putting up with for a signal advantage. Colour established form, confirming the contour established by the drawn line. This sense of colour stayed with Picasso till the end of his career: colour was intimately connected with form, and could be used to intensify or defamiliarize it. Still, Picasso's academic training alone could never have made him what he became, much as he owed it in later life.

A schoolbook in which the ten-year-old Picasso scribbled sketches has survived from 1891. On one of the sheets he drew a frontal view of a cat (p. 30). The head is so outsize that at first we do not notice the few lines that indicate the body.[48] Those lines are randomly placed and uncertain, while the head, somewhat clumsy though it may be, shows a clear attempt to render the animal precisely. If the study were one done from nature, this would be remarkable, since it would signify an inconsistency; and it would be all the more remarkable if we bear in mind that the cat would have had to be caught in motion, a task that even professional artists are not necessarily equal to. But in fact if we take a look at the drawings in Picasso's schoolbooks we find that most of them were copies of other work, mainly of folksy graphic art; so probably the cat too was copied from someone else's model drawing, not from nature.

In point of fact, art-college textbooks were full of schematic nature studies for copying purposes, many of them showing cats. They looked much like Picasso's hasty sketch,[49] with the difference that the head and body, united in Picasso's drawing, were separate.

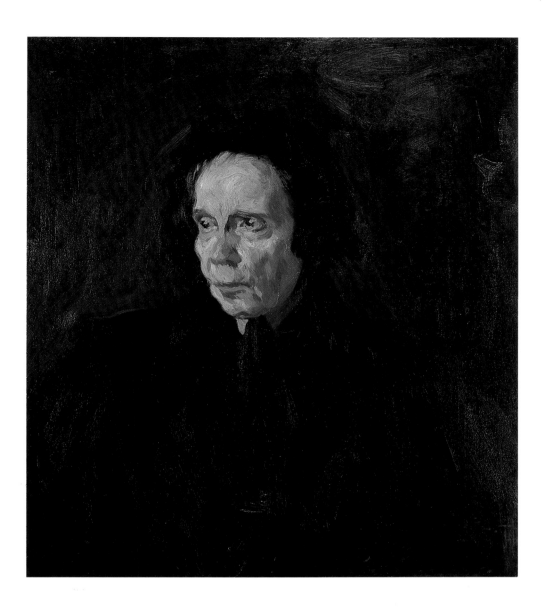

Portrait of Aunt Pepa
Portrait de la tante Pepa
Barcelona, summer 1896
Oil on canvas, 57.5 x 50.5 cm
Zervos XXI, 38; Palau 171; MPB 110.010
Barcelona, Museu Picasso

The inconsistency in his drawing resulted from an attempt to make a whole out of parts before he had the skill to do so. This is most instructive. It does not imply lack of ability; but it does point to a specific shortfall in his capacity at that stage. The boy will doubtless have known of these textbooks of model drawings through his father, who would have used them for teaching purposes himself. His father will have prompted the boy to copy the drawings in them.[50] Having seen his son's gift at work, he will have offered guidance – of a subtle and effective kind. If we look through the young Picasso's sketches, we see that his studies from academic originals were invariably done earlier than we might expect, given the stage he was at in his own training. At school he was already copying college work; at college he copied the next year's material in advance. His father enrolled the boy in courses ahead of normal schedules – though he also encouraged a free artistic imagination in the lad. The young Picasso's work includes not only studies of an academic nature but also an abundance of very different material, mostly caricatures and other studies of the home milieu, of parents and siblings, relations, friends. Caricatures were fun to do; but

A Quarry
Une carrière
Málaga, summer 1896
Oil on canvas, 60.7 x 82.5 cm
Not in Zervos; Palau 168; MPB 110.008
Barcelona, Museu Picasso

the pleasure Picasso presumably took in them must have afforded a safety valve for any irritation at his strict training, too. They also tell us that he had a sure hand at registering form with a constructive, creative imagination. No wonder he remained fond of caricature throughout his life.

Free work (of the student's own choice) was also a part of academic training. Students were encouraged to do their own studies outside studio requirements, to develop an ability to solve unusual problems. They were expected to have a sketchbook with them at all times, to record striking motifs.[51] Picasso's parents gave him his first album in early 1894, and that autumn gave him a second.[52] They were the first of a great many sketchbooks which served Picasso as his most direct and personal tool. The importance of these sketchbooks has only become evident in recent years.[53] Of course modern artists use sketchbooks; but to use them on Picasso's scale was more of a feature of art in older times. In this respect, again, Picasso was a creature of tradition.

Sketches of Boats
Etudes des bateaux à voiles
Barcelona, 1896
Pencil on paper, 3.5 x 13 cm
Not in Zervos; Palau 172; MPB 111.373
Barcelona, Museu Picasso

House in a Wheatfield
Maison dans un champ de blé
Horta de Ebro, summer 1898
Oil on canvas, 33 x 44 cm
Not in Zervos; Palau 254; MPB 110.936
Barcelona, Museu Picasso

Picasso's father was unremitting in moulding his son along his own lines. He wanted him to be the academic painter *par excellence*. He himself painted animal scenes and genre paintings, the kind of work traditionally considered of secondary value; and he wanted his son to paint figure and history paintings, which were then valued above all else.[54] And so Picasso's freely chosen studies turn out to be mainly figure and portrait studies. And his father's oppressive influence shows again in the fact that he himself was his talented son's preferred subject (cf. p. 40).

This process culminated in two paintings the father prompted the son to do in 1896 and 1897, "First Communion" (p. 38) and "Science and Charity" (pp. 50/51). Picasso's father sat for the doctor whose skill and knowledge will determine the patient's fate. And his father also influenced the reception of the pictures by using his contacts with newspaper critics.[55] He was omnipresent in the young Picasso's life. The boy's whole education took place in schools and colleges where his father was on the staff.

Deliberately though Picasso's training was steered by his father, and intelligent though it was, it was also outdated. Elsewhere in Europe, this academic method had been superseded. Compared with other countries, the art scene in Spain when Picasso was a youngster was decidedly on the conservative side. From 1860 to 1890 the history paintings of Eduardo Rosales, Mariano Fortuny and Francisco Pradilla dominated Spanish art; their work was comparable with that of a Thomas Couture in France, a Gustaaf Wapper in Belgium, or a Carl Friedrich Lessing in Germany – all of them artists clinging to a training acquired in the first half of the century, and to views on art that had peaked in mid-century.[56]

Sketches in the Style of El Greco
Feuilles d'études à la Greco
Barcelona, 1898
Ink on paper, 31.8 x 21.6 cm
Zervos VI, 152; Palau 330

So a crisis was inevitable in Picasso's life. In 1897, when his father sent the sixteen-year-old to the Royal Academy in Madrid, it was a great mistake. The legend-makers have tended to claim that Picasso attended none of his courses at all[57] – but he did in fact go to those of Moreno Carbonero. Still, he was profoundly disappointed by studies at the Academy, and concentrated on copying the old masters in the Prado. In June 1898 he gave up his Madrid studies for good.[58]

It was the first evidence of his unusual personality. He could not learn anything new or better in Madrid because the tuition methods were the same as in Corunna or Barcelona. He could see all the shortcomings clearly, his own as well as the Academy's. It was not as if he no longer needed guidance. His copy of Velázquez's portrait of King Philip IV of Spain, for instance, is a decidedly mediocre piece of work. His whole life long he had certain fundamental weaknesses, such as a tendency to apply his concentration one-sidedly. If a subject made a variety of demands on him, Picasso would prefer to tackle the one he thought important. His early academic studies were accomplished enough, but often they were sloppy in one way or another; later, he would still often make crucial mistakes. For instance, in his portraits he often positions the eyes wrongly, a typical result of an inadequate grasp of the overall relation of parts to the whole.

A letter he wrote to a friend on 3 November 1897 shows how much he craved good instruction in Madrid. In it he complains

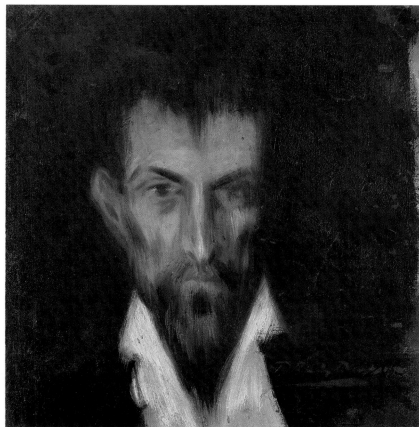

bitterly of the backwardness and incompetence of his teachers and says he would rather go to Paris or Munich, where the art tuition was the best in Europe. Munich would even be best, he said – although he was going to go to Paris – because in Munich people didn't bother with fashionable stuff such as pointillism![59] In other words, Picasso was longing for the kind of academic training a Franz von Stuck gave; but he was not interested in the methods and ideas that were currently considered avant-garde.

Though it may seem astonishing or paradoxical, the fact is that Picasso did not become Picasso under the influence of progressive ideas but because an old-fashioned milieu was imposing superannuated notions on him. He found it impossible to make do with routine and mediocrity. Fully aware that the decision to quit the Academy would seriously damage relations with his father, for whom Madrid still represented the gateway to desired success, Picasso made a radical break – despite the total uncertainty of his new future. Not yet seventeen, he set about achieving his independence in every respect. And from now on he went his own way.

Portrait of Philip IV (after Velázquez)
Portrait de Philippe IV (d'après Velázquez)
Madrid, about 1897/98
Oil on canvas, 54.2 x 46.7 cm
Not in Zervos; Palau 230; MPB 110.017
Barcelona, Museu Picasso

Self-portrait as an 18th-Century Gentleman
Autoportrait en gentilhomme du XVIIIe siècle
Barcelona, 1897
Oil on canvas, 55.8 x 46 cm
Zervos XXI, 48; Palau 149; MPB 110.053
Barcelona, Museu Picasso

Self-portrait with Close-Cropped Hair
Autoportrait aux cheveux courts
Barcelona, 1896
Oil on canvas, 46.5 x 31.5 cm
Not in Zervos; Palau 148; MPB 110.063
Barcelona, Museu Picasso

Head of a Man in the Style of El Greco
Tête d'homme à la Greco
Barcelona, 1899
Oil on canvas, 34.7 x 31.2 cm
Not in Zervos; Palau 332; MPB 110.034
Barcelona, Museu Picasso

Science and Charity
Science et charité
Barcelona, early 1897
Oil on canvas, 197 x 249.5 cm
Zervos XXI, 56; Palau 209; MPB 110.046
Barcelona, Museu Picasso

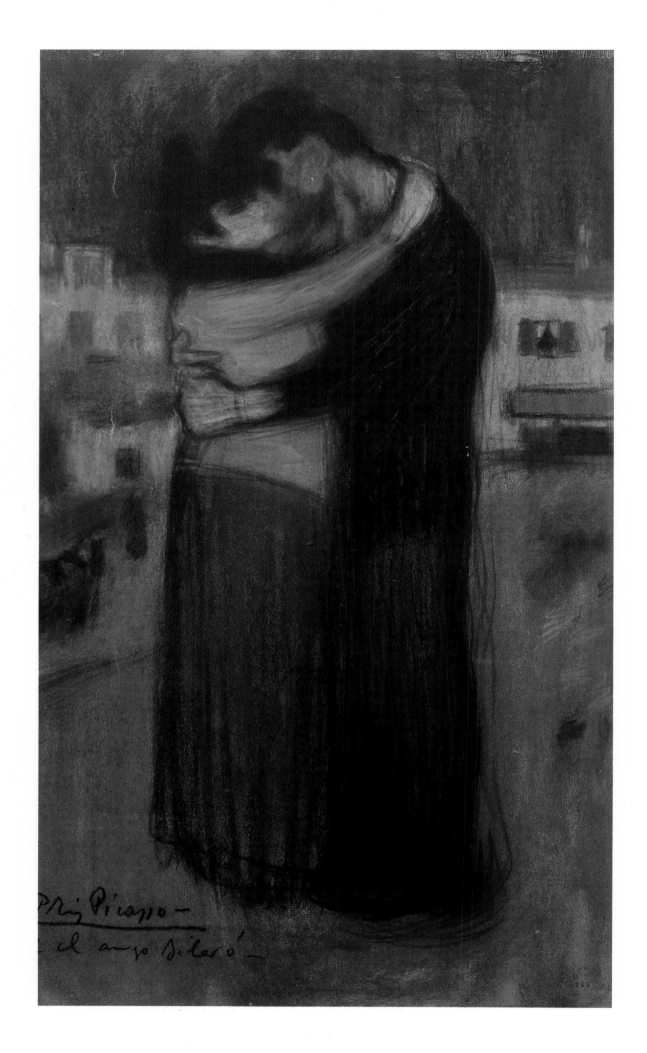

3 The Art of Youth 1898–1901

Picasso's decision to abandon his academic training was a decisive crisis in his youth. The upheaval of having to leave everything behind produced an immediate and visible result: he fell ill. In spring 1898 in Madrid he came down with scarlet fever, and was quarantined for forty days. We cannot say whether his psychological state was responsible for the illness, but his bad health hardened Picasso's resolve. He was scarcely recovered but he turned his back on Madrid. After spending a brief while in Barcelona, he went to Horta de Ebro with his friend Manuel Pallarès. He stayed for almost nine months in Pallarès's home village in the deserted hills of Catalonia, till February 1899. The two friends would go on long walks together, and painted and drew.

Picasso then returned to Barcelona and embarked on his independent career in art. The Catalan metropolis was his base till his definitive final move to France in 1904. They were restless years, and Picasso spent a number of longer periods in Paris as well as making a further five-month attempt to settle in Madrid in 1901[60]. And of course they were unsettled years of crisis for Spain, too. In 1898, through its colony Cuba, Spain became involved in a war with the USA. Defeat spelt the end of what remained of Spain's colonial empire and claims to be a world power.

It was a turning point, and brought profound political, social and cultural insecurity with it. People were torn between loyalty to a great past and new affiliation with Europe. Their ideas ran the entire gamut from liberal republicanism to anarchism. Castile and Andalusia lost their dominance, while the industrial north came into its own.[61]

In such a period, the seventeen-year-old Picasso had considerable capital, albeit not of a financial kind. He was confident, talented and young. He had contacts. And he had unlimited energy. His father's encouragement had married a natural talent that took demands easily in its stride, and the inevitable upshot was independence of character. It was helpful that his father indirectly cut the umbilical cord by renting a studio for his son during his studies in Barcelona.[62] More importantly, the father's strategies had already gained Picasso a certain professional recognition.

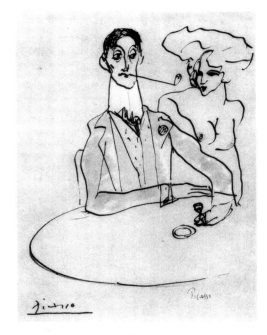

Angel Fernández de Soto at a Café
Angel Fernández de Soto au café
Barcelona, 1903
Ink, watercolour and crayon, 27 x 20 cm
Zervos XXI, 161; DB D IX, 9
Private collection

The Embrace in the Street
Les amants de la rue
Paris, 1900
Pastel on paper, 59 x 35 cm
Zervos I, 24; DB II, 12; Palau 498; MPB 4.263
Barcelona, Museu Picasso

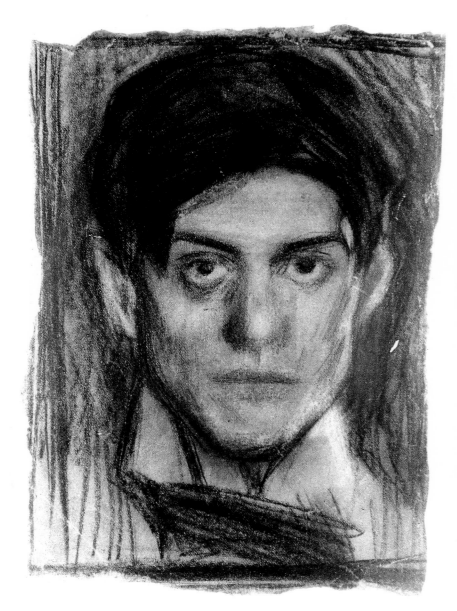

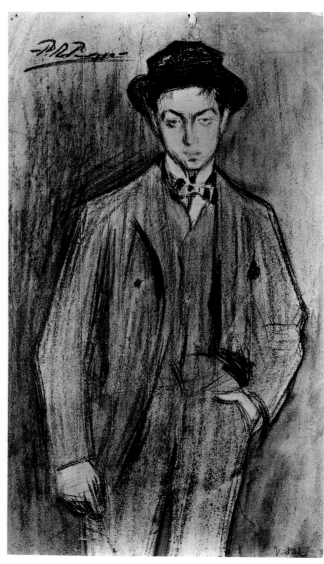

Self-portrait
Autoportrait
Barcelona, 1899–1900
Charcoal on paper, 22.5 x 16.5 cm
Not in Zervos; Palau 357; MPB 110.632
Barcelona, Museu Picasso

Portrait of Juan Vidal i Ventosa
Portrait de Juan Vidal i Ventosa
Barcelona, 1899–1900
Charcoal and watercolour on paper,
47.6 x 27.6 cm
Zervos VI, 252; Palau 410; MPB 70.802
Barcelona, Museu Picasso

In 1896 "First Communion" (p. 38) was exhibited in Barcelona. This was the third arts and crafts exhibition to be held there (after 1891 and 1894), a major event intended to showcase contemporary Catalan culture. Some thirteen hundred works were on show, by important artists of every aesthetic persuasion. The press response was also a major one. To be exhibited in that show was a triumph for a fifteen-year-old, even if his father's contacts had helped; to be praised in a leading newspaper, even if he won no prizes, was even better.[63]

A year later he painted the grand "Science and Charity" (pp. 50/51). Anecdotal realism was a popular variety of historical painting at the time. Picasso's picture had thematic links with various other paintings that had been successfully exhibited, some of them in the Barcelona show.[64] Again his father's prompting and influence were decisive. Picasso submitted the work to the Madrid General Art Exhibition, and it was taken by a jury that included the painter Antonio Muñoz Degrain, a friend and colleague of his

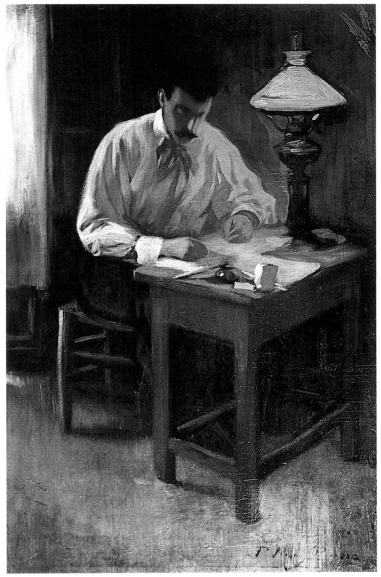

father's to whom the youth had already given a portrait study.[65] "Science and Charity" received an honourable mention at the exhibition, and subsequently a gold medal in Málaga.[66]

So Picasso was known to those who followed contemporary art when he set out on his own way. And Barcelona was a good place for it, a progressive city compared with traditionalist, academic Madrid. Spanish *art nouveau* was based in Barcelona, in the form of a group of artists known as the modernists, and in Barcelona too were their successors and antagonists, the post-modernists.[67] An architect of global importance, Antoni Gaudí, was changing the face of the city. The current aesthetic concerns of Europe were hotly debated, and adapted to local needs. Barcelona was the centre for avant-garde Spanish art, and at the nearby seaside resort of Sitges the Festa Modernista was held, an *art nouveau* event to which special trains were run.[68]

In June 1897 the Barcelona café "Els Quatre Gats" (The Four Cats) opened its doors. It was an artists' café and hosted changing

Portrait of Josep Cardona (by Lamplight)
Portrait de Josep Cardona (Homme à la lampe)
Barcelona, 1899
Oil on canvas, 100 x 63 cm
Zervos I, 6; Palau 320
Paris, Alex Maguy Collection

The Closed Window
La fenêtre fermée
Barcelona, 1899
Oil on panel, 21.8 x 13.7 cm
Not in Zervos; Palau 318; MPB 110.218
Barcelona, Museu Picasso

exhibitions in the spirit of "Le Chat Noir", the "Ambassadeur" or "Le Mirliton" in Paris. True, "Els Quatre Gats" survived only till 1903; but in its short life it was the hub of Catalonian artistic life. Leading "Modernistas" helped establish it: the painter Ramón Casas (who won an award at the exhibition of 1896), painter and writer Santiago Rusiñol, and the journalist Miguel Utrillo. And leading post-modernists were among its clientele, including Isidre Nonell, Joaquim Mir and Ricardo Canals.[69]

It cannot have been too difficult for Picasso to join these circles, since they would have heard his name; and belonging to them was a good start for his career. In the art world as in any other, talent and energy need personal contacts to help them on their way.

And it was contacts that helped decide Picasso for Paris. Though he was impressed by what he had heard about Munich, it was to Paris that he made his move. Munich art was seen in Barcelona, and indeed at the 1896 exhibition painters and sculptors from Munich constituted the largest foreign contingent.[70] But Paris was closer in various senses. It had an established Catalan community, including a number of artists temporarily living and working in the

Menu of "Els Quatre Gats"
Menu des "Quatre Gats"
Barcelona, 1899
Pencil and India ink, coloured,
22 x 16.5 cm
(cf. Zervos VI, 193; Palau 377)
Whereabouts unknown

Interior of "Els Quatre Gats"
Intérieur des "Quatre Gats"
Barcelona, 1900
Oil on canvas, 41 x 28 cm
Zervos I, 21; DB I, 9; Palau 375
New York, Simon M. Jaglom Collection

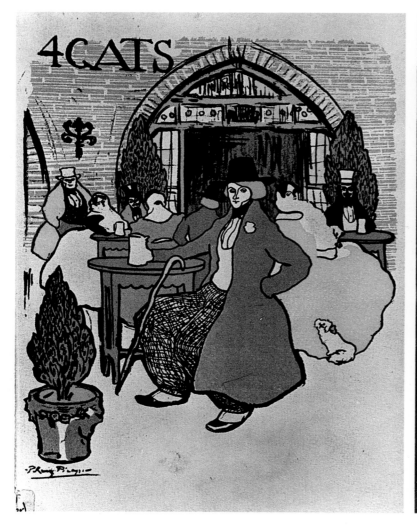

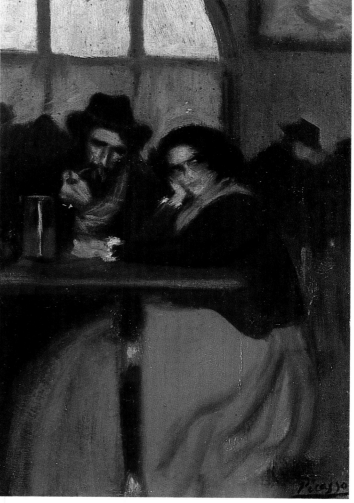

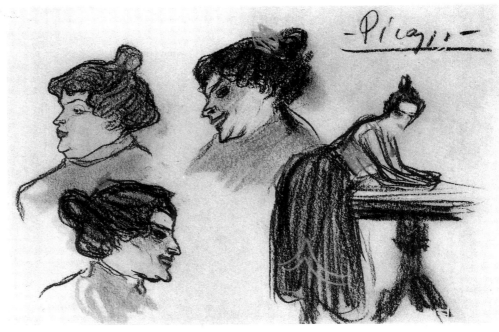

The Divan
Le divan
Barcelona, 1899
Pastel on paper, 26.2 x 29.7 cm
Zervos I, 23; DB I, 10; MPB 4.267
Barcelona, Museu Picasso

Woman Leaning on a Table. Three Female Profiles
Femme s'appuyant sur une table
et trois visages de profil
Paris, 1901
Coloured chalk on paper, 15 x 21 cm
Zervos XXI, 271

city. So Picasso did not have to conquer the great metropolis single-handed.

He first visited Paris in autumn 1900, for the World Fair, where his painting "Last Moments" had been chosen for the show of Spanish art.[71] Friends from "Els Quatre Gats" smoothed his way in Paris. He was able to use their studios when they were visiting Spain, and he was introduced to the industrialist and art dealer Pedro Mañach, who afforded him a first secure foothold. Mañach

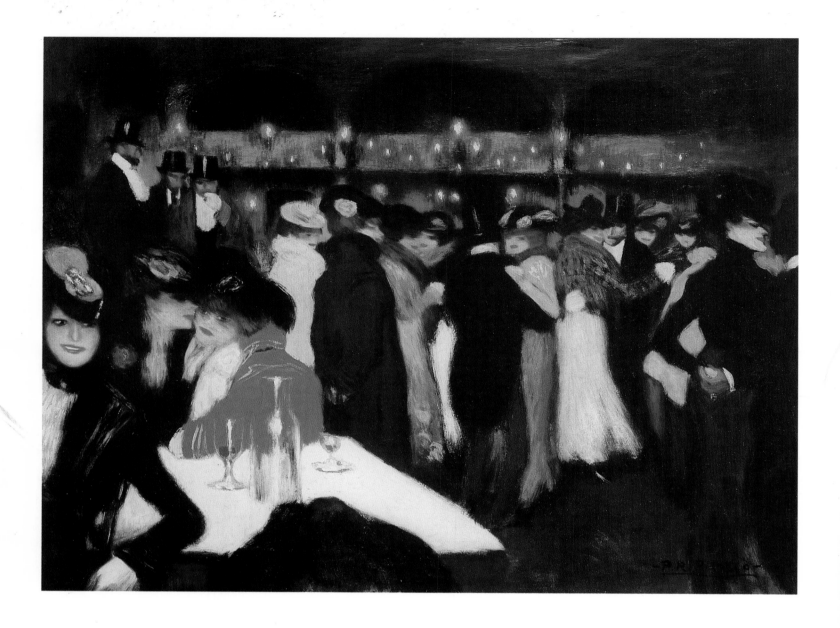

Le Moulin de la Galette
Paris, autumn 1900
Oil on canvas, 90.2 x 117 cm
Zervos I, 41; DB II, 10; Palau 509
New York, The Solomon R. Guggenheim Museum,
Justin K. Thannhauser Foundation

signed a contract with Picasso guaranteeing to take his pictures for two years and to pay 150 francs per month by way of fixed income. He also floated the idea of a first Paris Picasso exhibition at the Galerie Vollard in 1901[72].

To Picasso, this was no more than an entrée into the art market. For the moment, Spain seemed the better territory for his ambitions. In early 1901 he went to Madrid and started an art magazine together with a young writer, Francesc de Asis Soler. It was meant as a platform for Spanish *art nouveau* and was tellingly titled "Arte Joven" (Young Art). Benet Soler Vidal, whose family put up the money for the project, was the editor, while Picasso was the art director. It was not a particularly successful magazine and folded after five issues; but it was eloquent of Picasso's views on art at that period. Contributions were squarely in line with the "Modernista" spirit, though they had a distinctly satirical and even nihilist flavour to them. Picasso did the majority of the illustrations.[73] The maga-

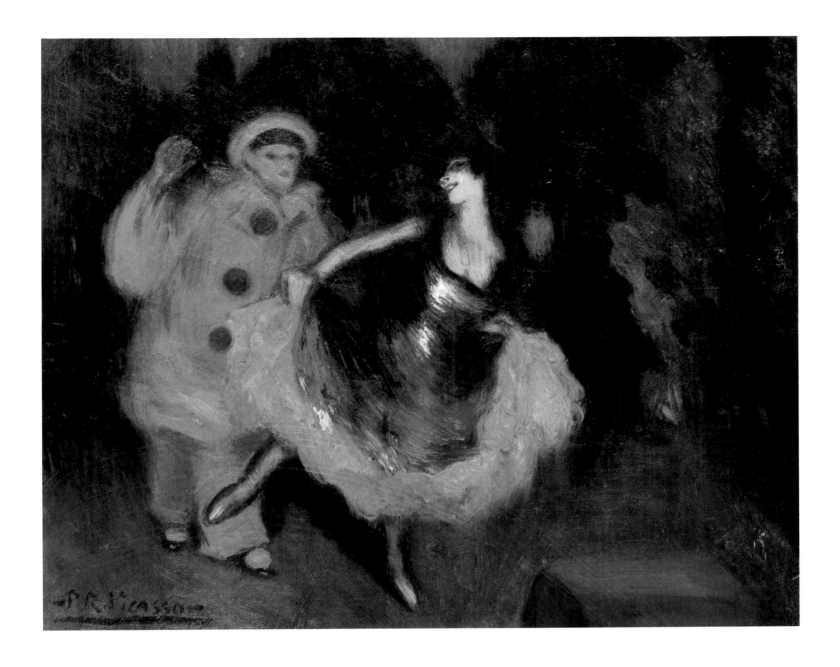

zine was modelled on the Barcelona modernist organ "Pél y Ploma" (Brush and Pen), the presiding artist of which was Ramón Casas.[74] The aim was plainly to take contemporary art to Madrid, the conservative heart of Spain. When failure became inevitable, Picasso returned to Barcelona, and subsequently devoted his attention to Paris.

At that time his work took its bearings from what the Spanish avant-garde approved. He put his academic leanings aside and adopted the new creative approaches of the period in the way he had learnt: by copying. The works shown in his first exhibition at "Els Quatre Gats", for instance, consisted mainly of portraits (cf. p. 54) done after the example of Casas' famous pictures of prominent people.[75] The people Picasso portrayed were not as well known, but he used the same approach, drawing them from the knees up against a colourful background, using a mixture of charcoal and watercolour.

The Blue Dancer
Pierrot et danseuse
Paris, autumn 1900
Oil on canvas, 38 x 46 cm
Zervos XXI, 224; DB II, 23; Palau 507
Sutton Place (Surrey), Private collection

Gypsy Outside "La Musciera"
Bohémienne devant "La Musciera"
Barcelona, 1900
Pastel on paper, 44.5 x 59 cm
Zervos XXI, 167; DB II, 8; Palau 447
Private collection

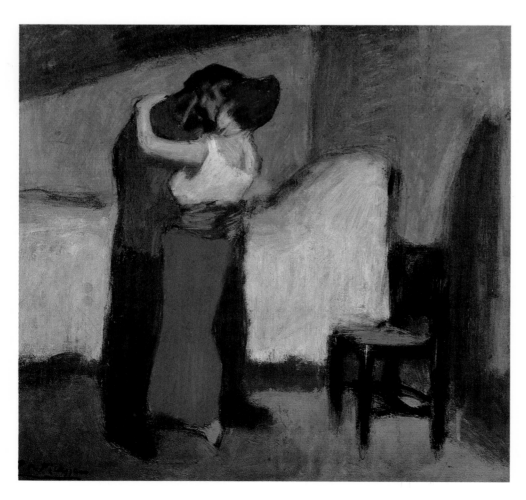

The Embrace
L'étreinte
Paris, 1900
Oil on paper on cardboard, 51.2 x 55.3 cm
Zervos I, 26; DB II, 14; Palau 499
Moscow, Pushkin Museum

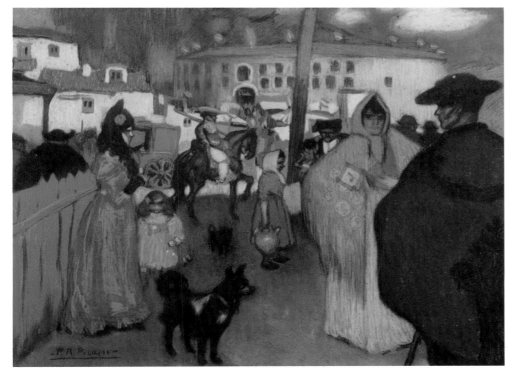

The Barcelona Bullring
L'entrée de la Plaza à Barcelone
Barcelona, 1900
Pastel on cardboard, 51 x 69 cm
Zervos XXI, 145; DB II, 9; Palau 454
Toyama (Japan), Toyama Prefectural Museum
of Modern Art

The Brutal Embrace
Frenzy
Paris, 1900
Pastel, 47.5 x 38.5 cm
Not in Zervos; Palau 500
Private collection; formerly Basel, Galerie Beyeler

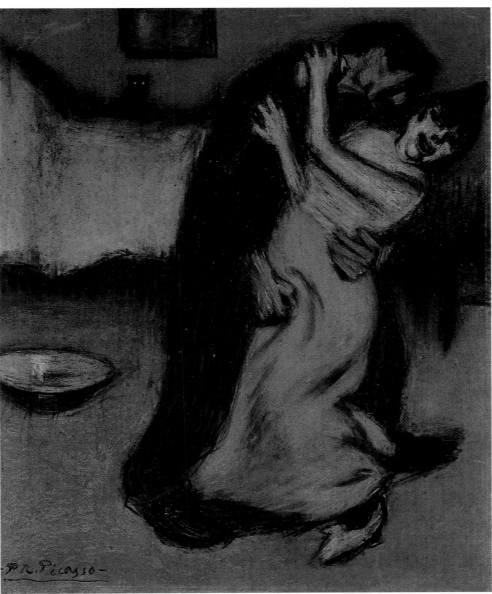

Pages 62 and 63:
The Montmartre Fair
Baraque de foire, Montmartre
Paris, autumn 1900
Oil on canvas, 36.5 x 44.5 cm
Zervos XXI, 227; DB V, 63; Palau 504
Private collection

Montmartre Brasserie: The Flower Vendor
Brasserie à Montmartre
Paris, 1900
Oil on cardboard, 43 x 53.5 cm
Zervos XXI, 281; Palau 579
Paris, Private collection; formerly Galerie Rosengart

La Corrida
Course de taureaux (Corrida)
Barcelona, spring 1901
Oil on canvas, 47 x 56 cm
Zervos I, 88; DB IV, 5; Palau 557
Paris, Max Pellequer Collection

Bullfighting Scene (Corrida)
Course de taureaux (Corrida)
Barcelona, spring 1901
Oil on cardboard on canvas, 49.5 x 64.7 cm
Zervos VI, 378; DB IV, 6; Palau 559
Stavros S. Niarchos Collection

The Art of Youth 1898 – 1901 **61**

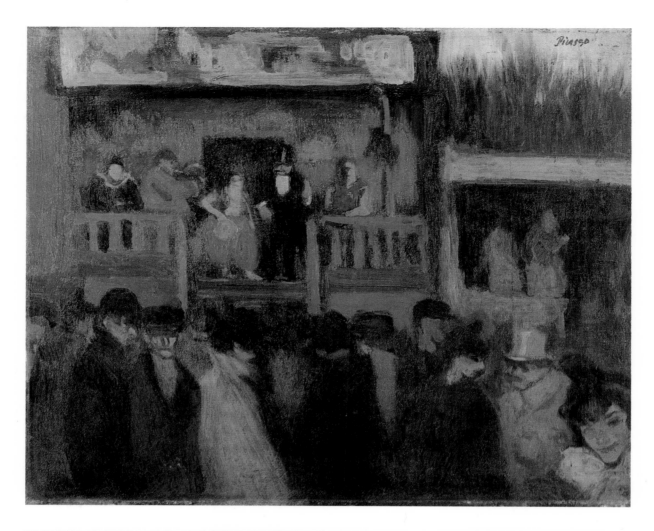

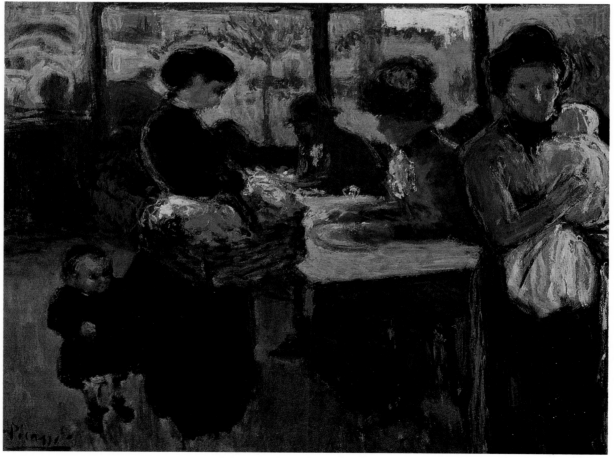

62 The Art of Youth 1898 – 1901

The Art of Youth 1898 – 1901 **63**

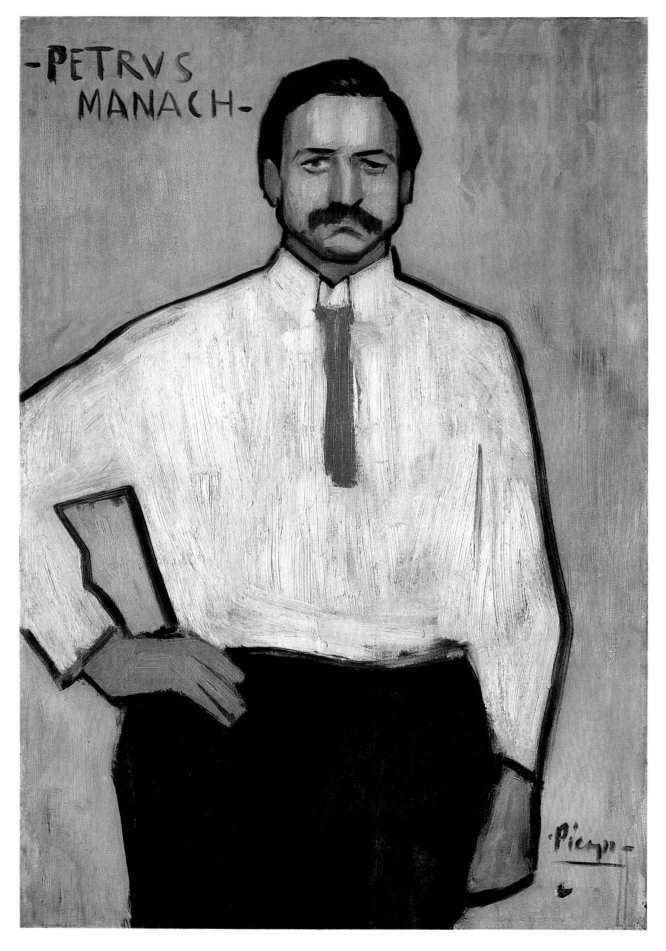

Portrait of Pedro Mañach. Paris, spring 1901
Oil on canvas, 100.5 x 67.5 cm
Zervos VI, 1459; DB V, 4; Palau 569
Washington (DC), National Gallery of Art

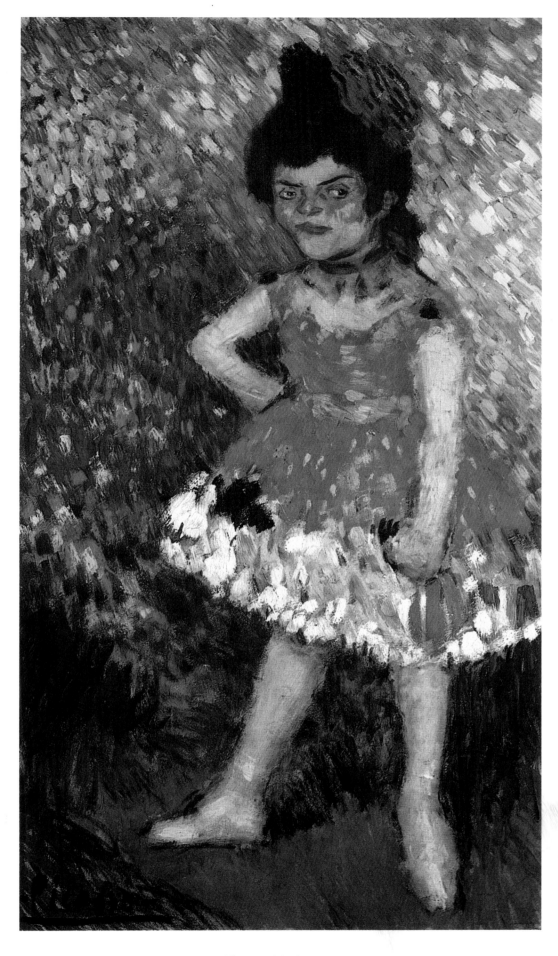

The Dwarf. Paris, 1901
Oil on cardboard, 104.5 x 61 cm
Zervos I, 66; DB IV, 2; Palau 602; MPB 4.274
Barcelona, Museu Picasso

65

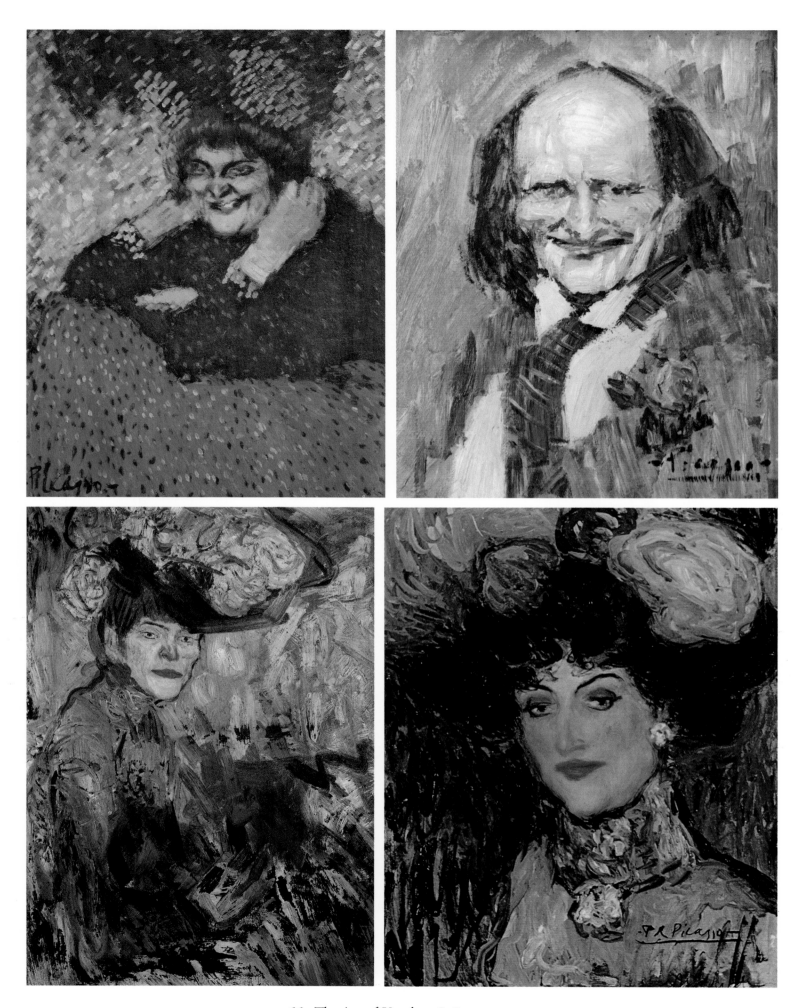

Portrait of Gustave Coquiot
Portrait de Gustave Coquiot
Paris, spring 1901
Oil on cardboard, 46 x 38 cm
Zervos I, 85; DB VI, 16; Palau 571
Zurich, E.G. Bührle Collection

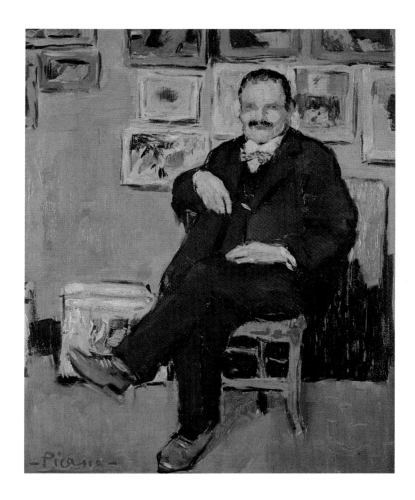

Above left:
Bedizened Old Woman
Femme aux bijoux
Barcelona, 1901
Oil on cardboard, 67.4 x 52 cm
Zervos VI, 389; DB IV, 4; Palau 600
Philadelphia (PA), Philadelphia Museum of Art,
The Arensberg Collection

Portrait of "Bibi la Purée"
Portrait de "Bibi la Purée"
Paris, 1901
Oil on canvas, 49 x 39 cm
Zervos VI, 360; DB V, 74; Palau 704
Paris, Musée National d'Art Moderne,
Centre Georges Pompidou

Portrait of Gustave Coquiot
Portrait de Gustave Coquiot
Paris, spring to summer 1901
Oil on canvas, 100 x 81 cm
Zervos I, 84; DB V, 64; Palau 605
Paris, Musée National d'Art Moderne,
Centre Georges Pompidou

Below left:
Overdressed woman
Femme dans la loge
Paris, 1901
Oil on canvas, 77 x 61 cm
Zervos XXI, 264; DB V, 71; Palau 648
Geneva, Charles Im Obersteg Collection

Woman with an Elaborate Coiffure (The Plumed Hat)
Femme au chapeau à plumes
Madrid, 1901
Oil on canvas, 46.5 x 38.5 cm
Zervos I, 39; DB III, 4; Palau 553
San Antonio (TX), Marion Koogler
McNay Art Institute

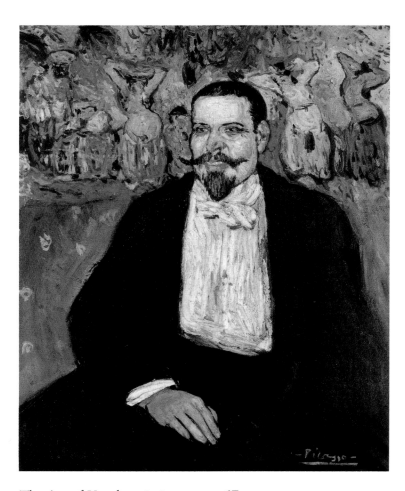

The Art of Youth 1898 – 1901 **67**

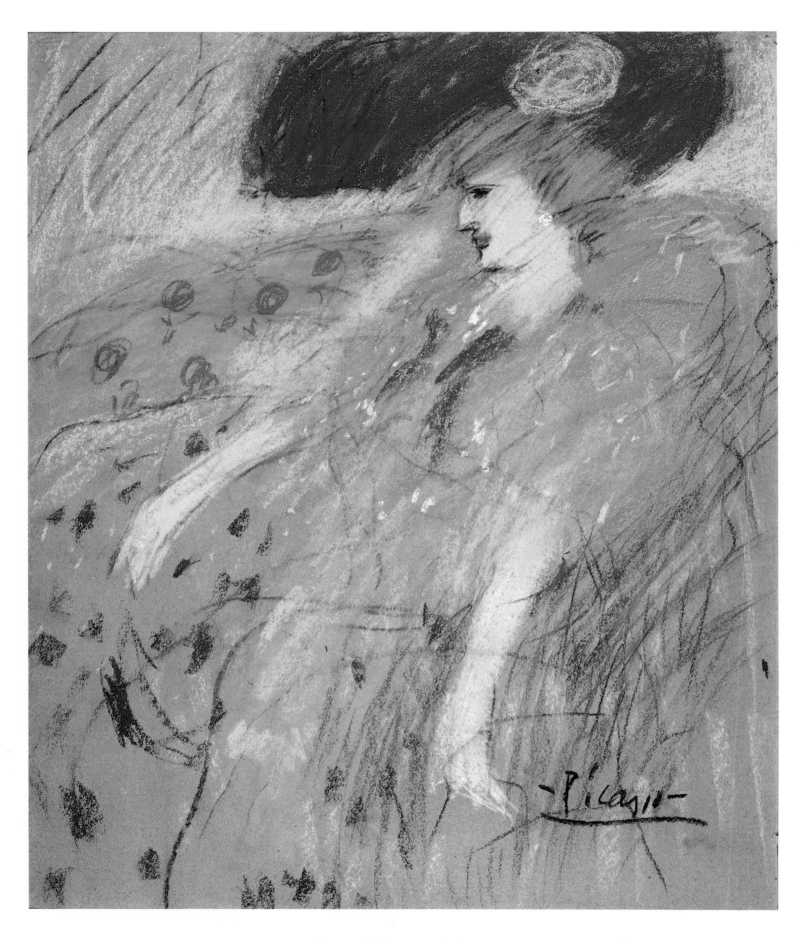

Woman with Blue Hat, Madrid, 1901
Pastel on cardboard, 60.8 x 49.8 cm
Not in Zervos
Private collection; formerly Galerie Rosengart

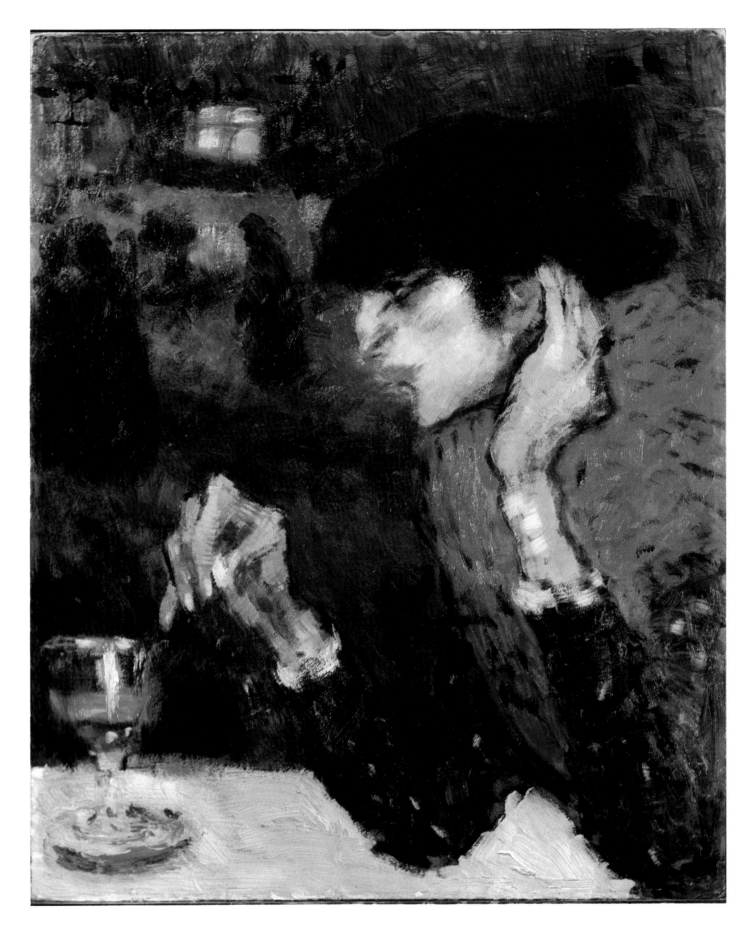

The Absinthe Drinker, Paris, 1901
Oil on cardboard, 65.5 x 50.8 cm
Zervos I, 62; DB V, 12; Palau 596
New York, Mrs. Melville Hall Collection

Stylistically, these works are strongly contoured with heavy outlines, and the facial features are highlighted with a few economical strokes. Picasso works in polarities. The overall shape is briskly established, but within it the face and body are differently treated. The long vertical lines or broad-area charcoal smudges are broken up with thick, obvious details. It is all done with great panache, but it is clearly simpler and even more schematic than pictures by Casas, where formal contrasts are far more subtly deployed. Picasso is out for rapid, foreground impact, and has reduced the structure of the models he is following to a principle, leaving the background a large bare space.

To reduce the given to a principle, and to define form in terms of linear contour and outline, were things that Picasso had learnt in his training; so the line-based art of *art nouveau* presented no problem to him. The menu he designed for "Els Quatre Gats" (p. 56) in 1899 is a good example. Every shape is rendered in clear line. Figures and background details work in plain zones of monochrome colour, or else are offset from each other by minor, stylized details. The illustration shows the speed and assurance with which Picasso had adopted a "Modernista" approach. There would be no real point in suggesting a specific influence on such a work.[76] Far too many of his works are much the same; Picasso was almost into serial production, and the tendency stayed with him later and repeatedly demonstrated the intensity with which he would pursue a subject or form. Themes such as an embrace or a kiss were to be repeated many times over, often varied only in some minor detail. He sketched poses and groupings over and over, deploying the results in various changing compositions.

But Picasso at that time did not confine himself to the repertoire of *art nouveau*. He was omnivorous in his taste for new aesthetic trends. Some of his drawings and paintings (cf. pp. 45 and 49) show him reworking the formal idiom of El Greco. The Greek-born painter had evolved his own distinctive style of elongated proportions and powerful colours in the late 16th and early 17th century in Spain. From El Greco Picasso borrowed the expressive elongation and the restless brushwork. He had seen original El Grecos in the Prado, of course; but his interest was also very much a product of the period. For centuries El Greco had been forgotten, and it was not till the 19th century that avant-garde artists rediscovered him. Charles Baudelaire was an admirer, Eugène Delacroix and Edgar Degas collected his work – though as late as 1881 a director of the Prado felt able to dismiss El Greco's paintings as "absurd caricatures". It was not till the "Modernistas" that this Spanish attitude really changed; Utrillo, above all, was instrumental in the revival of El Greco's fortunes.[77]

But it was Henri de Toulouse-Lautrec who made the most powerful impression on the youthful Picasso. His posters and paintings, draughtsmanlike in manner, economical, precise, often on the verge

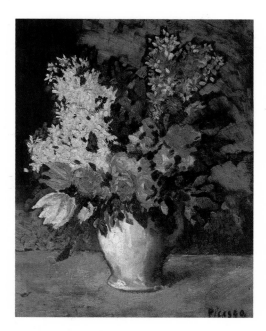

Floral Still Life
Nature morte aux fleurs
Paris, 1901
Oil on canvas, 65 x 49 cm
Zervos I, 61; DB V, 22; Palau 642
London, Tate Gallery

Pierreuse
Pierreuse, la main sur l'épaule
Paris, spring 1901
Oil on cardboard, 69.5 x 57 cm
Zervos I, 63; DB V, 11; Palau 598; MPB 4.271
Barcelona, Museu Picasso

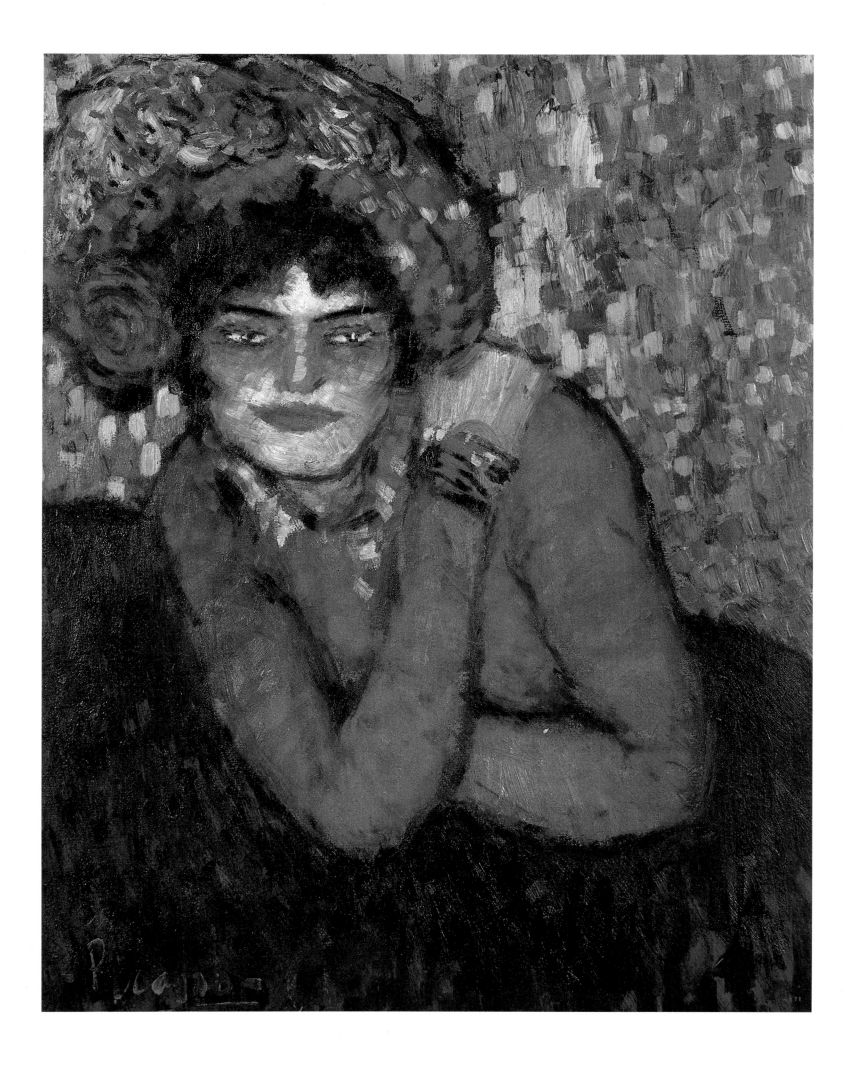

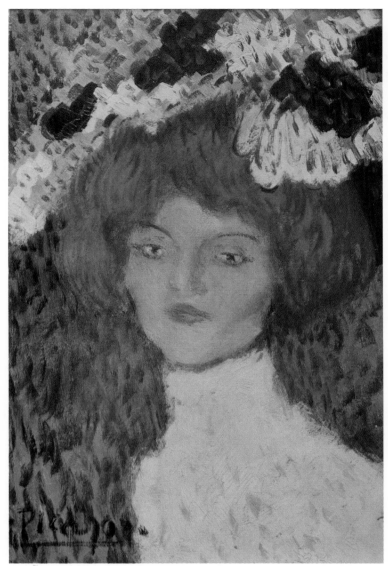 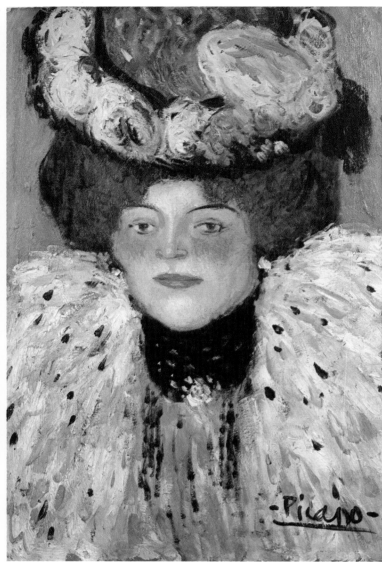

Portrait of a Woman
La Madrilène (Tête de jeune femme)
Paris, spring 1901
Oil on canvas, 52 x 33 cm
Zervos I, 64; DB V, 57; Palau 635
Otterlo, Rijksmuseum Kröller-Müller

Head of a Woman
Tête de femme
Paris, 1901
Oil on cardboard, 46.7 x 31.5 cm
Zervos I, 74; DB V, 59; Palau 631
Barcelona, Private collection

of being caricatures, held a particular appeal for Picasso. Toulouse-Lautrec was well known in Barcelona, but it was not till he visited Paris that Picasso saw originals and even bought posters to hang in his own studio.[78] As well as formal considerations , what interested him was the Frenchman's subject matter, the world of the cabaret and night club, the world of dancers and conviviality. Soon Picasso was producing his own pictures on these themes (cf. pp. 56 to 59).

In 1900, Picasso's interest in Toulouse-Lautrec peaked in his painting "Le Moulin de la Galette" (p. 58). Inside, there is a crowd; further on, beyond a diagonally cropped group of women seated at a table to the left, we see dancing couples as in a frieze. The subject and the treatment are reminiscent of a Toulouse-Lautrec done in 1889, which in turn was a reworking of Pierre-Auguste Renoir's 1876 painting of the merriment at the famous Moulin, transposing the colourful fun from the garden to the interior and to night.[79] Picasso follows Toulouse-Lautrec, and intensifies the effect by using the gas lighting to establish an atmosphere of half-light, a uniform duskiness in which the figures appear as patches of colour

against a dark background. Correspondingly, the style of brush-work is more summary, working in large blocks and pinpointing only a few characteristics of the people shown. The people have in fact been stripped of their individuality and are merely props to illustrate social amusement.[80]

So Picasso was not merely imitating. He also tried to reconceive the originals he copied. Very soon he was trying to rework diverse influences in a single work. A good example painted on cardboard in 1901 is "Pierreuse" (p. 71).[81] A young woman wearing a red top and a decorative hat is seated at a blue table, leaning on both elbows, her right arm crooked to clasp her left shoulder. Her atti-tude is one of protective barring and signals that she is withdrawn within herself. Dreamily she gazes away into an undefined and indistinct distance.

A sense of transported absence is conveyed not only by the woman's pose but also by Picasso's compositional subtlety. The woman is leaning across to the left side of the picture, establishing a falling diagonal and thus introducing a quality of movement into the work. But it is movement that is meticulously counterbalanced and neutralized by the composition as a whole. The use of spatial areas is richly ambivalent. Inclining across the table, the woman seems to be coming nearer to us, and with her hat cropped more than once by the picture edge it is as if she were on the point of stepping out towards us. At the same time, though, her position on

**The Kept Woman
(Courtesan with a Necklace of Gems)**
L'hétaïre
Paris, 1901
Oil on canvas, 65.3 x 54.5 cm
Zervos I, 42; DB VI, 17; Palau 662
New York, The Metropolitan
Museum of Art

Woman Wearing a Necklace of Gems
Femme au collier de gemmes
Paris, 1901
Oil on cardboard, 43.7 x 36.1 cm
Zervos VI, 385; DB V, 48; Palau 660
Toronto, Art Gallery of Ontario

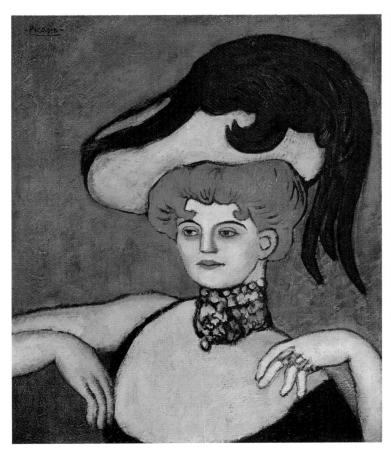
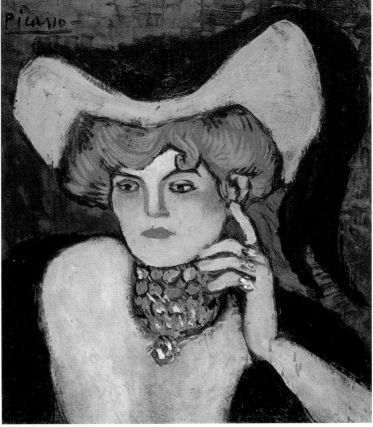

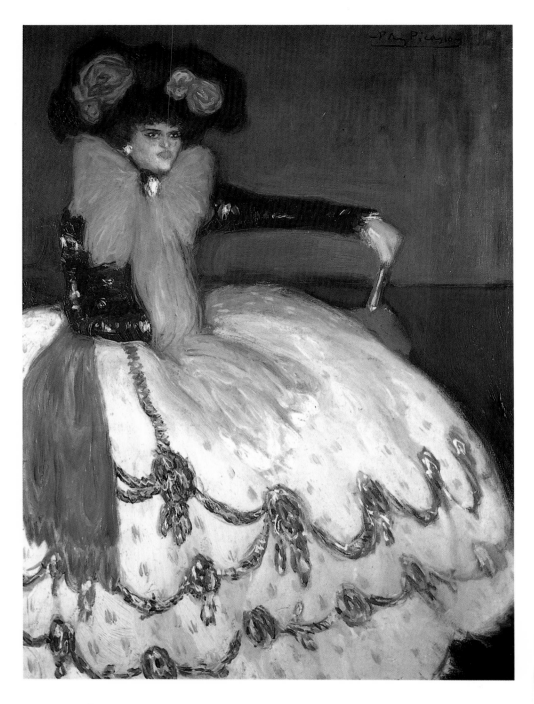

Lady in Blue
Femme en bleu
Madrid, early 1901
Oil on canvas, 133.5 x 101 cm
Zervos XXI, 211; DB III, 5; Palau 539
Madrid, Centro de Arte Reina Sofia

the other side of the table emphasizes inaccessibility. It is a painting of mood, and the contrastive use of colour, with the dichotomy of flat areas and broken-up form, serve to underline its mood. While the face and body are strongly outlined and colourfully painted in monochrome, the background is an iridescent tapestry of colour dabs. It is a restless patchwork of yellow, red, blue and green, and the pastose painting disturbs our eye and establishes productive unclarities. Picasso was using techniques borrowed from the pointillists, Vincent van Gogh, Paul Gauguin and the Nabis all in one, to make a style of his own.

The same applies to his portrait of Pedro Mañach (p. 64). It is an uncompromising frontal view. Mañach's right hand is on his hip, his left arm almost straight. The figure is a well-nigh pure study in

Right:
French Cancan
French Cancan
Paris, autumn 1901
Oil on canvas, 46 x 61 cm
Zervos XXI, 209; DB V, 55; Palau 508
Geneva, Raymond Barbey Collection

Women Chatting at the Races
Les courses
Paris, spring 1901
Oil on cardboard, 52 x 67 cm
Zervos XXI, 205; DB V, 31; Palau 587
France, Private collection

The Art of Youth 1898–1901 75

76 The Art of Youth 1898 – 1901

Mother and Child
Mère et enfant
Paris, spring 1901
Oil on canvas, 68 x 52 cm
Zervos XXI, 292; DB V, 10; Palau 576
Bern, Kunstmuseum Bern (on loan)

Woman Huddled on the Ground with a Child
Femme accroupie et enfant
Paris, 1901. Oil on canvas, 110.5 x 96.5 cm
Zervos I, 115; DB VI, 30; Palau 705
Cambridge (MA), Fogg Art Museum,
Harvard University

The Mother (Mother and Child)
La mère (Mère tenant deux enfants)
Paris, spring 1901
Oil on cardboard on panel, 74.4 x 51.4 cm
Zervos XXI, 291; DB V, 9; Palau 575
Saint Louis (MO), Saint Louis Art Museum

Mother and Child in Front of a Bowl of Flowers
Mère et enfant aux fleurs
Paris, spring to summer 1901
Oil on cardboard, 54 x 65 cm
Zervos I, 77; DB V, 7; Palau 629
Paris, Private collection

Still Life (The Dessert)
Nature morte (Le dessert)
Paris, 1901
Oil on canvas, 50 x 80.5 cm
Zervos I, 70; DB V, 72; Palau 659; MPB 4.273
Barcelona, Museu Picasso

outline, set against an ochre yellow and almost entirely undifferentiated background. Background and figure alike are done as large areas lacking finish, and the face too has been established with only a few lines and colours. It is a picture of contrasts, the yellow background offsetting the white and dark brown of the clothing; but the signal red of the tie, striking the sole aggressive note, has the effect of resolving polarities and bringing the whole work together. The influence of van Gogh's Provence work done late in life, and of the Pont-Aven school, is palpable.[82]

Of course contemporary critics were quick to notice Picasso's adoption of current avant-garde artistic styles. Reviewing the work shown in 1901 at the Galerie Vollard, Félicien Fagus wrote that Picasso had plainly been influenced by "Delacroix, Manet, Monet, van Gogh, Pissarro, Toulouse-Lautrec, Degas, Forain, perhaps even Rops".[83] The only thing wrong with this assessment is that it misses out an important name or two, such as that of Gauguin.

But the sheer number of influences on Picasso at that time need not only be seen in a negative light. It is normal for young artists to be influenced as they try to find their own style. And Picasso wasn't merely copying; he was quickly able to harmonize various influences into new wholes. If this had not been so, it would be hard to understand his early success on the art market. He had an excellent memory for formal qualities, one which stored them so deeply that they became part of his own way of thinking. He was imitating, yes – but he did so in order to find a style entirely his own.

77 The Art of Youth 1898 – 1901

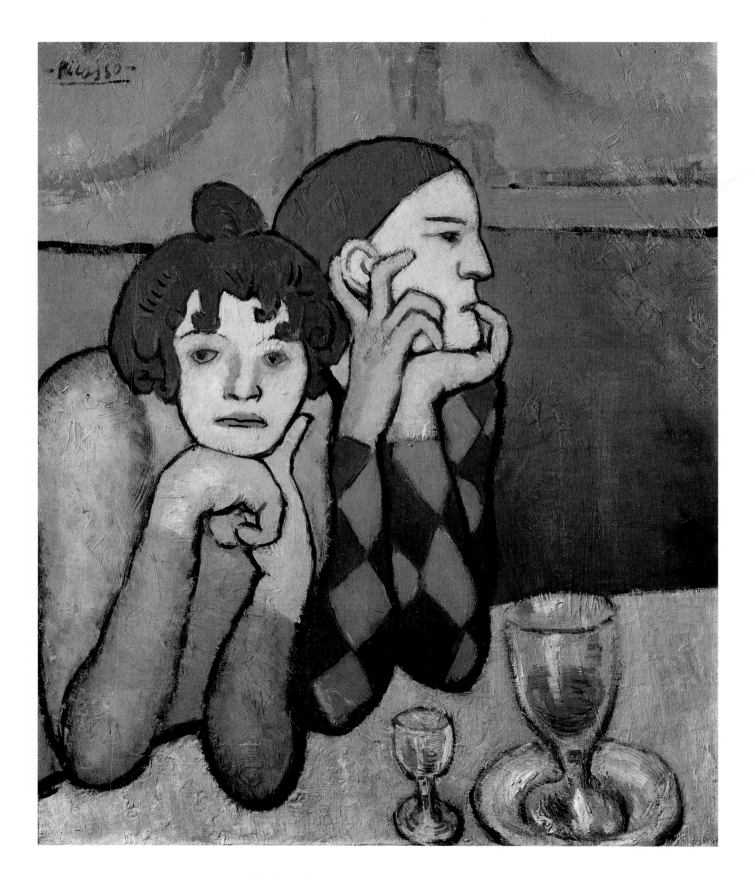

The Two Saltimbanques (Harlequin and His Companion)
Les deux saltimbanques (Arlequin et sa compagne)
Paris, autumn 1901
Oil on canvas, 73 x 60 cm
Zervos I, 92; DB VI, 20; Palau 666
Moscow, Pushkin Museum

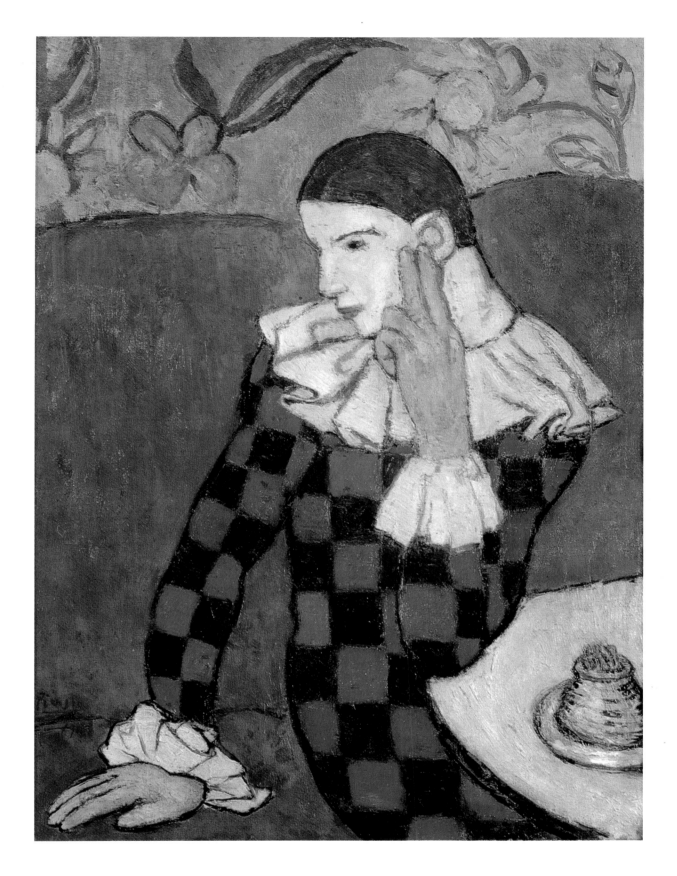

Harlequin Leaning on His Elbow
Arlequin accoudé
Paris, autumn 1901
Oil on canvas, 82.8 x 61.3 cm
Zervos I, 79; DB VI, 22; Palau 670
New York, The Metropolitan Museum of Art

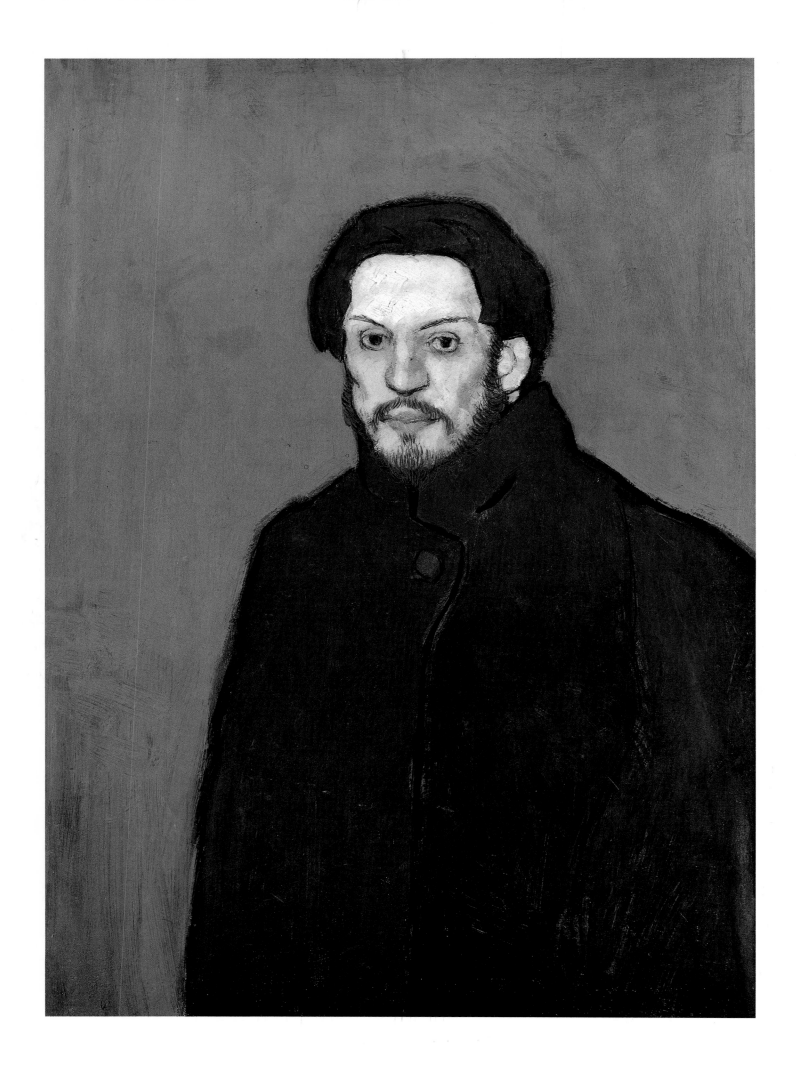

4 The Blue Period
1901–1904

Picasso's works in the period from 1898 to 1901 were most diverse in character; it was plainly a time when he was getting his bearings, as is confirmed by the fact that he was forever examining the creative principles of contemporary progressive art. His examination was a deliberate and selective process; one of Picasso's great abilities was his discernment of the strengths and weaknesses of new artistic movements, his gift for borrowing what he could use. As a pupil he had early on perceived the shortcomings of academic art and realised that it was irreconcilable with his own convictions; now, similarly, he saw the dead ends of the avant-garde, the tendency of *art nouveau* to use superficial ornamentation and stiff linearity, the vapid esotericism of symbolism. In the year 1901 Picasso was already in a position to make a response and create something new of his own – the long series of works known as his Blue Period.

The term places in the foreground the monochrome tendency of the work. It is striking, certainly; but merely to identify the colouring is to say little. Nowadays the pictures are valued for their accessible formal repertoire, which has a unified, homogeneous quality to it; but the fact is that they are by no means simple, but rather products of complex, multi-layered artifice. They constitute no less than a résumé of European artistic progress since the mid–19th century[84] – though Picasso did forgo the newly-discovered potential of colour. In this respect he was diametrically at odds with Fauvism, which flourished at the same time.[85] So his contemporaries had initial difficulties making out the intention and value of Picasso's work. Picasso could of course have gone about things an easier way: a lesser talent would have been satisfied with what had been achieved so far and would have continued turning out art that spelled success with the public.

Though the fundamentals of the Blue Period were evolved in Paris, Barcelona remained the centre of Picasso's actual labours till he finally moved to the French capital in April 1904. In fact his work in Catalonia was interrupted only by a brief (and commercially dismal) stay in Paris from October 1902 to January 1903. His pictures, not merely melancholy but profoundly depressed and

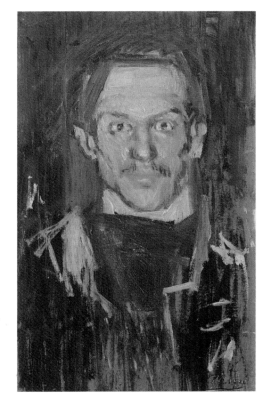

Self-portrait "Yo"
Autoportrait "Yo"
Paris, summer 1901
Oil on cardboard on panel, 54 x 31.8 cm
Zervos I, 113; DB V, I; Palau 678
New York, Mrs. John Hay Whitney Collection

Self-portrait with Cloak
Autoportrait
Paris, late 1901
Oil on canvas, 81 x 60 cm
Zervos I, 91; DB VI, 35; Palau 715; MPP 4
Paris, Musée Picasso

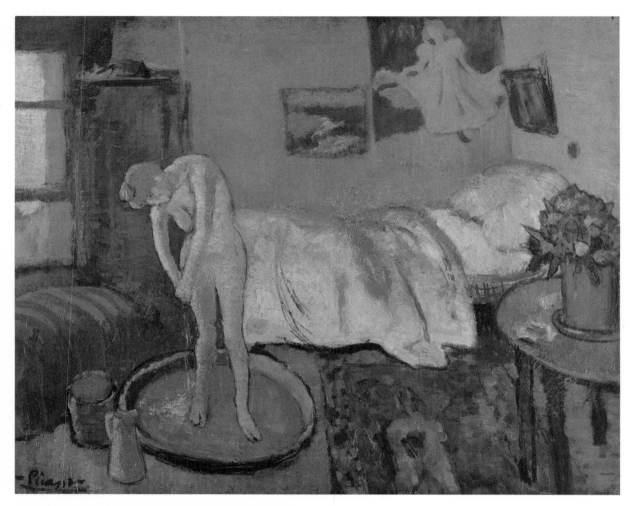

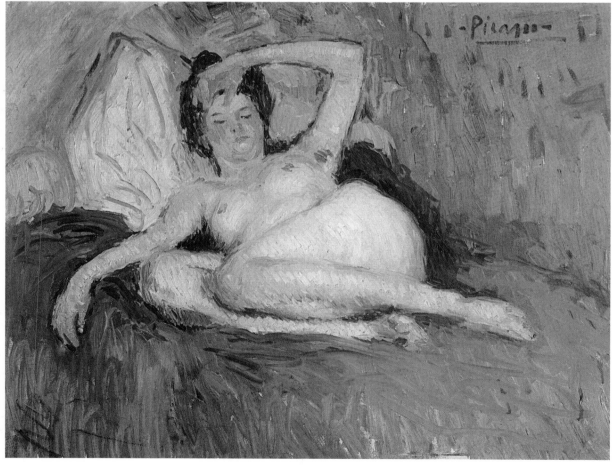

82 The Blue Period 1901 – 1904

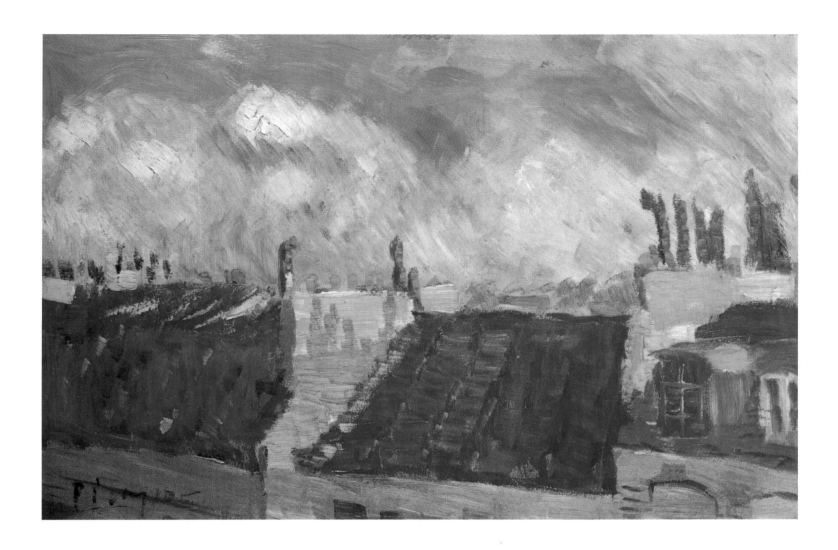

The Blue Roofs
Les toits bleus
Paris, 1901
Oil on cardboard, 40 x 60 cm
Zervos I, 82; DB V, 21; Palau 614
Oxford, Ashmolean Museum

The Blue Room
La chambre bleue (Le tub)
Paris, 1901
Oil on canvas, 51 x 62.5 cm
Zervos I, 103; DB VI, 15; Palau 694
Washington (DC), The Phillips Collection

Jeanne (Female Nude)
Jeanne (Nu couché)
Paris, 1901
Oil on canvas, 70.5 x 90.2 cm
Zervos I, 106; DB V, 52; Palau 606
Paris, Musée National d'Art Moderne,
Centre Georges Pompidou

cheerless, inspired no affection in the public or in buyers. Picasso had broken with Mañach, and his financial position was very bad indeed. The report that Picasso even burnt a large number of his drawings for heating that winter may be mere legend, but in terms of the art market he was certainly in the cold. And this isolation continued till 1905, when collectors began to take an interest in his work of the Blue and Rose Periods. It was not poverty that led him to paint the impoverished outsiders of society, but rather the fact that he painted them made him poor himself.[86] But he was neither lonely nor in critical straits. He was still an important figure in the Catalan scene. And he had his foothold in the Parisian Spanish community, and met new friends who consolidated his position, such as the writer Max Jacob.[87]

To understand Picasso's circumstances at that time helps us not only to grasp his life but also to grasp his subject matter. The beggars, street girls, alcoholics, old and sick people, despairing lovers, and mothers and children, all fit the despondent mood of the Blue Period so perfectly that it is as if Picasso had invented them. But of course all he invented was his treatment; otherwise he was squarely in the avant-garde line of development since the mid–19th century. The relinquishment of academic ideals and of the traditional valu-

83 The Blue Period 1901 – 1904

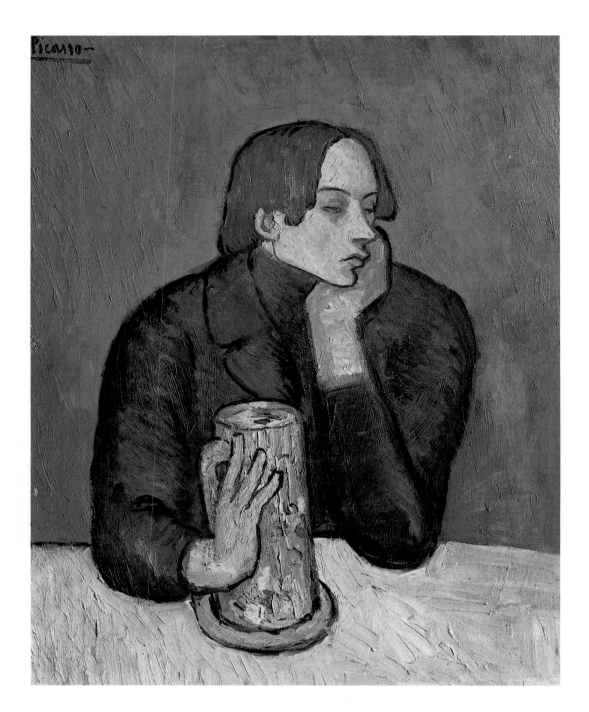

Portrait of Jaime Sabartés (The Glass of Beer)
Portrait de Jaime Sabartés (Le bock)
Paris, September to October 1901
Oil on canvas, 82 x 66 cm
Zervos I, 97; DB VI, 19; Palau 665
Moscow, Pushkin Museum

ations placed on supposedly higher or lower kinds of art, and the new stress that was placed on autonomy of form, had by no means implied indifference to content. It was just that content had changed. The subjects now considered fit to paint were different ones.

Gustave Courbet's realism located subjects in everyday village life. Courbet liked to give plain physical work the full monumental treatment, knowing the subject had hitherto not been taken seriously.[88] In Honoré Daumier's drawings, society's weaknesses were lampooned, but Daumier also took the lives of smiths, butchers or washerwomen seriously in paintings and graphic art that owed no slavish debt to any classical norm.[89] And Impressionism, of course, would be radically misunderstood if we saw it purely as formal

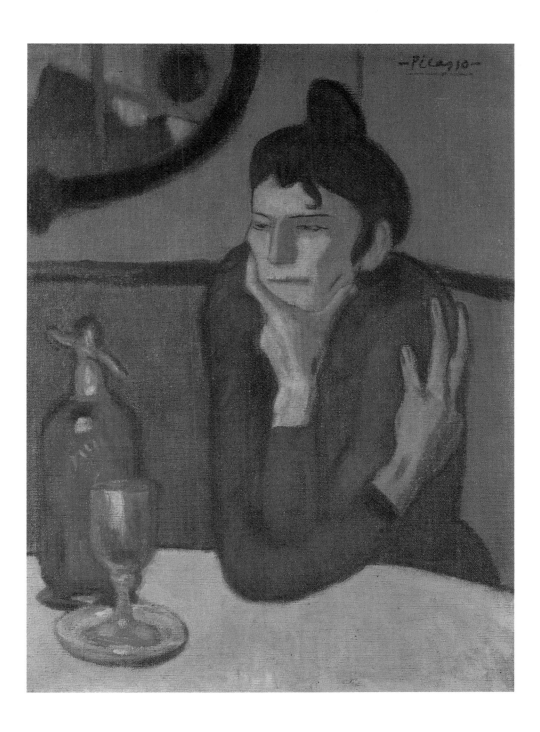

The Absinthe Drinker
La buveuse d'absinthe
Paris, 1901
Oil on canvas, 73 x 54 cm
Zervos I, 98; DB VI, 24; Palau 675
St. Petersburg, Hermitage

virtuosity, games played with colour, and atmospherics. Impress-
ionism has all this to offer, but more too: the Impressionists did not
only paint sunny landscapes, or scenes recorded in the moods of
different seasons or times of day, they also discovered the modern
city as a source of subjects. If they recognised no hierarchy of for-
mal values, they also knew no precedence of subjects. There were
no taboos in their approach to the new reality, no refusal to face
subjects that were beneath their dignity. Smoke-filled railway sta-
tions and cathedrals, boulevard life in Paris and night clubs and the
gloom of drinkers and whores, all appeared in their work. The
revolution in form was accompanied by a revolution in subject
matter. Their position as artistic outsiders prompted them to
examine social realities.[90]

85 The Blue Period 1901 – 1904

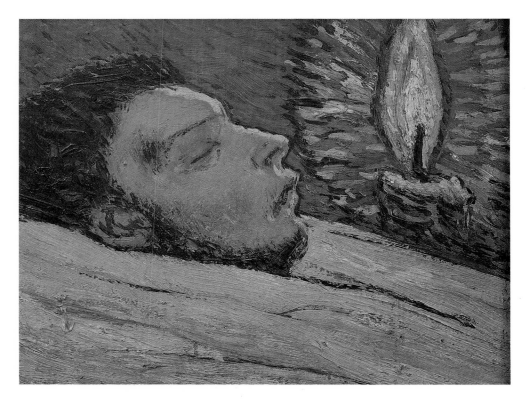

The Death of Casagemas
La mort de Casagemas
Paris, summer 1901
Oil on panel, 27 x 35 cm
Zervos XXI, 178; DB VI, 5; Palau 676; MPP 3
Paris, Musée Picasso

Picasso's Blue Period portrayals of beggars and prostitutes, workers and drinkers in bars, took up this line. His absinthe drinkers had antecedents in Degas and Toulouse-Lautrec.[91] And the Pierreuse staring dreamily into nowhere was of course a street girl. Many similar compositions followed from 1901 to 1904. Often they had thematic links to Degas and Toulouse-Lautrec, and links in terms of monumental treatment to Courbet, who – influenced by the revolutionary thinking of Pierre-Joseph Proudhon – had dared as early as 1856 to make two prostitutes by the Seine the subject of a large-scale painting.[92] Picasso's arresting "Woman Ironing" (p. 114) was also a product of a recent tradition, with affinities to works by Daumier and Degas.[93]

Of course it was not only the visual arts that were in flux. Political, philosophical and cultural thinking were expressed in literary form. Along with the work of Proudhon, there were the novels of the Naturalist Emile Zola. "Nana" in particular, the story of a prostitute, was well known, indeed notorious.[94] Just as Edouard Manet painted a "Nana" himself (Hamburg, Kunsthalle), so too Baudelaire and Zola responded to the new art in writing.[95]

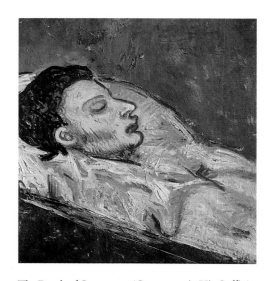

The Death of Casagemas (Casagemas in His Coffin)
La mort de Casagemas (Casagemas dans son cercueil)
Paris, summer 1901
Oil on cardboard, 72.5 x 57.8 cm
Zervos XXI, 179; DB VI, 6; Palau 677
Estate of the artist

We should also remember that the Paris milieu was not the sole influence on Picasso's Blue Period. Spanish culture played a considerable part too. After the 1868 revolution, which had led to a short-lived democratic republic[96], social injustice became a concern of Spanish art and writing too.[97] Of the various ideas that were imported into the country, anarchism was particularly influential; the Barcelona literary and artistic circles Picasso moved in were very interested in the tenets of anarchism, albeit in conjunction with other ideas too.[98] A self-portrait Picasso painted in the winter

Evocation (The Burial of Casagemas)
Evocation (L'enterrement de Casagemas)
Paris, summer 1901
Oil on canvas, 150.5 x 90.5 cm
Zervos I, 55; DB VI, 4; Palau 688
Paris, Musée d'Art Moderne
de la Ville de Paris

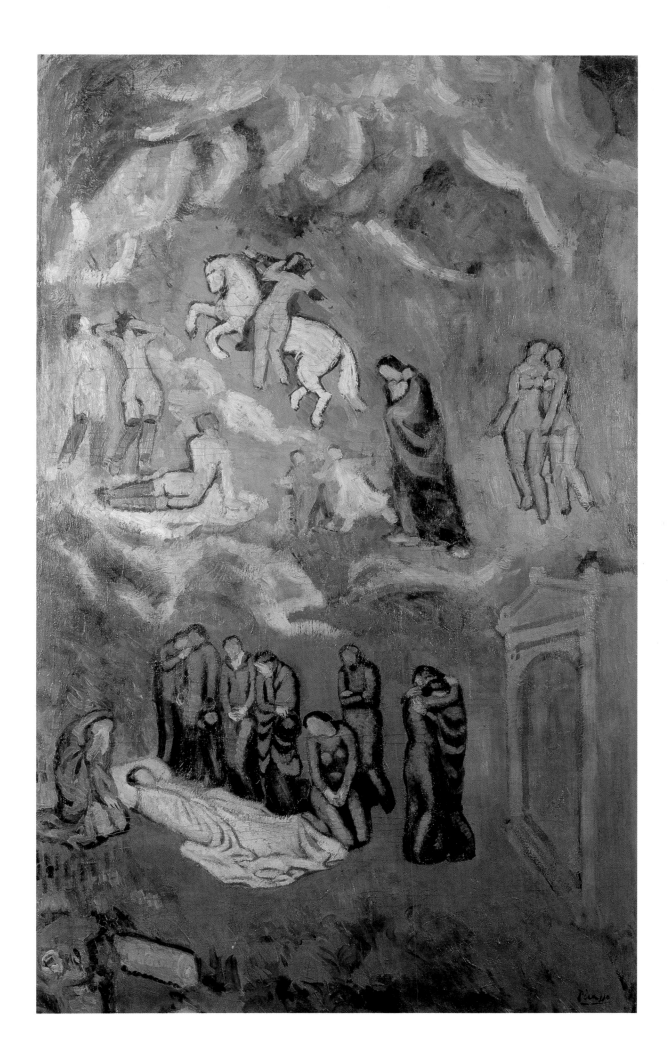

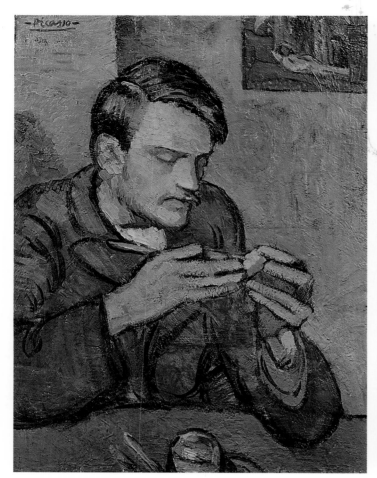

Portrait of Mateu Fernández de Soto
Portrait de Mateu Fernández de Soto
Paris, October 1901
Oil on canvas, 61 x 46.5 cm
Zervos I, 94; DB VI, 21; Palau 689
Winterthur, Oskar Reinhart Foundation

Portrait of Jaime Sabartés
Portrait de Jaime Sabartés
Paris, 1901
Oil on canvas, 44.5 x 36.8 cm
Zervos I, 87; DB VI, 34; Palau 706
Barcelona, Museu Picasso

of 1901/1902 (p. 80) captures the mood. It is as if Dostoyevsky's novels, Nietzsche's ideas and the theories of Mikhail Bakunin had stood godfather to the painting.

The "Modernista" painters and the post-modernists, foremost among them Nonell, used their work to explore social conditions following the collapse of the Spanish colonial empire and the consequent deterioration of the country's economic situation. Santiago Rusiñol used a subtle symbolism to describe Spain's ailing condition, painting dead and withered gardens time after time. Casas and Nonell, on the other hand, painted work that responded directly to political events and the miseries of the lower classes. Thus in 1894 Casas painted the public execution of anarchist bomber Santiago Salvador, while Nonell did numerous studies and paintings of slum life, men crippled in war, and social outcasts.[99] Together with Soler, Picasso had pursued radical ideas in "Arte Joven"; he attached especial importance to the writer Pio Baroja, whose tales lamented the lot of casual labourers and the unemployed.[100] The influence of anarchist literature and of Nonell's socio-critical art is apparent in many of Picasso's works of 1899 and 1900. But his new style of the Blue Period neither simply continued this line nor conformed with his sources. His formal approach was different for a start. Whereas Nonell (and Picasso himself in his "Arte Joven" days) had done compositions involving

several figures and having a narrative character, the Blue Period works established just a handful of emphatic motifs. In Nonell's panoramic works, human misery was seen as a slice of real life in its real environment and implied comment on larger societal conditions. But in Picasso's case fate was an individual thing, endured in isolation.

"The Absinthe Drinker" (p. 85), an emotionally arresting painting, draws its power from this. Everything seems stony: the glass, the bottle, the woman herself. A sense of volume is conveyed by juxtaposing variant tones of the same colour within purely linear spaces. Spatial values are produced less by perspective than by the overlapping of forms. It is a meticulous, clear, balanced composition, with lighter and darker echoes of the skin tonalities unifying the effect. The tonal differences are so slight that the impression borders on the monochrome, serving solely to intensify the atmospheric charge. The draughtsman's forms make a more powerful impact than the painter's colouring. The long, talon-like hands gripping the angular face and upper arm, with the overall elongation of proportions, serve to emphasize the isolation and introspectiveness of the sitter.

The Blue House
La maison bleue
Barcelona, 1902
Oil on canvas, 51.7 x 41.5 cm
Zervos XXI, 280; DB VII, I; Palau 721
Zurich, Dobe Collection

Man in Blue
Homme en bleu (Portrait d'homme)
Paris and Barcelona, winter 1902/03
Oil on canvas, 90 x 78 cm
Zervos I, 142; DB VIII, I; Palau 782; MPP 5
Paris, Musée Picasso

Mother and Child from Behind
Mère et enfant
Barcelona, 1902
Oil on canvas, 40.5 x 33 cm
Zervos XXI, 367; DB VII, 18; Palau 749
Edinburgh, Scottish National Gallery of Modern Art

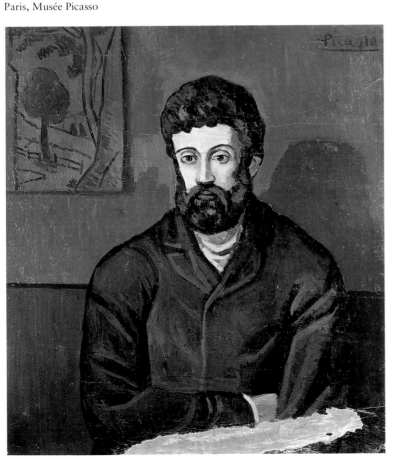

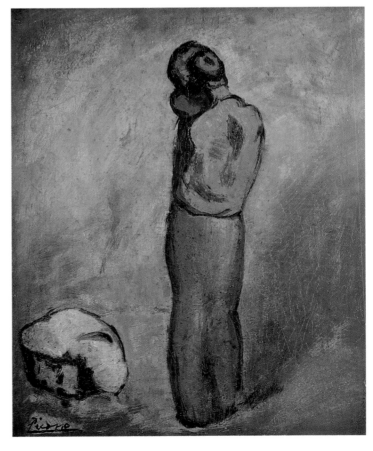

The Blue Period 1901 – 1904 **89**

Angel Fernández de Soto with a Woman
Angel Fernández de Soto avec une femme
Barcelona, about 1902/03
Watercolour and India ink on paper, 21 x 15.2 cm
Not in Zervos; MPB 50.494
Barcelona, Museu Picasso

"Crouching Beggar" (p. 93) shows Picasso developing his new stylistic resources. The crouching woman, cloaked in a blanket, her form contoured with flowing, forceful lines, is seen in some indeterminate location established by the mere indication of spatial levels. Blues of various kinds predominate. Even the ochre-brown blanket and the sallow face are shadowed with blue. The brushwork still juxtaposes thick and even, abrupt and smooth, as in the previous Paris paintings.

But the Blue Period Picasso did not merely pursue one-sided variations of an expressive approach. He produced very varied work, monumental, smoothly-constructed pieces alternating with detailed work the brushwork of which is nervy and dabbed. It is not only an art of considerable artifice, it is also an art which portrays

Reclining Nude with Picasso at Her Feet
Barcelona, about 1902/03
India ink and watercolour, 17.6 x 23.2 cm
Zervos XXI, 283; DB D IV, 5; MPB 50.489
Barcelona, Museu Picasso

The Mackerel (Allegorical Composition)
Le maquereau (Composition allégorique)
Barcelona, about 1902/03
Coloured India ink on cardboard, 13.9 x 9 cm
Not in Zervos; MPB 50.497
Barcelona, Museu Picasso

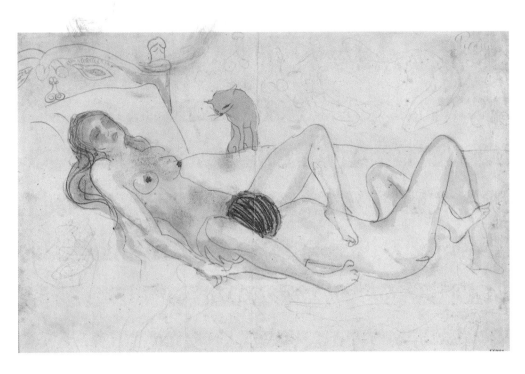

Two Figures and a Cat
Deux nus et un chat
Barcelona, about 1902/03
Watercolour and pencil on paper, 18 x 26.5 cm
Not in Zervos; MPB 50.497
Barcelona, Museu Picasso

an artificial world. For Picasso, confrontation with social reality was only a motivation; it was not an end in itself. For him it was more important to experiment, to try and test new visual approaches.

In "The Absinthe Drinker" the subject is not only the melancholy pub atmosphere and the dreariness of alcohol. The painting's meaning also lies in the autonomy of formal means. The erosion of defined spatiality, the abandoning of perspective construction, is only the most striking of several interesting features. It must be taken together with the accentuation of compositional fundamentals such as plenitude and emptiness, density and weight, emphasis and its lack. Picasso's composition uses three levels, the narrowest strip (contrary to usual practice) being the bottommost. It is also

91 The Blue Period 1901 – 1904

the brightest and thus, despite its weightless narrowness, nonetheless possesses force and presence.

The other main motifs are similarly treated. The woman is seated to the right, but turned to the left in such a way that her head and cupped hand establish a vertical axis that is not quite the centre line of the composition but nevertheless roughly corresponds to the traditional golden section. This axis is also at odds with the vertical of the picture edge. The woman is not in the geometrical centre, but the figure does link the upper and lower zones with a certain weight, creating a stable tension between them. The bottle and glass echo this function.

If "The Absinthe Drinker" is thus a textbook work of eccentric composition, in "Crouching Beggar" Picasso emphasizes compositional centrality to express the woman's self-absorbed state. She is crouching right on the central vertical axis, the turns of her body turning about it. Solid motifs, with spatially flat planes in the background, convey a sense of fullness and emptiness.

Ex-centricity and centralization were constants in this period. "The Blind Man's Meal" (p. 103) has a blind man up against the right of the composition, reaching across the table with unnaturally elongated arms, so that the rest of the picture seems somehow to be in his embrace or province. The radically monochromatic blue is married to a kind of formal crisscross procedure: the composi-

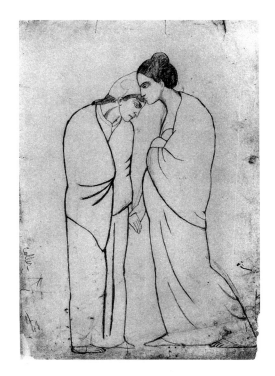

Study for "The Visit"
Etude pour "L'entrevue"
Paris and Barcelona, winter 1901/02
Pencil on paper, 45.9 x 32.8 cm
Zervos XXI, 369; Palau 737; MPP 447
Paris, Musée Picasso

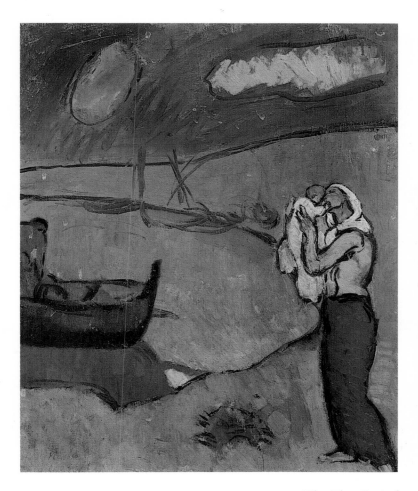

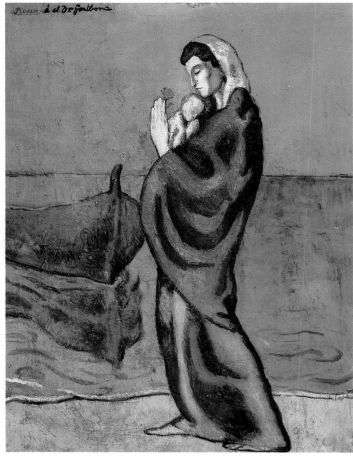

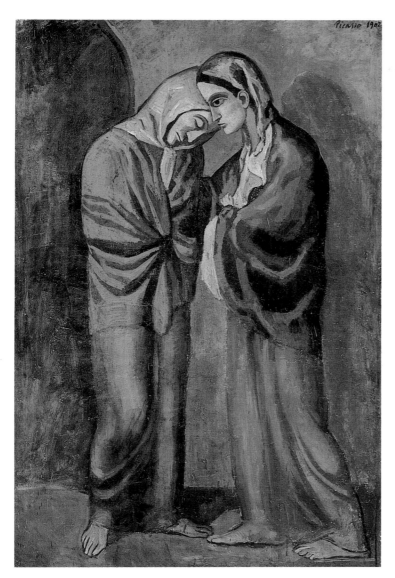

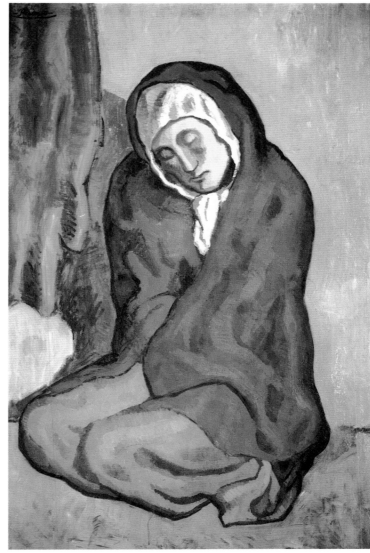

tion uses striking echo techniques, the pallor in the blind man's neck answered by parts of the table, the paler blue patches on his clothing corresponding to the pale blues on the rear wall.

Though there is no clear line of evolution, certain Blue Period motifs and formal groupings do recur. In essence, Picasso was working within a limited range: men and women seated at tables, alone or in twos, meals being eaten, figures crouching or hugging themselves as they stand or sit, people with head in hand or arms crossed – this modest repertoire, in variations, accounts for the Blue Period work.

Of course, if there were no more to it, those with no prior interest would no longer have any particular reason to be interested in these pictures. In fact Picasso was a master of intensifying contrast and evocative effects. His mastery came from his assured grasp of certain formal and thematic antecedents, and of the various media (such as drawing, graphics or paint). One of his earliest etchings was "The Frugal Repast" (p. 108), done in 1904 and one of the masterpieces of 20th-century printed graphic art. In it, Picasso's approach to line etching resembles his handling of colour tones in

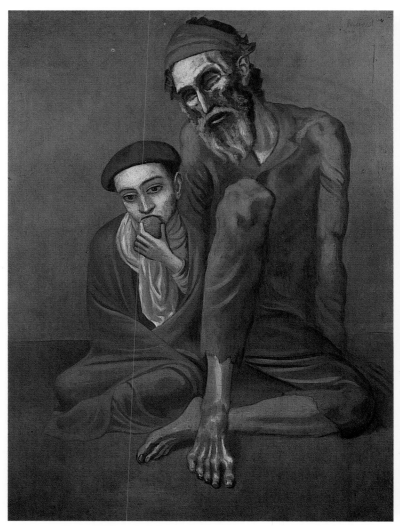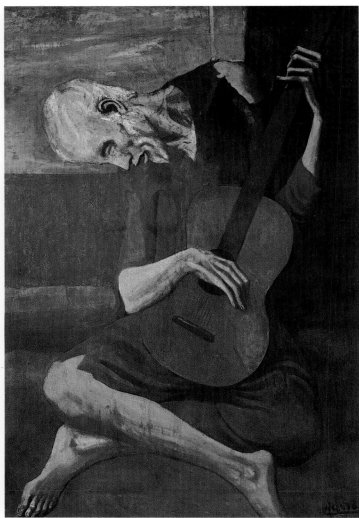

The Old Jew (Blind Old Man and Boy)
Le vieux juif (Le vieillard)
Barcelona, 1903
Oil on canvas, 125 x 92 cm
Zervos I, 175; DB IX, 30; Palau 936
Moscow, Pushkin Museum

The Old Guitar Player
Le vieux guitariste aveugle
Barcelona, autumn 1903
Oil on panel, 121.3 x 82.5 cm
Zervos I, 202; DB IX, 34; Palau 932
Chicago (IL), The Art Institute of Chicago

the paintings. Velvety black zones fade to grey and to bright clarity. As in "The Blind Man's Meal" Picasso plays with formal correspondences; but the cylindrical thinness of the arms, the elongated spread fingers, and the bony angularity of the figures with their dark and light areas, all recall El Greco. Not that the conspicuous influence of El Greco was the only presence in the Blue Period. It was not only the distortion of proportion that gave expressive force to these monochrome works, but also the grand, decorative linearity, a legacy of *art nouveau* and dialectically related to the subjects of the works. Monumentally conceived, solitary, emotionally intense figures, of course, were also standard fare in Symbolist art.

It is surely true that Picasso absorbed the influence of major artists such as Edvard Munch.[101] But another important influence was the minor French painter Eugène Carrière, who was well-known in Barcelona. A friend of Picasso's, Sebastián Junyent, was a pupil of Carrière, and Casas had earlier attended a Paris art school where Carrière taught.[102] His monochrome pictures using only a very few figures plainly influenced Picasso's numerous mother-and-child works. Other artists also influenced Picasso's monochrome

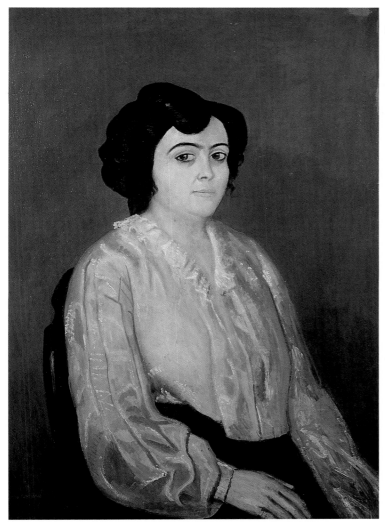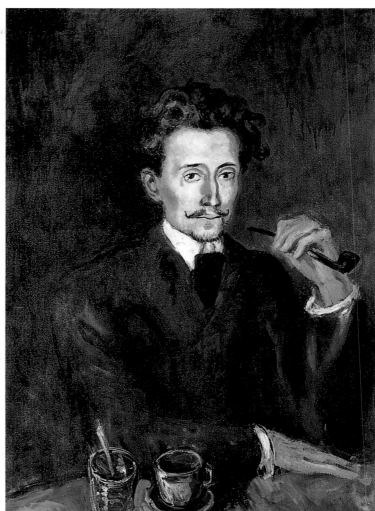

style. Indeed, it was a widely followed approach at the turn of the century, used by Symbolists, Impressionists and even Classicists. As well as Carrière's grey-brown paintings there were Pierre Puvis de Chavanne's allegorical works and James Abbott McNeill Whistler's tonal studies in blue and rose, seen in a large-scale Paris exhibition soon after the artist's death in 1903[103].

The colour blue was important in these experiments, and indeed, as we shall see, its meaning had a history. Its melancholy mood was often discussed in theoretical writings on art and in literature at the time. Painter-poet Rusiñol, one of the leading Catalan "Modernistas", published a short Symbolist tale, "El patio azul" (The Blue Courtyard), in the 10 March 1901 issue of Soler and Picasso's magazine "Arte Joven". The main character is a painter engaged in trying to capture the melancholy atmosphere of a courtyard surrounded by houses. In the process he meets a consumptive girl, who dies when he finishes his painting.[104] Shortly after, in his studio at Boulevard de Clichy 130 in Paris, Picasso painted "The Blue Room" (p. 82). He was joining the debate on the significance of the colour.

Blue not only denotes melancholy; it also carries erotic charges.[105]

Portrait of Señora Soler
Portrait de Madame Soler
Barcelona, 1903
Oil on canvas, 100 x 73 cm
Zervos I, 200; DB IX, 24; Palau 903
Munich, Staatsgalerie moderner Kunst

Portrait of Soler the Tailor
Portrait du tailleur Soler
Barcelona, summer 1903
Oil on canvas, 100 x 70 cm
Zervos I, 199; DB IX, 22; Palau 905
St. Petersburg, Hermitage

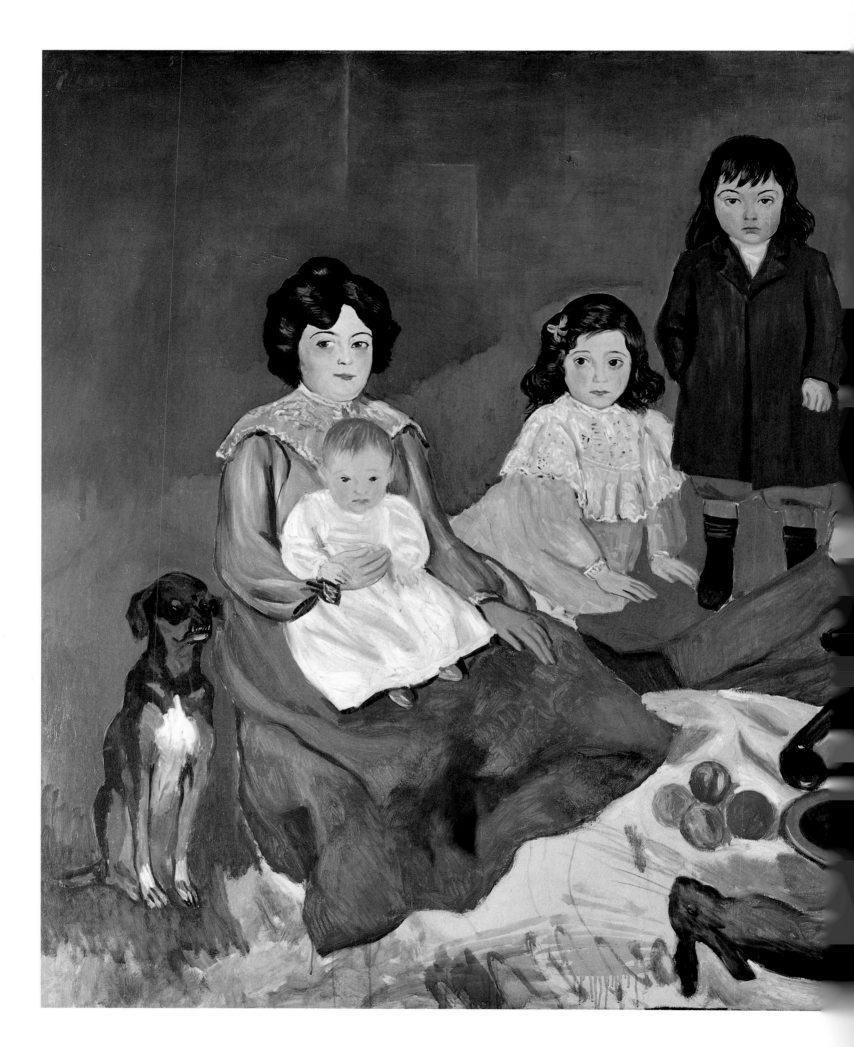

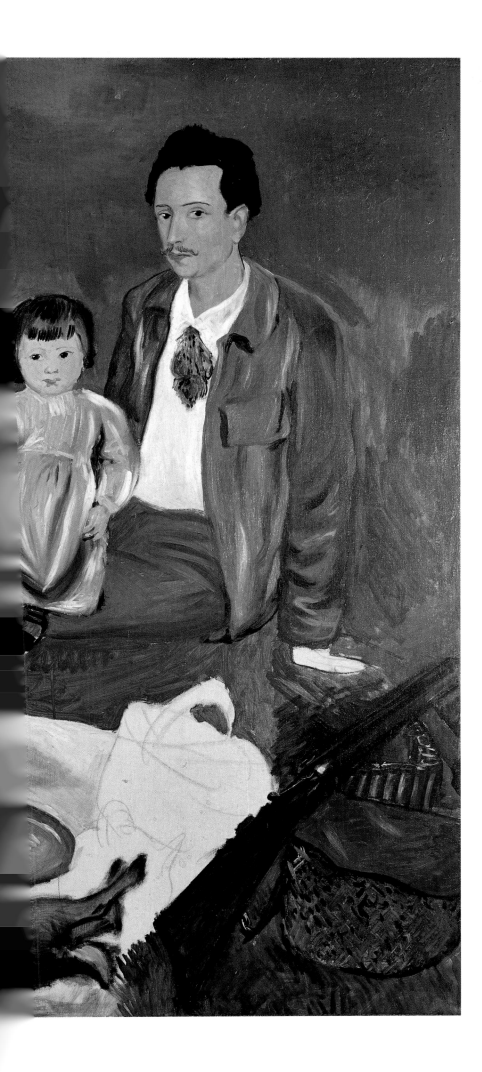

The Soler Family
La famille Soler
Barcelona, summer 1903
Oil on canvas, 150 x 200 cm
Zervos I, 203; DB IX, 23; Palau 904
Liège, Musée d'Art Moderne

Pages 98 and 99:
Nude with Crossed Legs
Femme nue aux jambes croisées
Barcelona, 1903
Pastel, 58 x 44 cm
Zervos I, 181; DB IX, 19
Private collection; formerly Basel, Galerie Beyeler

Celestina or Woman with a Cast
Celestina
Barcelona, March 1904
Oil on canvas, 81 x 60 cm
Zervos I, 183; DB IX, 26; Palau 958; MPP 1989–5
Paris, Musée Picasso

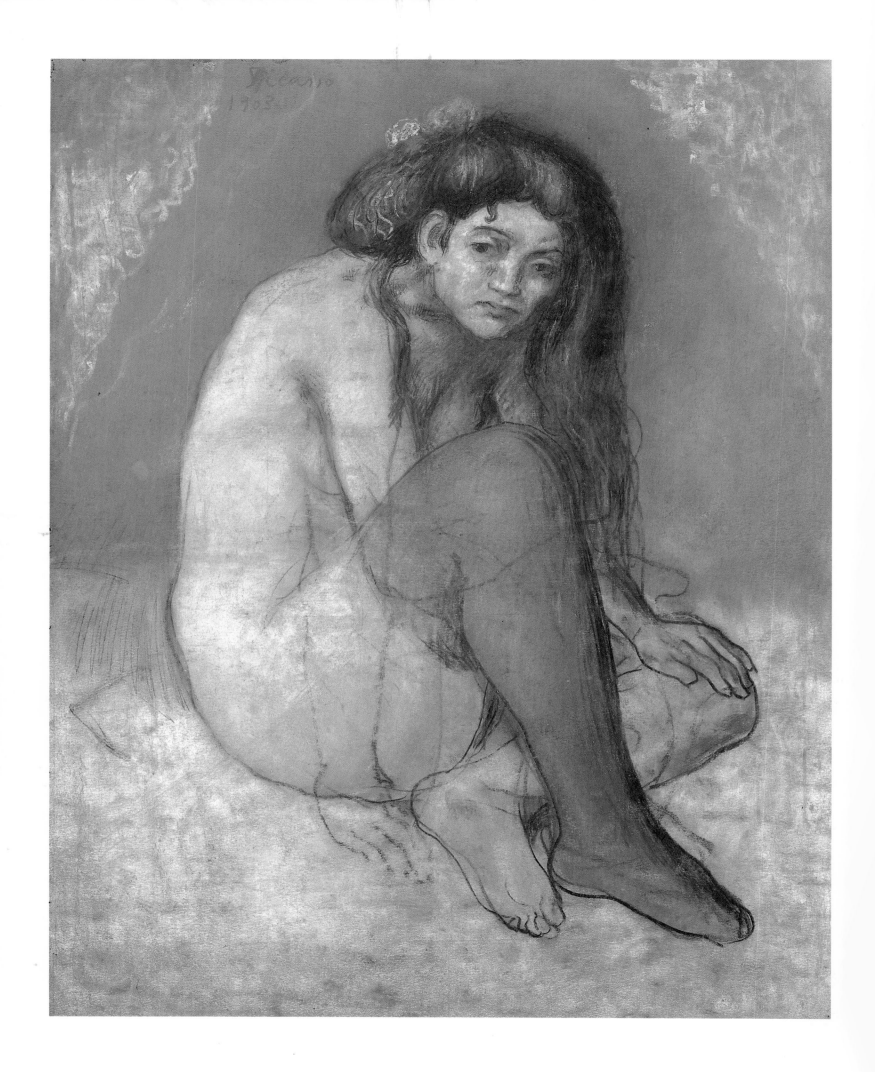

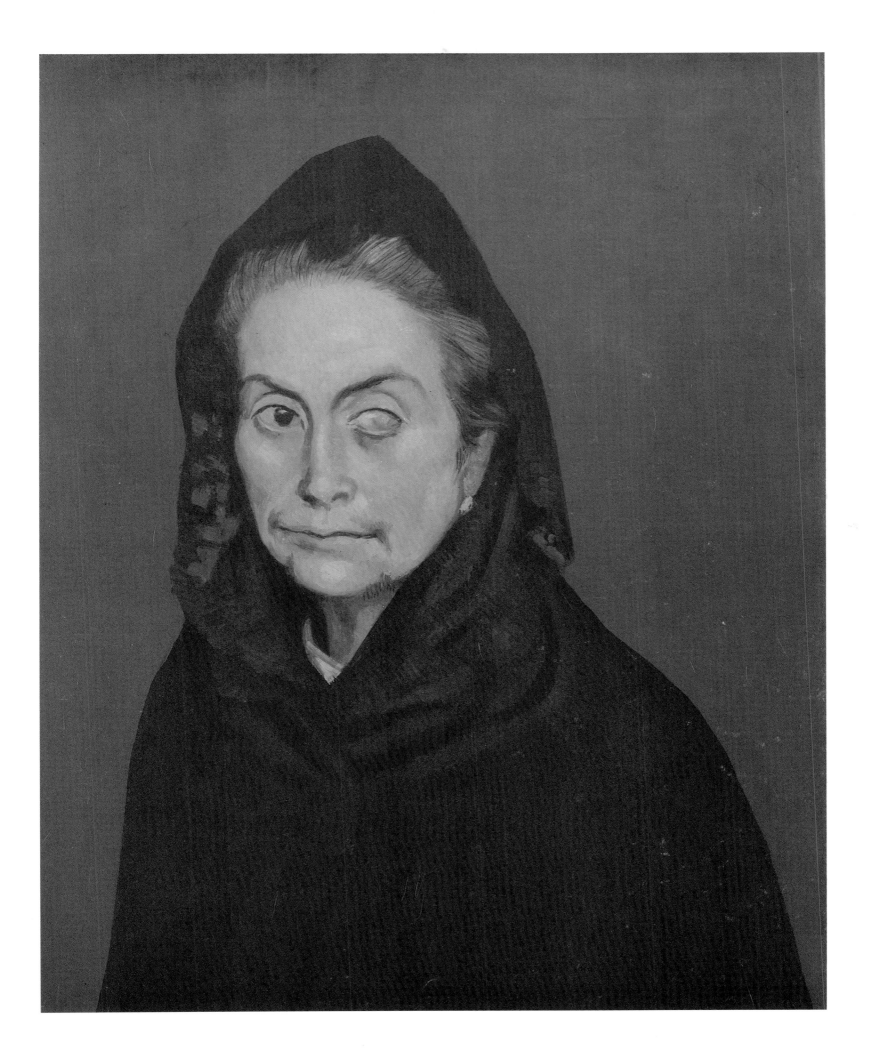

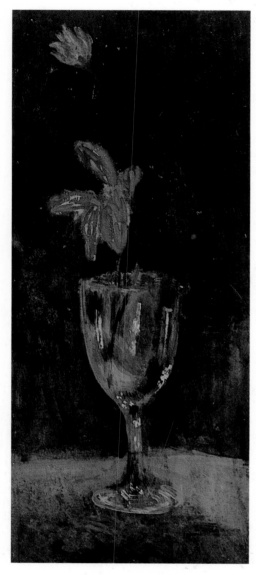

And it has a long tradition in Christian symbolic iconography, in which it stands for the divine.[106] German Romanticism gave blue the task of representing the transcendent ("The Blue Flower"), albeit in secular fashion.[107] Ever since the first third of the 19th century there had been a regular mania for blue, as it were, which peaked in 1826 in the tourist discovery of the Blue Grotto on Capri. As early as 1810, Goethe had advocated the use of dominant colours to set moods: blue light could be used for mourning, and one could look at one's surroundings through tinted glass in order to marshal divergent colours in a single tonality. In 1887 the French Symbolist painter Louis Anquetin actually adopted this method.[108]

Picasso's "The Visit" (p. 93) shows how consciously he was gathering these traditional values into a new synthesis. The attitudes and gestures of the figures are straight from Christian iconography. The visitation of Mary was portrayed in this way; and blue is the colour symbolically associated with the Virgin, the Queen of Heaven.[109] But Picasso was also at work on personal material in the painting. The women's heads are covered, as they are in many of his paintings of that period – and as they were at the women's prison of St. Lazare in Paris, to which Picasso had access in 1901 through a doctor he knew. It was an old building, in essence a converted 17th-century convent, and nuns of the Order of St. Joseph did the work of warders. Solitary confinement was a favourite punishment, though mothers were allowed to be with their children. It was a dismal place, full of women whose fates were desolate; and it made a profound impression on the young Spanish artist.[110] It was no coincidence that he chose the visitation, the meeting of Mary with the mother of John the Baptist, as a way of recording that impression. We have it from Picasso himself that "The Visit" shows an inmate and a nun, deliberately portrayed in equal fashion to emphasize their existential equality. Many of the mother-and-child pictures he painted at the time were affected by what he saw at St. Lazare too.[111]

The Blue Period peaked in "La Vie (Life)" (p. 105), a major composition which Picasso completed in May 1903. In many respects it is not only the major work of this phase but also the very sum of Picasso's art.[112] At first the structure seems straightforward, but in fact the history and message of the painting are complex. There are two groups of people, an almost naked couple and a mother with a sleeping babe, separated by half the picture's breadth. Between them we can see two pictures leaning against the wall, the lower showing a crouching person with head on knee, the upper – a kind of variant on the other – a man and woman crouching and holding each other. The top right corner of the upper picture has been cut off diagonally and slightly unevenly; it makes the impression of a study pinned up on the wall. The overall impression is of an artist's studio, so that we are tempted to see it as a representation of the life of the artist. But

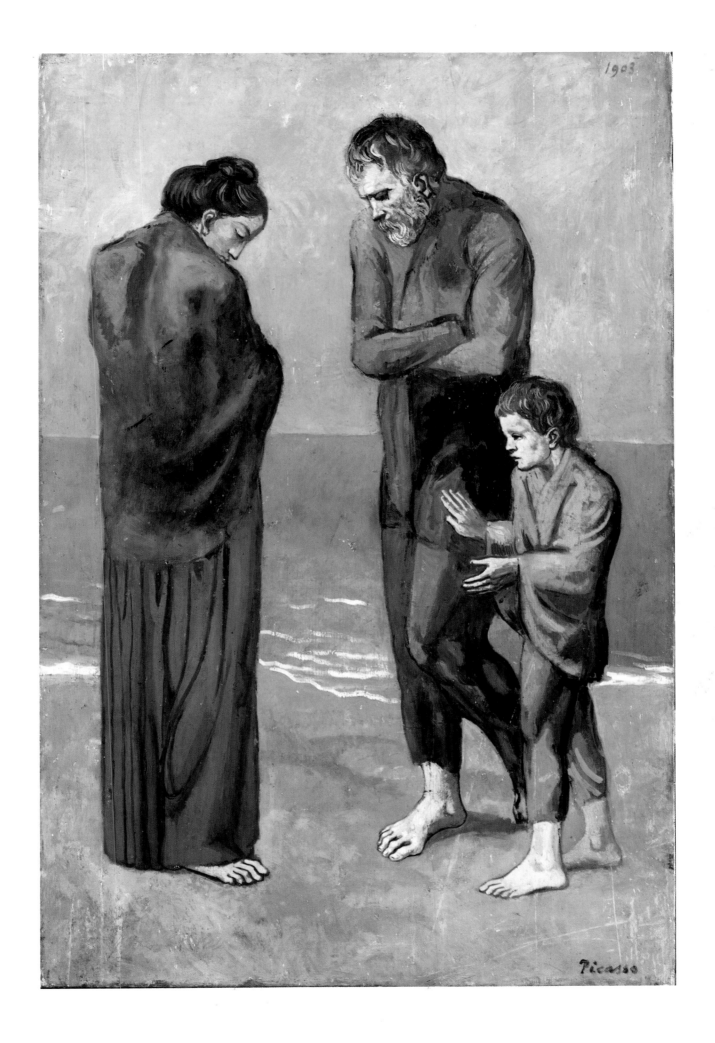

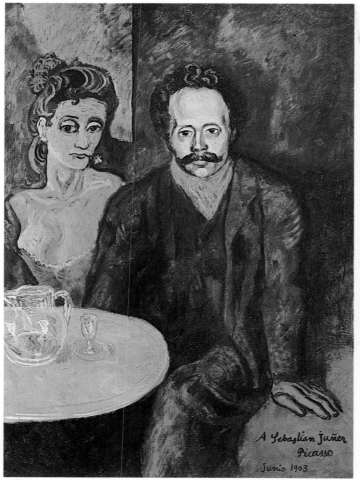

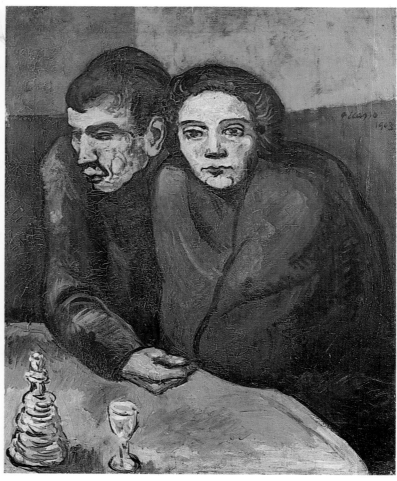

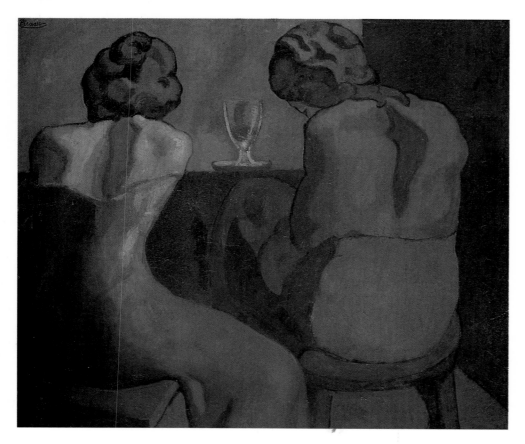

Portrait of Sebastián Junyer-Vidal
Portrait de Sebastián Junyer-Vidal
Barcelona, June 1903
Oil on canvas, 125.5 x 91.5 cm
Zervos I, 174; DB IX, 21; Palau 898
Private collection

Couple in a Café
Ménage des pauvres
Barcelona, April 1903
Oil on canvas, 81.5 x 65.5 cm
Zervos I, 167; DB IX, 9; Palau 887
Oslo, Nasjonalgalleriet

Two Women at a Bar (Prostitutes in a Bar)
Pierreuses au bar
Barcelona, 1902
Oil on canvas, 80 x 91.4 cm
Zervos I, 132; DB VII, 13; Palau 754
Hiroshima, Hiroshima Museum of Art

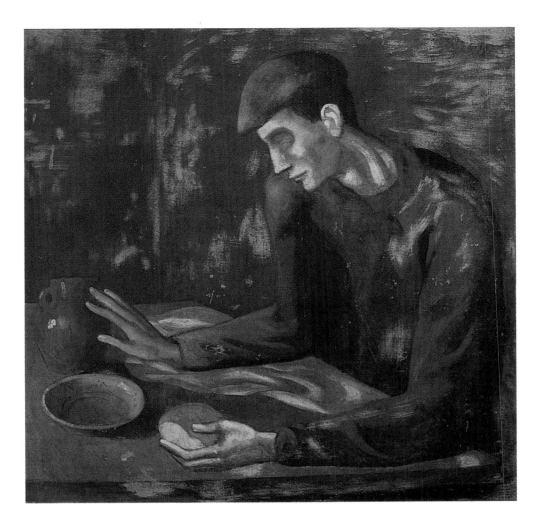

The Blind Man's Meal
Le repas d'aveugle
Barcelona, autumn 1903
Oil on canvas, 95.3 x 94.6 cm
Zervos I, 168; DB IX, 32; Palau 920
New York, The Metropolitan Museum of Art

The Palace of Fine Arts, Barcelona
Le Palais des Beaux-Arts à Barcelone
Barcelona, 1903
Oil on canvas, 60 x 40 cm
Zervos I, 122; DB IX, I; Palau 942
Private collection

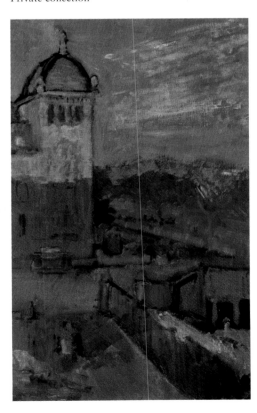

neither the subject nor the import of the work is easy to interpret. It is too fractured; nothing is what it seems, neither the place nor the people nor the action. Though the lovers at left seem intimate, their gestures are not. There is no trace of eye contact in the painting; all the characters are looking past one another into vacancy, with a melancholy air. They are not involved in a single action. And there are at least two different planes of reality.

And the location itself remains undefined, uncertain. The perspective angles are at odds with one another, the architectonic details ambiguous. It is an unreal and contradictory place, finally inaccessible to explanation, and the dominant blue even introduces a note of menace. Picasso has used Blue Period compositional techniques we can see in various pictures in one single, intense piece; and the same is true of his subjects. The embrace, seen here in a number of variations, was standard Picasso from 1900 to 1904, as was the mother and child, and the crouching posture. "La Vie" is a kind of pastiche of Picasso's Blue Period; yet it is no mere assemblage – rather, it is carefully planned, and its formal qualities and subject matter owed nothing to chance. Picasso did a number of instructive preliminary studies which show that a couple in a painter's studio were at the very heart of the composition from the start (cf. p. 104).[113]

103 The Blue Period 1901 – 1904

The other group, though, was only gradually fixed, and Picasso plainly first planned to position a bearded man at the right. Initially he gave the man standing with the woman his own features, as if the painting were of an autobiographical nature. Not till he was at work on the canvas did he make the decisive changes. But those changes themselves were directly related to matters in his own life. The man became his sometime friend Carlos Casagemas, who committed suicide in Paris in the year 1901 while Picasso was back in Spain. His unfulfilled passion for a young woman named Germaine, who was a model and lover for many in the Catalan artists' community, triggered his suicide. When Germaine spurned his affection, Carlos Casagemas tried first to kill her and then took his own life in the presence of a number of horrified friends.[114]

When Picasso heard the news in Spain, he was deeply affected. That same year he started to paint works that dealt with the dead man and his own relations with him. They were fictive, heavily symbolic paintings showing the dead Casagemas laid out, or even allegorically representing his funeral, attended by whores and the promiscuous sinners of Montmartre (p. 87). The fact that Picasso returned to Casagemas in the great 1903 composition means that the existential impact on him was profound. The biographical and non-personal strands in the work are in fact fully interwoven. During his first ever visits to Paris, Picasso led a bohemian life of drinking and sexual promiscuity with his Spanish friends.[115] His life style was partly a protest against conventionality in art and in life. The end of his friend Casagemas brought home to Picasso what was wrong with that life-style.

Study for "La Vie"
Etude pour "La vie"
Barcelona, May 1903
Pencil on paper, 14.5 x 9.5 cm
Not in Zervos; Palau 879; MPB 110.507
Barcelona, Museu Picasso

Study for "La Vie"
Etude pour "La vie"
Barcelona, May 1903
Ink and India ink on paper, 15.9 x 11 cm
Zervos VI, 534; DB D IX, 4; Palau 880; MPP 473
Paris, Musée Picasso

Study for "La Vie"
Etude pour "La vie"
Barcelona, 2 May 1903
India ink on paper, 26.7 x 19.7 cm
Zervos XXII, 44; DB D IX, 5; Palau 881
London, Penrose Collection

La Vie (Life)
La vie
Barcelona, spring to summer 1903
Oil on canvas, 196.5 x 128.5 cm
Zervos I, 179; DB IX, 13; Palau 882
Cleveland (OH), The Cleveland Museum of Art

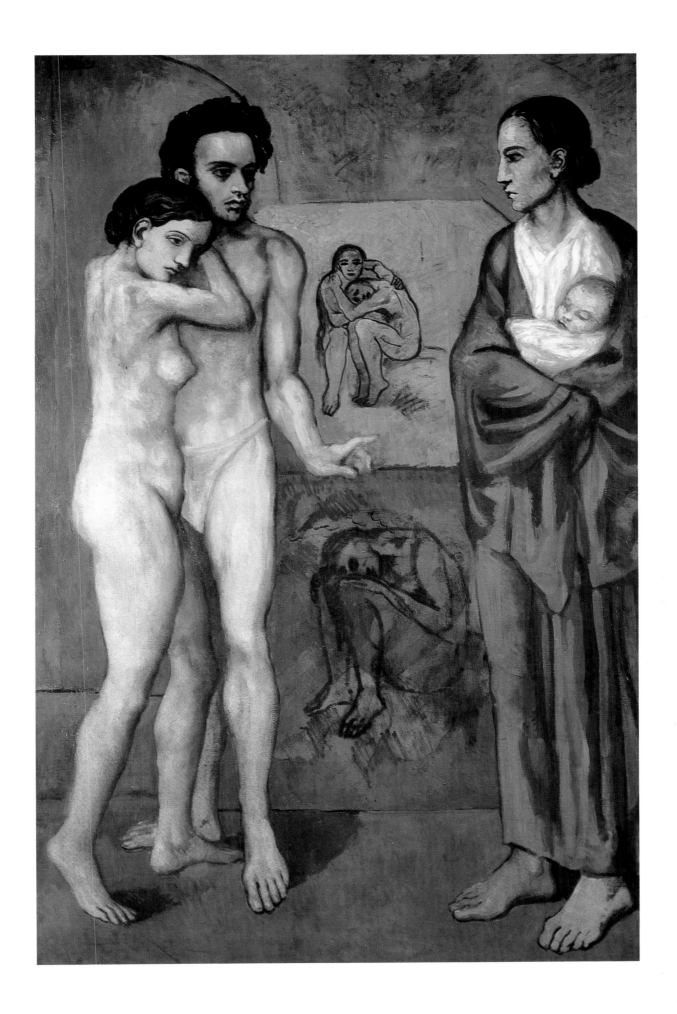

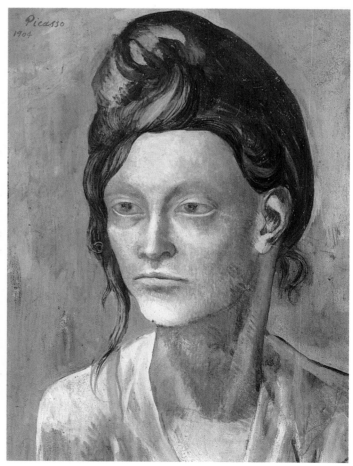

106 The Blue Period 1901 – 1904

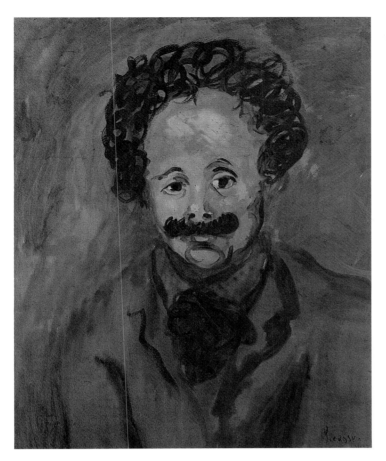

Portrait of Sebastián Junyer-Vidal
Portrait de Sebastián Junyer-Vidal
Barcelona, 1903
Oil on paper, 56 x 46 cm
Zervos I, 214; DB XI, 15; Palau 998; MPB 4.262
Barcelona, Museu Picasso

Portrait of Sebastián Junyent
Portrait de Sebastián Junyent
Barcelona, 1903
Oil on canvas, 73 x 60 cm
Not in Zervos; Palau 960; MPB 110.018
Barcelona, Museu Picasso

Left:
Mother and Child (The Sick Child)
Mère et enfant au fichu
Barcelona, 1903
Pastel on paper, 47.5 x 40.5 cm
Zervos I, 169; DB IX, 7; Palau 842; MPB 4.269
Barcelona, Museu Picasso

Woman with a Scarf
Femme au mouchoir
Barcelona, 1903
Oil on canvas on cardboard, 50 x 36 cm
Zervos I, 166; DB IX, 14
St. Petersburg, Hermitage

Portrait of Suzanne Bloch
Portrait de Suzanne Bloch
Paris, 1904
Oil on canvas, 65 x 54 cm
Zervos I, 217; DB XI, 18; Palau 981
São Paulo, Museu de Arte

Woman with Her Hair Up
(The Wife of the Acrobat)
Femme au casque de cheveux
(La femme de l'acrobate)
Paris, summer 1904
Gouache on cardboard, 42.8 x 31 cm
Zervos I, 233; DB XI, 7; Palau 977
Chicago (IL), The Art Institute of Chicago

Furthermore, Picasso's painting was in line with an artistic preoccupation of the times. The subjects of early death, despair of one's vocation, and suicide were frequently dealt with, and much discussed in Barcelona's artistic circles.[116] Whether the allegorical dimension implied in the title by which we now know the painting was intended is doubtful, since the title was not given by Picasso.[117] The treatment of the figures goes beyond the typical attitudes of metaphoric figures; yet manifestly they are close kin to Symbolic art.[118] Casagemas stood for Picasso himself – who had originally portrayed himself in the picture and included the unambiguous motif of the easel. X-ray examination has revealed, furthermore, that Picasso used a canvas on which something had already been painted – and not just any canvas, but in fact his painting "Last Moments", seen at the Paris World Fair in 1900 and in other words a thematically and biographically extremely significant picture.[119]

It is idle to want to read an exact message into "La Vie". Yet Picasso's meaning is clear enough. All that mattered in biographical, artistic, creative and thematic terms in those years is present in this one picture. The melancholy and existential symbolism of that period in Picasso's life are richly expressed in this ambitious work.

107 The Blue Period 1901 – 1904

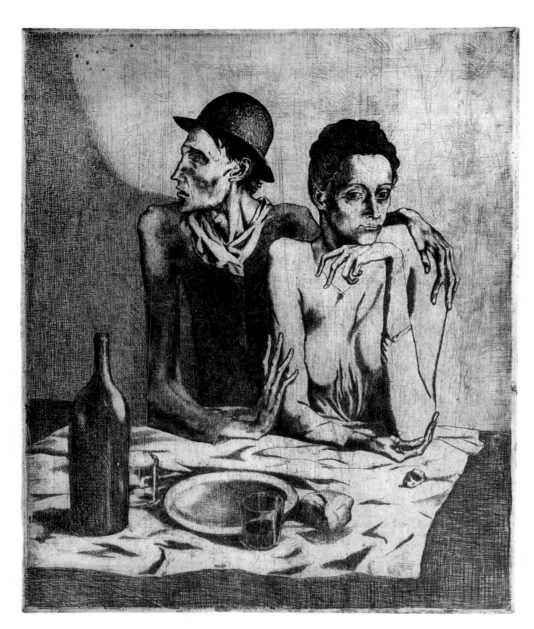

The Frugal Repast
Le repas frugal
Paris, autumn 1904
Etching, 46.5 x 37.6 cm
Bloch I; Geiser 2 II a

Standing Nude
Jeune fille nue debout
Paris, about 1904 (or Barcelona, 1902?)
Oil on canvas, 110 x 70 cm
Zervos XXI, 366
Estate of Jacqueline Picasso

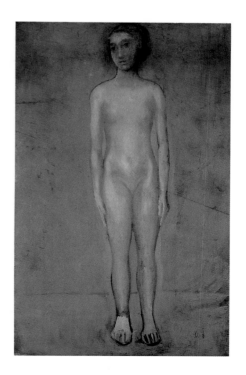

Picasso's technique of veiling the painting's meaning is in fact one of its signal qualities. He has managed to sidestep the vapidness of one-sided allegory; we are involved in this painting, drawn into it and – meditatively – into ourselves. The process opens up entirely new dimensions to historical painting.

Looking back, we can see the Blue Period works as a progression towards this goal, even though they were not specific preliminary studies, of course. For the first time we see in Picasso's art something that will strike us repeatedly in the sequel, a notable tension between the autonomy of the single work and the endeavour to gather the fruits of a line of development into one sum. "La Vie" is the first of a number of Picassos that stand out from the oeuvre by virtue of unusual formal and thematic complexity and an extraordinary genesis. The painting was both an end and a beginning: it was a prelude to paintings even more strictly monochromatic in their use of atmospheric blue and even more concerned with existential depths. The smooth, vast surfaces of the backgrounds, the

The Couple
Le couple
Paris, 1904
Oil on canvas, 100 x 81 cm
Zervos I, 224; DB XI, 5; Palau 985
Private collection

The Two Friends
Les deux amies
Paris, 1904
Gouache on paper, 55 x 38 cm
Zervos VI, 652; DB XI, 8; Palau 976
Paris, Private collection

clear structure pared down to the essentials, and the unifying contour, are all apt to the isolation of the figures – in other words, are cued by considerations of subject; yet still, Picasso is increasingly interested in other matters. Linear contour acquires an almost decorative flavour. Picasso tries out ways of concentrating formal options. He is plainly about to embark on something new.

5 The Rose Period
1904–1906

The distance conferred by history places things in a new perspective and enables us to see a pattern in what strikes contemporaries as chaotic. Picasso is a good example of this.

For some years we have been in the habit of seeing his art of the years from 1901 to 1906 as a sequence of two periods, the Blue and the Rose. The terms are prompted by the dominant colours, and their use arouses certain expectations in us. But Picasso's contemporaries felt that what we see as two separate things in fact constituted a single unity. Though they clearly saw his overriding use of pinks, they did not consider that this justified the distinction of a new period, and spoke throughout of the Blue Period – as did the artist himself when looking back.[120] From our point of view the differences are most striking; but, at the time, nobody felt there to be any notable departure from the pre–1904 work to that of 1904 to 1906. In reality there are new departures but there is also common ground, and this is true both of Picasso's subjects and of formal considerations.[121]

After three years of portraying the poor and needy and lonely, though, Picasso struck out in new directions. "Woman with a Crow" (p. 113) shows him doing so. It is made entirely of polarities. The dynamic contour, the contrasting black and red and blue, the large and small, open and closed forms, the emphasis on the centre plus the lateral displacement, light juxtaposed with dark and the white paper gleaming through, the deep black of the crow's plumage against the woman's chalk-white face – all of these features are extraordinarily evocative. The figures seem almost engraved. The delicacy of the heads and the long, slender fingers of the woman emphasize the intimacy of gesture. It is a decorative picture, a work of arresting grace and beauty. Painted in 1904, it also records Picasso's new approach: in the period ahead, he chose subjects to match his newly aestheticized sense of form.

Connoisseurs and friends recognised as we do now that there was a unity to Picasso's new realm, and they gave his new phase the label "Harlequin Period"[122] after a prominent character in the new work. True, artistes were not new in Picasso in 1905; but now they were likelier to make solo appearances.[123] The seemingly bright and

Mother and Child and Four Studies of her Right Hand
Mère et enfant et études de mains
Paris, winter 1904
Black chalk on paper, 33.8 x 26.7 cm
Zervos I, 220; Palau 1019; DB D XI, 26
Cambridge (MA), Fogg Art Museum,
Harvard University

Mother and Child
Mère et enfant (Baladins)
Paris, 1905
Gouache on canvas, 90 x 71 cm
Zervos I, 296; DB XII, 8; Palau 1021
Stuttgart, Staatsgalerie Stuttgart

merry world of the circus and cabaret and street artistes was as melancholy as that of the Blue Period's beggars and prostitutes and old people. Melancholy remained the core emotional note; but the form and message had changed.

It is true that the harlequins are outsiders too. But they have something to compensate for their low social rank – their artistry. Behind their gloom is great ability. They are downcast yet self-confident, presenting a dignified counter-image to the Blue Period's dejected figures passively awaiting their fates. And Picasso avails himself of their colourful costumes and graceful, decorative lines to create what can only be created by art: beauty.

It would doubtless be too simplistic to see Picasso's improved circumstances as the reason for his change from blue *tristesse* to rosy-tinted optimism.[124] But they must have played some part. He had made his final move to France in April 1904, taking a Montmartre studio on the Place Ravignan in May. It was one of a number in a barrack-like wooden building nicknamed the "bateau lavoir" from its similarity to the washboats on the Seine. Like Montmartre as a whole, it no longer had any central importance in the art scene: the focus had long shifted to Montparnasse. But in Impressionist days the likes of a Renoir had worked there.[125] Of course Picasso did not move solely among the artists of Montmartre and his old Spanish colony friends. He also knew the literary avantgarde in Paris.[126]

And he was increasingly establishing rewarding contacts with art dealers and collectors. In 1904 he exhibited at Berthe Weill's gallery, and in early 1905 he showed his first new pictures of travelling entertainers at Galerie Serrurière on the Boulevard Haussmann. He then agreed on terms with Clovis Sagot, a former circus clown who had set up a gallery in the Rue Laffitte. At this stage Picasso came to the attention of the wealthy American Leo Stein, and he and his sister, the Modernist writer Gertrude Stein, bought 800 francs' worth of Picassos. Shortly after, the dealer Ambroise Vollard even bought 2000 francs' worth. Other collectors such as the Russian Sergei Shchukin also invested.[127] Picasso's financial situation was improving noticeably. And his relationship with Fernande Olivier, which was to last for several years, introduced stability into his restless private life.[128]

Nonetheless, the Rose Period pictures are not merely records of a pleasant time in the artist's life. True, he often met other artists at Père Frédé's jokily named bar, the "Lapin agile", where the previous generation of artists had already been in the habit of gathering. And fashion required that one go to Medrano's circus on Montmartre.[129] But this is the small change of life, and Picasso's pictures speak plainly of his true concerns. "Woman with a Crow" was a portrait of Frédé's daughter Margot, who really did keep a pet crow.[130] In "At the 'Lapin Agile'" (p. 128) the scene is Picasso's favourite bar. Frédé himself appears as a musician in the back-

Meditation
Contemplation
Paris, autumn 1904
Watercolour and ink on paper, 34.6 x 25.7 cm
Zervos I, 235; DB XI, 12; Palau 1004
New York, Mrs. Bertram Smith Collection

Woman with a Crow
Femme à la corneille
Paris, 1904
Charcoal, pastel and watercolour on paper,
64.6 x 49.5 cm
Zervos I, 240; DB XI, 10; Palau 996
Toledo (OH), The Toledo Museum of Art

112 The Rose Period 1904 – 1906

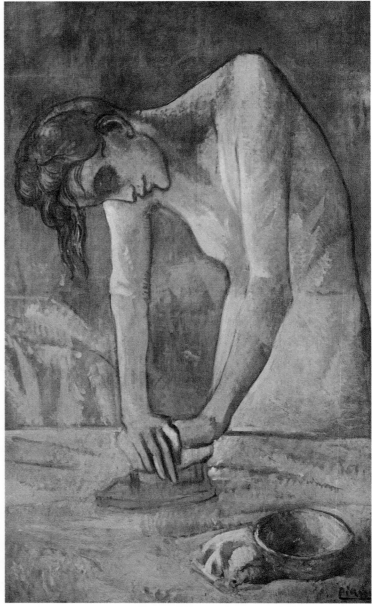

The Actor
L'acteur
Paris, late 1904
Oil on canvas, 194 x 112 cm
Zervos I, 291; DB XII, I; Palau 1017
New York, The Metropolitan Museum of Art

Woman Ironing
La repasseuse
Paris, spring 1904
Oil on canvas, 116.2 x 73 cm
Zervos I, 247; DB XI, 6; Palau 982
New York, The Solomon R. Guggenheim Museum

ground, and the harlequin is a self-portrait of Picasso.[131] Neither picture, however, is a straight representation of everyday reality. The woman with the crow is not so much a portrait as a type study, stylized beyond individuality. And in the bar scene Picasso is varying an approach he had used in his Blue Period for works such as "The Absinthe Drinker" (p. 85). In the new painting too, the people are gazing listlessly into vacancy, their bearing expressive of wearied lack of contact. The harlequin costume suggests that it is all a masquerade set up by an intellectual process: the creative artist poses as a performing artiste and in so doing takes artistry as his subject. The harlequins, street entertainers and other artistes of the Rose Period all enact the process of grasping the role of the artist. They were the product of complex reflection inspired not least by Picasso's relations with the literary world in Paris.

In later life, Picasso liked to present himself as essentially anti-

Portrait of Benedetta Canals
Portrait de Madame Benedetta Canals
Paris, autumn 1905
Oil on canvas, 88 x 68 cm
Zervos I, 263; DB XIII, 9; Palau 1152; MPB 4.266
Barcelona, Museu Picasso

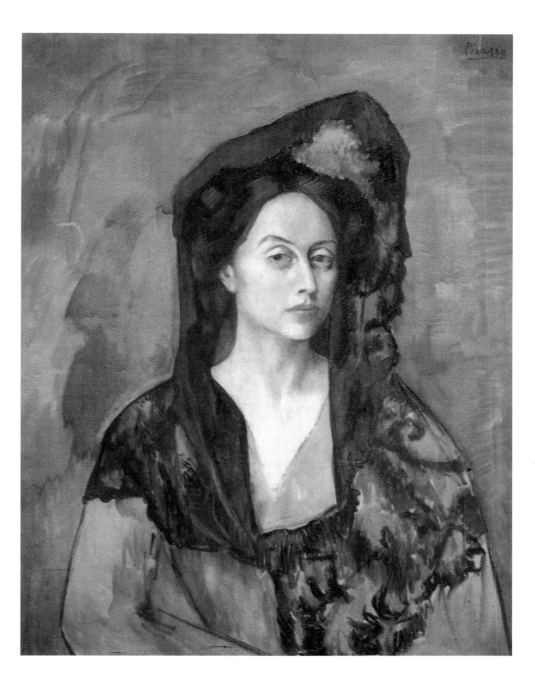

Study for "Woman Combing Her Hair"
Etude pour "Femme se coiffant"
Paris, 1905
Pencil and charcoal on paper, 55.8 x 40.7 cm
Zervos I, 341
Norwich, Robert and Lisa Sainsbury Collection,
University of East Anglia

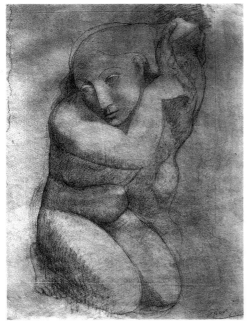

intellectual and purely interested in visual form. But at that early time in his career he was certainly interested in radical literary aesthetics, as his first encounter with writer André Salmon indicates. Picasso gave him a book of anarchic poetry by Fagus, the art critic. The poems were typical, in form and content, of what was then usual amongst the most progressive of the literati.[132] Picasso's acquaintance with Max Jacob had introduced him to this taste in 1901, and a few years later he was regularly at the "Closerie des Lilas", a Montparnasse café where the Parisian literary bohemia liked to meet. Under poet Paul Fort they met on Tuesdays for discussions, which were of particular interest to up – and – coming artists.[133]

Picasso's friend Guillaume Apollinaire was a prominent member of this group. The poet had recently published a play, "Les Mamelles de Tirésias" (The Breasts of Tiresias, 1903), which was sub-

115 The Rose Period 1904–1906

sequently to be of some significance for the Surrealists.[134] Apollinaire also wrote endless magazine articles dealing with the new political and cultural departures in Europe, preaching anarcho-syndicalism, anti-colonialism and anti-militarism. In 1905 he also took to writing art criticism, and this was to be of importance to Picasso. His features appeared in "Vers et prose" and mainly in "La Plume", a periodical which also held soirées at which everyone who was anyone in Parisian arts life liked to be seen. Apollinaire's consistent aesthetic radicalism strengthened Picasso's position. The poet repeatedly drew the public's attention to the Spaniard's work and so played an important part in Picasso's early recognition.[135]

One of Apollinaire's interests was directly related to Picasso's work. He liked to collect and edit erotica and pornographic literature, and established his own library of pornographic books, now in the Bibliothèque Nationale and still considered an authoritative collection. This breaching of a social taboo was partly inspired by contempt for bourgeois morality; Apollinaire created his

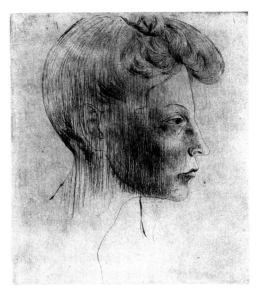

Head of a Woman in Profile
Tête de femme en profil. Paris, 1905
Etching, 29.2 x 25 cm
Bloch 6; Geiser 7 b

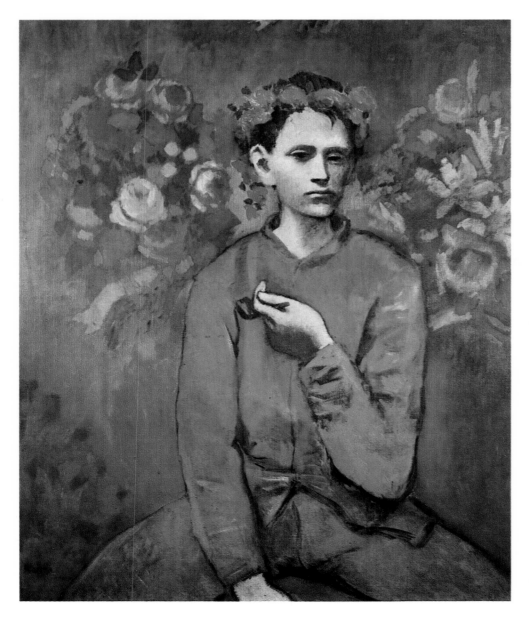

Boy with a Pipe
Garçon à la pipe
Paris, late 1905
Oil on canvas, 100 x 81.3 cm
Zervos I, 274; DB XIII, 13; Palau 1166
New York, Mrs. John Hay Whitney Collection

The Rose Period 1904–1906 **116**

own programme of immorality, even starting a short-lived magazine titled "La Revue Immoraliste".[136]

Apollinaire and Picasso shared this taste to an extent. Picasso's early work often included erotic or downright pornographic scenes (pp. 90 and 91). In old age he returned to these themes, though not till then. It is not so much a reflection of Picasso's own life in a promiscuous milieu (though it is that too) as an extension of basically political convictions. Taboos set up by mindless social convention are breached by the freedom of art.[137]

Salmon was also important to Picasso through his critical and theoretical work on new movements in the visual arts, in which he emphasized the significant role played by Picasso. Salmon too was radical in political matters, interested in anarchism, and a friend of many revolutionaries. Artistically he was most attached to Symbolism. He played an important part in the arts world, and as secretary of "Vers et prose" he organized Paul Fort's soirées at the "Closerie des Lilas".[138] Like Salmon, Picasso's first literary acquaintance,

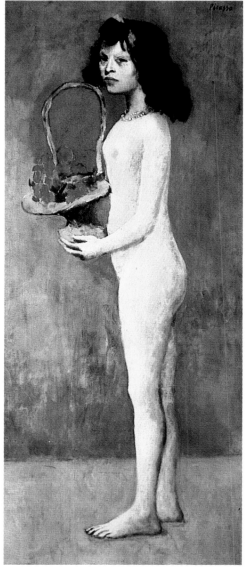

Young Girl with a Basket of Flowers
Fillette nue au panier de fleurs
Paris, autumn 1905
Oil on canvas, 155 x 66 cm
Zervos I, 256; DB XIII, 8; Palau 1155
New York, Private collection

Woman with a Fan
Femme à l'éventail
Paris, late 1905
Oil on canvas, 100.3 x 81.2 cm
Zervos I, 308; DB XIII, 14; Palau 1163
Washington (DC), National Gallery of Art,
Gift of W. Averill Harriman

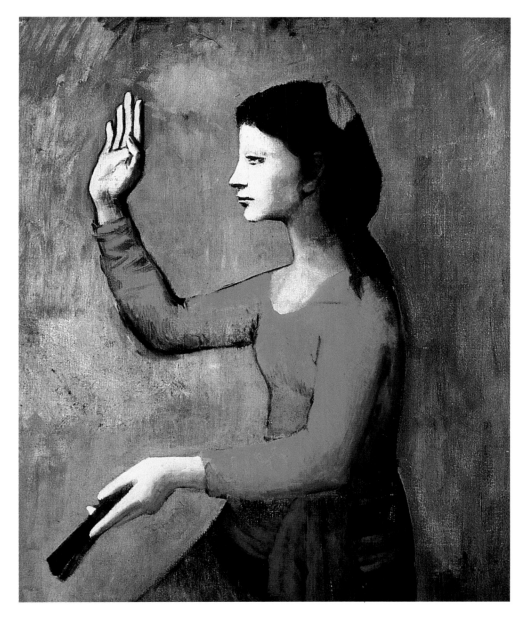

Pages 118/119:
The Marriage of Pierrette
Les noces de Pierrette
Paris, 1905
Oil on canvas, 95 x 145 cm
Zervos I, 212; DB XI, 22; Palau 1093
Japan, Private collection

The Rose Period 1904 – 1906 **117**

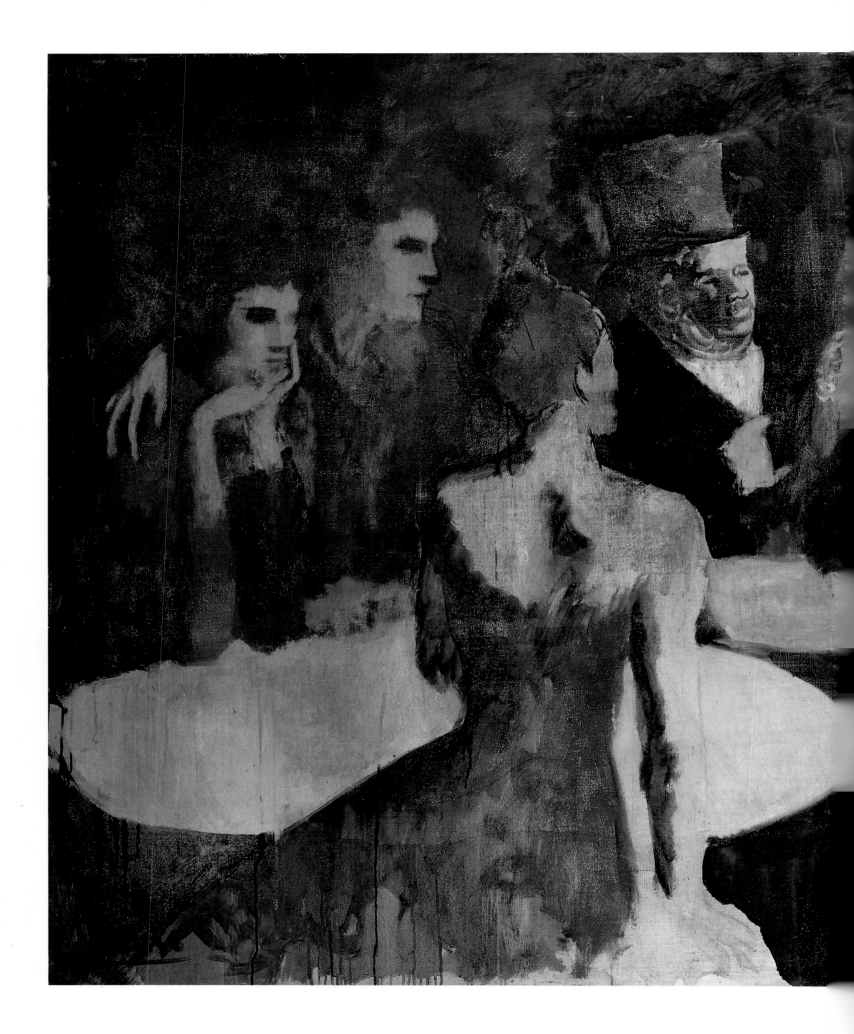

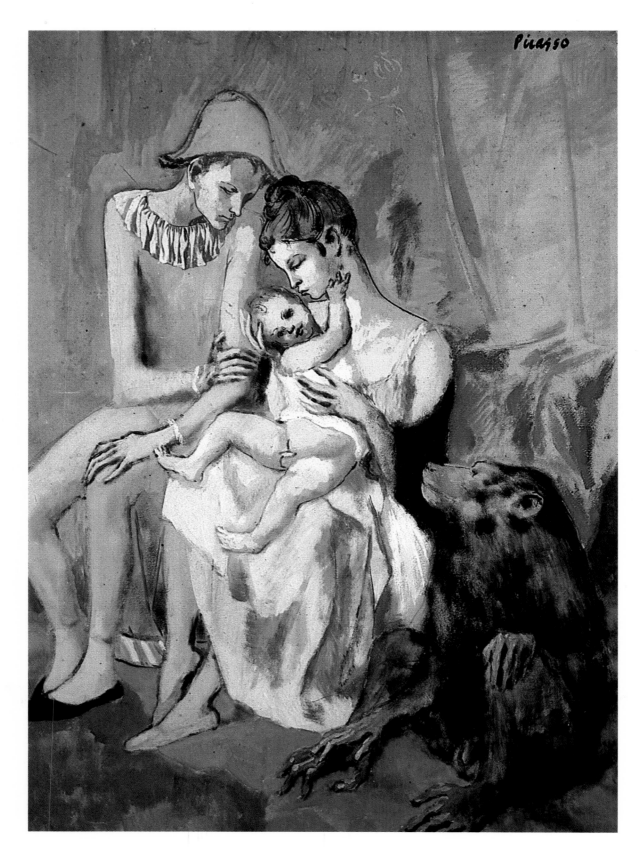

The Acrobat's Family with a Monkey
Famille d'acrobates avec singe
Paris, spring 1905
Gouache, watercolour, pastel and India ink
on cardboard, 104 x 75 cm
Zervos I, 299; DB XII, 7; Palau 1058
Göteborg, Göteborgs Konstmuseum

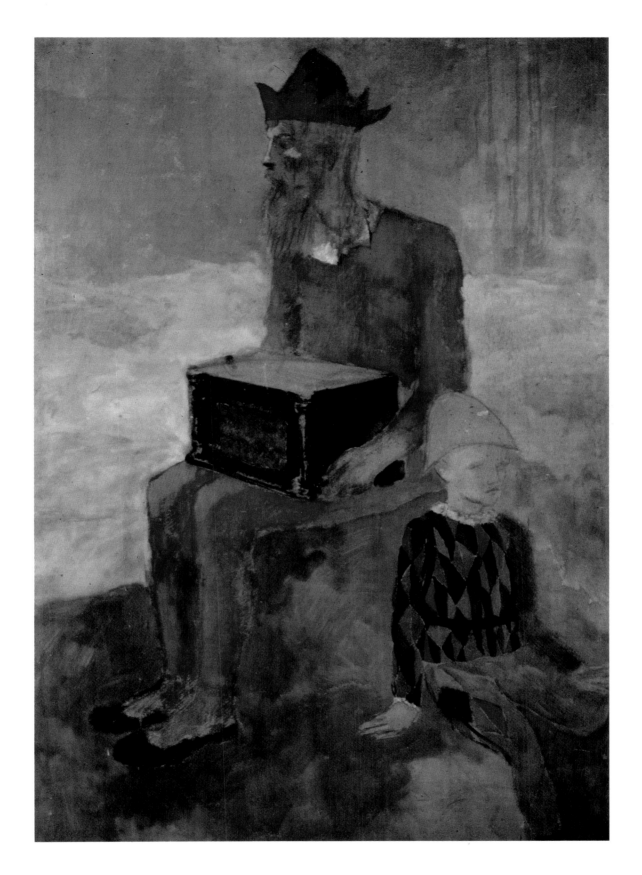

Hurdy-gurdy Player and Young Harlequin
Joueur d'orgue de barbarie et petit arlequin
Paris, 1905
Gouache on cardboard, 100.5 x 70.5 cm
Zervos VI, 798; DB XII, 22; Palau 1073
Zurich, Kunsthaus Zürich

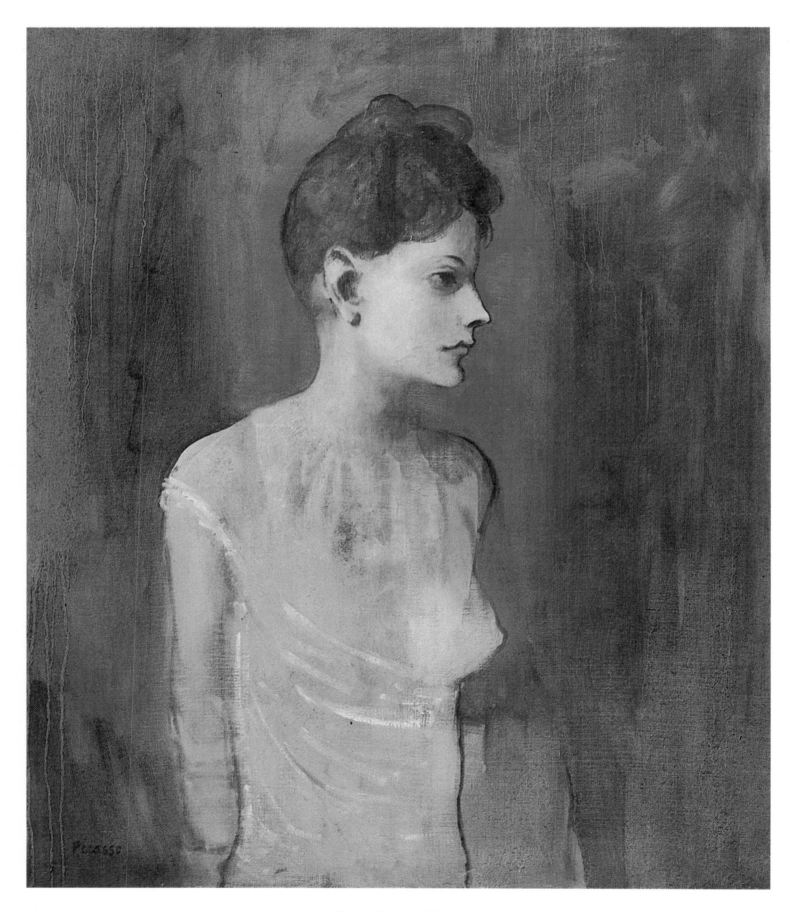

Woman Wearing a Chemise
Femme à la chemise
Paris, 1905
Oil on canvas, 73 x 59.5 cm
Zervos I, 307; DB XII, 5; Palau 1050
London, Tate Gallery

122

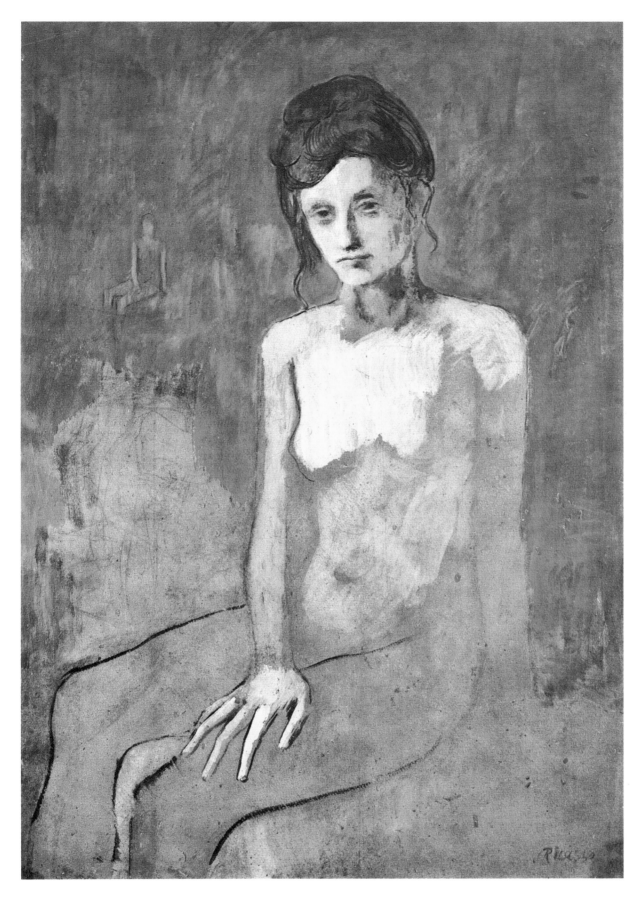

Seated Nude
Femme nue assise. Paris, early 1905
Oil on cardboard on panel, 106 x 76 cm
Zervos I, 257; DB XII, 3; Palau 1051
Paris, Musée National d'Art Moderne,
Centre Georges Pompidou

123

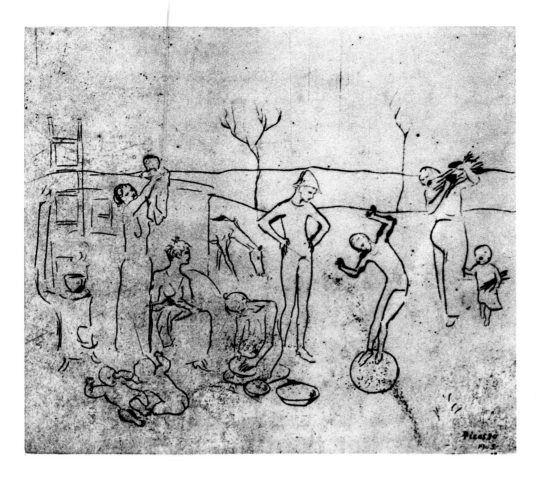

The Acrobats
Les saltimbanques
Paris, 1905
Etching, 28.8 x 32.2 cm
Bloch 7; Geiser 9 b

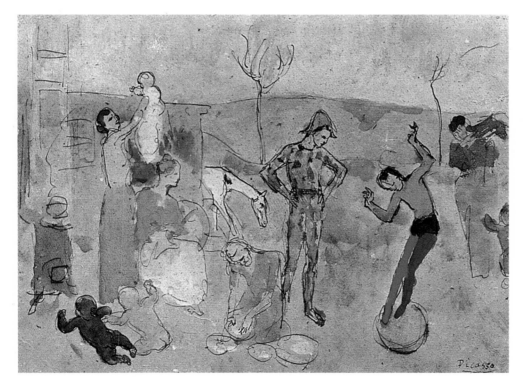

Circus Family (The Tumblers)
Famille de bateleurs
Paris, 1905
Watercolour and India ink on paper,
24.3 x 30.5 cm
Zervos XXII, 159; DB XII, 18; Palau 1031
Baltimore (MD), The Baltimore Museum of Art,
Cone Collection

Right:
The Death of Harlequin
La mort d'arlequin
Paris, 1906
Gouache on cardboard, 68.5 x 96 cm
Zervos I, 302; DB XII, 27; Palau 1182
Private collection

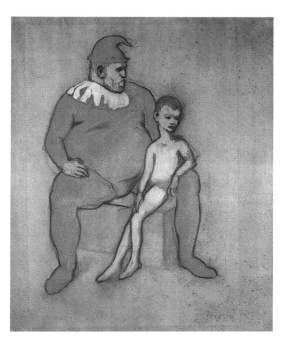

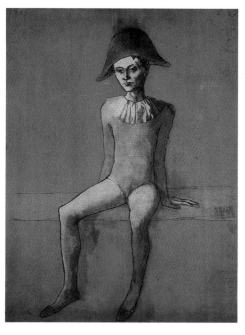

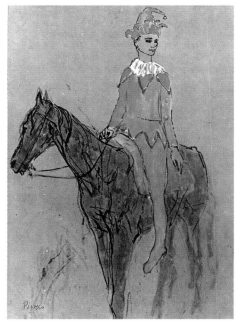

Clown and Young Acrobat
Bouffon et jeune acrobate
Paris, 1905
Charcoal, pastel and watercolour on paper,
60 x 47 cm
Zervos I, 283; DB XII, 29
Baltimore (MD), The Baltimore Museum of Art,
Cone Collection

Seated Harlequin
Arlequin assis
Paris, 1905
Watercolour and India ink; dimensions unknown
Zervos XXII, 237; DB XII, 10; Palau 1044
Paris, Private collection

Harlequin on Horseback
Arlequin à cheval
Paris, 1905
Oil on cardboard, 100 x 69.2 cm
Zervos I, 243; DB XII, 24; Palau 1065
Upperville (VA), Mr. and
Mrs. Paul Mellon Collection

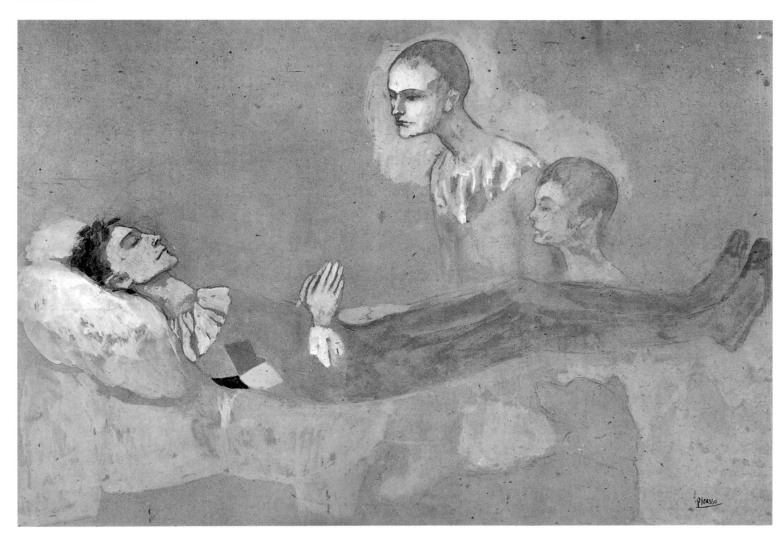

The Rose Period 1904 – 1906 **125**

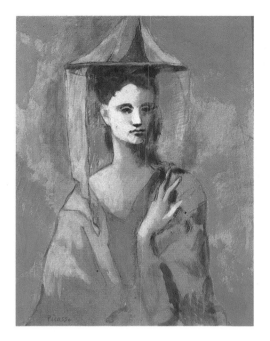

Spanish Woman from Majorca
(Study for "The Acrobats")
Paris, 1905
Gouache and watercolour on cardboard,
67 x 51 cm
Zervos I, 288; DB XII, 34; Palau 1149
Moscow, Pushkin Museum

Max Jacob, was a regular visitor to the Montmartre studio, and even took a room there to work in for a spell. His major writings, founding works of Surrealist poetry, came a few years later, but in those early days at the "bateau lavoir" he was already set firmly against senseless norms.[139]

And another acquaintance was one of French literature's most dazzling personalities, Alfred Jarry. For him, as for many of his generation, the Dreyfus affair had shown up the weaknesses of French society and political life at the turn of the century. Public opinion had moved decidedly to the left. Jarry became a literary radical. In his own life he attempted to obey his maxims as an artist, and so became the very incarnation of the creative outsider. The three Ubu plays that began with the controversial satirical farce "Ubu Roi" in 1896 were his major achievement. Ubu is a personification of the philistine rampant who attains power and plunges the world into chaos through his reckless brutality. The safe, structured existential certainties of the middle classes are turned topsyturvy. The play later served as a model for the Dadaists and Surrealists and is seen as a precursor of absurd drama.[140]

In other words, Picasso was moving in left-wing literary and artistic circles. Anarchist ideas prompted the rejection of tradi-

Salomé
Paris, 1905
Etching, 40 x 34.8 cm
Bloch 14; Geiser 17 a

Mother's Toilette
La toilette de la mère
Paris, 1905
Etching, 23.5 x 17.6 cm
Bloch 13; Geiser 15 b

126 The Rose Period 1904 – 1906

tional social structures and put unbridled individualism in their place. This individualism was expressed in a stylized role as outsider and artist. At this point we can return to Picasso's work. The Blue and Rose Period pictures of beggars, isolated people, harlequins, artistes and actors were a way of keeping "official" artistic values at arm's length, both thematically and formally. The paintings of Bonnat, Forain, Laurens, Béraud, Gervex, Boldini and others of their ilk presented society scenes and portraits of salon ladies.[141] The choice of an artistic milieu for the Rose Period works was a deliberate rejection of conventional subject matter. And that rejection went hand in hand with Picasso's quest for a new formal idiom. The subjects he painted came from a world he knew, and added up to a commentary of the role of the artist at that time; and the clowns and actors and artistes were widely viewed as symbols of the artistic life.

Traditionally, the fool or clown has a licence to utter unvarnished truth and so hold up a mirror to the mighty. During the Enlightenment the fool's fortunes were at their nadir; but, as the age of the middle class took a firm grip, the harlequin, pierrot or clown ac-

Acrobat and Young Equilibrist
Acrobate à la boule (Fillette à la boule)
Paris, 1905
Oil on canvas, 147 x 95 cm
Zervos I, 290; DB XII, 19; Palau 1055
Moscow, Pushkin Museum

Two Acrobats with a Dog
Deux saltimbanques avec un chien
Paris, spring 1905
Gouache on cardboard, 105.5 x 75 cm
Zervos I, 300; DB XII, 17; Palau 1035
New York, The Museum of Modern Art

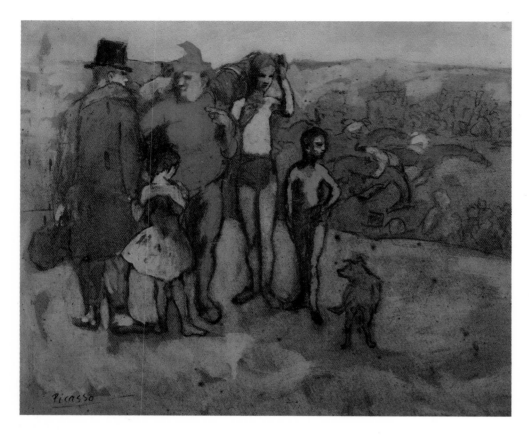

Family of Saltimbanques (Study)
Famille de saltimbanques (Etude)
Paris, 1905
Gouache and charcoal on cardboard,
51.2 x 61.2 cm
Zervos I, 287; DB XII, 33; Palau 1126
Moscow, Pushkin Museum

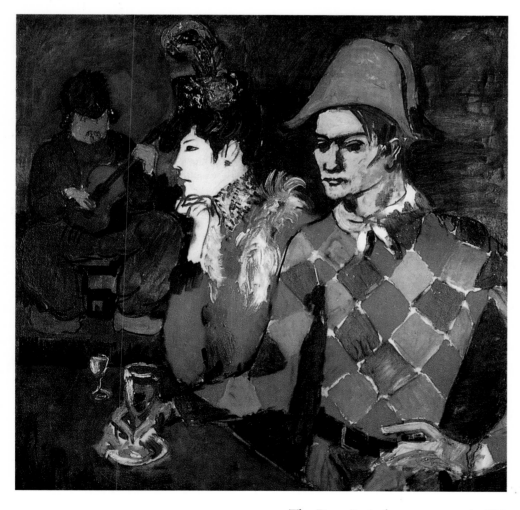

At the "Lapin agile"
Au "Lapin agile" (Arlequin au verre)
Paris, 1905
Oil on canvas, 99 x 100.5 cm
Zervos I, 275; DB XII, 23; Palau 1012
Rancho Mirage (CA), Mr. and Mrs.
Walther H. Annenberg collection

The Rose Period 1904–1906 **128**

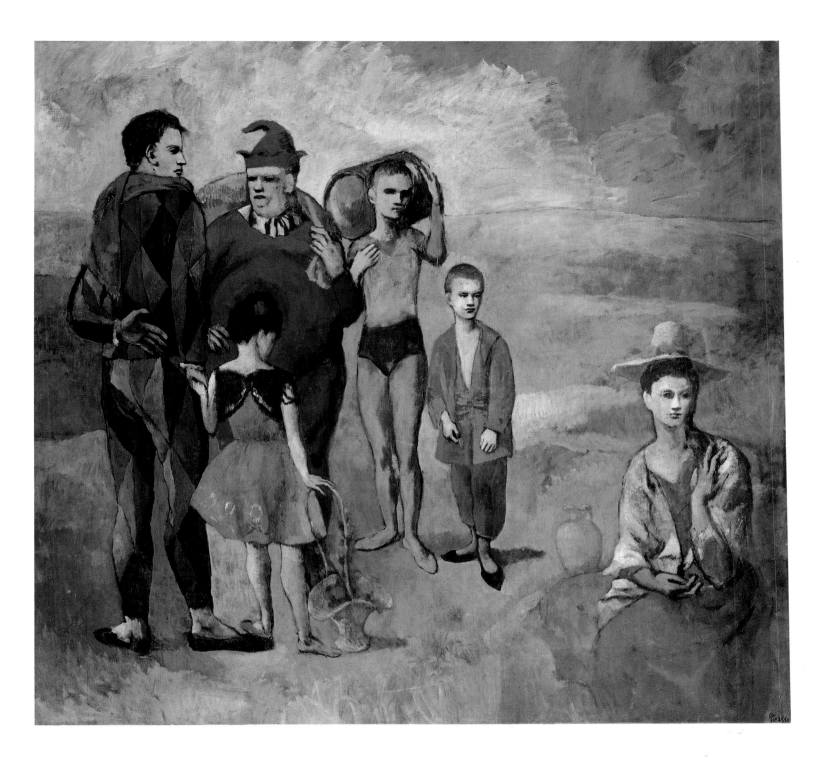

quired a new, higher value. In France in particular he was seen as the epitome of the rootless proletarian, the People in person. After the 1848 revolutions, the new symbolic figure of the sad clown became familiar.

Baudelaire immortalized the figure in a prose poem. Edmond de Goncourt published a circus novel which dealt allegorically with the artistic life; his Brothers Zemganno are tightrope walkers and gymnasts, misunderstood by the public and often facing death, and acting throughout from an inner sense of vocation. Daumier portrayed entertainers as restless itinerants, at home nowhere. By the end of the century, the tragic joker had become a cult figure in Ruggero Leoncavallo's opera "Pagliacci". Street artistes and the

The Acrobats
La famille de saltimbanques (Les bateleurs)
Paris, 1905
Oil on canvas, 212.8 x 229.6 cm
Zervos I, 285; DB XII, 35; Palau 1151
Washington (DC), National Gallery of Art,
Chester Dale Collection

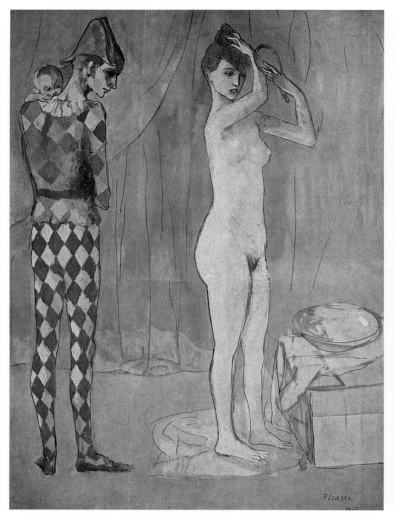

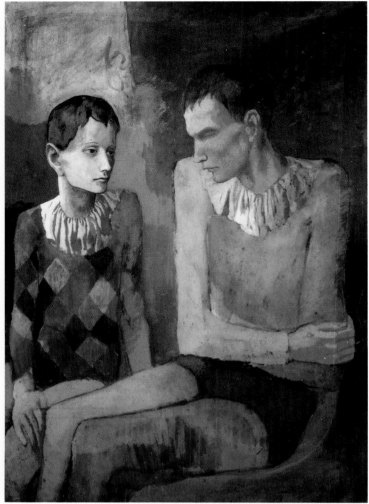

circus were a favourite subject of progressive art, from Manet's 1860 "Street Musician" (New York, Metropolitan Museum) to the circus pictures of Toulouse-Lautrec and Georges Seurat.[142]

In adopting this line, Picasso was not only succumbing to the powerful influence of the French cultural scene. His interest in the subject had Spanish roots too. The Symbolist "Modernista" Rusiñol had written a play titled "L'Allegria que passa" which made a strong impression on Picasso when he did illustrations for it in "Arte Joven". His painting of an actor in harlequin costume, done at the close of 1904 (p. 114), draws upon Rusiñol's play.[143] Picasso subsequently did studies and paintings of a melancholy harlequin, a sad jester, not in the limelight but withdrawn into a life devoted to art, lived on the periphery of society and at odds with it. Formally speaking, these works betray the influence of Daumier. He too concentrated on a very few, striking figures.

Just as in the Blue Period a number of sketches, studies and paintings culminated in a major work, "La Vie" (p. 105), so too the harlequin phase produced the huge canvas "The Acrobats" (p. 129). It was Picasso's definitive statement on the artistic life. And, tellingly, it was another artist, the Austrian poet Rainer Maria Rilke (who in 1916 spent some months in the home of the then

The Harlequin's Family
Famille d'arlequin
Paris, spring 1905
Gouache and India ink on paper, 57.5 x 43 cm
Zervos I, 298; DB XII, 6; Palau 1039
Private collection

Acrobat and Young Harlequin
Acrobate et jeune arlequin
Paris, 1905
Gouache on cardboard, 105 x 76 cm
Zervos I, 297; DB XII, 9; Palau 1040
Brussels, Private collection

Boy with a Dog
Garçon au chien
Paris, 1905
Gouache and pastel on cardboard,
57.2 x 41.2 cm
Zervos I, 306; DB XII, 16; Palau 1033
St. Petersburg, Hermitage

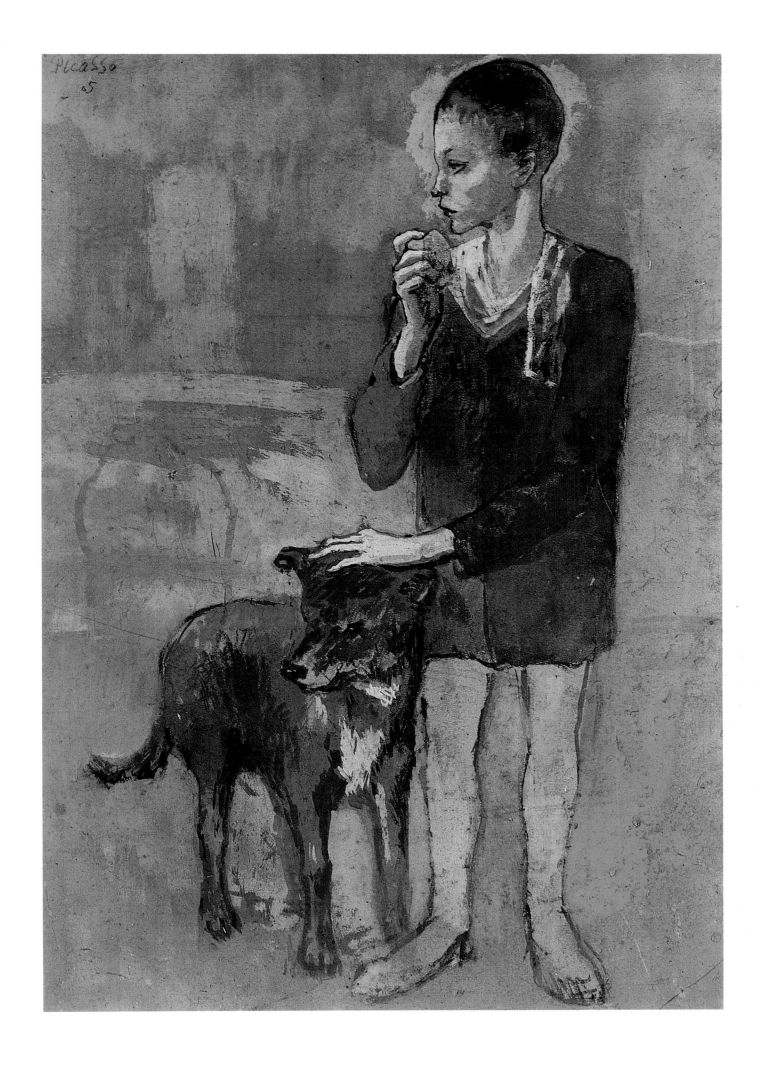

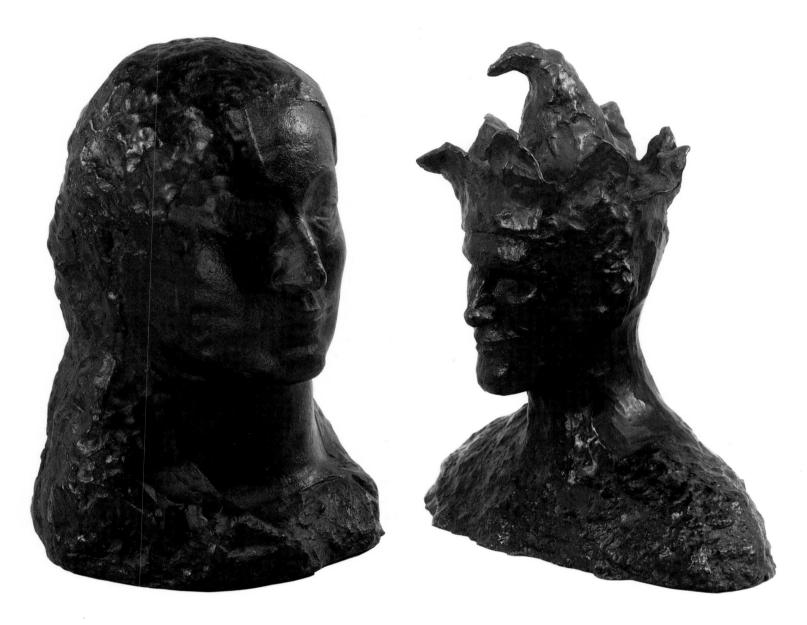

Head of a Woman (Fernande)
Tête de femme (Fernande)
Paris, 1906
Bronze, 35 x 24 x 25 cm
Spies 6 II; Zervos I,323; Palau 1205; MPP 234
Paris, Musée Picasso

The Jester
Le fou
Paris, 1905
Bronze (after a wax original),
41.5 x 37 x 22.8 cm
Spies 4; Zervos I,322; Palau 1061; MPP 231
Paris, Musée Picasso

owner of the painting), who found the aptest words to convey an impression of the work, in the fifth of his "Duino Elegies": "But tell me, who are they, these wanderers, even more / transient than we ourselves . . ."[144]

X-ray examination has shown that the final picture was the fruit of long, painstaking labours, of frequent new starts and changes. It was begun at the start of the Rose Period in 1904. That composition, later painted over, was like a study now in Baltimore (cf. p. 124).[145] This shows a number of artistes' wives and children seen against a sketchily indicated landscape. With them, only slightly off the centre axis of the composition, stands a youth in harlequin costume, hands on hips, watching a girl balancing on a ball. Plainly the idea interested Picasso; he did an etching at the same time (p. 124) in which it appears in almost identical form. A copy of the etching served him when he came to transpose the scene to the canvas: he superimposed a grid in order to get everything just right.

That first version shows that Picasso wanted to draw all his approaches to the entertainer motif together into one composition.

132 The Rose Period 1904 – 1906

All of the characters, even specific gestures and poses, appear in other Rose Period pictures, most famously "Acrobat and Young Equilibrist" (p. 127). But he was dissatisfied with the result, turned the canvas round, and painted over it. This changed the format into a vertical, and instead of a whole family there were now only two young acrobats. This picture too has survived in a gouache study now in the Museum of Modern Art, New York (p. 127).[146] Again the landscape is merely hinted at. The two youngsters facing us frontally almost fill the picture. The taller is in harlequin costume, while the other, still a child, has a dog with him.

Presumably Picasso felt that these figures were not sufficient to convey the various aspects of travelling entertainers' lives, for they too were painted over. Before resuming work on canvas he embarked on a set of preliminary studies. To an extent he fell back on his first idea. The centre was now occupied by a burly, seated man whom Picasso dubbed "El Tio Pepe Don José". A number of sketches tried out this compositional approach and the details involved.[147] At length the artist hit on a strategy that combined all three of the approaches he had been toying with, as we can see from a gouache now in the Pushkin Museum in Moscow (p. 128). Four male acrobats, standing, now provide the focus – among them Tio Pepe and two variants on the youngsters of the second version. What remained of the first version was a heavily adapted child motif, the young girl. In the background is a horse race. Picasso continued to sketch versions of the details till in summer 1905 he

Dutch Girl (La Belle Hollandaise)
Hollandaise à la coiffe (La belle Hollandaise)
Schoorl (Holland), summer 1905
Oil, gouache and blue chalk
on cardboard on panel, 77 x 66 cm
Zervos I, 260; DB XIII, 1; Palau 1134
Brisbane, Queensland Art Gallery

Three Dutch Girls
Les trois Hollandaises
Schoorl (Holland), summer 1905
Gouache and India ink on paper
on cardboard, 77 x 67 cm
Zervos I, 261; DB XIII, 2; Palau 1139
Paris, Musée National d'Art Moderne,
Centre Georges Pompidou

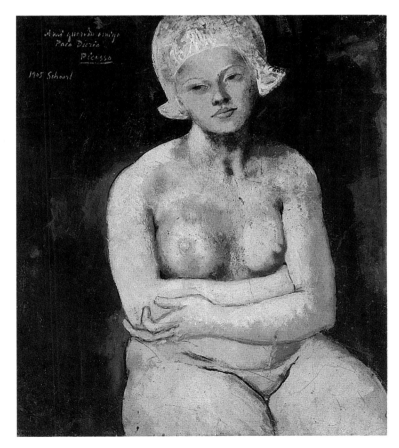

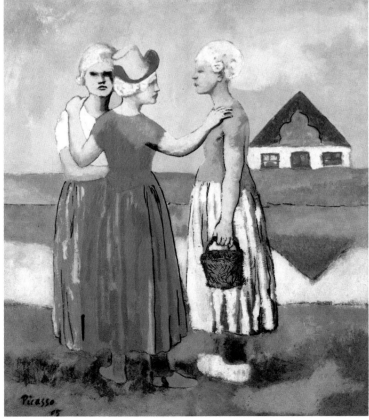

The Rose Period 1904 – 1906 **133**

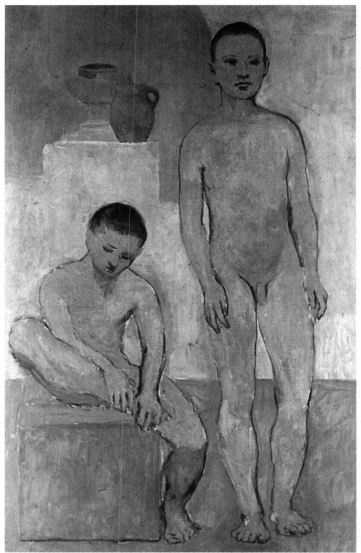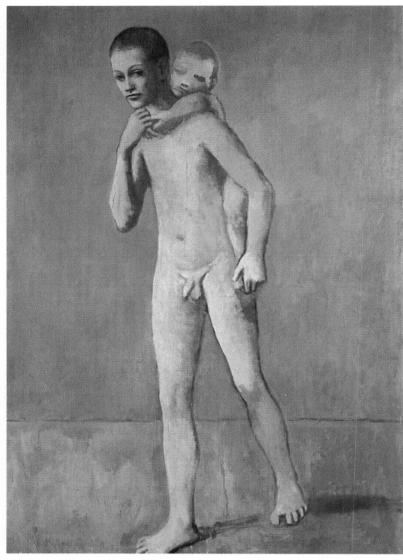

The Youths
Les adolescents
Gósol, spring to summer 1906
Oil on canvas, 151.5 x 93.5 cm
Zervos I, 305 and VI, 715; DB XV, 10; Palau 1241
Washington (DC), National Gallery of Art,
Chester Dale Collection

The Two Brothers
Les deux frères
Gósol, early summer 1906
Oil on canvas, 142 x 97 cm
Zervos I, 304; DB XV, 9; Palau 1233
Basel, Öffentliche Kunstsammlung Basel,
Kunstmuseum

finally painted over the canvas for the third time. At first he adopted the figural arrangement of the Moscow study; only with the fourth painting did Picasso at long last arrive at the version we now have. He put the man on the left in harlequin costume, replaced the boy's dog with a flower basket for the girl, and dressed the boy in a blue and red suit rather than a leotard. At bottom right he added a young seated woman. She too, rather than being a spontaneous inspiration, derived from a previously used motif (cf. p. 126). In other words, much as "The Acrobats" may make a unified impression, as if it had been achieved in one go, it in fact constitutes a synthesis of the motifs Picasso liked to paint during his Rose Period.

There are now six people; the background is not exactly defined. There are two blocks: the left-hand group, accounting for some two-thirds of the picture's breadth, consists of five people, while at right the young woman is sitting on her own. The contrast is heightened by subtle compositional means. The positioning of three of the figures at left very close together conveys a sense of

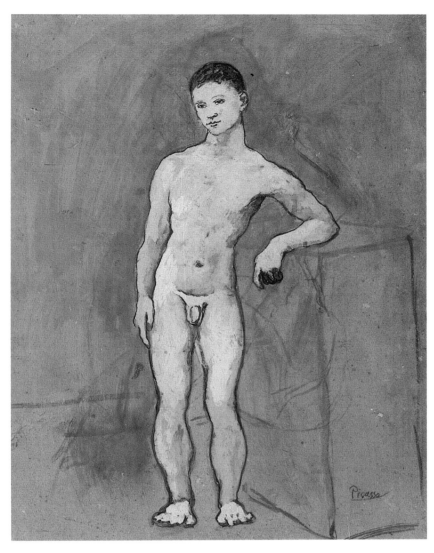

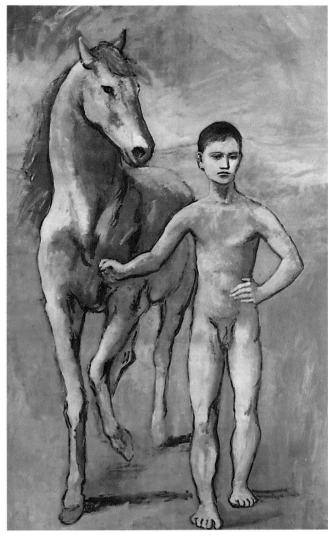

weight and unity, and the Mallorcan woman at right scarcely provides an effective counterbalance.

Picasso's palette consists basically of the three prime colours, plus shadings in black and white to enrich the detail. The reds and blues are graded in different degrees of brightness, but yellow only appears mixed with blues and browns, in unrestful presences that lack much formal definition. Thus various degrees of sandy yellow account for the unreal, spatially undefinable landscape. The other colours are caught up in similar spatial vagaries; depending on how bright or aggressive or foregrounded they are, they are coupled with darker, heavier shades that fade into the background. Only at first glance does this make an evenly balanced impression. As soon as we look more closely, things start to perplex us.

Take Tio Pepe, for instance, in whom Picasso's strategy of contrastive destabilization is most assertively seen. The massive red-clad man is conspicuous – and conspicuously lacks the lower half of his right leg! We can follow it only till just above the knee; and the buff background only makes his lack the more obvious. This

Naked Youth
Garçon nu
Paris, 1906
Tempera on cardboard, 67.5 x 52 cm
Zervos I, 268; DB XIV, 8; Palau 1196
St. Petersburg, Hermitage

Boy Leading a Horse
Meneur de cheval nu
Paris, early 1906
Oil on canvas, 220.3 x 130.6 cm
Zervos I, 264; DB XIV, 7; Palau 1189
New York, The Museum of Modern Art

cannot be a mere mistake, nor quite without importance. A defect in a figure of such thematic and formal importance serves to destabilize the entire compositional logic, and, once alerted, we see that it is unreal through and through. The picture lacks a single point of view: the figures are spatially placed in a curiously all-round way, as if each zone of the picture were subject to its own perspective. Picasso is in fact once again telling us that artistic viewpoints are relative.

And he is doing it in a narrative mode that would well suit a historical picture. His de-clarified world is precisely the one these melancholy, uncommunicative characters would inhabit. And Picasso's departure from the laws of Nature is apt since it matches the manner in which acrobats earn their living by defying the law of gravity. The harlequin theme offered not only a visual means of approaching the life of the artist but also a pretext to review formal fundamentals. Almost all the paintings of this period suggest that this was the case, perhaps above all the Moscow picture of the equilibrist (p. 127), a balancing act in a compositional as well as thematic sense.

In that picture, the visual mainspring is not only the usual fundamentals of top and bottom, left and right, big and small, but also light and heavy, foreground and background. These conceptual qualities are the product of technical tricks; they can be manipulated to the very limits of possibility, and indeed toying with those limits can be visually most attractive. Picasso has positioned one extremely large figure at the right, the seated acrobat, and by way of contrast on the left a petite, delicate young artiste. If the man were to stand up he would be taller than the picture. His muscularity emphasizes the impression of power. But it is passive power, resting, and so far to the right that we might almost expect the picture to list to that side. The girl seems feather-light and dainty by comparison, higher up and further into the midfield. It is this placing that establishes a balance with the man. We should note in passing that Picasso is playing with his motifs, teasing our sense of the differing mass of sphere and cube. The tendency to experiment formally grew upon Picasso throughout the Rose Period.

In summer 1905, at the invitation of writer Tom Schilperoort, he made a journey. The writer had inherited some money, and asked Picasso to join him on the homeward trip to Holland. It happened that Picasso saw little of the Netherlands; they changed trains in Haarlem and Alkmaar, but otherwise the small town of Schoorl was all he saw. Still, it was an encounter with an entirely new landscape and way of life.[148] The few drawings and paintings he did on the trip were markedly different from the acrobat pictures. They drew on classical sources and ancient forms. From Picasso's spontaneous decision to accompany the Dutchman we can probably infer that his interest in the harlequins and artistes was at an end and that he was looking for new inspiration.

The Rose Period 1904 – 1906 **136**

The Two Brothers
Les deux frères
Gósol, summer 1906
Gouache on cardboard, 80 x 59 cm
Zervos VI, 720; DB XV, 8; Palau 1229; MPP 7
Paris, Musée Picasso

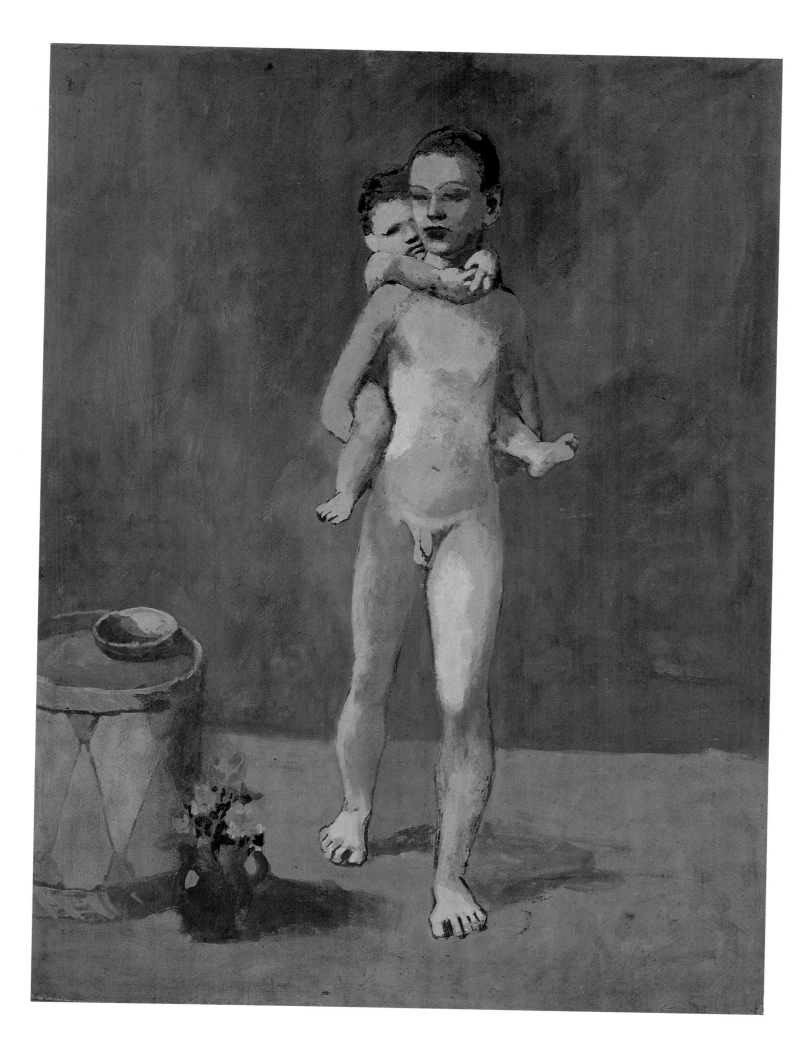

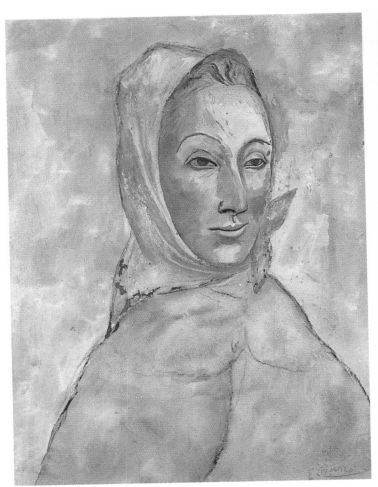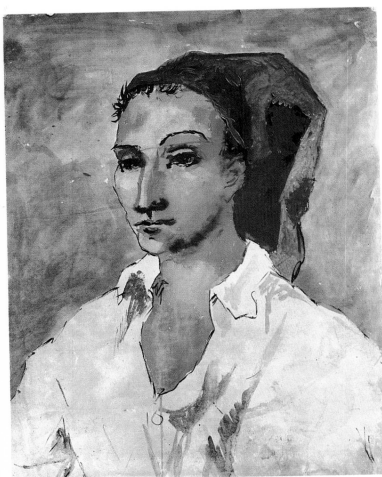

**Portrait of Fernande Olivier
with a Kerchief on her Head**
Portrait de Fernande Olivier au foulard
Gósol, spring to summer 1906
Gouache and charcoal on paper, 66 x 49.5 cm
Zervos I, 319; DB XV, 45; Palau 1307
Richmond (VA), Virginia Museum of Fine Arts

Young Man from Gósol
Jeune espagnol
Gósol, early summer 1906
Gouache and watercolour on paper, 61.5 x 48 cm
Zervos I, 318; DB XV, 37; Palau 1322
Göteborg, Göteborgs Konstmuseum

"Three Dutch Girls" (p. 133) was the most important fruit of his journey. It readily betrays its model: even if the young women are wearing Dutch national costume, they are still grouped as the Three Graces traditionally were. Since the Renaissance, the classical group motif had been a much-imitated, much-adapted staple of European art.[149] Picasso was well acquainted with one version by the Flemish baroque artist Peter Paul Rubens, in the Prado in Madrid.[150] It was a picture that apparently enjoyed unusual popularity in Spanish artistic circles in Picasso's day.[151] The creative involvement with the motifs of antiquity plainly sprang from inner necessity. After his visit to Holland, Picasso's work was noticeably informed by the wish to create dense forms of statue-like balance and poise.

It was a wish that he articulated in numerous new studies and paintings in which the colourful palette of the acrobat pictures was replaced by a monochrome red. Most of the sketches, as their subjects suggest, must have been preliminaries for a large composition Picasso never painted, showing a horses' watering place.[152] "Boy Leading a Horse" (p. 135) was modelled on archaic figures of youths in the Louvre.[153] Not only this boy but also male nudes in other paintings and even portraits done at the time make a three-dimensional impression, abstracted and simplified, like sculptures

transferred to canvas. At this time Pablo Picasso began to give greater attention to other media such as printed graphics or sculpture.

He had made an early attempt at sculpture in 1902, and "The Frugal Repast" (p. 108) in 1904 had shown him a master etcher at a date when he had only recently been taught the technique by the Spanish painter Canals.[154] Just as printed graphics had helped the pictures of acrobats on their way, so too three-dimensional work in wax or clay (cf. pp. 132 and 143) informed the formal vocabulary of the pictures that concluded the Rose Period. Picasso was developing in a new direction again.

Nude against a Red Background
Femme nue sur fond rouge
Paris, late 1906
Oil on canvas, 81 x 54 cm
Zervos I, 328; DB XVI, 8; Palau 1359
Paris, Musée de l'Orangerie

The Harem (Figures in Pink)
Le harem (Nus roses)
Gósol, early summer 1906
Oil on canvas, 154.3 x 109.5 cm
Zervos I, 321; DB XV, 40; Palau 1266
Cleveland (OH), The Cleveland Museum of Art

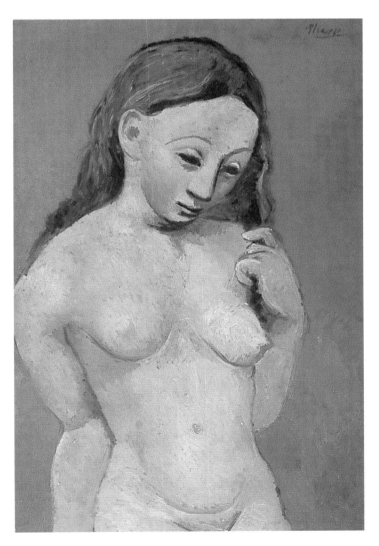

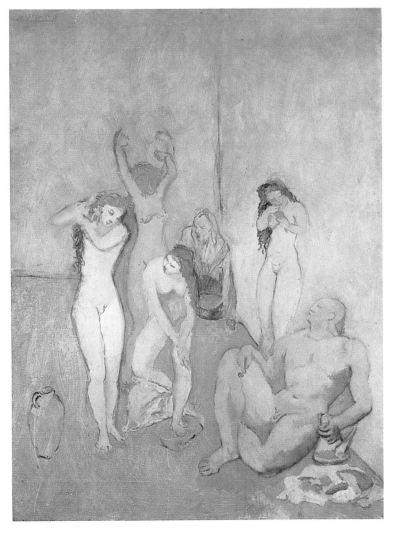

The Rose Period 1904 – 1906 **139**

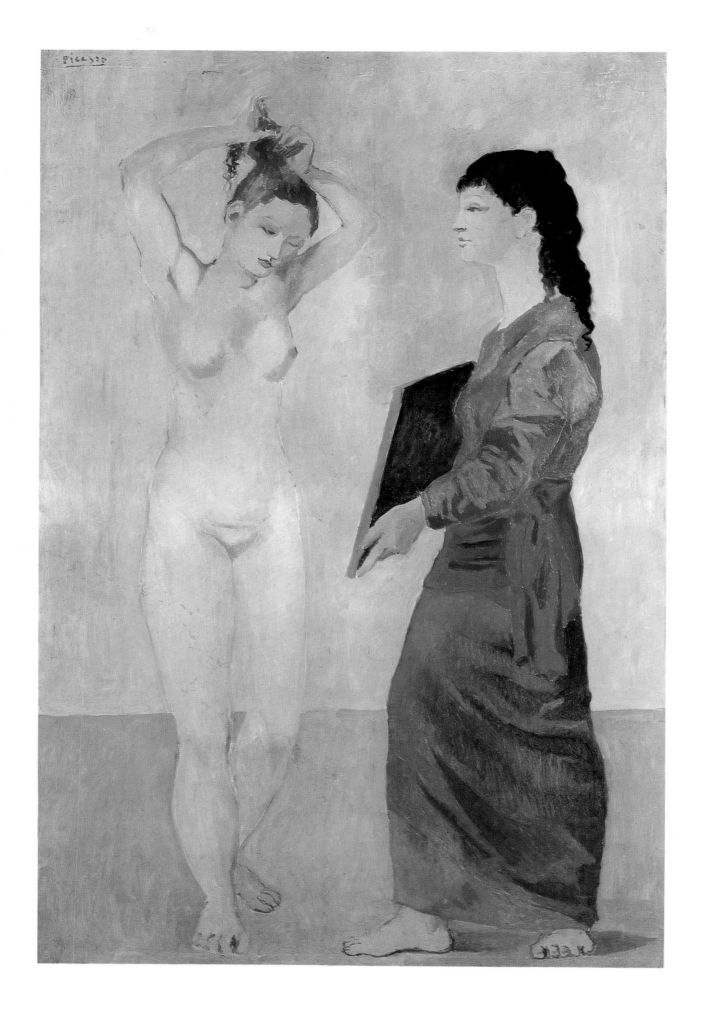

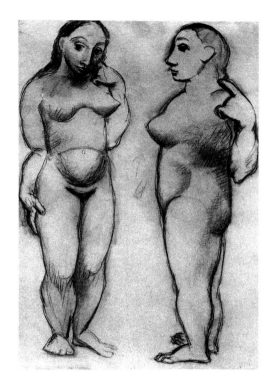

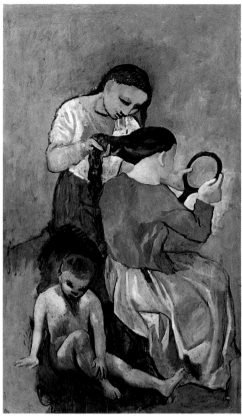

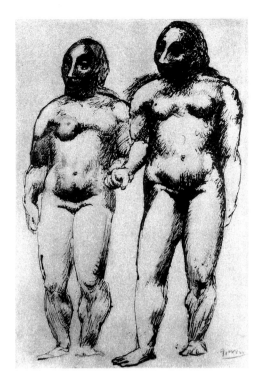

Two Nude Women
Deux femmes nues
Paris, autumn 1906
Pencil and charcoal, 63 x 47 cm
Zervos I, 365; Palau 1388

La Coiffure
La coiffure
Paris, spring to early autumn 1906
Oil on canvas, 175 x 99.7 cm
Zervos I, 313; DB XIV, 20; Palau 1213
New York, The Metropolitan Museum of Art

Two Nude Women
Deux femmes nues
Paris, autumn 1906
India ink and watercolour on paper,
48 x 31.5 cm
Zervos I, 359; DB D XVI, 21; Palau 1390
Geneva, Heinz Berggruen Collection

The Toilette
La toilette
Gósol, early summer 1906
Oil on canvas, 151 x 99 cm
Zervos I, 325; DB XV, 34; Palau 1248
Buffalo (NY), Albright-Knox Art Gallery

141 The Rose Period 1904–1906

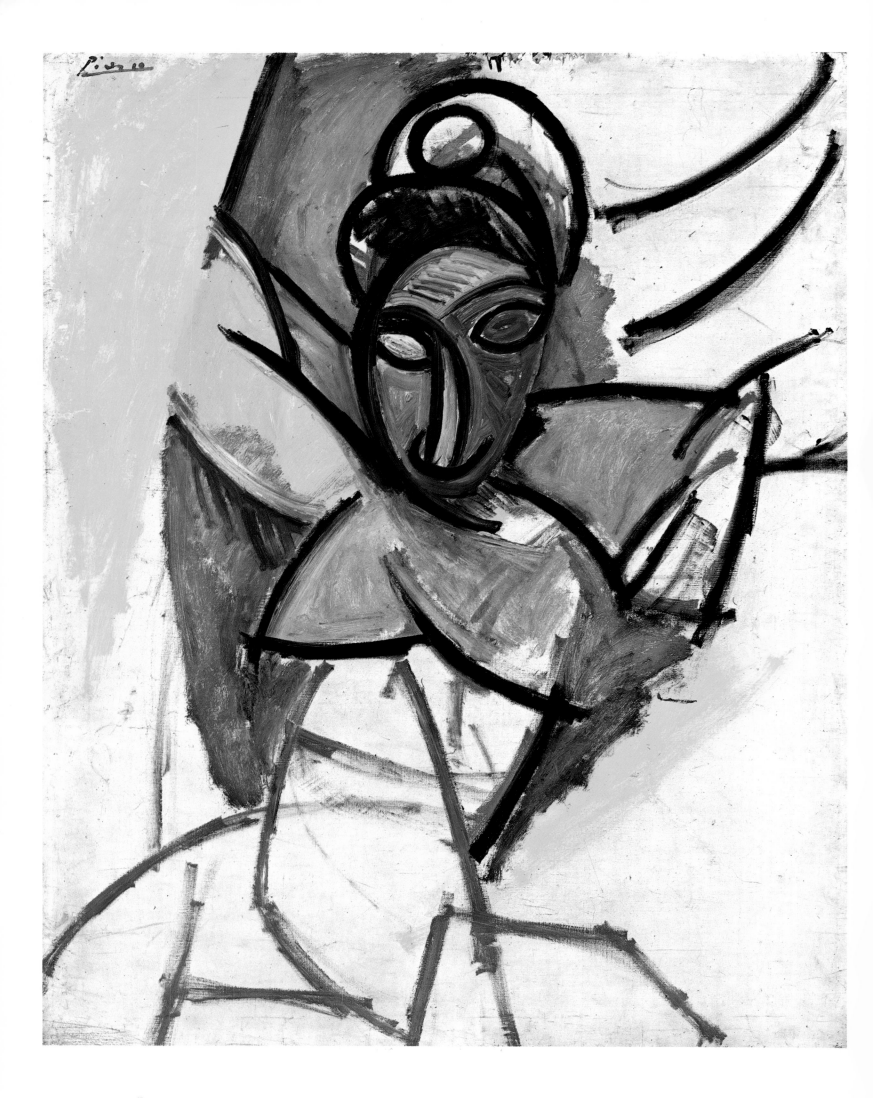

6 In the Laboratory of Art 1906/07

From the winter of 1905 on, Picasso did nothing but experiment – till he made the breakthrough and created modern art's first truly new idiom. Characteristically, though, he developed by moving backwards, via a well-considered and multi-layered engagement with tradition.

From 1905 on, Picasso strikingly gave central attention to nudes – the basic academic test of an artist's skill. He also cut back his deployment of colour once again. Now he was using it only to reinforce forms that had been simplified to a concentrated essential.

1905 was the year when the Fauves provoked a scandal at the autumn Salon. (In 1906, through Gertrude Stein, Picasso met the most important of them, Henri Matisse and André Derain.[155]) He also renewed his interest in Ingres, Gauguin and Cézanne. As well as the Fauves with their revolutionary use of autonomous colour, that autumn Salon had also had an Ingres retrospective and a small show of ten Cézannes.[156] The latter's way of rendering form and colour in accordance with the laws of painting rather than those of Nature was very much in line with Picasso's new principles. The academic classicism of Ingres, on the other hand, offered the perfection of draughtsmanlike form.

Furthermore, Picasso was significantly influenced by ancient sculpture, particularly from ancient Iberia. In the Louvre there was a section devoted to Iberian art, including artefacts that had been discovered in 1903 in excavations at Osuna. Archaeological research at the time went hand in hand with a widespread interest in primitive art, which was held to articulate the primal force of human expression.[157] Picasso was more interested in what the sculptures could tell him about form. Another kind of rudimentary simplicity did enter his life in summer 1906, though, when he spent a lengthy period in the Spanish province of Gósol amongst the peasants.[158]

Increasingly Picasso was seeing the human form in terms of its plastic volume. He simplified it, stripped it down to essentials, to a very few blocks, stylizing it into something that was less and less naturalistic. Any infringement of natural proportion he accepted

Woman Combing Her Hair
Femme se coiffant
Paris, 1906
Bronze (after a ceramic original),
42.2 x 26 x 31.8 cm
Spies 7 II; Zervos I, 329; Palau 1364; MPP 1981-3
Paris, Musée Picasso

Woman
Femme
Paris, early summer 1907
Oil on canvas, 119 x 93 cm
Zervos II**, 631; DR 75; Palau 1552
Basel, Beyeler Collection

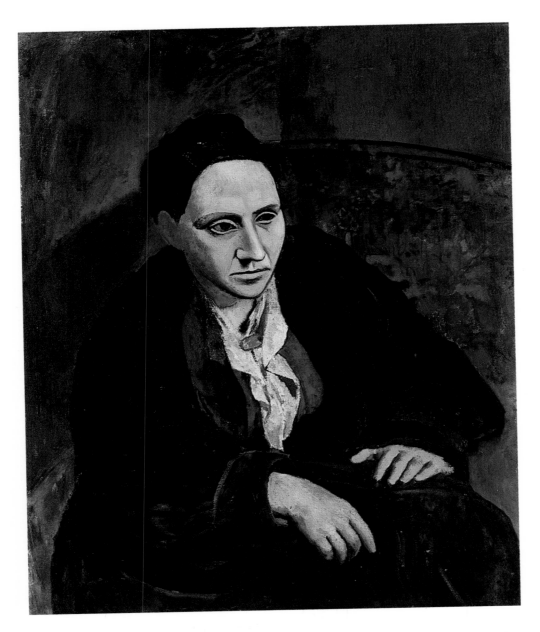

Portrait of Gertrude Stein
Portrait de Gertrude Stein
Paris, winter 1905 to autumn 1906
Oil on canvas, 99.6 x 81.3 cm
Zervos I, 352; DB XVI, 10; Palau 1339
New York, The Metropolitan Museum of Art

Portrait of Allan Stein
Portrait d'Allan Stein
Paris, spring 1906
Gouache on cardboard, 74.3 x 59.1 cm
Zervos I, 353; DB XIV, 2; Palau 1198
Baltimore (MD), The Baltimore Museum of Art,
Cone Collection

with a shrug, even accentuating it in order to highlight the independence of art. This process peaked in a sense in two portraits: the autumn 1906 "Self-portrait with a Palette" (p. 147) and the "Portrait of Gertrude Stein" (p. 144), for which the writer sat repeatedly in 1905 and 1906 and which Picasso finally completed in the autumn of the latter year. Principles that later matured can be seen at work in the two works. In the picture of Stein, the solid mass of the subject affords an excuse to play with form: Picasso blithely ignores perspective, the relations of body parts to each other, and the logic of natural appearance. The head is an irregular block with eyes and a nose that look as if they have a life of their own. The style, though, is still suited to the sitter, and even expresses her all the better for being slightly distorted. The self-portrait goes further. Picasso deliberately abandons professional technique, and places his outlines and areas of colour rawly and inchoately before us, making no attempt to flesh out an appearance of a living person. There are no illusions in these lines and this

paint. They are simply there on the canvas to do the job of establishing a form.

Picasso pursued this path in a lengthy series of studies. In summer 1907 they culminated (at least for the time being) in the famous "Demoiselles d'Avignon" (p. 159). It has long been recognised as a key work in modern art. Yet for years, indeed decades, relatively little was known about how the work came to be painted – and so vague opinions, misconceived judgements and legends inevitably filled the gap. For instance, it is widely supposed that Picasso, under the influence of African art, was establishing a new vocabulary of de-formation which not only opened up new expressive opportunities for the visual arts but also represented a personal conquest of traumatic feelings. The artist's putative fear of venereal disease, the great mystery of sexual energy, and his private attitude to women, were all thought to have been exorcized by a ferocious effort of labour that left Picasso liberated. His possessed state was also adduced as the reason why the "Demoiselles" was never completed, merely abandoned at a critical point.[159]

Since it has been possible to view the preliminary studies in the Picasso estate, and to trace the path that led to "Les Demoiselles d'Avignon", this has all changed.[160] Speculation has yielded to fact. It is interesting to see how long it took Picasso to achieve the picture we now have.

Self-portrait
Autoportrait
Paris, autumn 1906
Oil on canvas, 65 x 54 cm
Zervos II*, 1; DB XVI, 26; Palau 1376; MPP 8
Paris, Musée Picasso

Self-portrait (Head of a Young Man)
Autoportrait (Tête de jeune homme)
Paris, autumn 1906
Oil on cardboard, 26.6 x 19.7 cm
Zervos I, 371; DB XVI, 27
Mexico City, Jacques and Natasha Gelman
Collection

He began it in autumn 1906 after his return from Spain, doing sketches all that winter. In March 1907 he had a first composition ready, the study now in Basel (p. 155) which shows seven people in a brothel. Picasso subsequently altered the form and content significantly. The new compositional design (now in Philadelphia) cut the number of figures to five (cf. p. 155), and it was this version that the painter then transferred to canvas. He did not stop sketching further ideas, though; and it was not till July 1907 that he painted the final work we now have.[161]

It took him a full three-quarters of a year. And the intensity of labour can be proven by statistics: no fewer than 809 preliminary studies! Not only scrawls in sketchbooks but also large-scale drawings and even one or two paintings.[162] This is unparalleled in the history of art. His sheer application shows that Picasso cannot have been working in a possessed, spontaneous frame of mind. On the contrary, he worked in rational and impressively consistent fashion, unswervingly.

The sketches and studies are difficult to date or define, though, and a detailed account of the painting's evolution is therefore problematic.[163] "Normal" representative pictures appear alongside de-formed ones with no date to suggest a line for us to follow. For example, in a sketchbook he was using in March 1907 Picasso drew a sailor's torso and a masked face on the two sides of one and the same sheet. They were done one after the other, possibly even on the same day. The purest of position studies appear alongside sketches for the overall composition, again with no clear guidelines for dating. And there are even studies that have nothing at all to do with a brothel, and sketches that were not used for the painting in any way at all (pp. 153, 154 and 156).

This plural copiousness is instructive in itself. For one thing, it proves that Picasso was not influenced by "Negro" sculpture at all (as is still assumed in many quarters).[164] Picasso himself always denied it – and rightly so. The assumption rests on the fact that in summer 1907 he went to the Trocadéro Museum in Paris and was

Studies for "Self-portrait with a Palette"
Etudes pour "Autoportrait à la palette"
Paris, early autumn 1906
Pencil on paper, 31.5 x 47.5 cm
Zervos XXVI, 5; Palau 1377; MPP 524(r)
Paris, Musée Picasso

Studies for "Self-portrait with Palette"
Etudes pour "Autoportrait à la palette"
Paris, early autumn 1906
Pencil on paper, 31.5 x 47.5 cm
Zervos XXVI, 7; Palau 1378
Estate of the artist

Self-portrait with a Palette
Autoportrait à la palette
Paris, autumn 1906
Oil on canvas, 92 x 73 cm
Zervos I, 375; DB XVI, 28; Palau 1380
Philadelphia (PA), Philadelphia Museum of Art,
A. E. Gallatin Collection

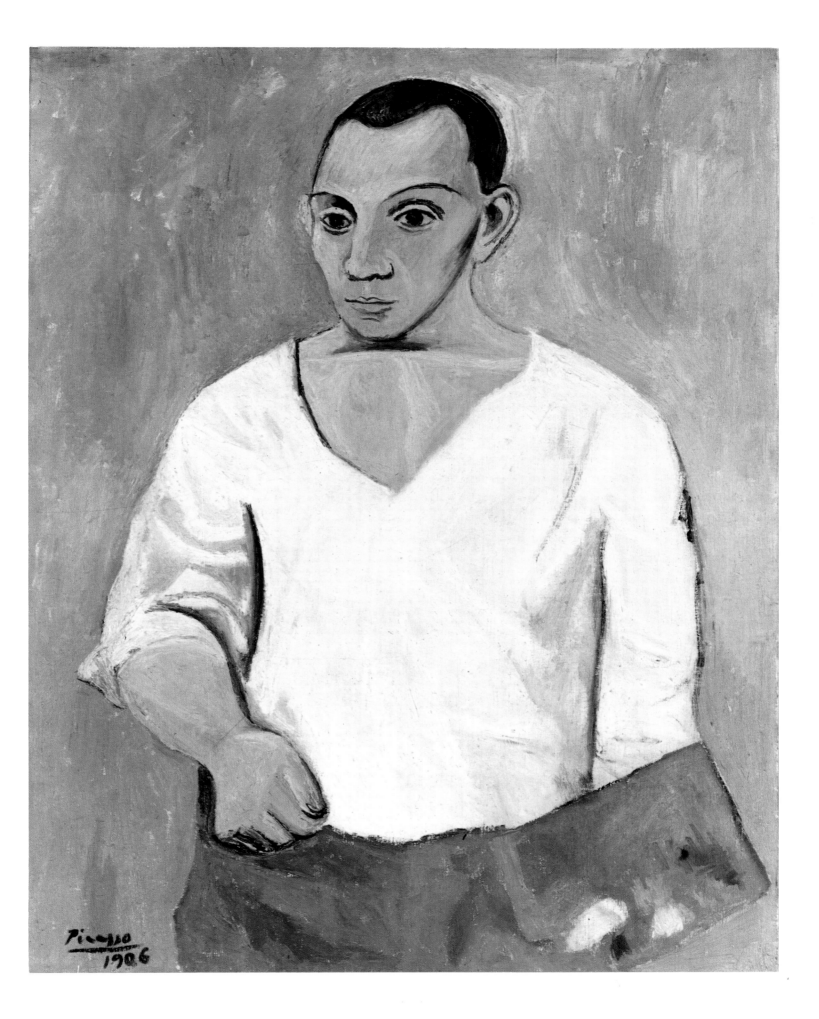

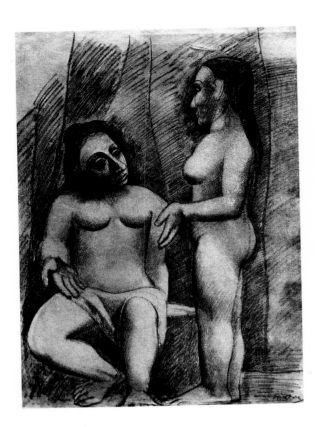
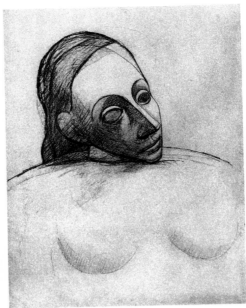
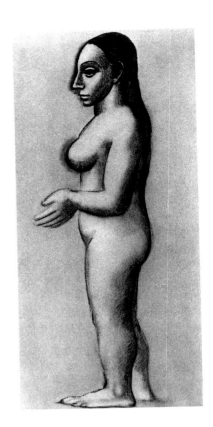

deeply impressed, indeed shocked, by a room of African sculpture, because the figures were made in much the same way as the deformed figures in his own work.[165] But those sculptures cannot have influenced him – because he had already arrived at the form he was after. Back in March 1907 he had done a head study that proves as much (p. 154), and he used it for the masked faces in the "Demoiselles". His shock in the museum was not caused by the sight of something new but by the recognition that what he thought he had invented already existed.[166]

We can follow Picasso's method clearly enough. There were two strands of evolution, one formal, one thematic. In Picasso's mind they were distinct, as we can see from the fact that most of the sketches only ever tackle one formal or one thematic problem. Picasso drew in any sketch-book as the ideas came to him, so that the most different of materials can be found together. But it was a useful working method in that it organically achieved the juxtapositions and synthesis Picasso was ultimately after. At irregular intervals he would therefore sketch combinations of distinct lines of development; some of these document the deconstruction of spatial and figural values and changes of content too. They are jottings; they record solutions to problems; and they establish a repertoire of images for the artist to use whenever he chooses. The yokings become ever more radical till at last the goal is in sight. The final stage involves work at the canvas itself.

As we can now see, in most of the individual sketches Picasso was striving for clear insight into the nature of artistic mimesis. Generally speaking, a line is drawn in such a way as to imitate the contour

Sitting Nude and Standing Nude
Femme nue assise et femme nue debout
Paris, autumn to winter 1906
Pencil and charcoal on paper, 63.6 x 47.6 cm
Zervos I, 368; DB XVI, 17; Palau 1406
Philadelphia (PA), Philadelphia Museum of Art,
The Arensberg Collection

Bust of Woman with Inclined Head
Buste de femme
Paris, winter 1906
Charcoal on paper, 62.5 x 47 cm
Zervos II**, 597 and VI, 877; Palau 1419
Estate of the artist

Standing Nude in Profile
Femme nue debout de profil
Paris, autumn to winter 1906
Pencil and charcoal; dimensions unknown
Zervos I, 369; Palau 1404

Seated Nude with Crossed Legs
Femme nue assise, les jambes croisées
Paris, autumn 1906
Oil on canvas, 151 x 100 cm
Zervos I, 373; DB XVI, 25; Palau 1397
Prague, Národni Gallery

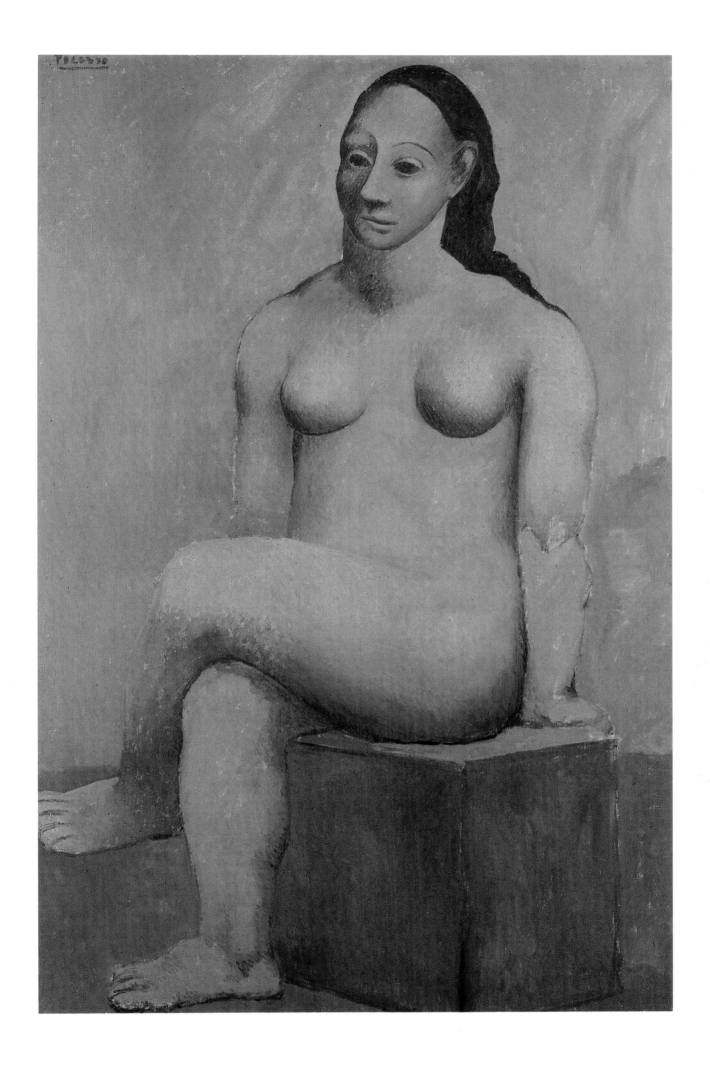

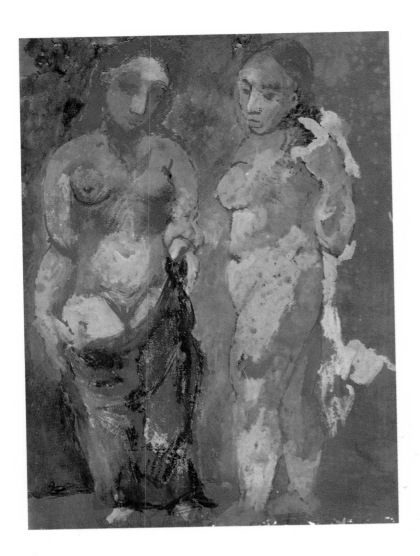

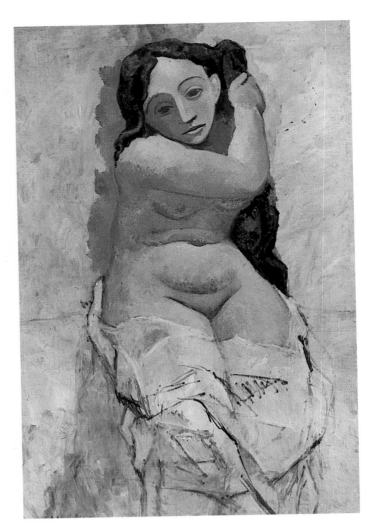

Two Nudes
Femme nue de face et nue de profil
Paris, autumn 1906
Gouache on paper on canvas, 58.5 x 43.2 cm
Zervos I, 361; DB XVI, 14; Palau 1391
Locarno, Walter D. Floersheimer Collection

Woman Combing Her Hair
La coiffure
Gósol and Paris, late summer and autumn 1906
Oil on canvas, 126 x 90.7 cm
Zervos I, 336; DB XVI, 7; Palau 1363
New York, Schoenborn and Marx Collection

of an object; and when we look at that line we can identify it as a mimetic image because it resembles our own image of the object. Three things are involved in this process: the imagined image, the line, and the hand. If the hand does not obey the draughtsman's will, be it because he lacks the skill or the concentration, the lines will be distorted or meaningless. But lines can be used to convey meaning and character; concepts such as fat or thin, beautiful or ugly, become visually communicable. A line in itself lacks content or meaning. As Gertrude Stein might have put it: a line is a line is a line. But for that very reason lines can be made into figural complexes that are not mimetic and yet convey a conceptual image (cf. p. 154).

This was a truism to Picasso as to any draughtsman. The value of seeing it so clearly lay in recognising the twin poles of mimesis: on the one hand the ideal co-incidence of object and representation, and on the other hand the complete absence of any representational value. Every mimetic drawing contains elements of both extremes.

Picasso's conclusion, like all things of genius, was in essence very simple, but it has been of revolutionary importance for 20th-century art: the mimetic image is a compound of elements that do not intrinsically belong together. Their yoking is dictated by chance. So

it must be possible to mix them quite differently and thus create forms that can still, it is true, be understood as representational in some sense, but which are pure art rather than a mimetic imitation of Nature.

The new formal language must contain as much of a representational nature as is necessary for it to be comprehensible, and at the same time must have as much non-referential visual material as possible without being entirely abstract. Picasso tried out his method on that most familiar of objects, the human body.

His studies of heads and faces are typical. The images we have of things already constitute an abstraction; so it takes little to draw a generalized representation of an object. In sketches done during winter 1906, the method Picasso used to draw a face was a simple, indeed conventional one. Two irregular lines indicated the breadth and shape of a nose, and parallel hatched lines on one side conveyed its size by means of shadow. The same procedure was then applied to other parts of the face (cf. p. 154). Now all that was

Two Nude Women Arm in Arm
Deux femmes nues se tenant
Paris, autumn 1906
Oil on canvas, 151 x 100 cm
Zervos I, 360; DB XVI, 13; Palau 1354
Switzerland, Private collection

Two Nudes
Deux femmes nues
Paris, late 1906
Oil on canvas, 151.3 x 93 cm
Zervos I, 366; DB XVI, 15; Palau 1411
New York, The Museum of Modern Art

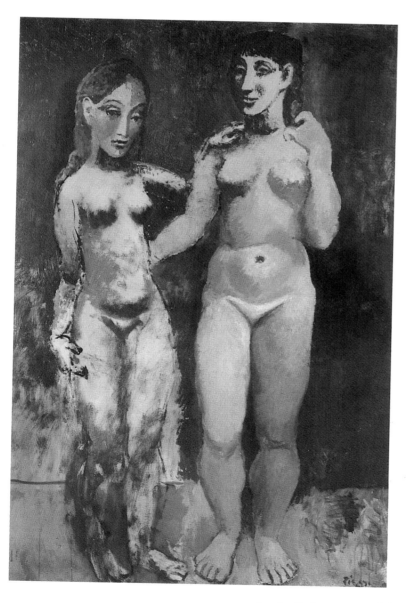 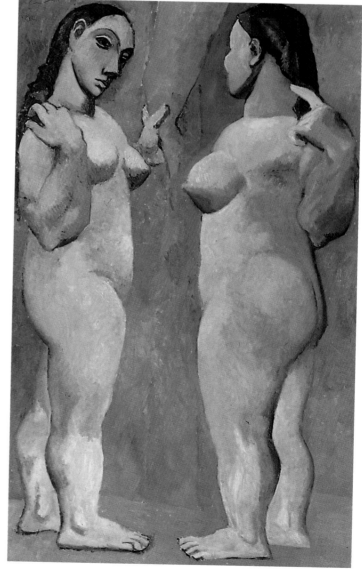

In the Laboratory of Art 1906/07 **151**

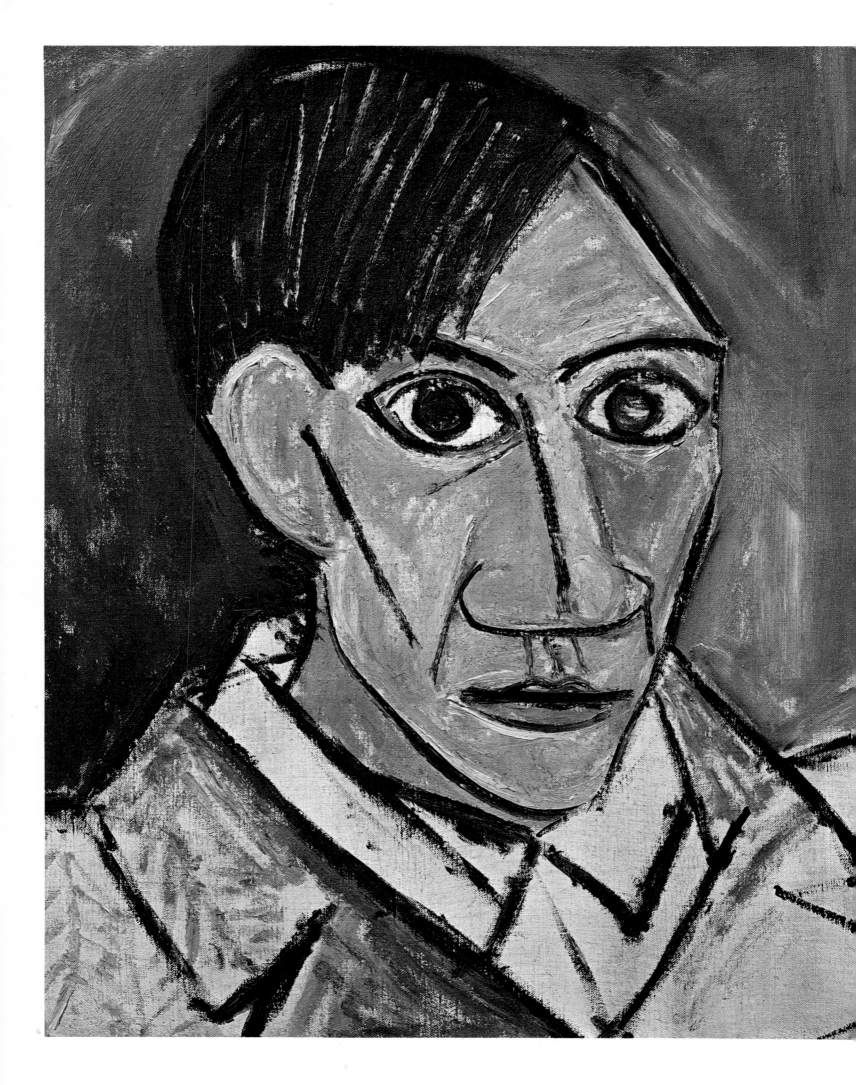

required was to stylize all the principal and secondary lines, in a mechanistic fashion, and a far more artificial impression would be conveyed.

In May and June of 1907 he resumed this quest, to see how relatively minor alterations could change a faithful copy of Nature into something remote from it. He drew the bridge of the nose in strictly parallel lines, which devolved the hatched areas into a graphic autonomy. Then he angled the elliptical eyes and constructed a head out of unnatural straight lines and arcs. In March he had already tested distortions of this kind and had created a mask face. It still remained a head, conceptually speaking; but the random changes made it a new, unfamiliar image.

Picasso also used this same method of free combination of formal fundamentals in his use of colour in his oil studies. He changed the mimetic function and meaning of colours – such as skin colour and the way in which a three-dimensional effect was established – by juxtaposing lighter and darker areas (p. 158). In other studies he made his faces out of contrasts. Uniform prime colours remote from the reality of the subject were deployed in an anti-naturalist manner, the facial character heightened by a few complementary tonalities borrowed from colours in the background. In the process, Picasso travelled a great distance along the road of combining the colourist's and the draughtsman's evolutionary techniques (cf. pp. 156 and 157).

The final oil version of "Les Demoiselles d'Avignon" (p. 159) brought together the results of Picasso's experimentation in such a way that we can trace the entire spectrum of his options from the central figures out to the sides. It is the programmatic statement of a new formal vocabulary, created from the systematic scrutiny of conventional representational approaches and the development of a new synthesis out of them. It has not the slightest in common with specific historical styles of art such as Iberian or African sculpture.[167]

Everything in the picture is of fundamental importance, starting with the size of the canvas: the picture is often referred to as square, but is not, being in fact 243.9 x 233.7 cm in size. The marginal difference between the height and the breadth is significant because it leaves us irresolute: the picture is a rectangle but looks like a square. Everything in this picture teaches us of the inadequacy and randomness of customary concepts in visual representation.

The colour scheme is a synthesis of the monochromatic and the contrastive. The figures are painted in colours ranging from whitish yellow to brown, as are areas of the background; this contrasts with the blue that divides the right group from the left. The blue is agitated, disruptive, fractiously foregrounded; but on closer inspection we find that the contrast is less violent than it appears. Lighter or darker blues appear elsewhere, weakening the shock by establishing a sense of transition. And Picasso modifies the impact any-

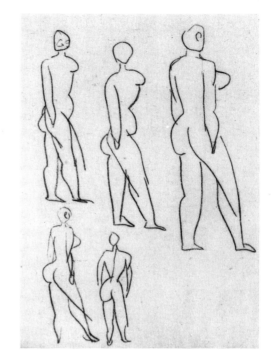

Female Nudes. Study for "Les Demoiselles d'Avignon"
Femmes nues. Etude pour "Les Demoiselles d'Avignon"
Paris, autumn 1906
Pencil on paper, 26 x 20 cm
Zervos VI, 848; Palau 1425; MPP 1858
Paris, Musée Picasso

Group of Seven Figures. Study for "Les Demoiselles d'Avignon"
Ensemble à sept personnages. Etude pour "Les Demoiselles d'Avignon"
Paris, March 1907
Crayon on paper, 19.3 x 24.2 cm
Zervos XXVI, 97; Palau 1522; MPP 1861
Paris, Musée Picasso

Self-portrait
Autoportrait
Paris, spring 1907
Oil on canvas, 50 x 46 cm
Zervos II*, 8; DR 25
Prague, Národni Gallery

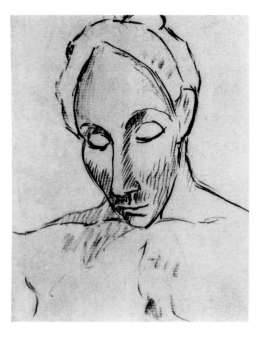

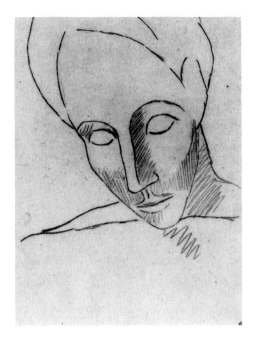

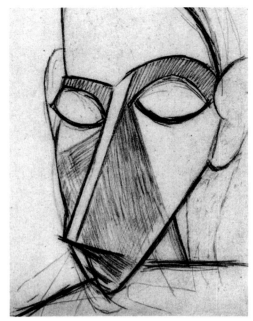

**Head of a Woman. Study for
"Les Demoiselles d'Avignon"**
Tête de femme. Etude pour
"Les Demoiselles d'Avignon"
Paris, winter 1906
Pencil on paper, 14.7 x 10.6 cm
Zervos II**, 603; Palau 1479; MPP 1859
Paris, Musée Picasso

**Head of a Woman. Study for
"Les Demoiselles d'Avignon"**
Tête de femme. Etude pour
"Les Demoiselles d'Avignon"
Paris, winter 1906
Pencil on paper, 32 x 24 cm
Zervos VI, 855; Palau 1481
Estate of the artist

**Head of a Woman. Study for
"Les Demoiselles d'Avignon"**
Tête de femme. Etude pour
"Les Demoiselles d'Avignon"
Paris, June to July 1906
Pencil on paper, 31 x 24 cm
Zervos VI, 968; Palau 1484
Private collection

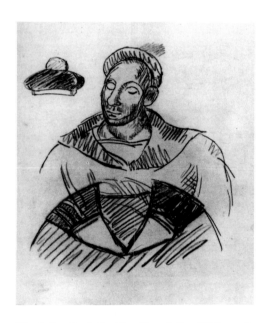

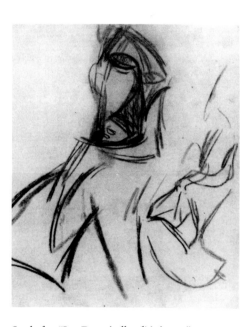

The Sailor. Study for "Les Demoiselles d'Avignon"
Le marin. Etude pour "Les Demoiselles d'Avignon"
Paris, March 1907
Pencil on paper, 19.3 x 24.2 cm
Zervos XXVI, 100; Palau 1443; MPP 1861
Paris, Musée Picasso

Study for "Les Demoiselles d'Avignon"
Etude pour "Les Demoiselles d'Avignon"
Paris, March 1907
Charcoal on paper, 19.3 x 24.2 cm
Zervos XXVI, 101; Palau 1554; MPP 1861
Paris, Musée Picasso

Study for "Les Demoiselles d'Avignon"
Etude pour "Les Demoiselles d'Avignon"
Paris, June to July 1907
Pencil on paper, 31.2 x 24.7 cm
Zervos VI, 936; Palau 1466
Private collection

Page 155:
Study for "Les Demoiselles d'Avignon"
Etude pour "Les Demoiselles d'Avignon"
Paris, March to April 1907
Pencil and pastel on paper,
47.7 x 63.5 cm (sheet size)

Zervos II*, 19; DR 29; Palau 1511
Basel, Öffentliche Kunstsammlung Basel,
Kupferstichkabinett

Study for "Les Demoiselles d'Avignon"
Etude pour "Les Demoiselles d'Avignon"
Paris, spring 1907
Watercolour on paper, 17.5 x 22.5 cm
Zervos II*, 21; DR 31; Palau 1543
Philadelphia (PA), Philadelphia Museum of Art

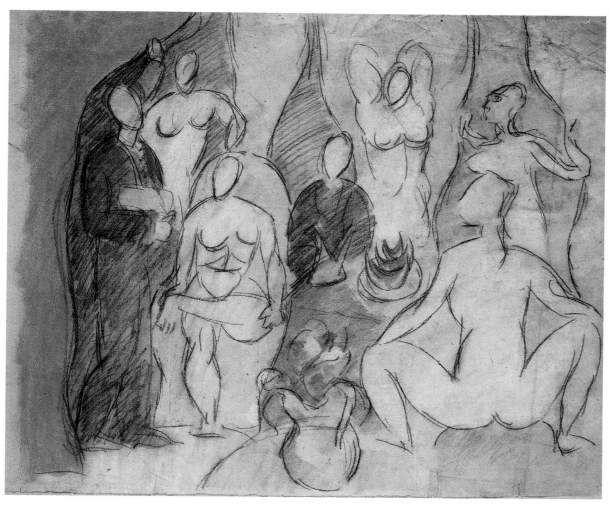

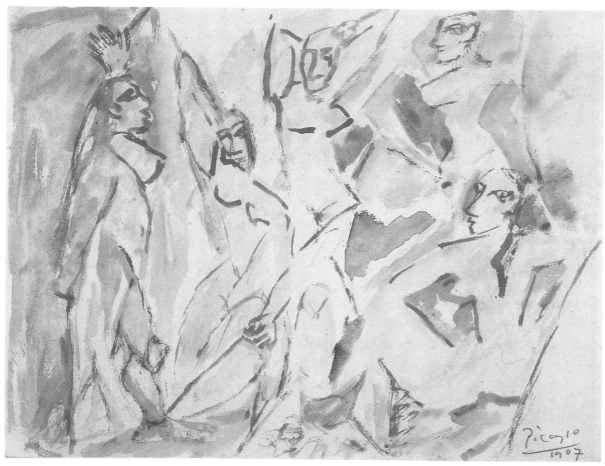

In the Laboratory of Art 1906/07 **155**

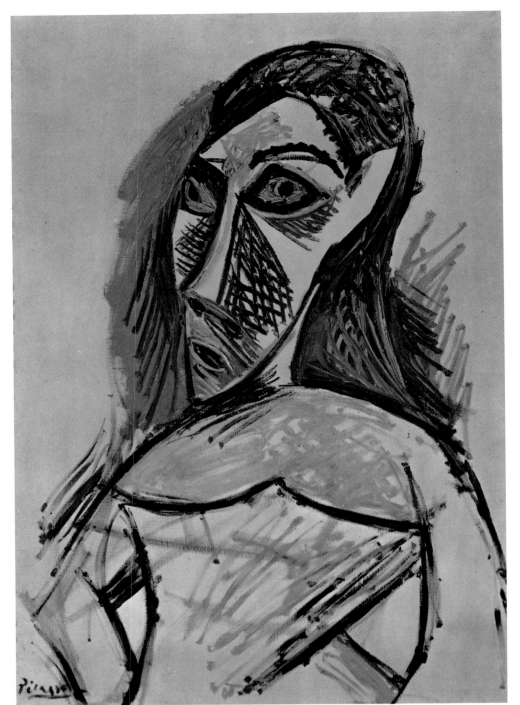

**Female Nude. Study for
"Les Demoiselles d'Avignon"**
Femme nue. Etude pour
"Les Demoiselles d'Avignon"
Paris, autumn 1906
Pencil on paper, 26 x 20 cm
Zervos VI, 903; MPP 1858
Paris, Musée Picasso

**Female Nude. Study for
"Les Demoiselles d'Avignon"**
Femme nue. Etude pour
"Les Demoiselles d'Avignon"
Paris, spring to summer 1907
Oil on canvas, 81 x 60 cm
Zervos II*, 24; DR 41; Palau 1550
Geneva, Heinz Berggruen Collection

way, by placing the contrastive blue zone almost in the position of
the classical golden section. In Renaissance art theory, to divide the
space in proportions such as these was to express ideal harmony –
which is the very opposite of what we first feel on seeing Picasso's
painting.

Compositionally, the placing of the subjects breaches conven-
tional ideas of clarity and order. Critics tend to see two unequal parts
in this picture, the group of three women on the left and that of two
on the right defining these parts. But once we register the figures'
relations to the background we do better to identify three zones, in-
creasing in size from left to right: first the woman at far left, then the

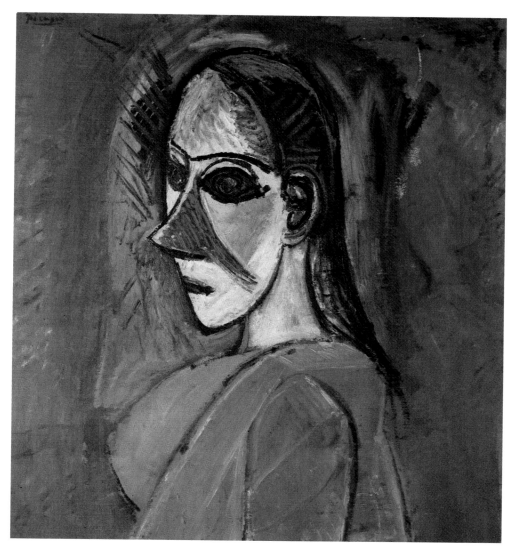

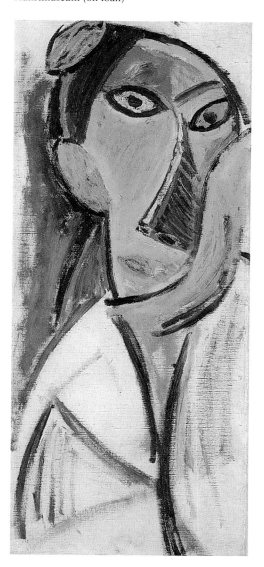

two frontally positioned women against the whitish-grey background, and then, seemingly split off by a harsh colour contrast, the two at the right. But this irregular tripartite scheme is at odds with a more orderly spatial division marked by the still life at the foot of the canvas: the table, seen as a triangular shape pointing upwards, coincides precisely with the centre axis. Logically, that axis is occupied by the middle one of the five women. The angle at which her arms are held behind her head restates the axis by inverting the triangle. Seen like this, the composition proves to be divided exactly in two. And to classical ways of thinking, symmetrical composition was a token of ideal order, of an austere kind.

Three grouping principles at least are at work in this painting. The use of all three together puts each into a new, relativized perspective. It is the same with the spatial values. The classical ideal of perspective as a means of establishing meaning has been conspicuously thrown overboard – thus the received wisdom claims, but it is too one-sided a way of seeing the picture. True, there is no perspective spatial depth in the work. But the overlapping of the figures most certainly does create some sense of space. And Picasso

157 In the Laboratory of Art 1906/07

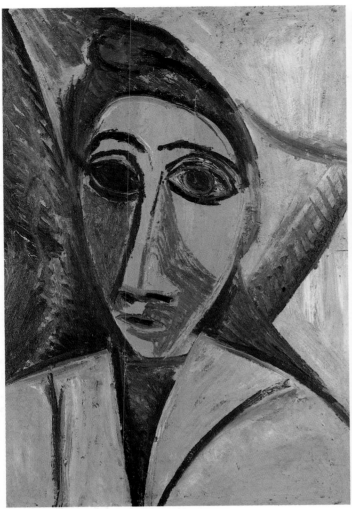 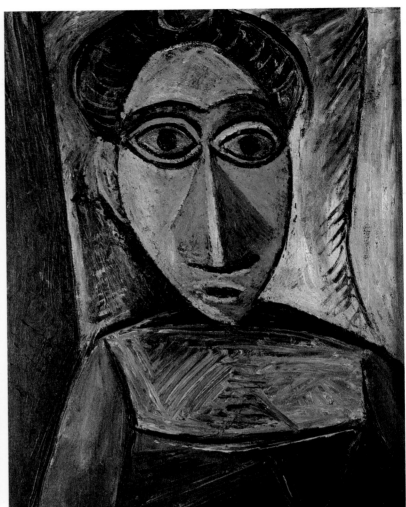

Bust of a Woman or Sailor
Study for "Les Demoiselles d'Avignon"
Buste de femme ou de marin
Etude pour "Les Demoiselles d'Avignon"
Paris, spring 1907
Oil on cardboard, 53.5 x 36.2 cm
Not in Zervos; DR 28; MPP 15
Paris, Musée Picasso

Bust of a Woman
Buste de femme
Paris, spring to summer 1907
Oil on canvas, 64.5 x 50 cm
Zervos II*, 16; DR 33; Palau 1546
Prague, Národni Gallery

has also fixed a set point of view for us – albeit ironically, since the lower half of the painting looks up to the subjects, while in the upper it is impossible to be definite about the angle. The line separating these two ways of seeing is almost exactly the horizontal mid-composition line, where the classical code of central perspective required the viewer's horizon to be.

We also need to register the different ways of presentation within individual figures and objects. The bodies are seen at once from the front and the side, in a way not naturally possible. Lines, hatchings and blocks of colour are used to make random changes and de-formations in parts of the women's bodies, and Picasso's over-layering makes for entire areas of abstraction. In overall terms this is also true of the relation of the figures to the background, which the artist has treated as one of despatializing formal analogy.

Still, Picasso has not completely abandoned mimetic representation. The lines and colours still plainly show naked women in various positions. It is because this is still apparent that the deviations from a conventional aesthetic shock us. And the shock was only heightened, for Picasso's contemporaries, by the ostentatious and provocative nakedness of the women. The mask-like, barely human faces highlight the relativity of our ideas of beauty: the two

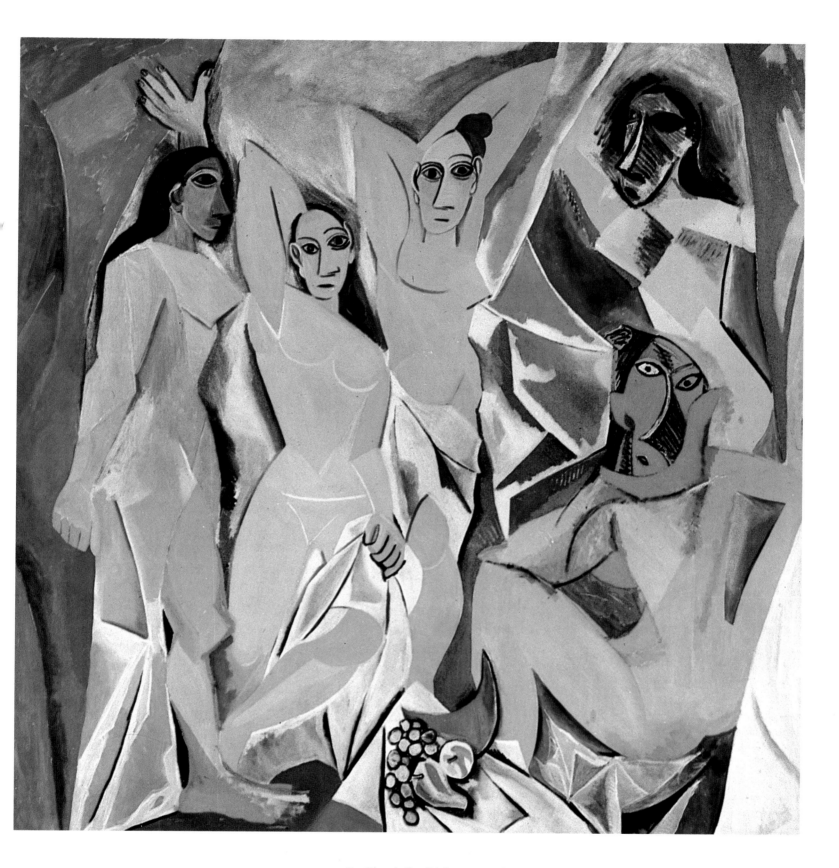

Les Demoiselles d'Avignon
Paris, June to July 1907
Oil on canvas, 243.9 x 233.7 cm
Zervos II*, 18; DR 47; Palau 1557
New York, The Museum of Modern Art

159

more recognisably human women in the centre begin to look lovely by comparison, though taken alone their cartoon faces and distorted bodies would be anything but beautiful. The face of the woman at left, also mask-like but less distorted than the two right-hand faces, is a halfway point between these extremes; just as the darker colouring he has used for her provides a compositional balance.

Picasso uses counterpoints and checks and balances of this kind throughout the painting, and this fact alone will suffice to demolish the widely-believed legend that the work is unfinished. A detailed analysis shows "Les Demoiselles d'Avignon" to be a meticulously considered, scrupulously calculated visual experience without equal. The formal idiom and utterly new style were by no means a mere relinquishing of prevailing norms in the visual arts but rather a subtly elaborated marriage of relinquishing and preservation. The same is true of the subject matter.

The first complete compositional plan, done in March 1907 and now in Basel (p. 155), shows an interior with seven people: five naked women and two clothed men. Studies of bearing, clothing and attributes tell us that the man on the left was envisaged as a student and the one in the middle as a sailor. This unambiguous scene, according to Picasso himself, showed a brothel in Barcelona's Carrer d'Avinyó: in other words, it had nothing in particular to do with the French town of Avignon. It was not till 1916 that Salmon put about the innocuous and simply wrong title by which the picture is now known; this title drew on in – jokes familiar among Picasso's circle of friends.[168] The fact that it is a brothel scene has prompted people to feel that Picasso had indeed been coming to terms with sexual troubles in painting the picture, a feeling they have felt confirmed in by the fact that Picasso studied venereal (particularly syphilitic) patients in St. Lazare.[169] Yet this view is not consistent. For one thing, Picasso painted prostitutes earlier, in pictures that alluded to works by Degas and Toulouse-Lautrec. And for another, after he did the Basel drawing he changed the composition so utterly that everything was dropped that could unambiguously suggest a brothel interior. This implies that the subject in itself no longer had any significance. The figure of a sailor with a death's-head shows that Picasso was initially planning a historical allegory.[170] But he departed from that as well, and in so doing put the conventional norms of the genre behind him.

Picasso's new idea for his subject was in fact a far more complex and inventive one. Just as he had examined traditional methods of representation and located a new solution, so too he examined the problem of iconography, of conveying content meaning through standard images, of re-using the idiom of existing visual ideas. There is a traditional model for the general theme of women showing off their bodily charms for a verdict. It shows three naked women standing in front of seated or standing males and goes by

Study for "Three Women" (1908)
Etude pour les "Trois femmes" (1908)
Paris, 1907
Watercolour, gouache and pencil on paper,
61.5 x 47.3 cm
Zervos II**, 707
Mexico City, Jacques and Natasha
Gelman Collection

Woman in Yellow
Femme au corsage jaune
Paris, spring 1907
Oil on canvas, 130 x 97 cm
Zervos II*, 43; DR 51
Private collection

the name of the judgement of Paris.[171] But Picasso had other antecedents in mind too.

Picasso's two frontal figures parody the conventional use of drapes and concealment to heighten the aesthetic impact of the naked female body. Here the drapes are used to emphasize the painter's departure from the norm. Since the Renaissance, the ancient sculptural ideal of the human form had provided a constant touchstone. In the 19th century and down to Picasso's time, one female figure of a deity had seemed the very epitome of ideal beauty: the Venus of Milo. Picasso's middle woman quite plainly is modelled on her, the one leg placed to the fore as in the sculpture. There is a Hellenistic version of the sculpture in the Louvre, the

161 In the Laboratory of Art 1906/07

Head of a Woman
Tête de femme
Paris, 1906/07
Wood, carved and partially painted,
39 x 25 x 12 cm
Spies II; Zervos II**, 611; Palau 1413;
MPP 1990-51
Paris, Musée Picasso

pose of which Picasso copied.[172] In any case it was a position that he was perfectly familiar with, since it was regularly used in academic life classes.[173]

The judgement of Paris, and Venus, were logical choices for Picasso: the first involved that ideal beauty which the second personified. And it was the problem of artistically presenting aesthetic norms that decided Picasso on a composition involving five different women. He had an ancient anecdote in mind. Zeuxis the painter, faced with the task of portraying the immortally beautiful Helen, took as his models the five loveliest virgins of the island of Kroton and combined their finest features in order to achieve a perfection of beauty that did not exist in Nature.[174]

The still life in the "Demoiselles" adds a theoretical statement. Critics have routinely commented that this detail seems unmotivated in what is supposedly a brothel scene, and have also pointed out that the fruit is done in a fairly true-to-life style unlike that of the figures. Picasso is alluding to another anecdote about Zeuxis, who was said to have painted fruit – grapes in particular – so skilfully that birds were fooled and pecked at them.[175] The Zeuxis tales are commonplaces of art history, but they also have an important place in that history, since Zeuxis is considered the forefather of illusionist art, the very kind of art and aesthetic rules that Picasso's non-normative painting "Les Demoiselles d'Avignon" swept aside.

Figure (Three views)
Figure
Paris, 1907
Wood, carved and painted; height: 25 cm
Spies 16; Palau 1441; Zervos II**, 608 to 610
Private collection

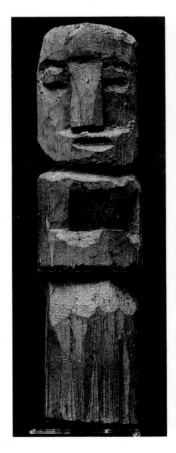

162 In the Laboratory of Art 1906/07

Impartial analysis shows the painting together with its preliminary studies to be radical in the true sense: Picasso re-conceived the entirety of the European art tradition from the roots up, and used its constituents to create a new visual language. It was not his intention to break with tradition. Rather, he was out to destroy convention – an altogether different undertaking. This painting, more than any other work of European Modernism, is a wholly achieved analysis of the art of painting and of the nature of beauty in art.

Standing Man (two views)
Homme debout
Paris, 1907
Wood, carved and painted, 37 x 6 x 6 cm
Spies 20; Zervos II**, 656 and 657
Private collection

Standing Nude
Femme nue debout
Paris, 1907
Wood, carved and painted, 31.8 x 8 x 3 cm
Spies 17; Zervos II**, 667; MPP 236
Paris, Musée Picasso

Standing Nude
Femme nue debout
Paris, 1907
Wood, carved and painted, 35.2 x 12.2 x 12 cm
Spies 15; Zervos II**, 668; MPP 237
Paris, Musée Picasso

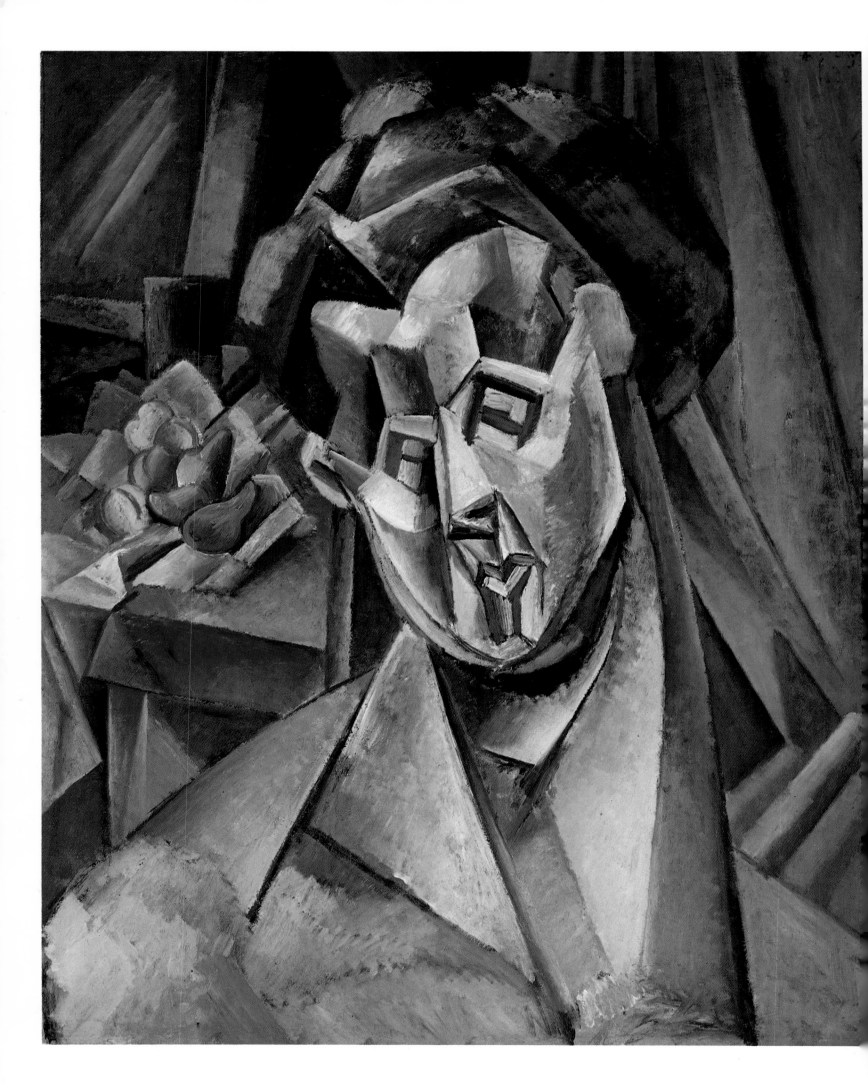

7 Analytical Cubism
1907–1912

Looking back on the history of modern art from today's perspective, it is difficult to conceive of the bewilderment "Les Demoiselles d'Avignon" occasioned among Picasso's contemporaries. One German critic, Wilhelm Uhde, thought it "Assyrian" in some way or other; Georges Braque felt it was as if a fire-eater had been drinking petrol; and Derain ventured that some day Picasso would hang himself behind his picture.[176] Comments such as these seem all the more incomprehensible in view of the importance the painting was soon to have: Cubism derived its formal idiom from it. Most emphatically there were two sides to the work's reception.

The contemporary verdict is illuminating. After all, it was not the opinion of the general public – Picasso kept the picture under wraps, so it was not widely seen till the 1920s and thus not widely subject to the opinion of the public.[177] The bewilderment came from art dealers, fellow artists and friends, all of them insiders with progressive, avant-garde views, surely the ideal receivers of work so profoundly innovative. Why were they so helpless and shocked? Because the painting really was utterly new, something that had never before been seen. And yet, like all things revolutionary, the "Demoiselles d'Avignon" signalled not only a new start but also the end of a long process of development.

Picasso had evolved a new form by examining the idiom that had prevailed in European art since the Renaissance, dismantling its rules, and re-applying its mechanisms. In doing so he transcended that idiom and – logically – the principles underlying it. This was his declared aim, and he succeeded in achieving it.

Picasso marked the end of a historical process that had begun in the mid–18th century. At that time, writers on aesthetics, thinkers such as Denis Diderot or Gotthold Ephraim Lessing, had scrutinized and re-defined the meaning and function of painting. Since the Renaissance, art had been of a functional, content-oriented nature, serving to convey messages in visual form. The imitation of Nature and the illusionistic reproduction of the appearance of things was a way of making the world comprehensible. Paintings could tell stories by showing narrative actions, representing emotions, and expressing the movements of the soul. The dichotomy

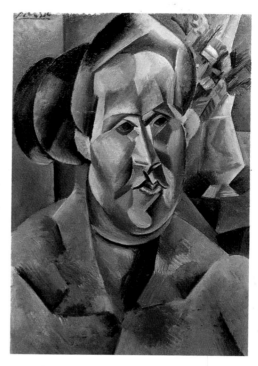

Bust of Fernande
Buste de femme au bouquet (Fernande)
Horta de Ebro, summer 1909
Oil on canvas, 61.8 x 42.8 cm
Zervos XXVI, 419; DR 288
Düsseldorf, Kunstsammlung
Nordrhein-Westfalen

Woman with Pears (Fernande)
Femme aux poires (Fernande)
Horta de Ebro, summer 1909
Oil on canvas, 92 x 73 cm
Zervos II*, 170; DR 290
New York, Private collection

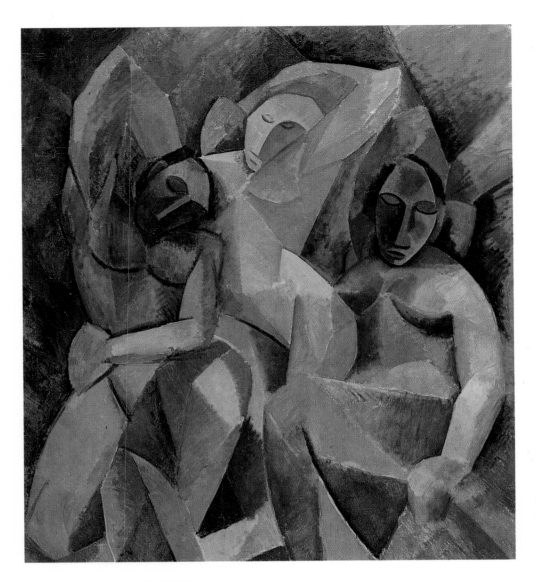

Three Women
Trois femmes
Paris, autumn 1907 to late 1908
Oil on canvas, 200 x 178 cm
Zervos II*, 108; DR 131
St. Petersburg, Hermitage

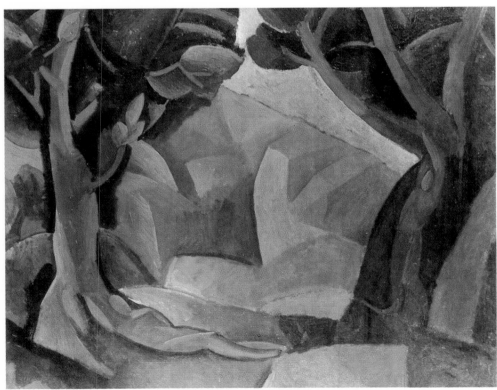

Landscape with Two Figures
Paysage aux deux figures
Paris, late 1908
Oil on canvas, 60 x 73 cm
Zervos II*, 79; DR 187; MPP 28
Paris, Musée Picasso

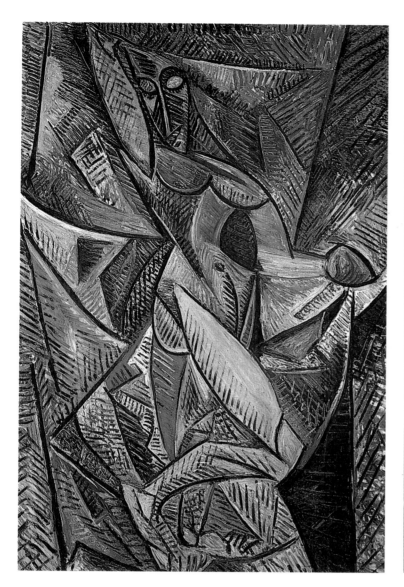

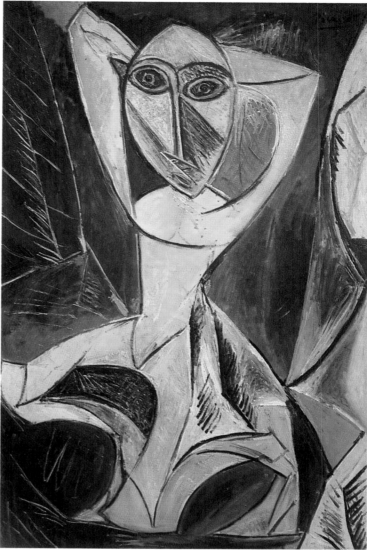

The Dance of the Veils (Nude with Drapes)
La danse aux voiles (Nu à la draperie)
Paris, summer 1907
Oil on canvas, 152 x 101 cm
Zervos II*, 47; DR 95
St. Petersburg, Hermitage

Nude with Raised Arms (The Dancer of Avignon)
Femme nue (La danseuse d'Avignon)
Paris, summer to autumn 1907
Oil on canvas, 150.3 x 100.3 cm
Zervos II*, 35; DR 53
Private collection

between given reality and imitation produced numerous possible ways of communication.[178] In the 18th century this changed significantly. The frontiers of painting were defined anew and it was stripped of its narrative side; now it could only represent.[179] It was not long before the representational function of painting was questioned too, since it was essentially an illusionist process dependent on purely technical and unreliable processes. The philosophy of Kant, Hegel and Schopenhauer prompted a recognition of the absolute aesthetic impact of painting and the autonomous status of draughtsmanship and colour.[180]

This was a fundamental change. Where once content and form, message and image had needed to harmonize, now form became dominant, and indeed became the content. If ways of seeing, conceptualization, and cognition were to be considered inseparable, then the cognitive content of painting must logically enough be purely a matter of how the observer looked at it.[181] Inevitably, once this view gained ground, painting would tend to lose its mimetic character and become detached from the things which it claimed to represent. French 19th-century art and the art of post-Romantic

northern Europe underwent a parallel move towards greater abstraction.[182]

That evolution peaked in Picasso's "Demoiselles". It is the key work of Modernist art. Of course Picasso had his precursors – but the Impressionists' colourful attempts to capture the fleeting moment, and the Fauves' orgiastic use of colour, essentially remained faithful to the principle of mimesis. Random changes of natural form and colour, such as the Impressionists and Fauves used in their different ways, were psychologically prompted, and aimed at establishing moods. The natural original which the painting represented remained unaffected. Deviations were merely shifts in expressive emphasis.

Cézanne was of greater significance for High Modernism, though. However, his deconstruction of the given, and his treatment of form and colour, were stylistically determined. His reduction of natural shapes to geometrical solids upheld the traditional technical repertoire of the academies. Still, Cézanne did show what an individualist approach could accomplish. And his work served as a vital point of reference in the turning-point year of 1907: a

Woman with a Fan (After the Ball)
Femme avec éventail (Après le bal)
Paris, late spring 1908
Oil on canvas, 152 x 101 cm
Zervos II*, 67; DR 168
St. Petersburg, Hermitage

Seated Woman
Femme nue assise
Paris, spring 1908
Oil on canvas, 150 x 99 cm
Zervos II*, 68; DR 169
St. Petersburg, Hermitage

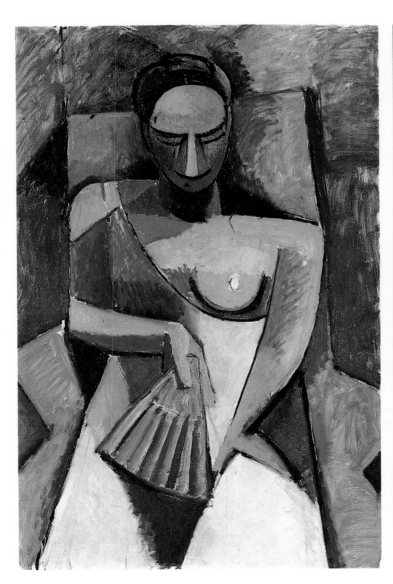

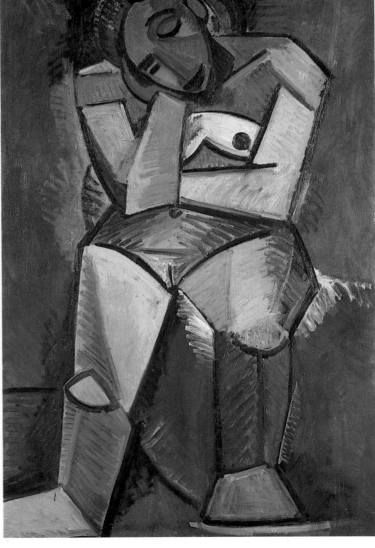

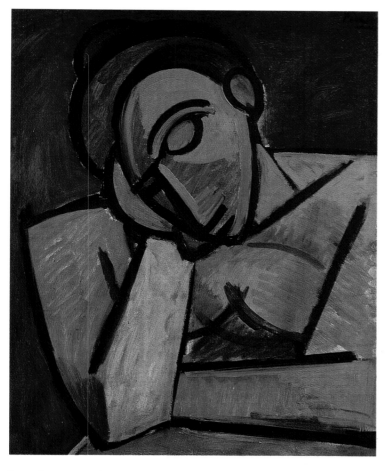

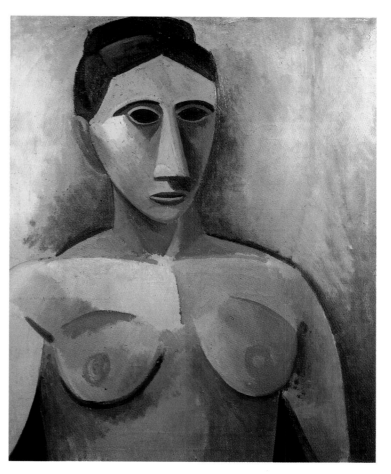

Bust of a Woman (Sleeping Woman)
Buste de femme accoudée (Femme dormante)
Paris, spring to summer 1908
Oil on canvas, 81.3 x 65.5 cm
Zervos XXVI, 303; DR 170
New York, The Museum of Modern Art

Bust of a Woman
Torse de femme
Paris, summer 1908
Oil on canvas, 73 x 60 cm
Zervos II*, 64; DR 134
Prague, Národni Gallery

direct line of evolution runs from his "Bathers" to Matisse's "Blue Nude" (Baltimore, Museum of Art), Derain's "Bathers" (New York, Museum of Modern Art), and finally the "Demoiselles d'Avignon" (all three of which were painted in 1907).[183] It is a telling fact that it was a painter academic in the cast of his thinking – Picasso – who created the formal approach of the new art.

Picasso started not from colour but from form and form alone. This too reflected his place in history. In the 19th century, scientists made important discoveries relating to the human organs and the principles of sense perception. The physiological independence of cognitive processes was established, and this legitimized aesthetic views on the subject and indeed provided artists with a new impetus.[184] Experiments in colour vision conducted by the Frenchmen Joseph Plateau and Eugène Chevreul in 1834 and 1839 influenced painters from Delacroix to Georges Seurat. Hermann Helmholtz's "Physiology of Optics" (1867) and Wilhelm Wundt's "Physiological Psychology" (1886) were widely available in the French translations.

The Parisian literary avant-garde liked to discuss the ideas on the spatial sense which William James, taking Helmholtz further, had

Standing Nude
Femme nue debout
Paris, spring 1908
Gouache on paper, 62 x 46 cm
Zervos XXVI, 286; DR 154
Otterlo, Rijksmuseum Kröller-Müller

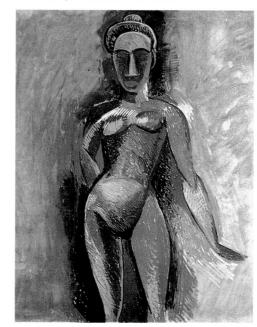

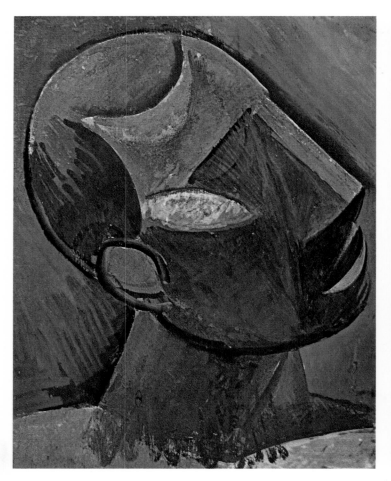
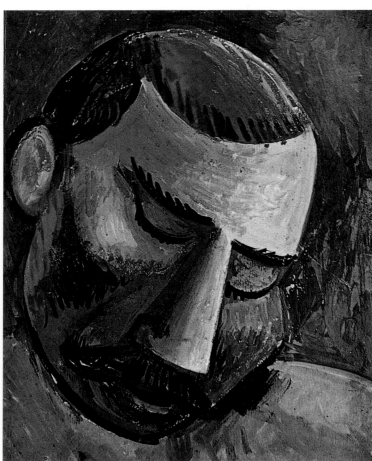
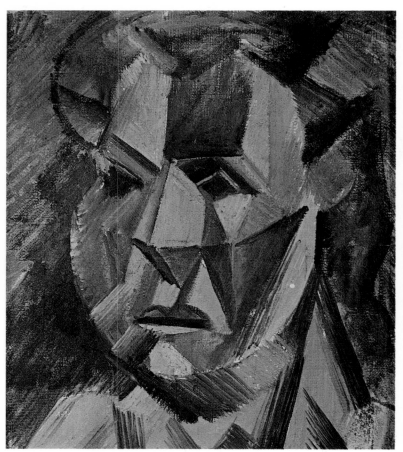
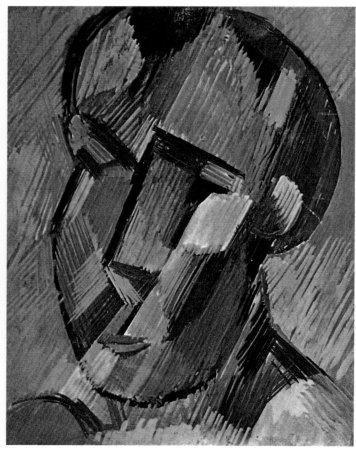

170 Analytical Cubism 1907 – 1912

Peasant Woman (Half-length)
La fermière (buste)
La Rue-des-Bois, August 1908
Oil on canvas, 81.2 x 65.3 cm
Zervos II*, 92; DR 194
St. Petersburg, Hermitage

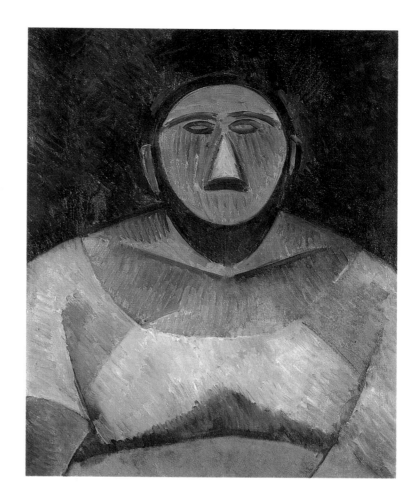

Above left:
Head of a Man
Tête d'homme
Paris, autumn 1908
Gouache on panel, 27 x 21.3 cm
Zervos XXVI, 394; DR 152; MPP 25
Paris, Musée Picasso

Head of a Man
Tête d'homme
Paris, autumn 1908
Gouache on panel, 27 x 21.3 cm
Zervos XXVI, 392; DR 153; MPP 26
Paris, Musée Picasso

Peasant Woman (Full-length)
La fermière en pied
La Rue-des-Bois, August 1908
Oil on canvas, 81.2 x 65.3 cm
Zervos II*, 91; DR 193
St. Petersburg, Hermitage

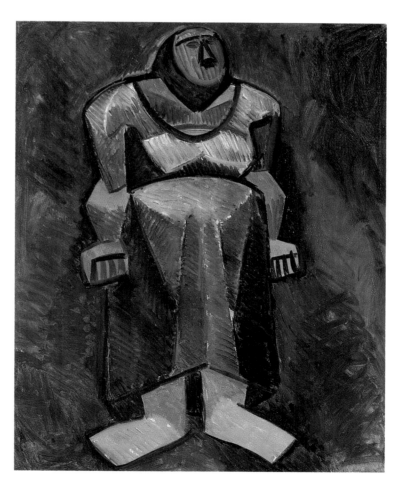

Below left:
Head of a Woman
Tête de femme
Paris, spring 1909 (?)
Oil on canvas, 25 x 22 cm
Not in Zervos; DR 252
Berlin, Nationalgalerie, Staatliche Museen
zu Berlin-Preußischer Kulturbesitz

Head of a Man
Tête d'homme
Paris, spring 1909
Gouache on panel, 27.1 x 21.3 cm
Zervos XXVI, 412; DR 251; MPP 29
Paris, Musée Picasso

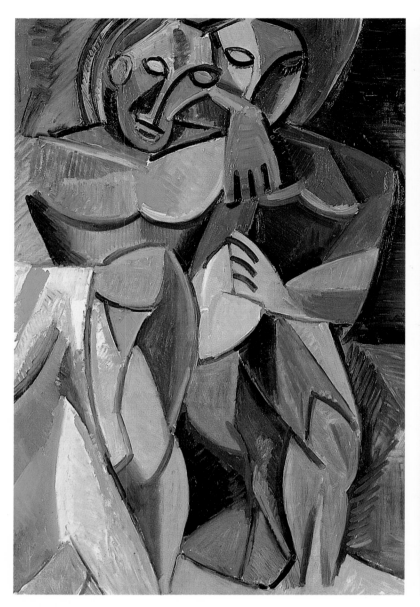

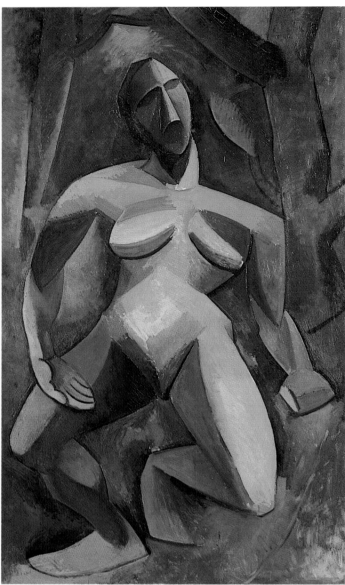

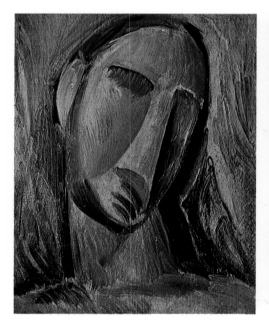

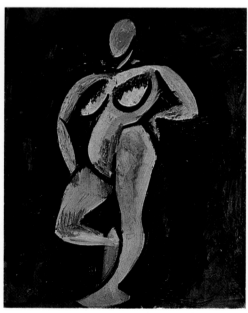

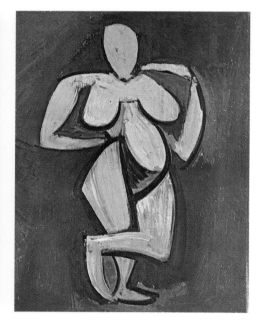

172 Analytical Cubism 1907 – 1912

Above left:
Friendship
L'amitié
Paris, winter 1907
Oil on canvas, 152 x 101 cm
Zervos II*, 60; DR 104
St. Petersburg, Hermitage

The Dryad (Nude in a Forest)
La dryade (Nu dans une forêt)
Paris, spring to autumn 1908
Oil on canvas, 185 x 108 cm
Zervos II*, 113; DR 133
St. Petersburg, Hermitage

Above right:
Seated Nude
Femme nue assise
Paris, winter 1908
Oil on canvas, 73 x 60 cm
Zervos II*, 118; DR 230
Houston (TX), Private collection

Below right:
Bathers
Baignade
Paris, spring 1908
Oil on canvas, 38 x 62.5 cm
Zervos II*, 93; DR 184
St. Petersburg, Hermitage

Below left:
Head of a Woman
Tête de femme
Paris, early 1908
Gouache on panel, 27 x 21 cm
Zervos XXVI, 393; DR 140
Estate of the artist

Standing Nude
Femme nue debout
Paris, spring 1908
Oil on panel, 27 x 21.2 cm
Zervos XXVI, 365; DR 157; MPP 23
Paris, Musée Picasso

Standing Nude
Femme nue debout tournée vers la droite
Paris, spring 1908
Gouache on panel, 27 x 21 cm
Zervos XXVI, 366; DR 158
Estate of the artist

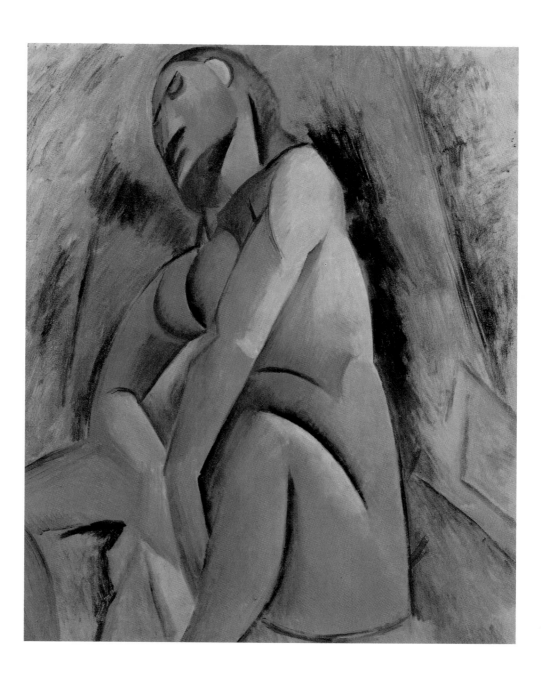

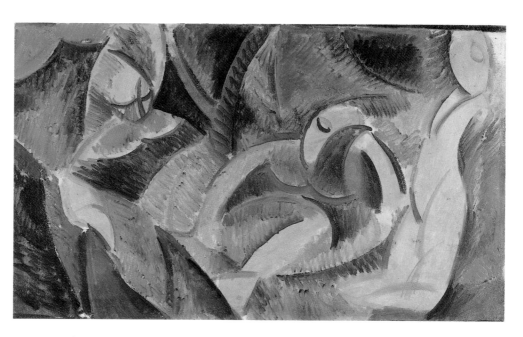

173 Analytical Cubism 1907 – 1912

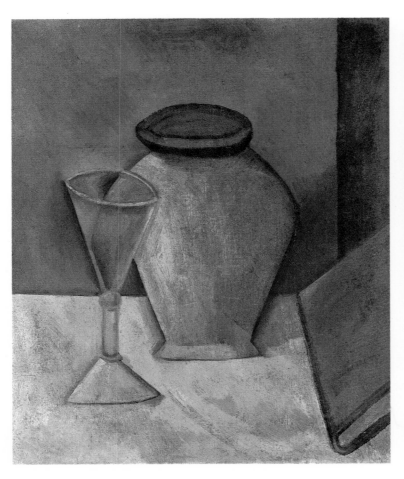

Green Bowl and Black Bottle
Bol vert et flacon noir
Paris, spring to summer 1908
Oil on canvas, 61 x 51 cm
Zervos II*, 89; DR 173
St. Petersburg, Hermitage

Below right:
Still Life with Fishes and Bottles
Nature morte avec poissons et bouteilles
Paris, early 1909
Oil on canvas, 73 x 60 cm
Zervos II*, 122; DR 213
Paris, Private collection

**Bowl of Fruit and Wine Glass
(Still Life with Bowl of Fruit)**
Compotier, fruits et verre
(Nature morte au compotier)
Paris, late 1908
Oil on canvas, 92 x 72.5 cm
Zervos II*, 124; DR 209
St. Petersburg, Hermitage

**Flowers in a Grey Jug and Wine Glass
with Spoon**
Bouquet de fleurs dans un pot gris
et verre avec cuillère
La Rue-des-Bois, August 1908
Oil on canvas, 81 x 65 cm
Zervos II*, 88; DR 196
St. Petersburg, Hermitage

Above left:
Pot, Wine Glass and Book
Pot, verre et livre
Paris, August to September 1908
Oil on canvas, 55 x 46 cm
Zervos II*, 87; DR 198
St. Petersburg, Hermitage

Pitcher and Three Bowls
Carafe et trois bols
Paris, summer 1908
Oil on cardboard, 66 x 50.5 cm
Zervos II*, 90; DR 176
St. Petersburg, Hermitage

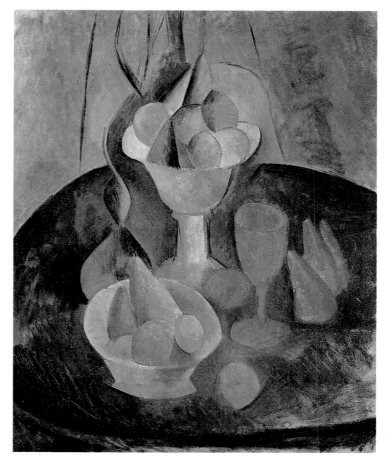

Analytical Cubism 1907 – 1912 **175**

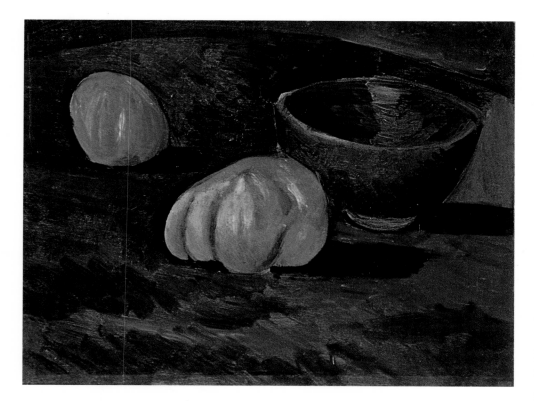

Green Bowl and Tomatoes
Bol vert et tomates
Paris, spring to summer 1908
Gouache on panel, 21 x 27 cm
Zervos XXVI, 362; DR 175
Estate of the artist

Above right:
Landscape
Paysage
La Rue-des-Bois, August 1908
(or Paris, July 1908)
Watercolour and gouache on paper,
64 x 49.5 cm
Zervos XXVI, 174; DR 183
Bern, Kunstmuseum Bern,
Hermann and Margrit Rupf Foundation

House in a Garden (House and Trees)
Maisonnette dans un jardin (Maisonnette et arbres)
La Rue-des-Bois, August 1908
(or Paris, winter 1908)
Oil on canvas, 92 x 73 cm
Zervos II*, 81; DR 190
Moscow, Pushkin Museum

expressed in his "Principles of Psychology" (1890). The book did not offer Picasso any direct inspiration to revise figurational procedures, and indeed he would have found little more in the physiological mechanics described than techniques of formal figuration which he had long been familiar with through drawing.[185] Still, these publications hallmarked the spirit of the age. It was a period when an artist might be in a position to rethink first principles. This was also true of the discovery of unfamiliar modes of expression – the contemporary enthusiasm for what was considered primitive or exotic art. We need only recall the influence Japanese woodcuts had on van Gogh and Toulouse-Lautrec, and the interest in archaic art which Picasso himself had recently demonstrated. This all resulted from the quest for new ways of creating visual images, traditional methods no longer seeming adequate to the needs of the age.[186] There is nothing more indicative of his contemporaries' helplessness, and their way of clinging to newly-established conventions, than the terms that were applied to Picasso's painting. To Uhde the "Demoiselles" seemed "Assyrian", and Henri ("Le Douanier") Rousseau, prized for his naive art, said Picasso's Cubism was "Egyptian". The inapt supposition that the new visual idiom drew on black, African art – though this did play some part for the Cubists later – was a product of this way of thinking too.[187] Of course Picasso saw it all, and was prompted to find a basic solution to the problem. He drew till he had devised a new formal language, which he then articulated in "Les Demoiselles d'Avignon" – showing how the old could be re-used to make something altogether new. If they were perplexed at first, his fellow artists soon understood what he was doing. Cubism became established, slowly but

Landscape
Paysage
La Rue-des-Bois, August 1908
(or Paris, September 1908)
Oil on canvas, 73 x 60 cm
Zervos II*, 82; DR 192
Private collection

House in the Garden
Maisonnette dans un jardin
La Rue-des-Bois, August 1908
Oil on canvas, 73 x 61 cm
Zervos II*, 80; DR 189
St. Petersburg, Hermitage

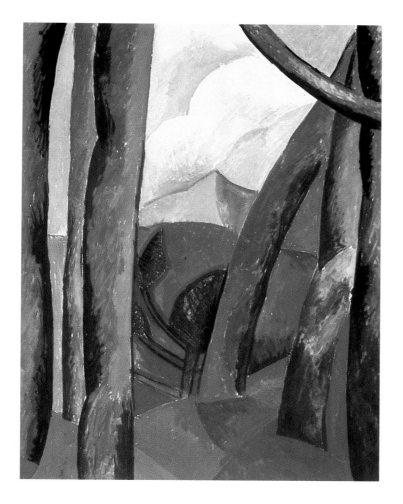

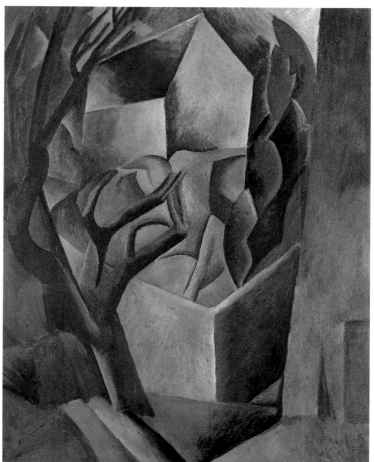

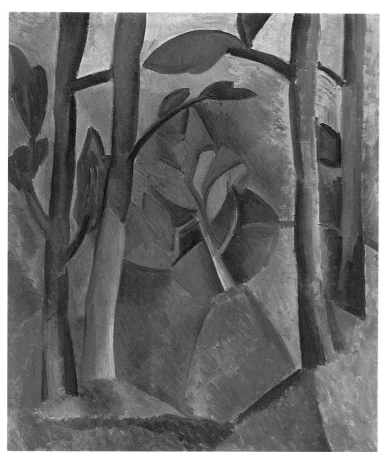

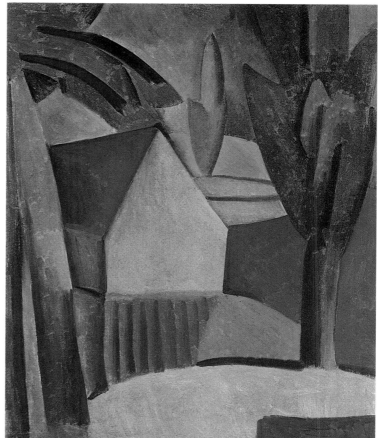

Analytical Cubism 1907 – 1912 **177**

surely: the first major peak that it reached is generally known as Analytical Cubism.

Picasso's famous portrait of art dealer Ambroise Vollard is an arresting example (p. 189). Amidst the complex criss-cross of lines and overlapping colour zones we are immediately struck by the head. It is done entirely in shades of yellow; and it also strikes us because, unlike the composition as a whole, it clearly represents the outline, structure and features of a human head. The oval broadens at the jowls. About the middle there are lines to denote eyebrows and the bridge of the nose. At right and left, narrow patches of white clearly indicate sideburns. We see the face of a man with a high, commanding forehead and a short beard already grey at the sides – a somewhat older man, presumably. The central lines delineate a strong, straight nose with a noticeable dent and broad nostrils. The thin upper lip also conveys the sitter's personality.

Picasso's painting fulfils the main requirements of a portrait: it represents the outer appearance of a certain individual in a recognisable way. But the artist is also displaying his skill at playing with the natural image. The lines are continued at random, no longer restricted to defining an available form. They have a life of their own. So do the colours: lighter and darker shades, with little regard for the subject, obey the curious rules of the composition instead. The subject is dissected, as it were, or analyzed. And hence this kind of Cubism has become known as "Analytical Cubism".[188]

Though the laws of the random afford common ground, the portrait of Vollard remains a distinctly different work from "Les Demoiselles d'Avignon". In the 1907 painting the aim was closed form; in the 1910 work it is open figuration. The dissolution of the subject establishes a kind of grid in which overlaps and correspondences can constantly be read anew. The essential characteristics of the subject are preserved purely because Picasso is out to demon-

Study for "Carnival at the Bistro"
Etude pour "Carnaval au bistrot"
Paris, winter 1908
Gouache on paper, 32 x 49.5 cm
Zervos VI, 1074; DR 219
Estate of the artist

Study for "Carnival at the Bistro"
Etude pour "Carnaval au bistrot"
Paris, winter 1908
Pencil on paper, 31.3 x 23.8 cm
Zervos VI, 1067; MPP 622
Paris, Musée Picasso

Study for "Carnival at the Bistro"
Etude pour "Carnaval au bistrot"
Paris, winter 1908
Watercolour and pencil on paper, 24.2 x 27.5 cm
Zervos VI, 1066; DR 217
Estate of the artist

Loaves and Bowl of Fruit on a Table
Pains et compotier aux fruits sur une table
Paris, winter 1908
Oil on canvas, 164 x 132.5 cm
Zervos II*, 134; DR 220
Basel, Öffentliche Kunstsammlung Basel,
Kunstmuseum

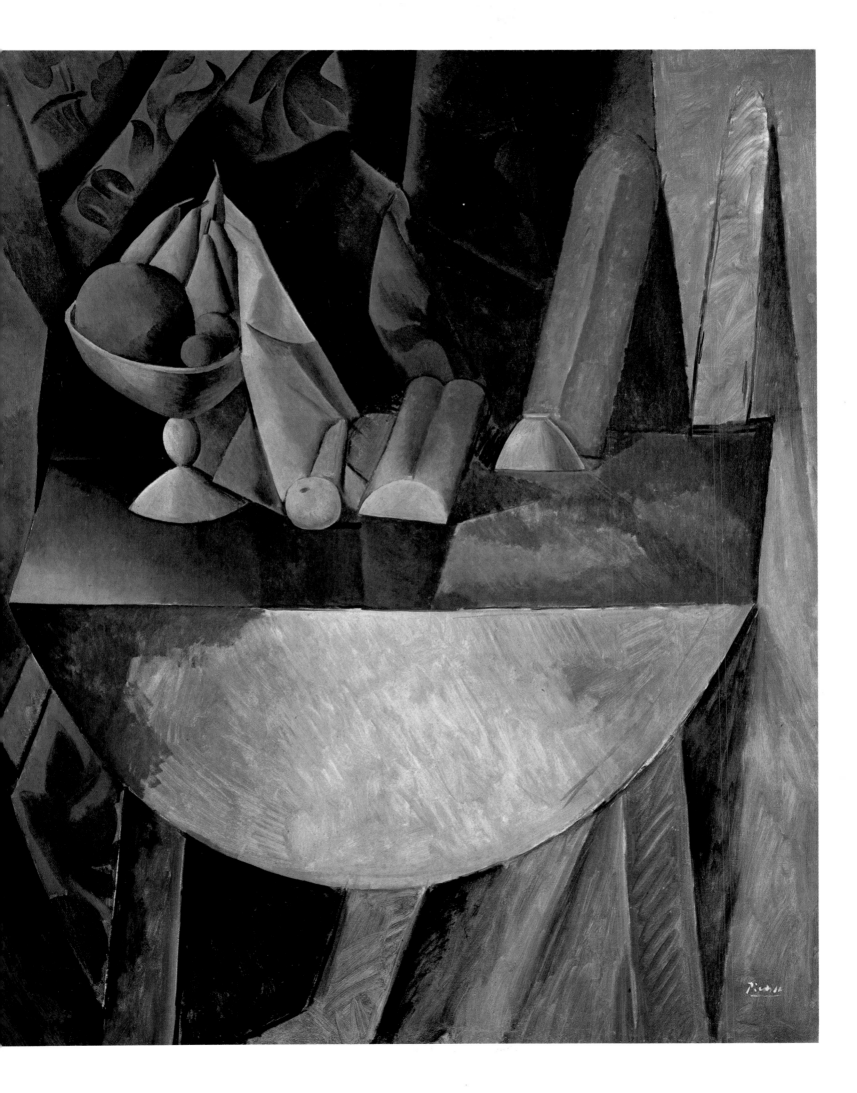

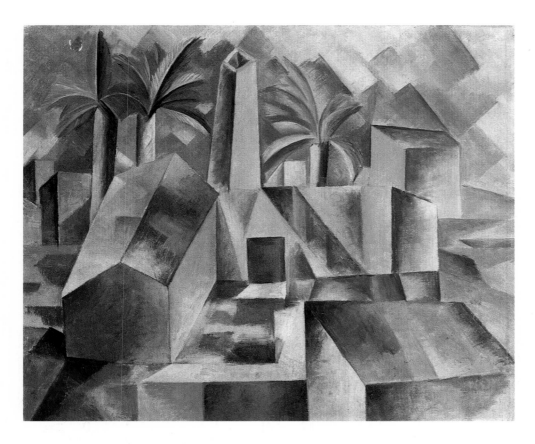

**Brick Factory in Tortosa
(Factory at Horta de Ebro)**
Briqueterie à Tortosa (L'usine)
Horta de Ebro, summer 1909
Oil on canvas, 50.7 x 60.2 cm
Zervos II*, 158; DR 279
St. Petersburg, Hermitage

strate that the autonomy of line and colour is on a par with straightforward representation, and just as convincing aesthetically. His new approach put an end to the traditional scheme of foreground, middleground and background, and the demarcation of subject and setting, which were still present in the "Demoiselles". Between the two extremes lay a three-year transitional period. It began in 1908 and can be seen as the phase in which Cubism was established.

The first works to follow the "Demoiselles" highlighted the draughtsmanship and the correspondence of subject and background. Colour and line were juxtaposed or at times contraposed, as in the famous "The Dance of the Veils (Nude with Drapes)" (p. 167). Picasso's 1908 "Composition with a Skull" (p. 15) must be seen as a continuation of this line. But in the two great nudes that he worked on from spring to autumn 1908 the emphases were clearly being placed differently. In both "Three Women" (p. 166) and "The Dryad (Nude in a Forest)" (p. 172) the draughtsman's lines are no longer so independent of the subject. Now, the lines and colour zones are creating shapes of geometrical import. But the perspective has been exploded, so that various points of view are at work in the same composition. The light and shade are not juxtaposed in a spatial relation; yet spaces and areas derived from the construction of form evolve a spatial presence.

In midsummer 1908 Picasso made a breakthrough with his landscapes. "House in a Garden (House and Trees)" and the simply-titled "Landscape" (both p. 177) take the principle of autonomous

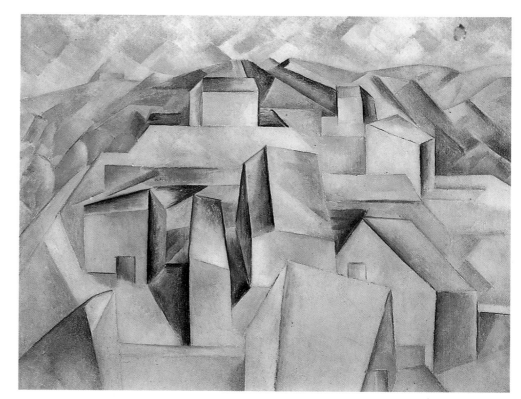

Houses on the Hill (Horta de Ebro)
Maisons sur la colline (Horta de Ebro)
Horta de Ebro, summer 1909
Oil on canvas, 65 x 81 cm
Zervos II*, 161; DR 278
New York, The Museum of Modern Art

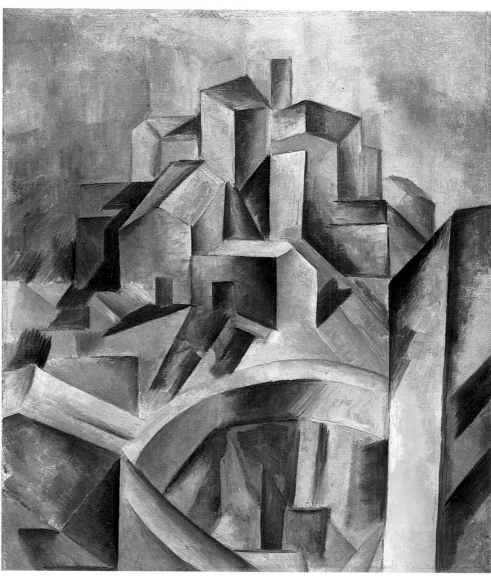

The Reservoir (Horta de Ebro)
Le réservoir (Horta de Ebro)
Horta de Ebro, summer 1909
Oil on canvas, 60.3 x 50.1 cm
Zervos II*, 157; DR 280
New York, Mr. and Mrs. David Rockefeller
Collection

181 Analytical Cubism 1907 – 1912

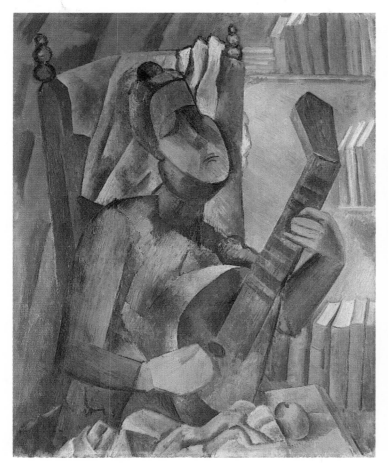

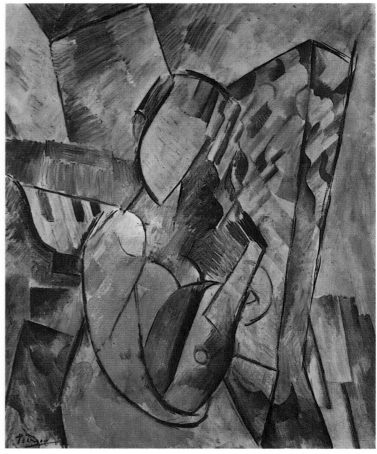

Two Nudes
Deux figures nues
Paris, 1909
Etching, 13 x 11 cm
Bloch 17; Geiser 21 III b

spatial values and evolve forms that make a stereometrically stylized impression. At the same time, the young French painter Braque had arrived at a similar position. He had met Picasso in spring 1907, and had seen "Les Demoiselles d'Avignon" at Picasso's studio that November. Though it startled him at first, the painting's impact stayed with him, and mingled with ideas derived from Cézanne. During two stays in southern France in summer 1908, painting the landscape near L'Estaque, Braque deconstructed representational and spatial values. The fundamental coincidence of his approach and that in Picasso's landscapes is arresting. But they were working independently of each other, with no direct contact.

At first glance, the motifs look like cubes – which is why the term "Cubism" was coined in the first place. In autumn 1908, Braque unsuccessfully submitted his new work for the Paris autumn Salon. Matisse, who was a member of the jury, observed to the critic Louis Vauxcelles that the pictures consisted of lots of little cubes. Vauxcelles adopted the phrase in a review he wrote in the magazine "Gil Blas" when Braque showed the paintings at the Kahnweiler gallery in November. And thus (as is so often the case) a misunderstanding produced a label; and by 1911 everyone was using the term "Cubism".[189]

In the winter of 1908, following Braque's exhibition, Picasso and Braque developed a give-and-take that often verged on collabora-

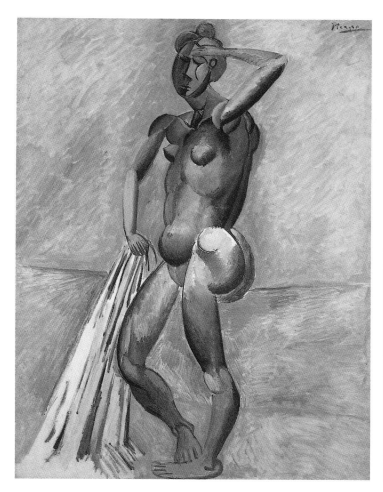
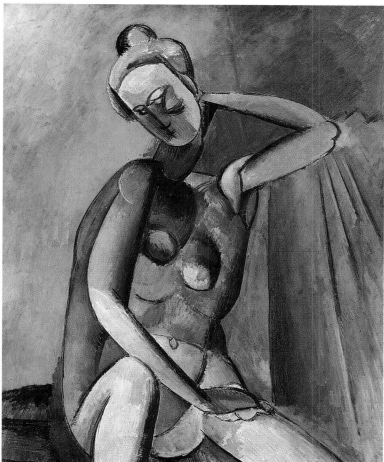

tion. The Spaniard's misgivings about the Frenchman vanished. (That spring he was still accusing Braque of pirating his inventions without making any acknowledgement.)[190] They did not share a studio, though; both artists worked resolutely on their own. But they did meet constantly to discuss their progress and learn from each other. They took trips – Picasso to Spain in 1909 and 1910, Braque twice to La Roche-Guyon in the Seine valley. Not till summer 1911 did they spend time together in Céret in the south of France, a popular artists' colony. They compared the fruits of their labours and debated new possibilities, often in a competitive spirit. Thus, for instance, Picasso's "Girl with a Mandolin (Fanny Tellier)" (p. 186) is plainly a response to a painting by Braque.[191] Both artists – and this is unique in the history of art – were developing a new style together. It was emphatically a give-and-take process: both artists have the same standing in the history of Cubism. The painstaking Braque, a slow worker, painted extraordinarily subtle works incomparable in their aesthetic effect. By contrast, Picasso was more restless and abrupt, jumping to and fro amongst various formal options. Both were experimenting in their own way, and both, independently, hit upon significant innovations. For Picasso, drawing and the investigation of form were always the focus of his interest.

One of the finest and most instructive of his games played with

Woman with a Mandolin
Femme à la mandoline
Paris, winter 1908
Oil on canvas, 91 x 72.5 cm
Zervos II*, 133; DR 236
St. Petersburg, Hermitage

Woman with a Mandolin
Femme à la mandoline
Paris, spring 1909
Oil on canvas, 100 x 81 cm
Zervos II*, 115; DR 271
Düsseldorf, Kunstsammlung
Nordrhein-Westfalen

Bather
Baigneuse
Paris, (early) 1909
Oil on canvas, 130 x 97 cm
Zervos II*, 111; DR 239
New York, Mrs. Bertram Smith Collection

Nude
Femme nue
Paris, early 1909
Oil on canvas, 100 x 81 cm
Zervos II*, 109; DR 240
St. Petersburg, Hermitage

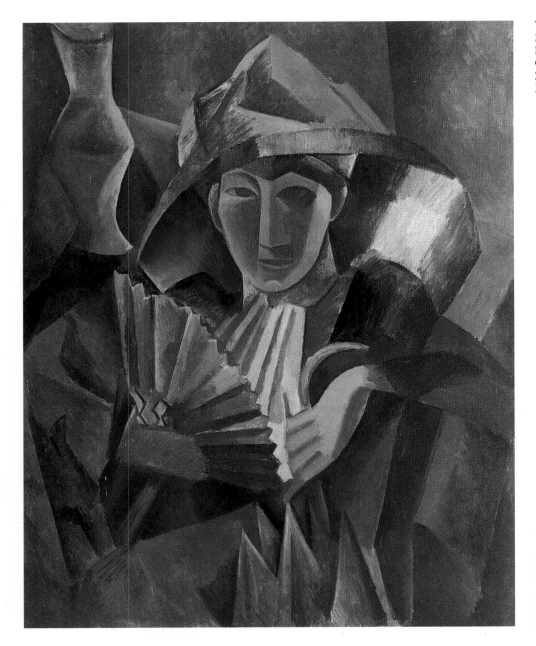

Woman with Fan
La femme à l'éventail
Paris, early spring 1909
Oil on canvas, 101 x 81 cm
Zervos II*, 137; DR 263
Moscow, Pushkin Museum

Head of a Woman (Fernande)
Tête de femme (Fernande)
Paris, autumn 1909
Bronze, 40.5 x 23 x 26 cm
Spies 24 II; Zervos II**, 573; MPP 243
Paris, Musée Picasso

form is the still life "Loaves and Bowl of Fruit on a Table" (p. 179), painted in winter 1908/09, a drop-leaf table with loaves of bread, a cloth, a bowl of fruit and a lemon on it. The informing principle is not one of Cubist transformation, though, so much as a genuine metamorphosis – for the picture began by showing not objects in a still life but carnival merry-makers in a bistro! Picasso pursued his idea through a number of studies. The first showed a flat-perspective group of six at a drop-leaf table.[192] Subsequently he interwove the forms so as to blur the distinction between the subject and the background. His most conspicuous stylistic feature was the spatial extension of lines to include the figures in a veritable scaffolding of major diagonals and curves that dominated the entire picture. In other sketches (p. 178) he bunched lines together, and made visible progress in the deconstruction of form. The motifs and directional movements assembled into geometrical figures – trapeziums, rhombuses – which, taken individually, had already

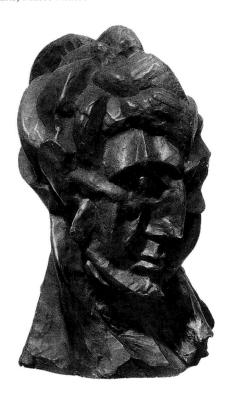

Analytical Cubism 1907 – 1912 **184**

Queen Isabella
La reine Isabeau
Paris, winter 1908
Oil on canvas, 92 x 73 cm
Zervos II*, 136; DR 222
Moscow, Pushkin Museum

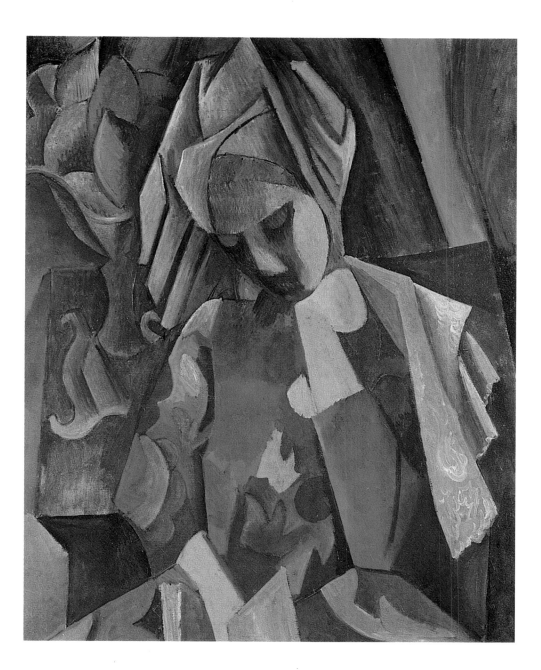

Study for "Fernande"
Etude pour "Fernande"
Horta de Ebro, summer 1909
Charcoal and pencil on paper, 63.2 x 48 cm
Zervos XXVI, 417; MPP 641
Paris, Musée Picasso

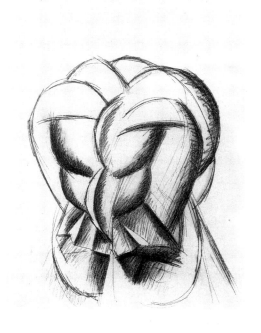

become completely non-representational. Light and shadow like-wise acquired a life of their own, appearing in contrastive shades of lighter and darker.

At this stage, Picasso had put mimesis aside and was free to define his forms anew. As he went on, formal similarities remained – though we would not perceive them if we did not have the prelimi-nary studies. Thus the man's left arm propped on the table became a baguette, and his right arm became another, while the hand he was resting on the table became an upturned cup with no handle. The loaf in mid-table, cut into, was formerly the left forearm of a harlequin. The bust of the woman seated at left became the fruit bowl. These metamorphoses occurred in the smallest details; X-ray examination has shown that Picasso accomplished this fundamen-tal transformation of what was once a figure composition in one bout of work on the canvas.

With such rethinking of visual possibilities in his mind, Picasso,

185 Analytical Cubism 1907 – 1912

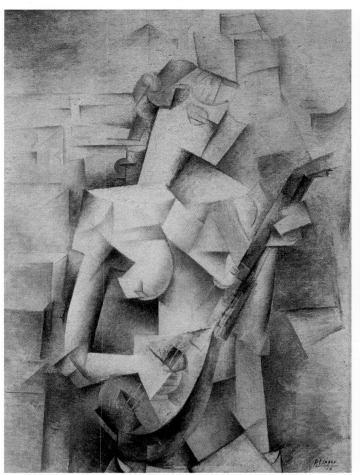
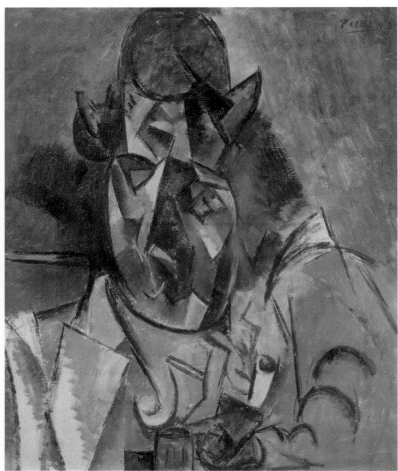
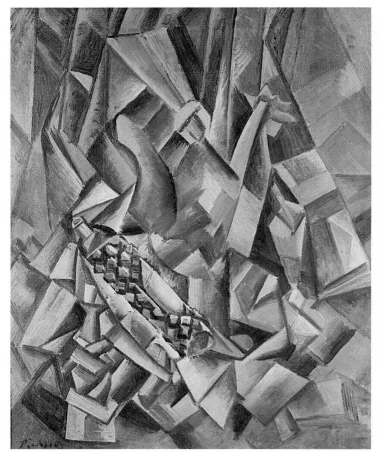
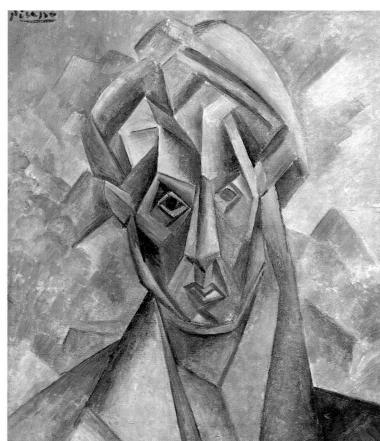

186 Analytical Cubism 1907 – 1912

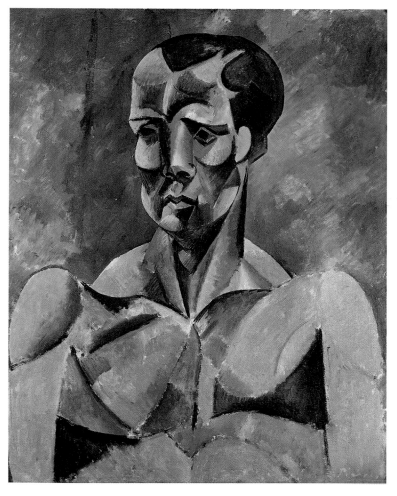

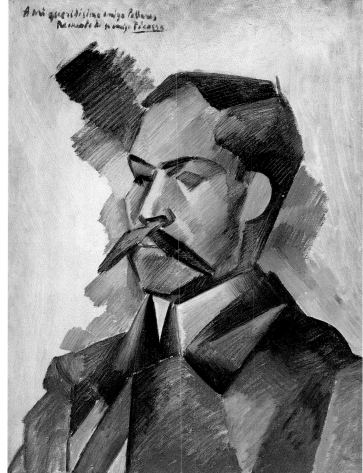

Bust of a Man (The Athlete)
Horta de Ebro, summer 1909
Oil on canvas, 92 x 73 cm
Zervos II*, 166; DR 297
São Paulo, Museu de Arte

Portrait of Manuel Pallarés
Barcelona, May 1909
Oil on canvas, 68 x 49.5 cm
Zervos XXVI, 425; DR 274
Detroit (MI), The Detroit Institute of Arts

Page 186 top:
Girl with a Mandolin (Fanny Tellier)
Jeune fille à la mandoline (Fanny Tellier)
Paris, late spring 1910
Oil on canvas, 100.3 x 73.6 cm
Zervos II*, 235; DR 346
New York, The Museum of Modern Art,
Nelson A. Rockefeller Bequest

Portrait of Georges Braque (?)
Paris, winter 1909. Oil on canvas,
61 x 50 cm. Zervos II*, 177; DR 330
Geneva, Heinz Berggruen Collection

Page 186 bottom:
Still Life with Aniseed Brandy Bottle
Nature morte à la bouteille d'anis del Mono
Horta de Ebro, August 1909
Oil on canvas, 81.6 x 65.4 cm
Zervos II*, 173; DR 299
New York, The Museum of Modern Art

Head of a Woman against Mountains
Tête de femme sur fond de montagnes
Horta de Ebro, summer 1909
Oil on canvas, 65 x 54.5 cm
Zervos II*, 169; DR 294. Frankfurt am Main,
Städelsches Kunstinstitut und Städtische Galerie

prompted by the southern light when he was in Spain during 1909, created pictures that approached perspective and optics as an interweaving of geometrical shapes and colour tonalities. Eloquent examples are "The Reservoir (Horta de Ebro)", "Houses on the Hill" and "Brick Factory in Tortosa" (pp. 180 and 181).

It is characteristic of Picasso (and a contrast to Braque) that he never saw Cubism purely in terms of painting. He tackled spatial values and planes in various media, using various motifs. Braque at that time restricted himself to relatively few kinds of picture, preferring those such as landscapes or still lifes that were conducive to abstracted formal games, and in his work he experimented with the manifold opportunities that monochrome painting afforded. Picasso, for his part, stuck to his usual repertoire of subjects. He tried to introduce them into his new experiments, and did not flinch from strong colour contrasts. Thus in 1909 he did a number of portraits that explored the analytic breakdown of form (cf. pp. 164 and 165). The areas of the human face defined by the placing of nose, mouth, cheeks, forehead and eyes, and resolved by light and shadow, were now a fabric of juxtaposed planes. And, as in 1906,

187 Analytical Cubism 1907–1912

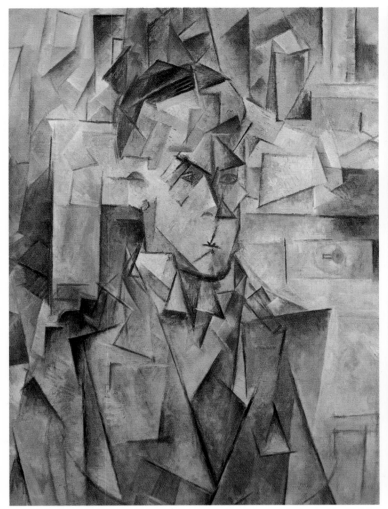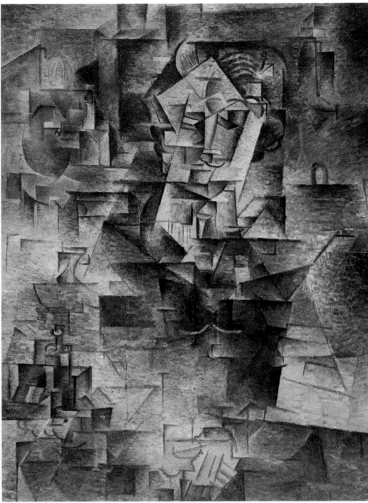

Picasso went into questions of volume in sculpture, to see if they too had autonomous values. In preparing the near-lifesize "Head of a Woman (Fernande)", a portrait of Fernande Olivier (p. 184), Picasso made his experiment using plaster; a small edition was later cast in bronze for Vollard.

In this sculpture, three-dimensional volume appears to be made of particles roughly equal in size. The ruling structural principle is an equilibrium of volume and emptiness. The most important points – the eye sockets, nose, lips – are done in accordance with their natural appearance. But in the forehead, cheeks and neck the natural lie of the features has been inverted – most noticeably in the neck and nape – so that a new rhythmic sense arises that introduces dynamics to the work.

Picasso used the same procedure in the three portraits of his dealers, the Germans Kahnweiler and Uhde and the Frenchman Vollard (above and right), painted in 1910. He did so in a way adapted to painting, by dissecting the space and fragmenting the image. This is the apogee of a line he had been following through a number of pictures in 1909, most doggedly in "Still Life with Aniseed Brandy Bottle" (p. 186). It says a lot for the non-representational autonomy of form in this work that for many years its

Portrait of Wilhelm Uhde
Portrait de Wilhelm Uhde
Paris, spring (to autumn) 1910
Oil on canvas, 81 x 60 cm
Zervos II*, 217; DR 338
Saint Louis (MO),
Joseph Pulitzer Jr. Collection

Portrait of Daniel-Henry Kahnweiler
Portrait de Daniel-Henry Kahnweiler
Paris, autumn to winter 1910
Oil on canvas, 100.6 x 72.8 cm
Zervos II*, 227; DR 368
Chicago (IL), The Art Institute of Chicago

Portrait of Ambroise Vollard
Portrait d'Ambroise Vollard
Paris, spring (to autumn) 1910
Oil on canvas, 93 x 66 cm
Zervos II*, 214; DR 337
Moscow, Pushkin Museum

Analytical Cubism 1907 – 1912 **188**

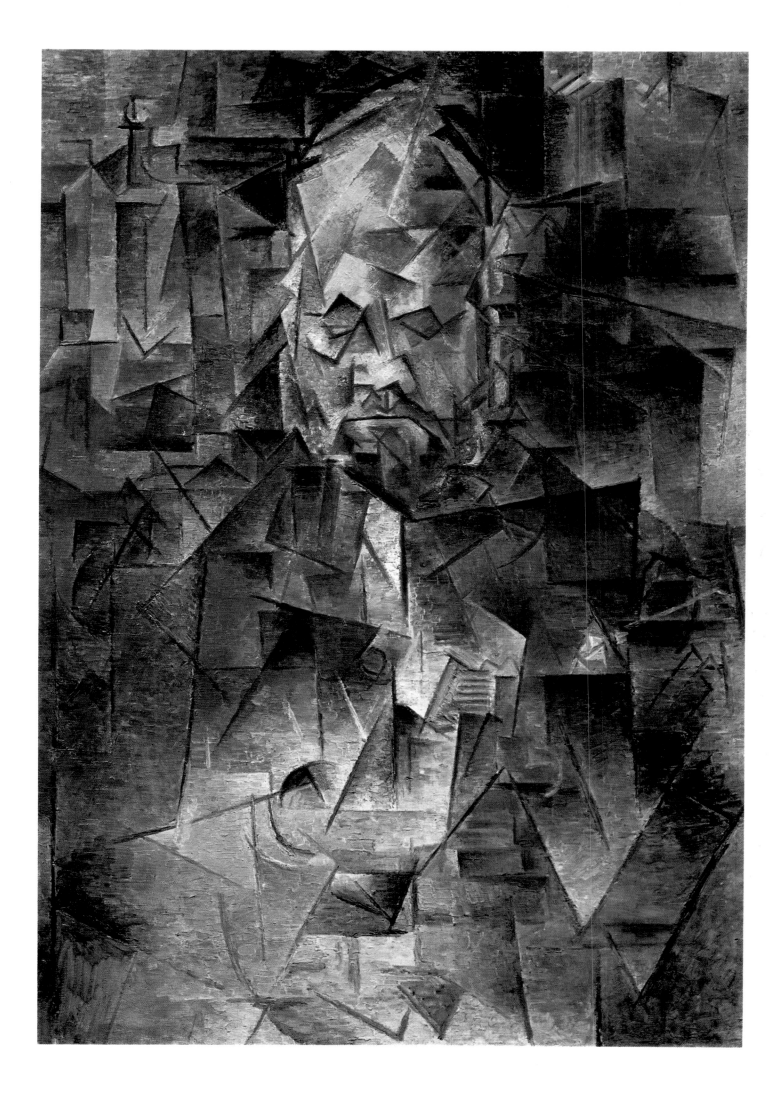

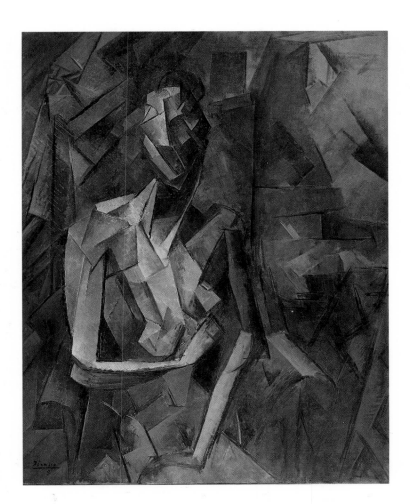

Seated Nude
Femme nue assise
Paris, spring 1910
Oil on canvas, 92 x 73 cm
Zervos II*, 201; DR 343
London, Tate Gallery

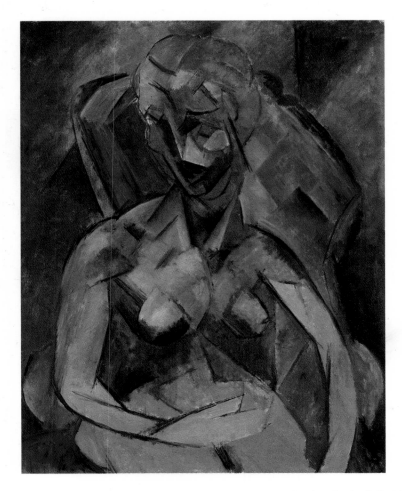

Seated Nude in an Armchair
Femme nue assise dans un fauteuil
Paris, winter 1909
Oil on canvas, 91 x 71.5 cm
Zervos II*, 195; DR 332
St. Petersburg, Hermitage

Seated Woman in an Armchair
Femme assise dans un fauteuil
Paris, spring 1910
Oil on canvas, 94 x 75 cm
Zervos II*, 213; DR 344
Prague, Národni Gallery

190 Analytical Cubism 1907 – 1912

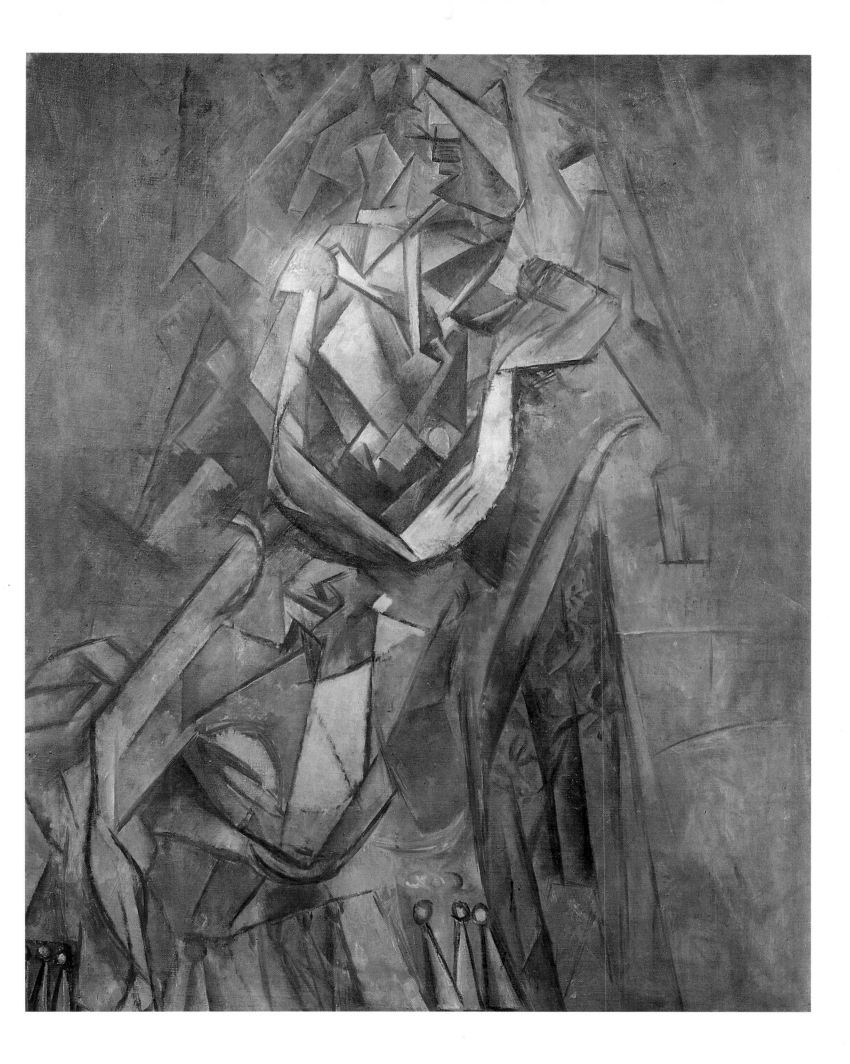

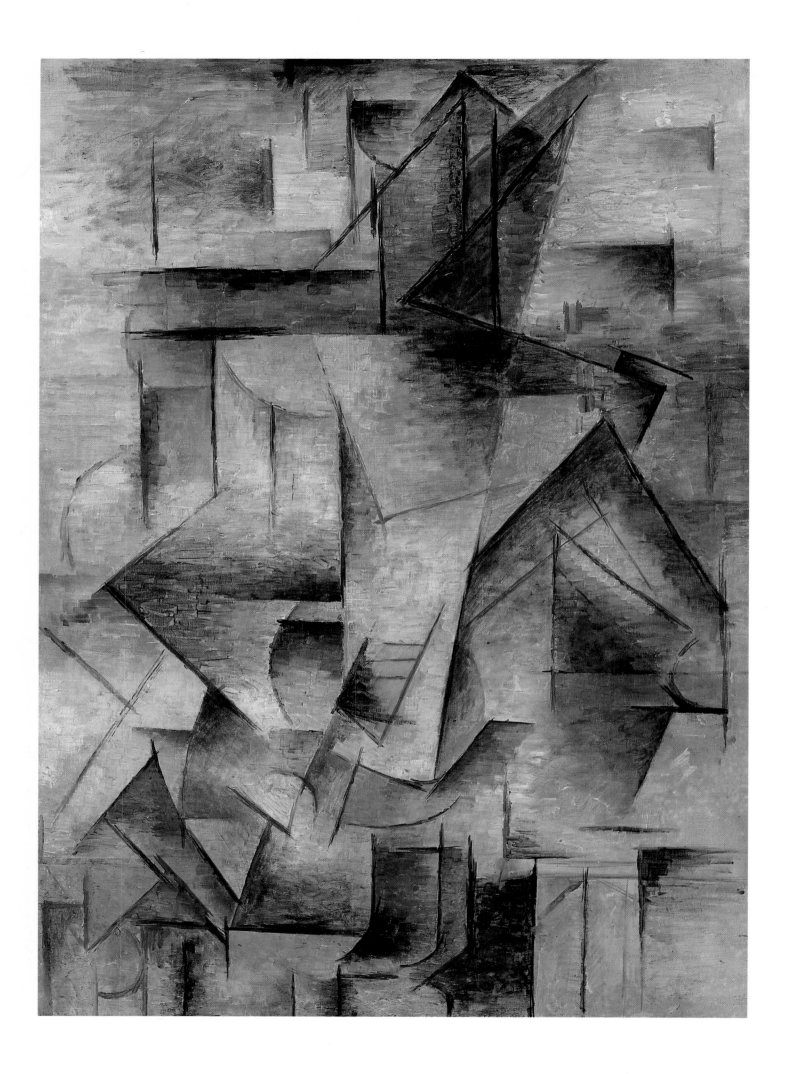

Left:
The Guitar Player
Le joueur de guitare
Cadaqués, summer 1910
Oil on canvas, 100 x 73 cm
Zervos II*, 223; DR 362
Paris, Musée National d'Art Moderne,
Centre Georges Pompidou

Still Life with Bottle of Rum
La bouteille de rhum
Céret, summer 1911
Oil on canvas, 60.3 x 48.8 cm
Zervos II*, 267; DR 414
Mexico City, Jacques and Natasha
Gelman Collection

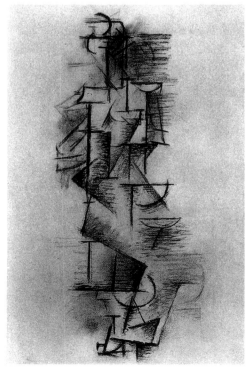

Man with a Moustache and a Clarinet
Homme moustachu à la clarinette
Céret and Paris, summer to autumn 1911
Ink, India ink and black chalk,
30.8 x 19.5 cm
Zervos XXVIII, 48; MPP 659
Paris, Musée Picasso

Standing Nude
Femme nue debout
Paris, autumn 1910
Charcoal on paper, 48.3 x 31.2 cm
Zervos II*, 208
New York, The Metropolitan Museum of Art

193 Analytical Cubism 1907 – 1912

subject was misinterpreted.[193] In the middle is a bottle of aniseed brandy. The translucent, reflective glass offered the artist a teasing visual surface, especially because of the fluting. In every painting, this analytic deconstruction of form inevitably led to the presence of non-representational elements; and this led Picasso and Braque to scrutinize the function of drawing and of signs.

The line outlines the object and establishes a visual sign. In a Cubist picture, though, this mimetic function is dissolved. Picasso and Braque now extended the scope of signs in pictures, and alongside representational images they included symbols and juxtaposed colourful structures without content. It was a new approach to a problem long familiar to painters, and the Cubists found new solutions. Titian and Velázquez had drawn strength from the combination of mimetic representation, in line and colour, and the sheer virtuosity of the artist's craft – a combination which accounts for much of their appeal to us today. In 1910, Picasso and Braque took the strategy to the borders of pure abstraction. Paintings such as "The Guitar Player" (p. 192) or "The Clarinet" (p. 196), compositions of great artistic charm, clearly demonstrate that beauty in art need not be pinned down to illusionist representation.

Cubism now entered a somewhat different phase, one that was heralded in 1911 and led the following year to new visual forms different in structure and principle. Braque, who had already used

Woman with a Guitar by a Piano
Femme à la guitare près d'un piano
Paris, (spring) 1911
Oil on canvas, 57 x 41 cm
Zervos II*, 237; DR 388
Prague, Národni Gallery

Woman with Guitar or Mandolin
Femme à la guitare ou mandoline
Paris, February 1911
Oil on canvas, 65 x 54 cm
Zervos II*, 257; DR 390
Prague, Národni Gallery

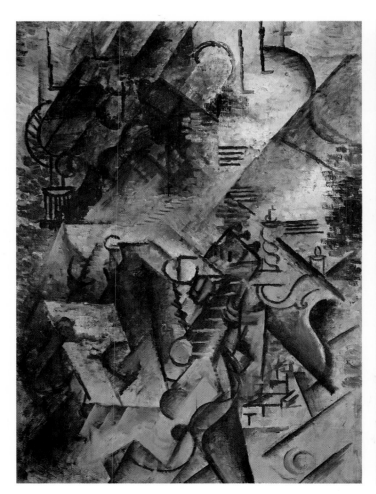

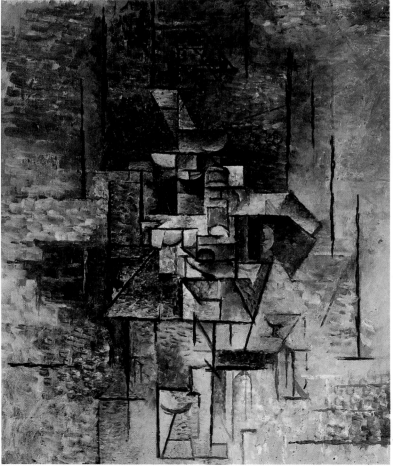

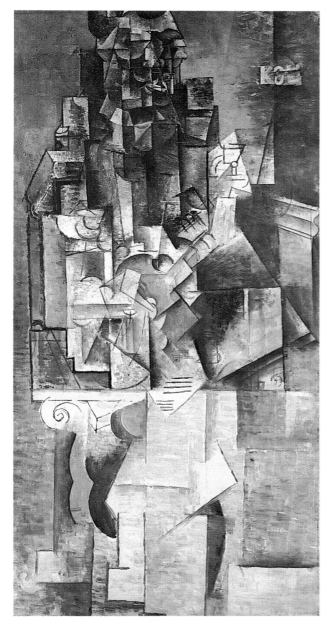

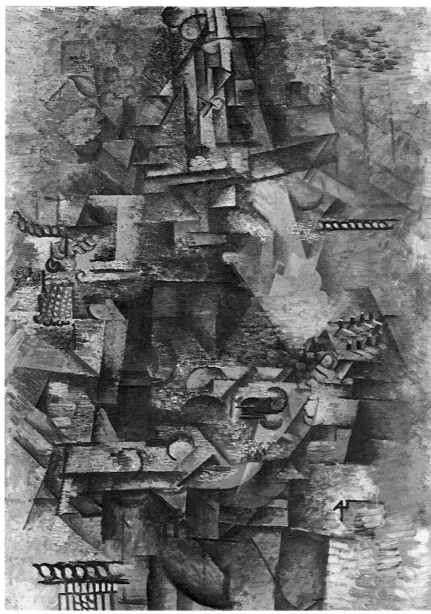

Man with a Guitar
Homme à la guitare
Paris, begun autumn 1911, finished 1913
Oil on canvas, 154 x 77.5 cm
Zervos XXVIII, 57; DR 427; MPP 34
Paris, Musée Picasso

The Mandolin Player
La mandoliniste
Paris, autumn 1911
Oil on canvas, 100 x 65 cm
Zervos II*, 270; DR 425
Basel, Beyeler Collection

single letters of the alphabet in Cubist paintings of 1909, now took to using entire words.[194] It was not a new idea; but in painting it had been restricted to producing the illusion of real lettering actually before the beholder.[195] Picasso borrowed this, and in "Still Life on a Piano ('CORT')" (pp. 198–199) transposed it to a new level of meaning. Whereas Braque retained the meanings of words and thus their value as communications, Picasso was pointing up the random quality of meaning in signs. The word "CORT" was a meaningless abbreviation for the name Alfred Cortot (a pianist). But it was also a witty riposte to Braque, who had included the words "Mozart" and "Kubelik" to suggest a concert. Picasso's still life also used musical instruments upon a piano, motifs which are directly related to concerts. It is an enigmatic picture, walking a thin line between meaning and nonsense and tantamount to a visual statement of epistemological tenets – and yet insisting on the truth of art.

195 Analytical Cubism 1907 – 1912

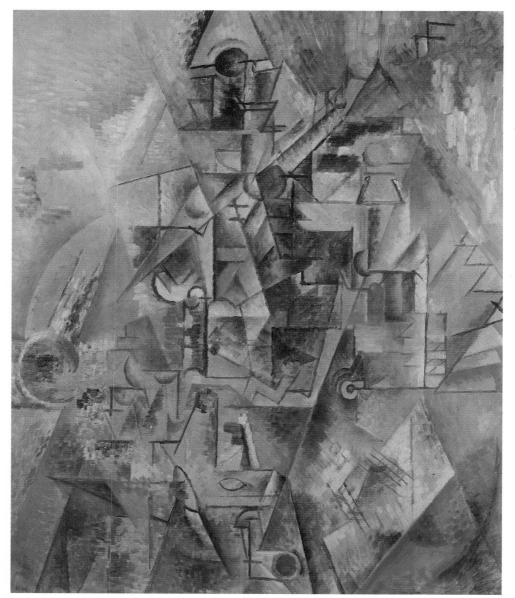

The Clarinet
La clarinette
Céret, (August) 1911
Oil on canvas, 61 x 50 cm
Zervos II*, 265; DR 415
Prague, Národni Gallery

Standing Nude
Femme nue debout
Paris, 1911
India ink on paper, 31 x 19 cm
Zervos XXVIII, 38

Cubist Nude
Femme nue debout
Cadaquès, summer 1910
Ink and India ink, 31.5 x 20.9 cm
Zervos XXVIII, 20
Stuttgart, Staatsgalerie Stuttgart

Violin Player with a Moustache
Violoniste moustachu
Céret and Sorgues, summer 1912
Ink, India ink, charcoal and pencil
on paper, 30.8 x 18.8 cm
Zervos XXVIII, 78; MPP 666
Paris, Musée Picasso

Analytical Cubism 1907 – 1912 **196**

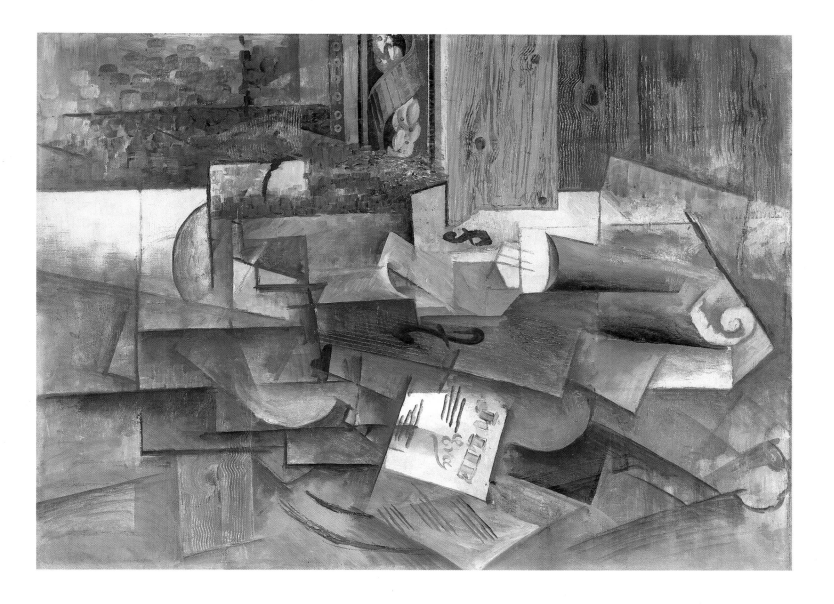

Another innovation also originated with Braque. As a youngster he had been an apprentice house painter, and was familiar with a number of trade techniques, such as the "comb" – a template for mechanically establishing a whole area of parallel lines. Braque used it to imitate the graining of wood, and achieved a higher level of illusionism, conveying not only the appearance but also the material consistency of an object – a technical trick dazzlingly and absurdly used. Picasso borrowed the method for a number of still lifes (cf. pp. 208, 209 and 212), partly combined with letters. Cubism had changed considerably. A "simple" deconstruction of the mimetic, representational function of a picture had become an art which used the picture, itself a system of signs, to prove the random contingency of signs.

Violin "Jolie Eva"
Violon "Jolie Eva"
Céret or Sorgues, spring 1912
Oil on canvas, 60 x 81 cm
Zervos II*, 342; DR 480
Stuttgart, Staatsgalerie Stuttgart

Still Life on a Piano ("CORT")
Nature morte sur un piano ("CORT")
Céret, summer 1911 to spring 1912, Paris
Oil on canvas, 50 x 130 cm
Zervos II**, 728; DR 462
Geneva, Heinz Berggruen Collection

The Poet
Le poète
Sorgues-sur-Ouvère, summer to autumn 1912
Oil on canvas, 60 x 48 cm
Zervos II*, 313; DR 499
Basel, Öffentliche Kunstsammlung Basel,
Kunstmuseum, Gift of Maja Sacher-Stehlin

The Aficionado (The Torero)
L'aficionado (Le torero)
Sorgues-sur-Ouvère, summer 1912
Oil on canvas, 135 x 82 cm
Zervos II**, 362; DR 500
Basel, Öffentliche Kunstsammlung Basel,
Kunstmuseum

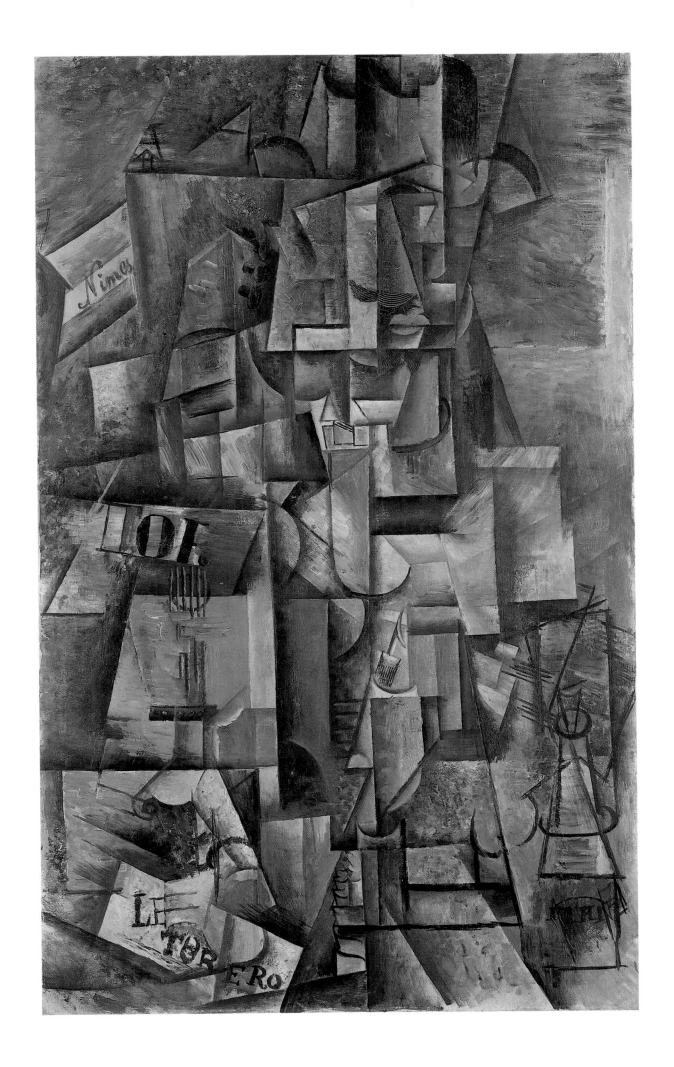

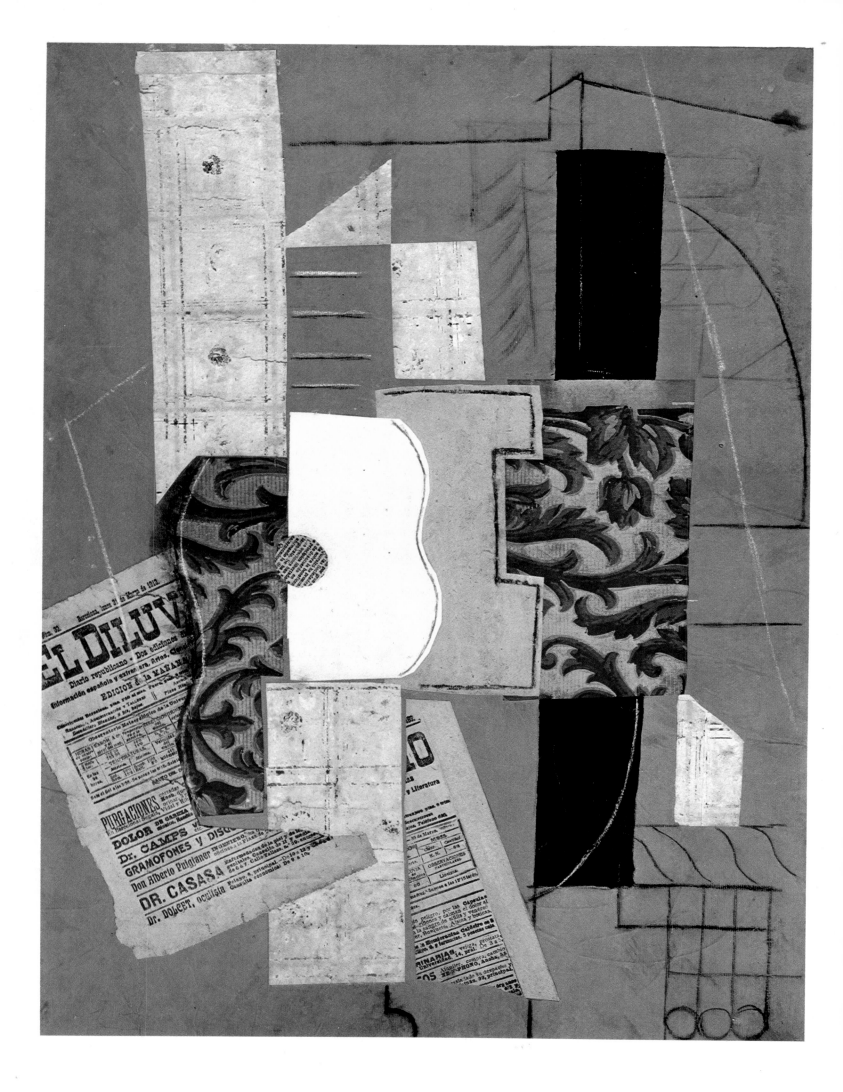

8 Synthetic Cubism
1912–1915

The work Picasso did in 1907 on "Les Demoiselles d'Avignon" placed him squarely in the contemporary vanguard. But in his radicalness he stood alone. From 1908 to 1911, together with Braque, he developed Cubism, and moved on to the frontiers of abstraction. Only a very few insiders were in a position to follow this progress, though. When the two artists created Synthetic Cubism from 1912 onwards, the situation had changed, and Cubism was no longer the property of the experts, a style hidden away in a handful of galleries, but rather the new sensational talking point among all who had an interest in contemporary art.

Late in 1911, a number of young artists calling themselves Cubists exhibited in the Salon des Indépendants and at the autumn Salon.[196] But Picasso and Braque were not the stars of these shows; they were not even to be seen. The most important artists of the Cubist group were Albert Gleizes, Jean Metzinger, Henri Le Fauconnier, Robert Delaunay, Roger de la Fresnaye and Fernand Léger. In 1912, the now expanded group again exhibited at both Salons. By now, public interest was even greater, and there was a scandal comparable only with that which had accompanied the arrival of the Fauves in 1905[197]. From our point of view, if we compare their work with what Picasso and Braque had just been doing, the fuss is difficult to understand. The Cubism that caught the public eye was by no means a genuinely revolutionary, innovative art. Almost all the pictures on show can be seen as pleasing variants on what the two true revolutionaries had been painting earlier, around 1908–1909. Only Delaunay and Léger had ideas of their own about abstraction from the representational.[198]

Nevertheless, the controversy raged in the press and even at political meetings. This rapid reception was doubtless assisted by the fact that the group offered the public a readily-grasped notion of Cubism. Their work was essentially geometrically abstract, taking its cue from the cube. Without taking Picasso's and Braque's latest work into account, the painters had gone back to Cézanne, and to the older work Braque had exhibited at Kahnweiler's in 1908[199].

The twin lines of development were plainly not running in synch. Artistic approaches, their significance for progress in art, and their

Various Studies: Guitars
Feuille d'études: guitares
(Etudes pour une sculpture)
1912/13
Ink, India ink and pencil on paper,
35.7 x 22.6 cm
Zervos XXVIII, 282; MPP 683
Paris, Musée Picasso

Guitar
La guitare
Céret, after 31 March 1913
Papiers collés, charcoal, India ink and chalk
on paper, 66.4 x 49.6 cm
Zervos II*, 348; DR 608
New York, The Museum of Modern Art,
Nelson A. Rockefeller Bequest

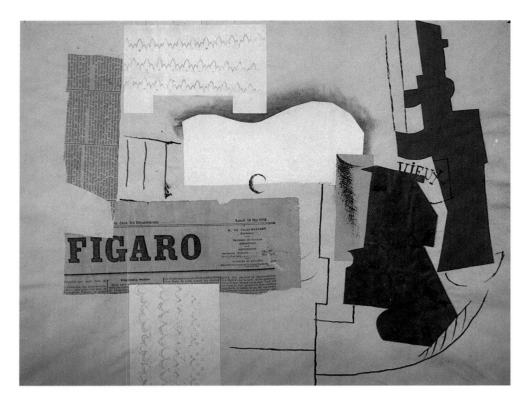

Guitar, Newspaper, Glass and Bottle
Guitare, journal, verre et bouteille
Céret, 1913
Papiers collés and ink on paper,
46.5 x 62.5 cm
Zervos II*, 335; DR 604
London, Tate Gallery

recognition in the public arena, were evolving in dislocated fashion. The reason must be sought in the new conditions of art and its reception in the early 20th century – which will also account for the shift in the evaluation of various Cubist artists that occurred during the debate of 1912.

In the 19th century it was the official Salons, and they (very nearly) alone, that decided the recognition of artists. Discussion divided according to whether artists were Salon or anti-Salon artists: we need only recall Courbet, or the Impressionists.[200] But since the turn of the century it had been commercial galleries and the press that steered the reception. Most important shows of avant-garde art were to be seen in the galleries. They acted as middlemen between the studios and the public, ensuring that the latest work was seen and providing journalists and critics with the material for reviews and essays. Of course the motives of the galleries were commercial, at least in part. Certain artists were promoted and marketed. This, after all, was the dawn of middle-class society's commercialization of art.[201]

Till the decisive Cubist breakthrough, Picasso's career too was one that depended on dealers' speculation. His early exhibition at Vollard's in 1901 represented an investment in his future productivity. Everyone who knew what was what realised, after all, that Salon art was being superseded by something new. Thus in early 1907 Vollard bought up everything of Picasso's, including all his sketches, for 2500 francs.[202] Both Picasso and Braque had contracts with the young German dealer Daniel Henry Kahnweiler, who paid a fixed price for their startling new work. An arrangement of this kind gave the artists a degree of security and also enabled them to

Bottle on a Table
Bouteille sur une table
Paris, after 8 December 1912
Papiers collés and charcoal on newspaper,
62 x 44 cm
Zervos II**, 782; DR 551; MPP 369
Paris, Musée Picasso

ignore the processes of official recognition. Picasso, in fact, never exhibited at a Paris Salon; instead, Kahnweiler sold his work to collectors, and introduced it to other galleries and dealers via his contacts. In 1911, both Picasso and Braque had exhibitions abroad – in the Galerie Thannhauser in Munich, for instance. These shows familiarized experts with their work but were largely ignored by the broader public.[203]

The official Cubist shows of 1911, at which Picasso and Braque were not represented, inevitably changed things. The public debate forced their work into the open and made it imperative to establish their significance in the evolution of Cubism. In 1912 Metzinger and Gleizes published "Du cubisme", a theoretical, popularizing view of Cubism that took Cézanne as the great exemplar.[204] But numerous writers in Picasso's circle published other views. That same year, Salmon published two books which are seen to this day as vital sources in the history of Modernist art: his "Histoire anecdotique du cubisme", and "La jeune peinture française". He was the first to stress Picasso's key position and the seminal importance of "Les Demoiselles d'Avignon" in the founding of Cubism. Then in 1913 Apollinaire's book "Les peintres cubistes" appeared, and made an attempt to distinguish and characterize groupings within the movement. Braque and Picasso were labelled "scientific" Cubists.[205]

All of this produced a fundamental revaluation of Cubism and the individual painters. Now Picasso stood centre-stage, vilified and acclaimed as the innovator *par excellence*. Though it does not fit the facts, Braque has been viewed ever since as Picasso's junior partner. This too can be accounted for if we look at the art scene

The Tavern (The Ham)
La guinguette (Le jambon)
Paris, winter 1912 (or spring 1914?)
Oil and wood shavings on cardboard,
29.5 x 38 cm (oval)
Zervos II**, 534; DR 704
St. Petersburg, Hermitage

of the time. Before Cubism, Picasso already had a name, while Braque was merely the young man among the Fauves. Though Picasso was the elder by a mere half year, he retained his advantage. From the start it was a financial advantage too: though both artists were under contract to Kahnweiler, the dealer paid Picasso four times what he paid Braque for his Cubist work.[206] This appears to have had no effect on the two artists' personal relations, though, and Picasso certainly seems to have considered Braque his equal. The letters they wrote each other – even if they were partly playing to the gallery, so to speak – record real friendship and mutual respect.[207]

Their exchange entered a new phase in 1912. Braque was continually trying to adapt craft techniques to Cubism, to put it on a new footing. The tactile sense could be appealed to in more ways than paint and a drawing pencil. He tested materials and methods familiar to the house decorator but new to art. Along with templates and other illusionist tricks, he mixed his paint with sand or plaster to create a rough, textured surface like that of a relief.[208] In

Still Life with Chair Caning
Nature morte à la chaise cannée
Paris, May 1912
Oil on oilcloth on canvas framed
with cord, 29 x 37 cm
Zervos II*, 294; DR 466; MPP 36
Paris, Musée Picasso

Synthetic Cubism 1912 – 1915 **207**

Still Life with Violin
Violon
Sorgues-sur-Ouvère, summer 1912
Oil on canvas, 55 x 46 cm
Zervos II*, 358; DR 483
Moscow, Pushkin Museum

Head of a Harlequin
Tête d'arlequin
Paris, 1913
Pencil on paper, 62.5 x 47 cm
Zervos II**, 425
Paris, Musée Picasso

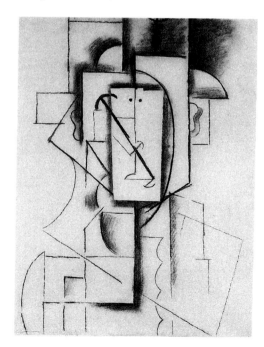

place of two-dimensional, surface mimesis on canvas or panel, Braque now used material textures of various kinds as an expressive value in itself. The next step, logically (as we can now see), was to redefine the visual function of technique and of the material(s) used.

In early 1912, following a stay at Sorgues, Braque showed Picasso his new work. It was three-dimensional. He had been cutting sculptural objects together, using paper or cardboard, and then painting or drawing over them. The spatial experiment was designed as a way of assessing illusionist techniques. He then applied the same ideas to two-dimensional work, retaining paper and cardboard as materials; and a new kind of work, the papiers collés, was born.[209] Subsequently he varied the textural effects and tried out further ways of developing them. In particular, he used pre-formed, printed, coloured and structured pieces of paper.

Synthetic Cubism 1912 – 1915 **208**

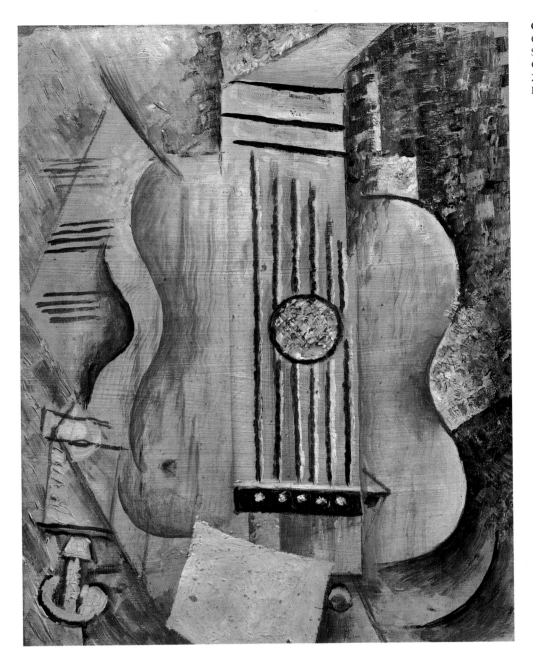

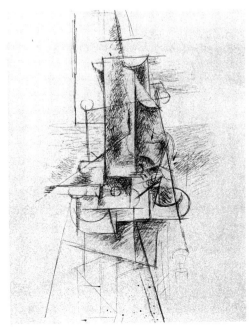

Guitar "I love Eve"
Guitare "J'aime Eva"
Sorgues-sur-Ouvère, summer 1912
Oil on canvas, 35 x 27 cm
Zervos II*, 352; DR 485; MPP 37
Paris, Musée Picasso

Guitar Player
Guitariste
Sorgues-sur-Ouvère, summer to autumn 1912
India ink and black chalk on paper, 64 x 49 cm
Zervos XXVIII, 67; MPP 680
Paris, Musée Picasso

For Picasso, Braque's latest innovations provided the occasion to extend Cubism's visual system. Paintings such as the 1914 "Ma Jolie" (p. 241), personal in their allusive range, were the result. In these works, Picasso used letters and words as graphic, indeed iconic signs. The conventional meanings remain, since the letters can still be read, but the statement is puzzling. Picasso deploys messages that seem unambiguous but which become inaccessible once they appear in the context of his pictures. Thus in "Ma Jolie" the guitar, the make-believe music, the pipe, glass, playing card, dice, and the word "Bass", implying a drink, all provide ready associations with a café interior. The words "Ma Jolie" on the music would be perceived by contemporaries as a quotation from a popular chanson by Fragson; but the phrase also had a private meaning intended only for the artist's closest friends. It referred to Eva Gouel, a young woman who had entered the artistic milieu of

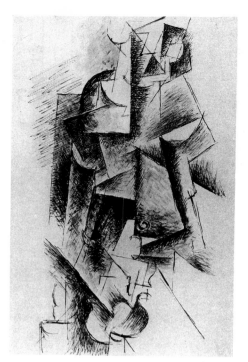

Montmartre as painter Louis Marcoussis's girlfriend and then became Picasso's partner.[210] Picasso similarly attached messages to his use of the house painter's "comb" template. In "The Poet" (p. 200) it not only provided texture, as it had for Braque. By using it for the poet's hair and moustache, Picasso introduced a mechanistic component into the representational process, well-nigh destroying all trace of illusionism and thereby redoubling the iconographic effect.

His approach to Braque's new papiers collés method was similar. The graphic structure of the printed paper produced a quality that was figuratively random in terms of a picture's import. In 1912 Picasso produced a number of masterly works of striking economy of means, one of the finest of them being the "Violin" (p. 217). Two scraps of newspaper, a few lines and charcoal hatchings – and the picture is finished. It is one of the loveliest and most intelligent Cubist pictures. First, Picasso clipped an irregular piece of newspaper and stuck it on cardboard. Then he drew a stylized violin's neck with the characteristic curled head. Following the precept of Analytical Cubism, he added formally deconstructed lines to suggest the parts of a violin. The newspaper text is still decipherable, but its original function and meaning have vanished. Though identifiably from a paper, it is seen purely as a graphic design, an image. The yellowing adds an extra interest, echoing the brownish colour of the violin. But Picasso did not merely defamiliarize his found material: the part of the newspaper from which he had clipped the first was reversed and placed at top right, where it acts as a background, this function being at odds with its identity as a newspaper fragment. We are offered an object and spatial dimensions – but, even as Picasso establishes them, he destroys them once again.

Violin Player
Violoniste
Sorgues-sur-Ouvère, summer 1912
Ink and India ink on paper, 30.7 x 19.5 cm
Zervos XXVIII, 102; MPP 673
Paris, Musée Picasso

Seated Man
Homme assis
1911/12
India ink and pencil on paper, 28.8 x 22.6 cm
Zervos XXVIII, 101; MPP 697
Paris, Musée Picasso

Man with Guitar (Study for a Sculpture)
Homme à la guitare (Etude pour une sculpture)
1912
India ink on paper, 30.5 x 19.5 cm
Zervos XXVIII, 126

Dove with Green Peas
Le pigeon aux petits pois
Paris, (spring) 1912
Oil on canvas, 65 x 54 cm
Zervos II*, 308; DR 453
Paris, Musée d'Art Moderne
de la Ville de Paris

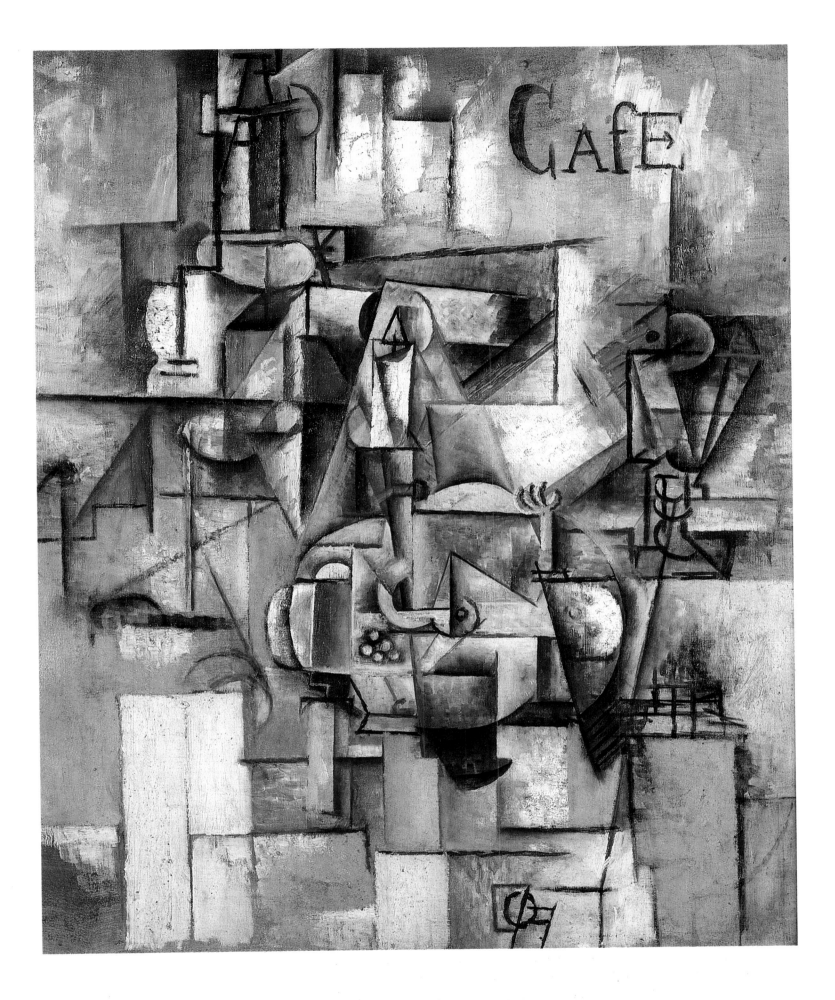

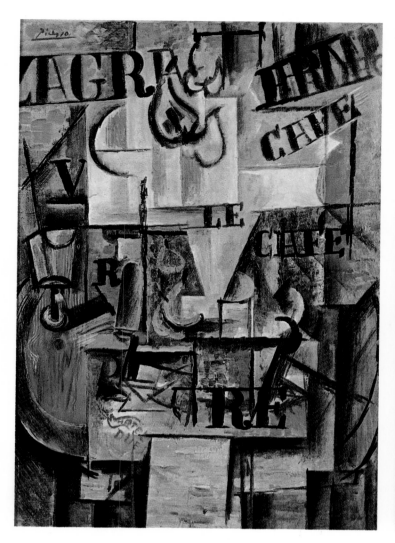

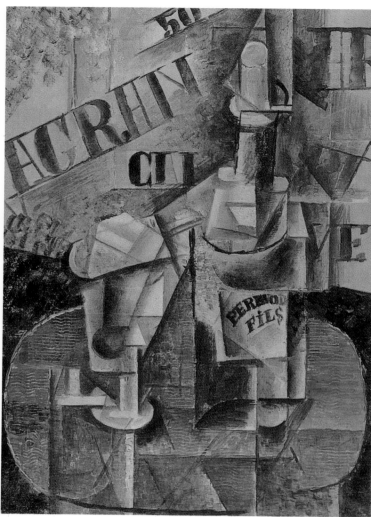

The newspaper scraps are placed to mark an irregular vertical diagonal, a visual instability which the artist has echoed in the charcoal hatching. The tonal polarity creates a balance of the white card, the printed and yellowed paper, and the economical lines of the drawing. The form and content of the picture are at variance, but they are necessarily combined; and thus a subtle tension of great aesthetic and intellectual presence is created.

Picasso varied this stylistic approach in a number of *papiers collés* done in 1912. In one work (p. 205) he explored presence and vacancy by cutting an irregular rectangular shape out of a sheet of newspaper and then sticking the sheet upside-down on a sheet of cardboard. The art consists primarily in an intellectual rather than a technical process. Once again, Picasso deploys the first principles of representational art in absurd fashion. The table and bottle in the still life are presented with a few charcoal lines using the vacant space in the paper. Bottles are three-dimensional, and in terms of solid geometry cylinders. In transferring his bottle to the two dimensions of a picture, Picasso dispensed with any attempt at illusionist spatiality and rendered the bottle in two flat dimensions. Seen two-dimensionally, though, bottles are long rectangles; so that was the shape the artist cut out of the paper. The bottom of a bottle

Bowl of Fruit (The Fruit Dish)
Compotier et fruits
Céret, spring 1912
Oil on canvas, 55.3 x 38 cm
Zervos II*, 302; DR 475
New York, Private collection

Bottle of Pernod and Glass
Bouteille de Pernod et verre
Céret, spring 1912
Oil on canvas, 45.5 x 32.5 cm
Zervos II*, 307; DR 460
St. Petersburg, Hermitage

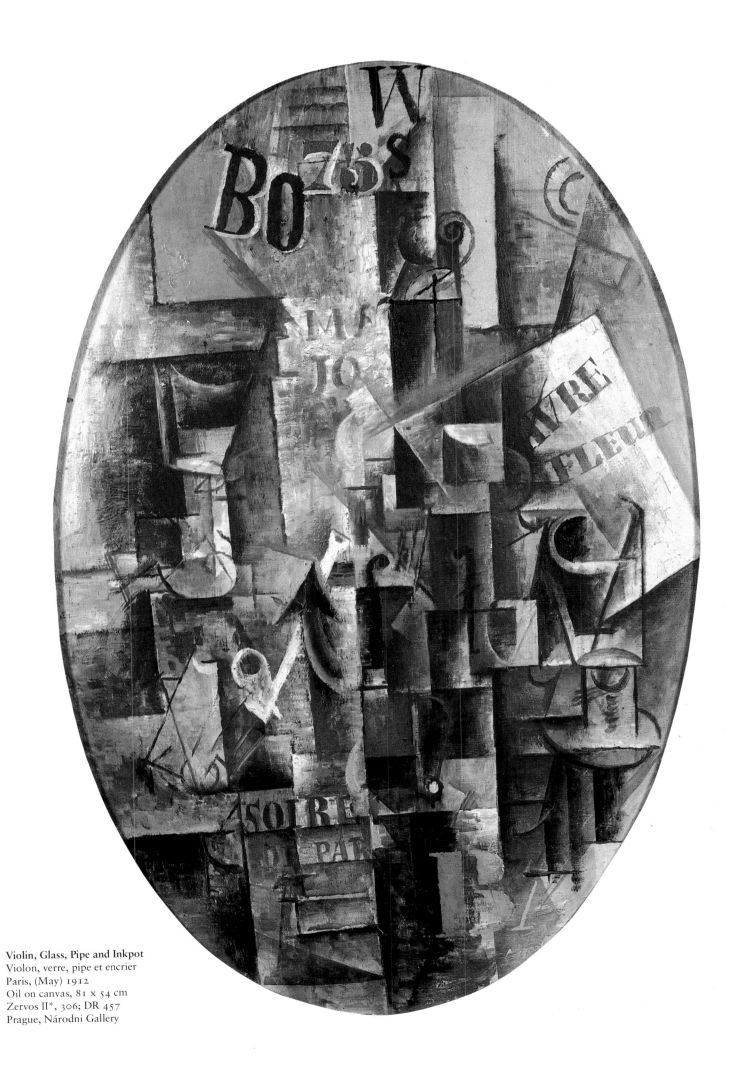

Violin, Glass, Pipe and Inkpot
Violon, verre, pipe et encrier
Paris, (May) 1912
Oil on canvas, 81 x 54 cm
Zervos II*, 306; DR 457
Prague, Národni Gallery

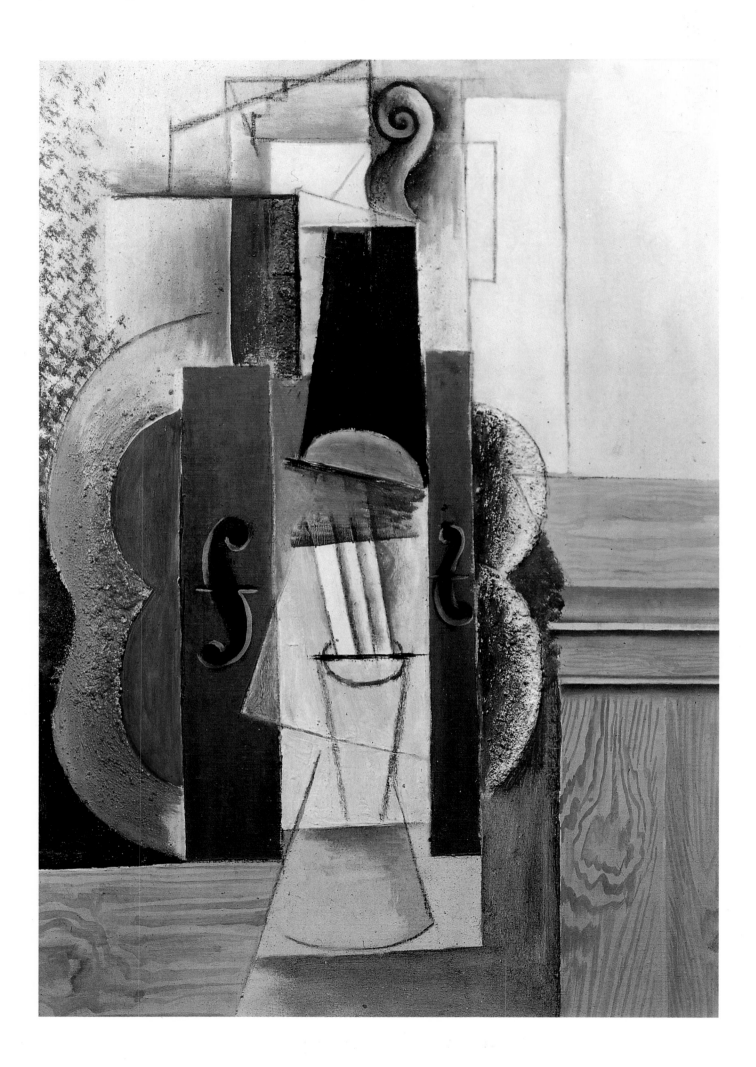

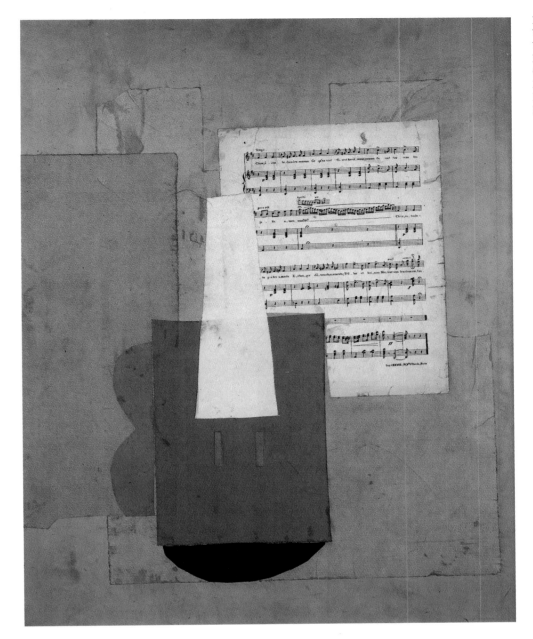

Page 214:
Violin
Violon accroché au mur
Paris, early 1913 (?)
Oil and sand on canvas, 65 x 46 cm
Zervos II**, 371; DR 573
Bern, Kunstmuseum Bern,
Hermann and Margrit Rupf Foundation

Violin and Sheet Music
Violon et feuille de musique
Paris, autumn 1912
Papiers collés on cardboard, 78 x 65 cm
Zervos II**, 771; DR 518; MPP 368
Paris, Musée Picasso

is circular, so Picasso's peculiar logic renders a circle in the two-dimensional projection. This circle is in fact a surviving area of newspaper in the cut-out section, displaced sideways. A few days later, in December 1912, Picasso made an exact counterpart of this picture, the bottle now represented – conversely – by the newspaper.[211]

During that period, Picasso also used other patterned materials such as wallpaper, advertisements, cloth and packaging, to good visual effect. Though unfamiliar materials were being introduced into the pictures, the iconic quality of presentation remained. The materials were integrated perfectly into the style and logic of Picasso's compositions, and were there primarily to add texture or patterning.[212] These *papiers collés* can thus be read as systems of signs producing a new level of effect. The best example is perhaps a painting done in Céret in 1913. According to its title, it shows a guitar (p. 220).

Pages 216 and 217:
Head of a Girl
Tête de jeune fille
Paris or Céret, early 1913
Pencil, charcoal and India ink
on paper, 63.5 x 48 cm
Zervos II**, 427; DR 589
Private collection

Violin
Violon
Paris, winter 1913
Papiers collés and charcoal on paper,
62 x 47 cm
Zervos XXVIII, 356; DR 524
Paris, Musée National d'Art Moderne,
Centre Georges Pompidou

Synthetic Cubism 1912 – 1915 **215**

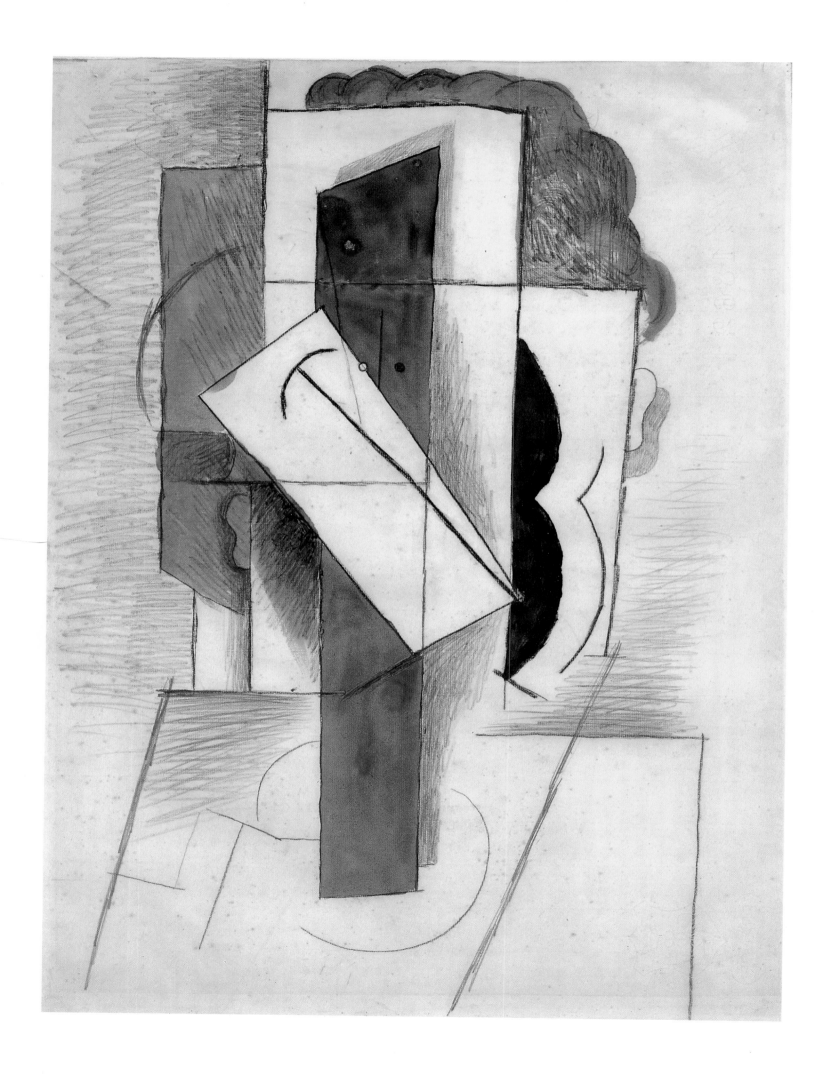

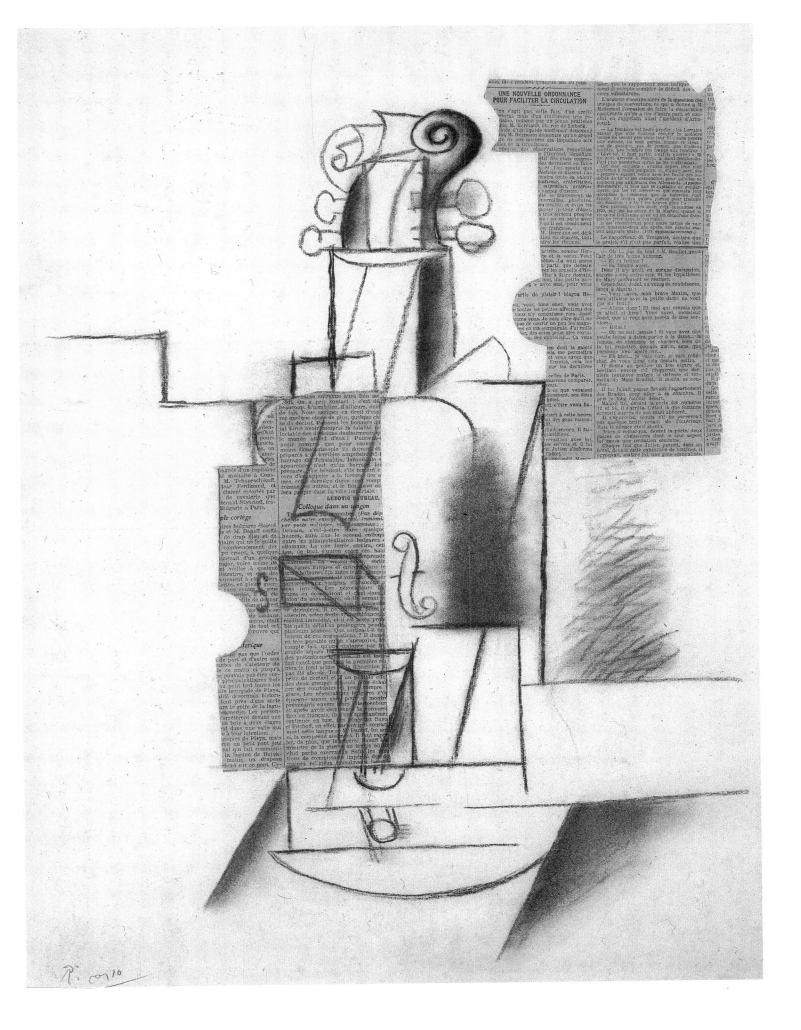

Guitar
Guitare
Paris, after 3 December 1912
Cardboard, paper, canvas, string and pencil,
22.8 x 14.5 x 7 cm
Spies 29; DR 556; Zervos II**, 779; MPP 245
Paris, Musée Picasso

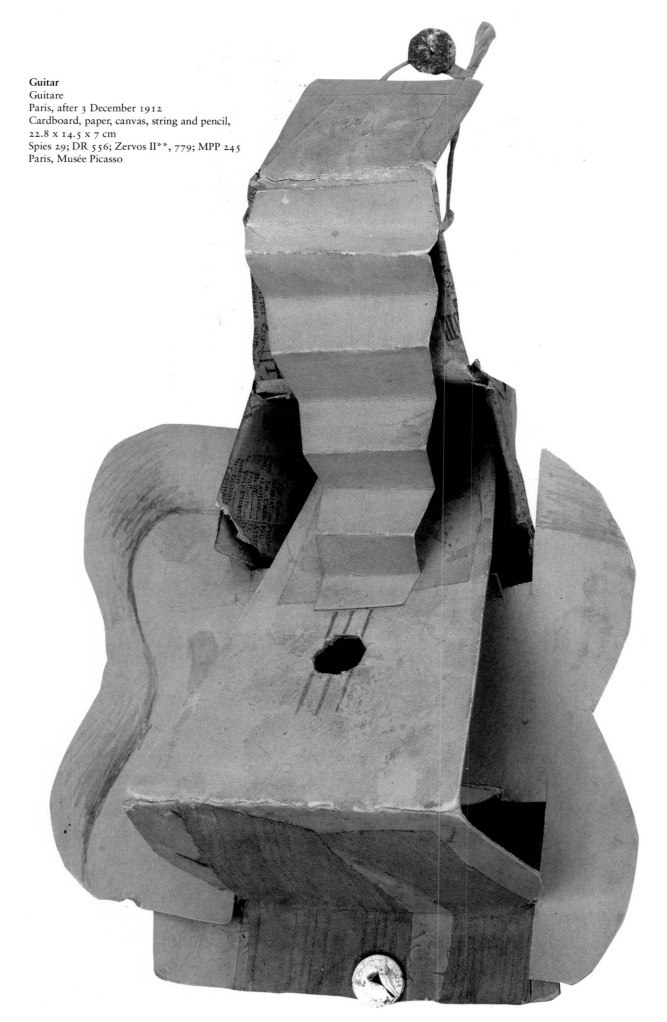

218

Guitar
Guitare
Paris, after 3 December 1912
Cardboard, paper, canvas, string, oil
and pencil, 33 x 18 x 9.5 cm
Spies 30; DR 555; Zervos II**, 770; MPP 244
Paris, Musée Picasso

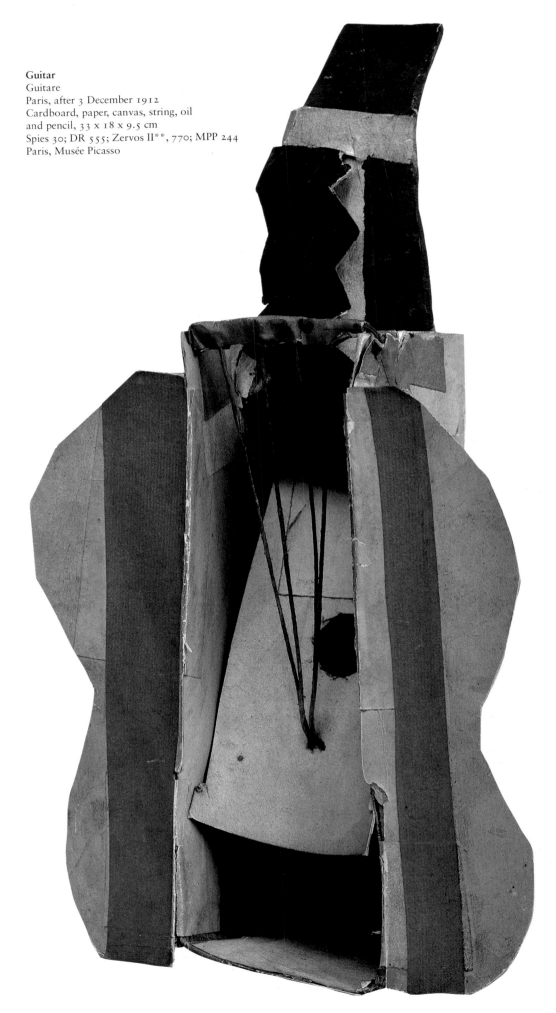

219

Geometrical Composition: The Guitar
Guitare
Céret, spring 1913
Oil on canvas on panel,
87 x 47.5 cm
Not in Zervos; DR 597; MPP 38
Paris, Musée Picasso

Mandolin and Clarinet
Mandoline et clarinette
Paris, early 1914
Painted pinewood and pencil,
58 x 36 x 23 cm
Spies 54; Zervos II**, 853; DR 632; MPP 247
Paris, Musée Picasso

221

Bottle of Vieux Marc, Glass and Newspaper
Bouteille de Vieux Marc, verre et journal
Céret, after 15 March 1913
Papiers collés, pins and charcoal on paper,
62.5 x 47 cm
Zervos II*, 334; DR 600
Paris, Musée National d'Art Moderne,
Centre Georges Pompidou

222

**Bottle of Bass, Clarinet, Guitar,
Newspaper, Ace of Clubs**
Bouteille de Bass, clarinette, guitare, violon,
journal, as de trèfle
Paris, winter 1913
Oil on canvas, 81 x 75 cm
Zervos II**, 487; DR 624
Paris, Musée d'Art Moderne,
Centre Georges Pompidou

223

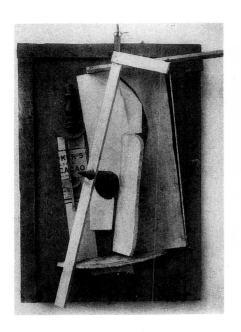 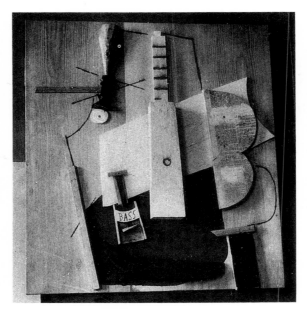 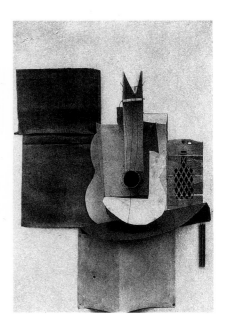

The picture consists of a few irregular, angular areas of khaki, white and black. It is a copy of a *papier collé* that Picasso had recently done[213] – that is to say, it imitates an imitation. This defamiliarization is intensified by the use of angular shapes, since they are plainly at variance with the rounded shapes of what is supposedly the picture's subject, a guitar. And, further, the fundamentals of illusionism – light and shadow, perspective foreshortening – are not meaningfully deployed but are absurdly juxtaposed. The overlapping which at other times conveys spatial dimensions completes the defamiliarization in this picture so effectively that we would have no idea what it represented were it not for the title. The picture seems wholly abstract.

This defamiliarization still works entirely within the parameters of mimetic iconography. Picasso went about his work quite differently in the collage technique he devised at the time. In collage – unlike *papier collé* - an object is introduced into a context in such a way as to alter not only the medium but also the style and meaning of the motif.[214] "Still Life with Chair Caning" (p. 207), done in May 1912, is the cornerstone work of this new method. A composition in the manner of Analytical Cubism has been joined to a slant rectangular area showing the weave of a cane chair. This naturalistic component is at odds with the style of the rest. In fact it is not a representational piece of work by the artist, but a printed scrap of oilcloth. The semblance of reality is deployed as an illusion, identified as such, and exploited iconographically.

During this phase of Cubism, using new materials and techniques, Picasso was exploring the problem of spatial values in the illusion established by pictures. Many of his works therefore started from three-dimensional work. Alongside the *papiers collés* he began to make guitars out of cardboard (cf. pp. 218 and 219). The instrument is crudely but recognisably made: the brown colours of the cardboard, reminiscent of the wood of guitars,

Bottle and Guitar
Bouteille et guitare
Paris, autumn 1913
Wood, glued paper, plasticine cone;
dimensions unknown
Spies 56; DR 631; Zervos II**, 578
Probably destroyed (photo dated 1917)

Guitar and Bottle of Bass
Guitare et bouteille de Bass
Paris, spring to autumn 1913
Pieces of wood, glued paper, nails, charcoal,
89.5 x 80 x 14 cm
Spies 33 a; DR 630; Zervos II*, 575; MPP 246
Original state (photo dated 1917)
(Present state: see opposite page)

Guitar and Bottle
Guitare et bouteille
Paris, autumn 1913
String, cardboard and paper, 102 x 80 cm
Spies 48; DR 633; Zervos II**, 577

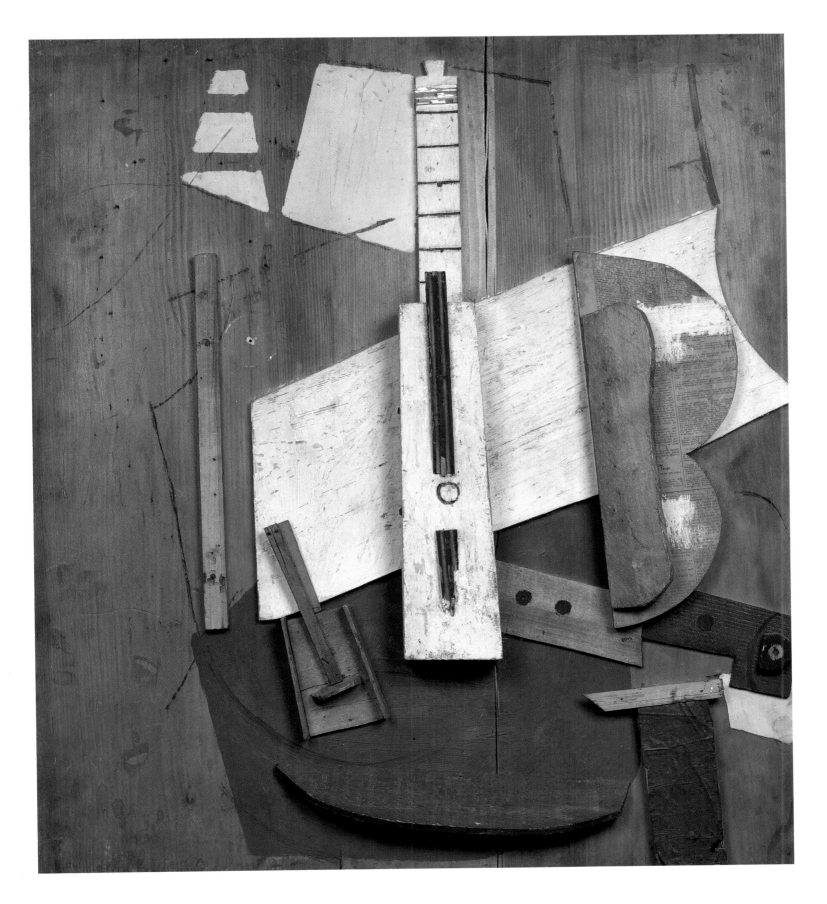

Guitar and Bottle of Bass
Guitare et bouteille de Bass
Paris, (spring to autumn) 1913
Pieces of wood, paper, charcoal and nails
on wooden board, 89.5 x 80 x 14 cm
Spies 33 b; Zervos II**, 575; DR 630; MPP 246
Paris, Musée Picasso

225

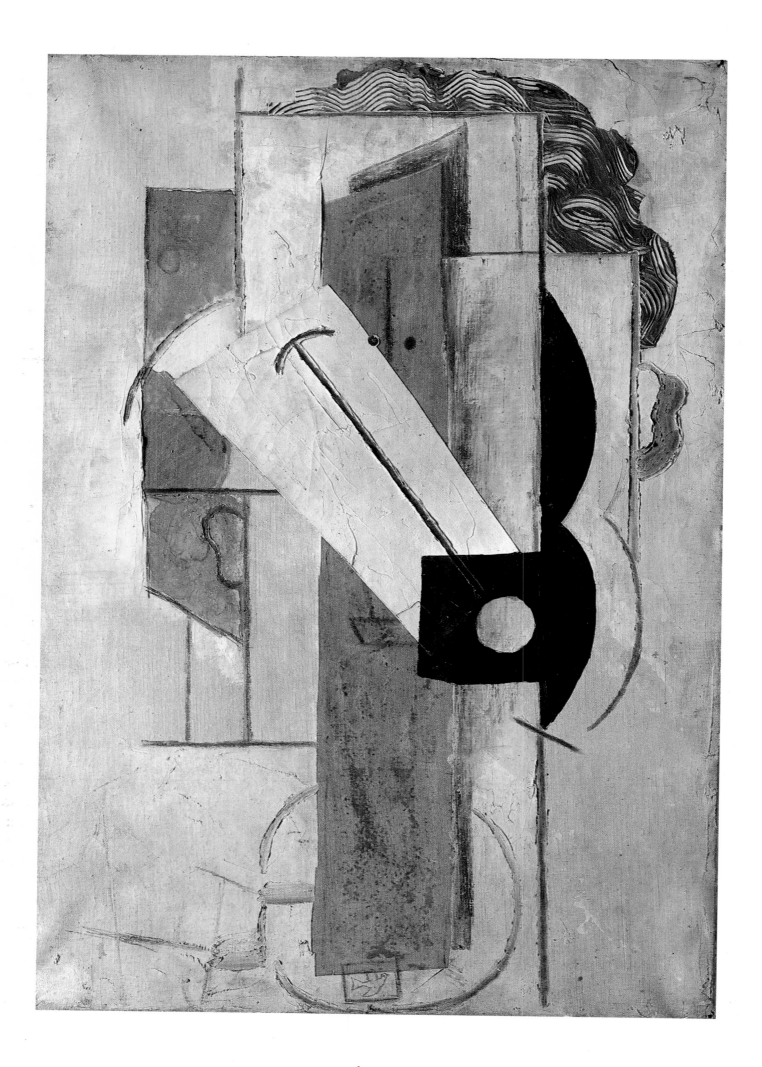

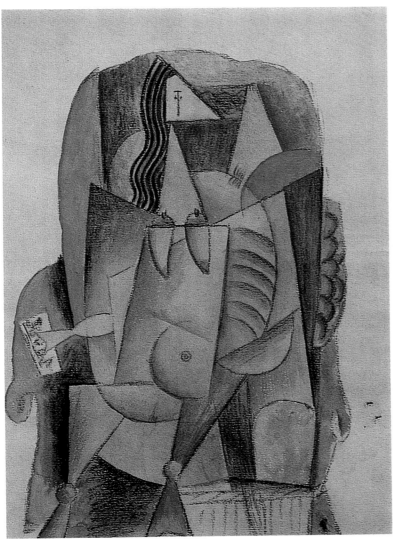

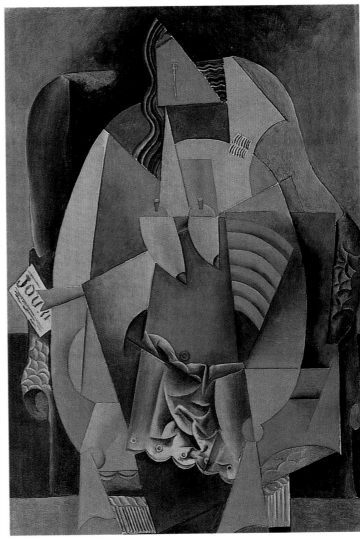

doubtless help us in the recognition. But inappropriate materials are used too, and spatial values subverted. The lid, bottom and side walls of the cardboard boxes are flattened to equal status. The basic Cubist rule of combining the representational and the random applies to these works too. But in contrast to Analytical Cubism, which dissected objects, here they are re-assembled. And for this reason a different term is used: Synthetic Cubism.[215]

Following this line, Picasso devised another new form, the assemblage. Basically it transposes the methods and effects of collage into three dimensions.[216] Two still-life works from 1913 are good examples: "Guitar and Bottle of Bass" (p. 225) and "Mandolin and Clarinet" (p. 221). The vehicle, structurally and visually, is wood. Picasso uses its tactile and visual properties, such as the graining and colour. By adding extra colour and drawing, he intensifies the effect, levels out spatial qualities, covers textures – but also contrasts his materials and techniques. It is a style that is nicely visible in the tondo "Glass, Pipe, Ace of Clubs and Dice" (p. 240). As well as wood, Picasso uses metal here; but it is painted over, and its original textural properties are no longer recognisable. The ace of clubs is sheet metal, the club symbol punched out. The dice is a

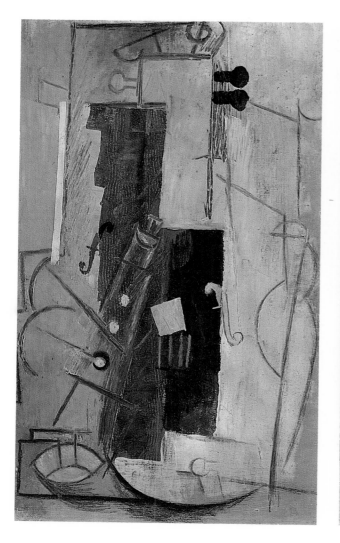
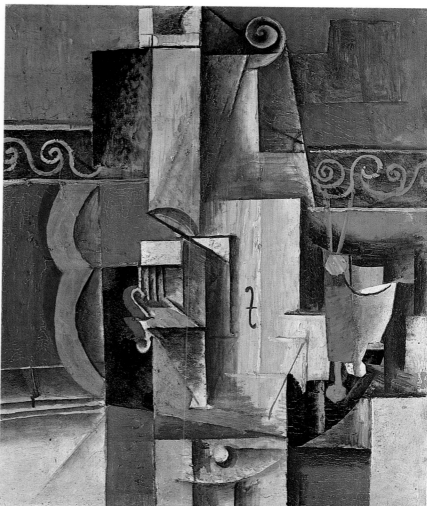

slant, cut-off section of a cylinder; only the painted motifs convey what it is meant to be.

Picasso also combined multi-level semantic defamiliarizations with tandem aesthetic and intellectual appeals in his only regular sculpture from this period, a famous serial work of which six copies were made: "The Glass of Absinthe" (p. 232). He made a wax and plasticine mould and variously painted the bronze casts. Absinthe (a vermouth brandy now banned because it is a health risk) was drunk from a glass goblet of the kind the sculpture shows. Picasso dissolved its transparent volume, with various highlights occasioned by the light, into isolated zones which he then juxtaposed, adding a genuine little spoon with a wax model of a sugar lump.

A great many things that are demonstrably wrong have been written about this yoking of different materials and methods of presentation. It is true that three formal levels meet in a mould: the reality of a genuine spoon, simple representation in the form of a wax copy of a sugar lump, and defamiliarization of the appearance of the glass.[217] But this is of no relevance in artistic terms, and is merely of practical significance. In the casting process of all six copies, the distinction between reality and simple representation inevitably vanished, because the spoon too now became only a

Violin and Clarinet
Violon et clarinette
Paris, early 1913
Oil on canvas, 55 x 33 cm
Zervos II**, 437; DR 575
St. Petersburg, Hermitage

Violin and Glass on a Table
Violon et verre sur une table
Paris, early 1913
Oil on canvas, 65 x 54 cm
Zervos II**, 370; DR 572
St. Petersburg, Hermitage

Violin at a Café (Violin, Glass, Bottle)
Violon au café (Violon, verre, bouteille)
Paris, early 1913
Oil on canvas, 81 x 54 cm
Zervos II**, 438 bis; DR 571
Galerie Rosengart

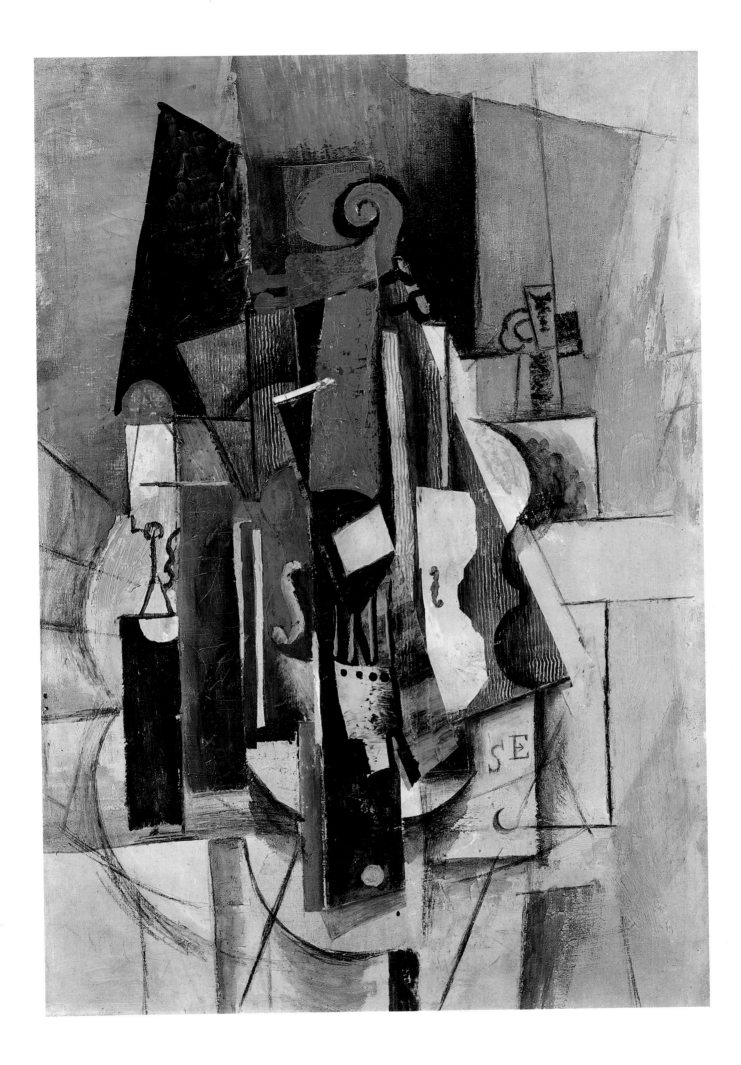

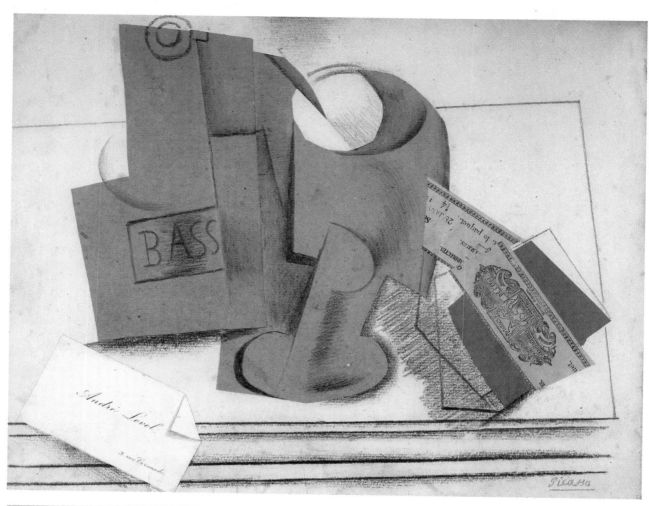

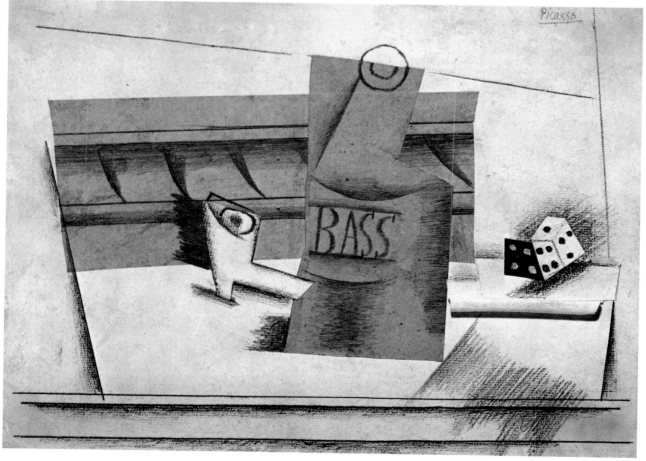

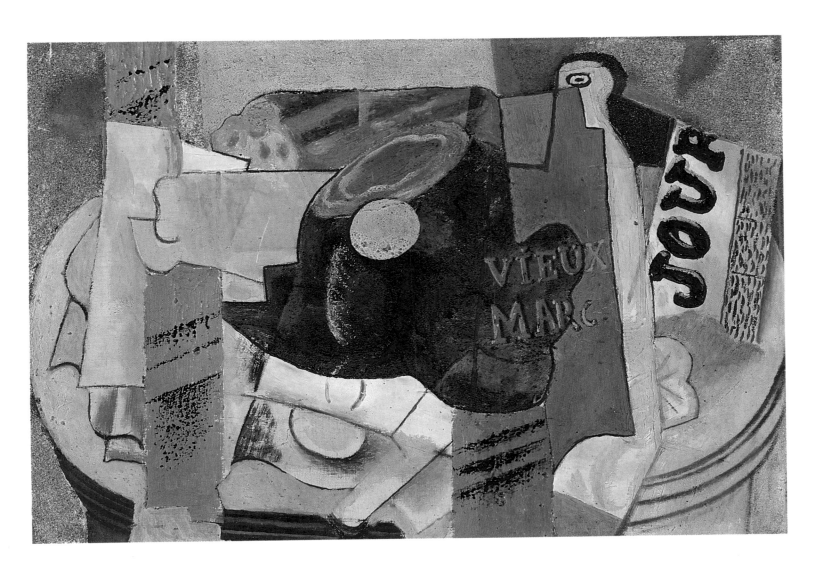

Ham, Glass, Bottle of Vieux Marc, Newspaper
Jambon, verre, bouteille de Vieux Marc, journal
Paris, (spring) 1914
Oil and sand on canvas, 38.5 x 55.5 cm
Zervos II**, 508; DR 705
Paris, Musée d'Art Moderne de la Ville de Paris

**Bottle of Bass, Glass, Pack of Tobacco,
Visiting Card**
Bouteille de Bass, verre, paquet de tabac,
carte de visite
Paris, early 1914
Papiers collés and pencil, 24 x 30.5 cm
Zervos II**, 456; DR 660
Paris, Musée National d'Art Moderne,
Centre Georges Pompidou

Pipe, Bottle of Bass, Dice
Pipe, bouteille de Bass, dé
Paris, early 1914
Papiers collés and charcoal on paper,
24 x 32 cm
Zervos II**, 469; DR 664
Basel, Galerie Beyeler

representation of itself. The wax model of the genuine sugar lump was technically necessary because sugar, being porous, was unsuitable for bronze casting. All that really matters, in terms of the principles of Synthetic Cubism, is the contrast between conventionally faithful representation (the spoon and sugar) and Cubist methods. In all six copies this contrast is observed. The various painting merely served purposes of accentuation.

Thus the processes of deception underlying the art of illusion are excellently displayed in the assemblages and sculptures of Synthetic Cubism. Picasso arguably took this line of thinking to the logical extreme in his metal "Violin" (p. 242), done in 1915 and a full metre high. It is made of cut sheet metal, but the parts are wired in and colourfully overpainted so that the nature of the material is once again not immediately apparent. The volume of the metal components and the spatial values implied by the painting are at variance. The impact is further blurred because Picasso, partly harking back to the 1912 "Guitar", has interchanged spatial values. Parts that should occupy a foreground position in the object supposedly represented, and others that would be further from us in a conventional three-dimensional treatment, have exchanged places. The two holes in the soundboard are not depressions or

holes in the metal but added components. Reversing their state in the real world, they have here become small rectangular boxes lying on the board. Then there are the colours, white, black and blue areas alongside the brown ones suggesting the actual colour of a violin. Black areas seem suggestive of shadow, just as white ones imply bright light; yet this contrasts with the way things appear in reality. Graphic and spatial approaches, and the art of the painter, have all been combined in a sophisticated synthesis in this sculptural construction.

This playful approach to form can hardly be taken any further without exceeding the bounds of meaning – and evolving an altogether new artistic idiom. Constructions such as these thus took Cubism to the furthest limit of its options. The art scene had changed in the meantime. Cubism, still far from being publicly recognised as an apt response to the times, was now seen as the precursor of the artistic avant-garde throughout Europe. The dogmatic group centred on Metzinger and Gleizes no longer existed and the Cubist visual language had altered, acquiring international currency. In 1912, the Galerie La Boétie in Paris established a "Section d'Or" in which Marcel Duchamp and Juan Gris set the tone. Gris extended Analytical and Synthetic Cubism, while Duchamp's "Nude Descending a Staircase" found new ways of presenting motion. Braque and Picasso had invented a style which could now serve the formal needs of many different kinds of artists.[218]

The Futurist movement, for instance, sponteously proclaimed in Paris in 1909 by the Italian writer Filippo Tommaso Marinetti, was devoted to dynamism and movement, and played its own variations on the fragmentation technique of Analytical Cubism.[219] The

The Glass of Absinthe
Le verre d'absinthe
Paris, spring 1914
Painted bronze after a wax maquette with silver absinthe spoon, 21.5 x 16.5 x 8.5 cm
Spies 36 d; Zervos II**, 584; DR 756
New York, The Museum of Modern Art

The Glass of Absinthe
Paris, spring 1914
Painted bronze after a wax maquette with silver absinthe spoon, 21.5 x 16.5 x 8.5 cm
Spies 36 f; Zervos II**, 583; DR 758
Private collection

The Glass of Absinthe
Paris, spring 1914
Painted bronze after a wax maquette with silver absinthe spoon, 21.5 x 16.5 x 8.5 cm
Spies 36 e; Zervos II**, 582; DR 757
Philadelphia (PA), Philadelphia Museum of Art, A. E. Gallatin Collection

Below right:
Glass and Sliced Pear on a Table
Verre et poire coupée sur une table
Paris, April 1914
Gouache, pencil, wallpaper and paper on cardboard, 35 x 32 cm
Zervos II**, 481; DR 678
St. Petersburg, Hermitage

Bowl of Fruit with Bunch of Grapes and Sliced Pear
Compotier avec grappes de raisins et poire coupée
Paris, spring 1914
Gouache, tempera, pencil and wood shavings on cardboard, 67.6 x 52.2 cm
Zervos II**, 480; DR 680
St. Petersburg, Hermitage

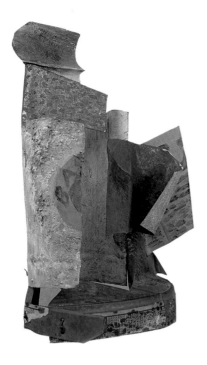

Bottle of Bass, Glass and Newspaper
Bouteille de Bass, verre et journal
Paris, (spring) 1914
Tinplate, sand, wire and paper,
20.7 x 14 x 8.5 cm
Spies 53; Zervos II**, 849; DR 751; MPP 249
Paris, Musée Picasso

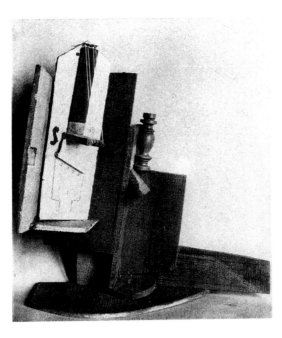

Violin and Bottle on a Table
Violon et bouteille sur une table
Paris, autumn 1915
Wood, string, nails, painted, and charcoal,
41 x 41 x 23 cm
Spies 57; Zervos II**, 926; DR 833; MPP 253
Paris, Musée Picasso

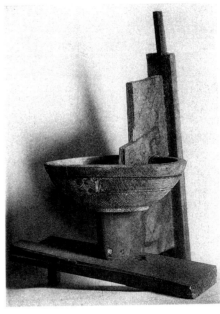

Bottle of Aniseed Brandy with Fruit Bowl and Grapes
Bouteille d'Anis del Mono et compotier
avec grappes de raisins
Paris, autumn 1915
Wood, tinplate, nails and charcoal,
35.5 x 27.5 x 26 cm
Spies 58; Zervos II**, 927; DR 834; MPP 254
Paris, Musée Picasso

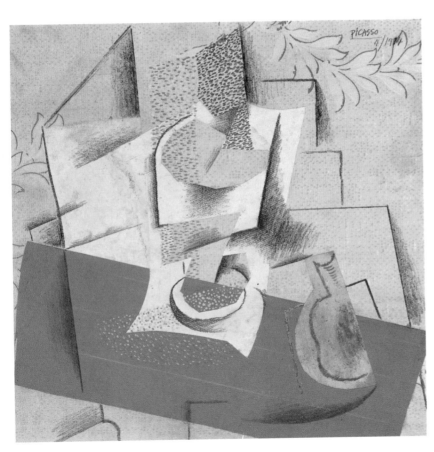

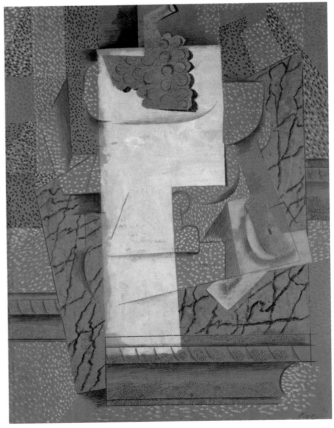

Synthetic Cubism 1912 – 1915 **233**

Dutch painter Piet Mondrian exhibited at the 1911 Salon des Indépendants together with the other Cubists – but then accused Picasso, Braque and others of having failed to grasp the true aims of Cubism with the necessary precision. Mondrian advocated totally abstract art. With a number of others he started the "De Stijl" movement in Holland in 1917 – one of the core groups in European Constructivism.[220] The importance of Cubism was international. It inspired the avant-garde everywhere.

From 1908 on, thanks to the collector Sergei Shchukin, Picasso's latest Cubist work cold be seen in Moscow. Contemporary west European art was seen in a number of exhibitions not only in the main cities of Russia but also (for example) in Odessa, and was soon well known, spurring the abstract programmes of Suprematism (practised by Kasimir Malevich) and Rayonism (Michail Larionov).[221] The Swiss artist Paul Klee and the Germans August Macke and Franz Marc saw Cubism in Paris and subsequent developments such as Delaunay's Orphism; what they saw fed their own varieties of German Expressionism. In December 1911, Delaunay had exhibited in the first Blauer Reiter show in Munich's Thannhauser gallery. Klee and the American-born Lyonel Feininger subsequently took their impressions with them to the Bauhaus.[222] In Prague there was a veritable Cubist centre, with groups of artists organizing shows of French Cubism and doing their own Cubist paintings and sculptures.[223] As early as 1911, Alfred Stieglitz exhibited Picasso's work in his New York gallery, introducing the Spaniard to America.[224] The great Armory Show, held in New York in 1913, was the US breakthrough for many of the new European artists, among them the Nabis, the Fauves and the Cubists.[225]

So Cubism was a determining factor for many different kinds of Modernist art, as a model and a catalyst. Encouraged by Cubism, Wassily Kandinsky – precursor of total abstraction in art – was able to pursue his course. Yet Cubism did not directly initiate all of Modernism's artistic styles; abstract art in particular drew upon a complex variety of sources, including the decorative style of *art nouveau*. Taking that style as his point of departure, the German Adolf Hölzel painted almost abstract pictures as early as 1905. But it remains true that without the authority of Cubism, Modernism as we know it would quite simply not have existed.[226]

Moreover, Picasso and Braque had invented new media such as collage and assemblage, enriching the expressive repertoire. From Dada to the present, artists of every stylistic persuasion have used and developed these methods. Small wonder, then, that as Cubism gained ground it also founded international recognition of Picasso's special status in 20th-century art. In the second decade of the century he was already being seen as the artist who initiated the great Modernist breakthrough. Whenever new movements were started, it was Picasso and his work that served as a rallying cry. In a word: he became the hero of 20th-century art.[227]

Synthetic Cubism 1912 – 1915 234

Harlequin
Arlequin
Paris, autumn 1915
Oil on canvas, 183.5 x 105.1 cm
Zervos II**, 555; DR 844
New York, The Museum of Modern Art

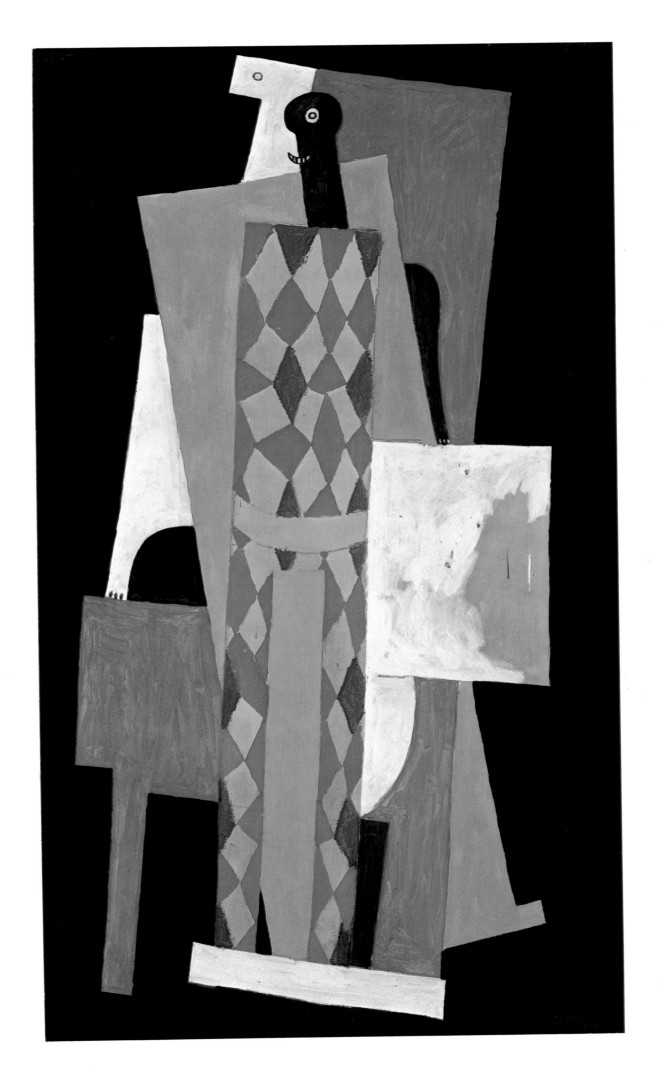

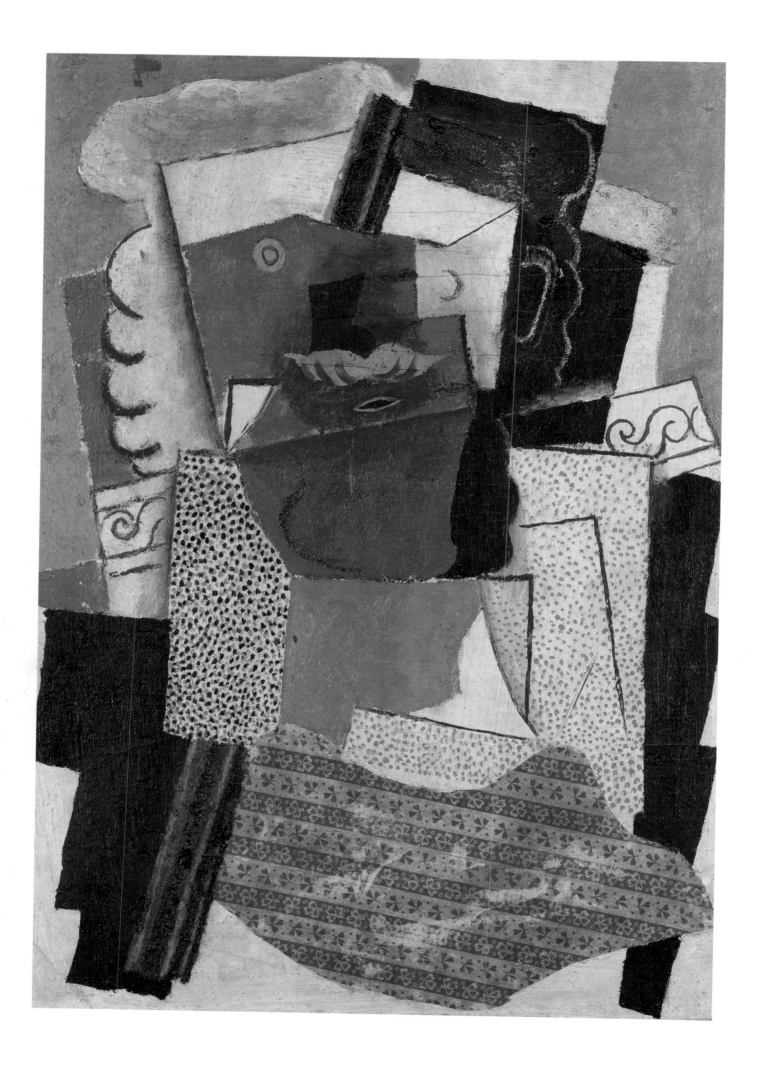

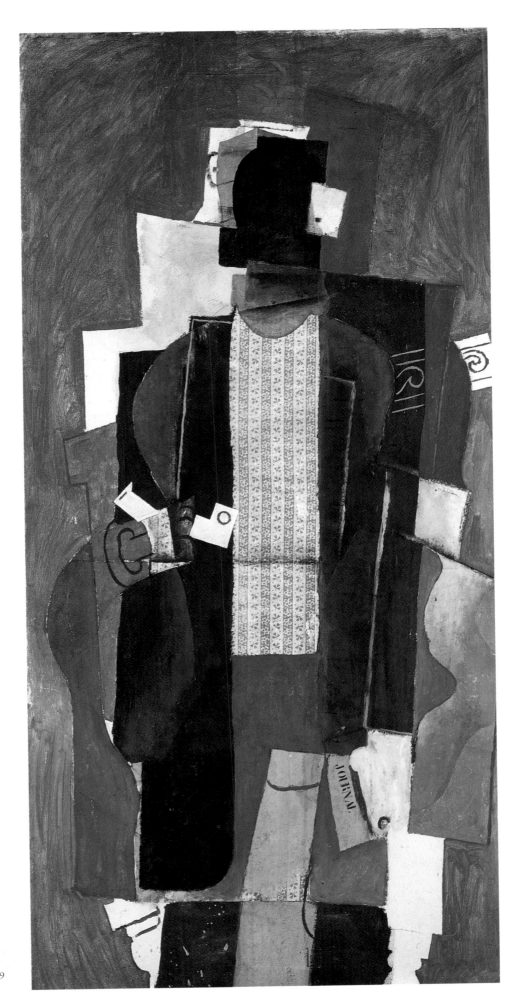

Man with a Moustache
Homme à la moustache
Paris, spring 1914
Oil and glued printed fabric
on canvas, 65.5 x 46.6 cm
Zervos II**, 468; DR 759; MPP 40
Paris, Musée Picasso

Man with a Pipe (The Smoker)
Homme à la pipe (Le fumeur)
Paris, spring 1914
Oil and pasted paper on canvas,
138 x 66.5 cm
Zervos II**, 470; DR 760; MPP 39
Paris, Musée Picasso

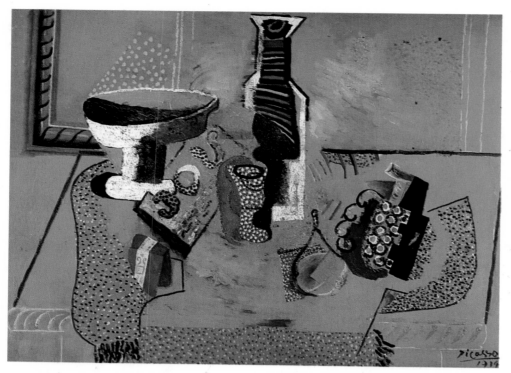

Green Still Life
Nature morte verte
(Compotier, verre, bouteille, fruits)
Avignon, summer 1914
Oil on canvas, 59.7 x 79.4 cm
Zervos II**, 485; DR 778
New York, The Museum of Modern Art,
Lillie P. Bliss Collection

Still Life with Fruit, Glass and Newspaper
Nature morte avec fruits, verre et journal
Paris, summer 1914
Oil and sand on canvas, 34.5 x 42 cm
Zervos II**, 530; DR 781
Washington (DC), Mr. and Mrs. David
Lloyd Kreeger Collection

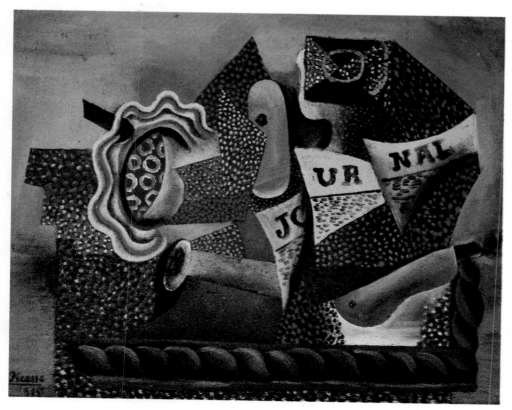

Portrait of a Young Girl
Portrait de jeune fille
(Femme assise devant une cheminée)
Avignon, summer 1914
Oil on canvas, 130 x 96.5 cm
Zervos II**, 528; DR 784
Paris, Musée National d'Art Moderne,
Centre Georges Pompidou

238 Synthetic Cubism 1912 – 1915

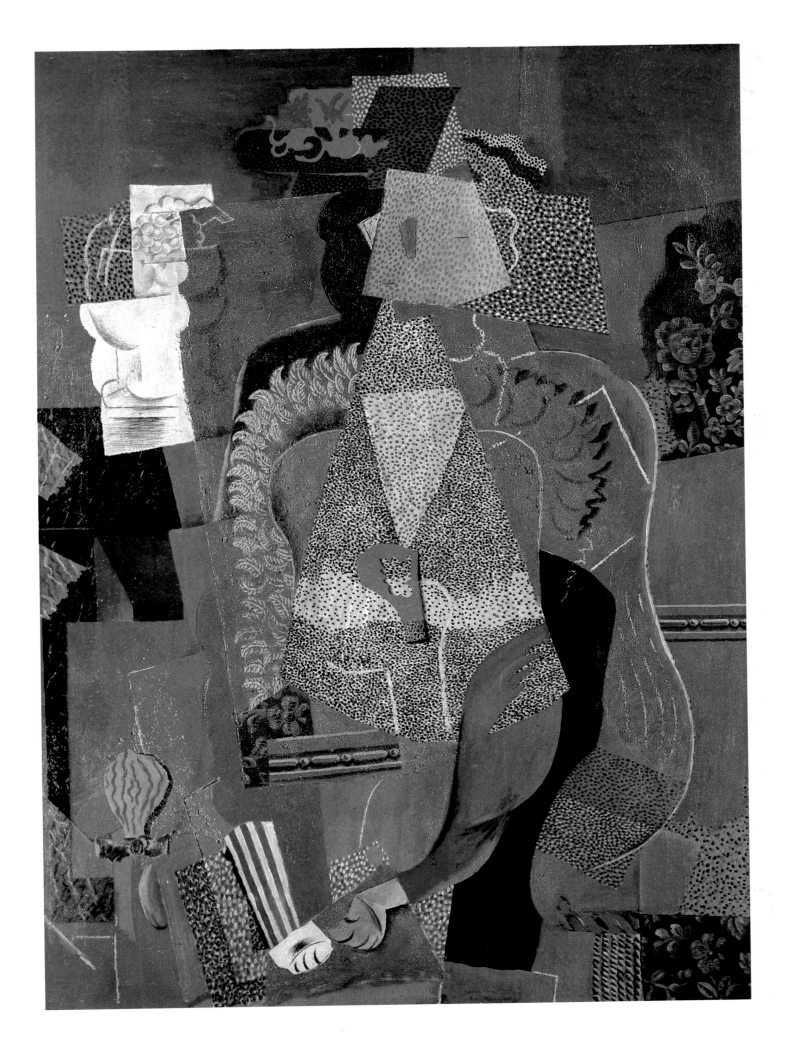

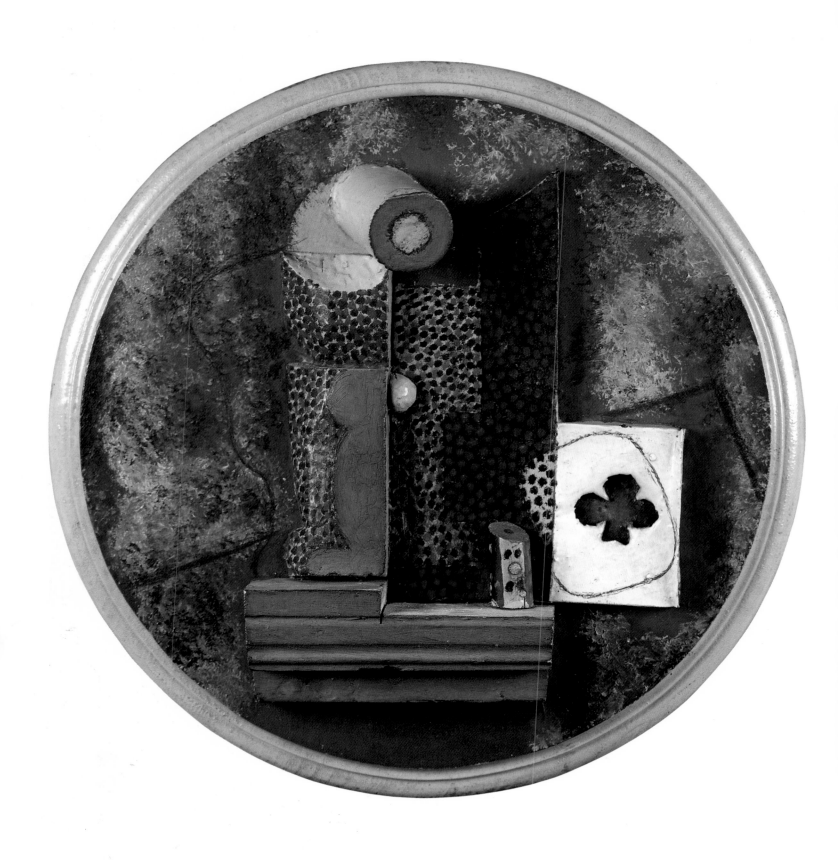

Glass, Pipe, Ace of Clubs and Dice
Verre, pipe, as de trèfle et dé
Avignon, summer 1914
Painted pieces of wood and metal on wooden board,
diameter 34 cm, depth 8.5 cm
Spies 45; Zervos II**, 830; DR 788; MPP 48
Paris, Musée Picasso

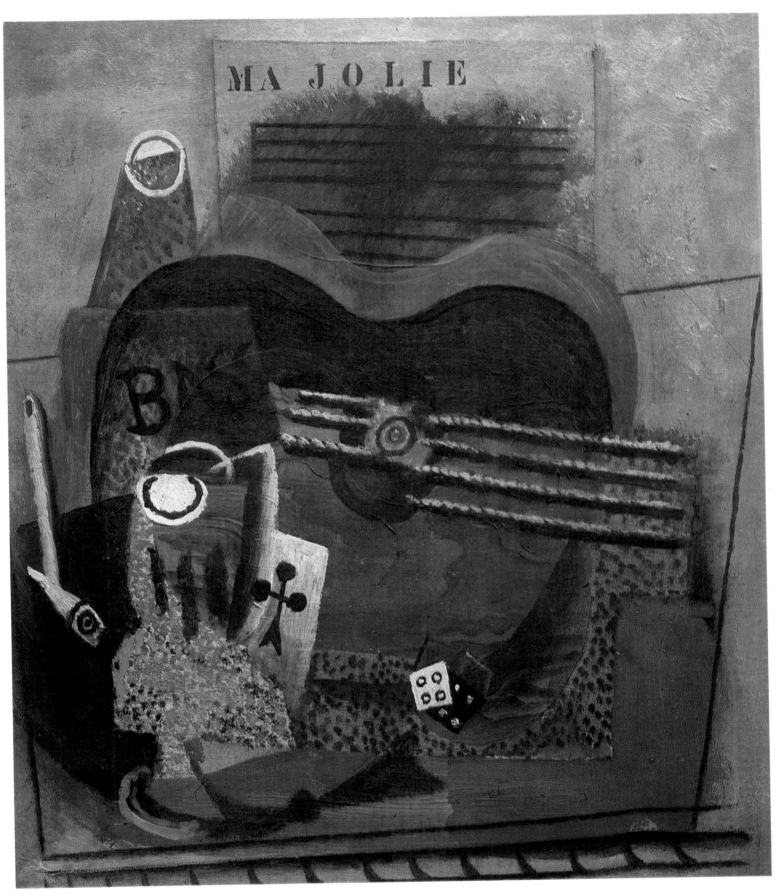

"Ma Jolie"
"Ma Jolie" (Pipe, verre, carte à jouer, guitare)
Paris, (spring) 1914
Oil on canvas, 45 x 41 cm
Zervos II**, 525; DR 742
Geneva, Heinz Berggruen Collection

241

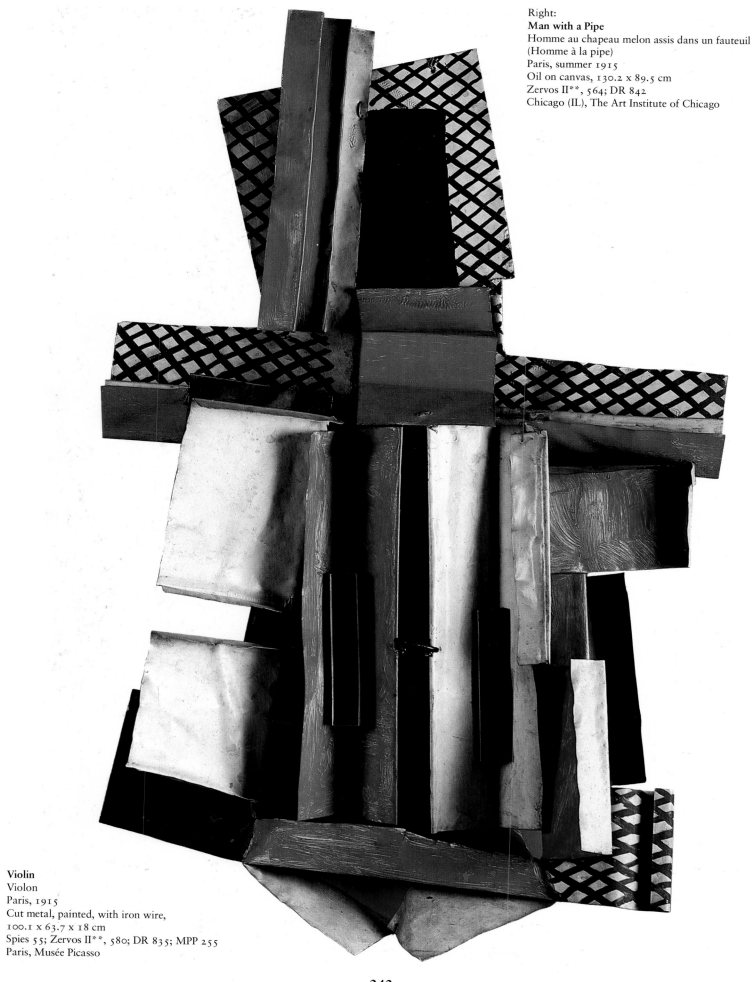

Right:
Man with a Pipe
Homme au chapeau melon assis dans un fauteuil
(Homme à la pipe)
Paris, summer 1915
Oil on canvas, 130.2 x 89.5 cm
Zervos II**, 564; DR 842
Chicago (IL), The Art Institute of Chicago

Violin
Violon
Paris, 1915
Cut metal, painted, with iron wire,
100.1 x 63.7 x 18 cm
Spies 55; Zervos II**, 580; DR 835; MPP 255
Paris, Musée Picasso

242

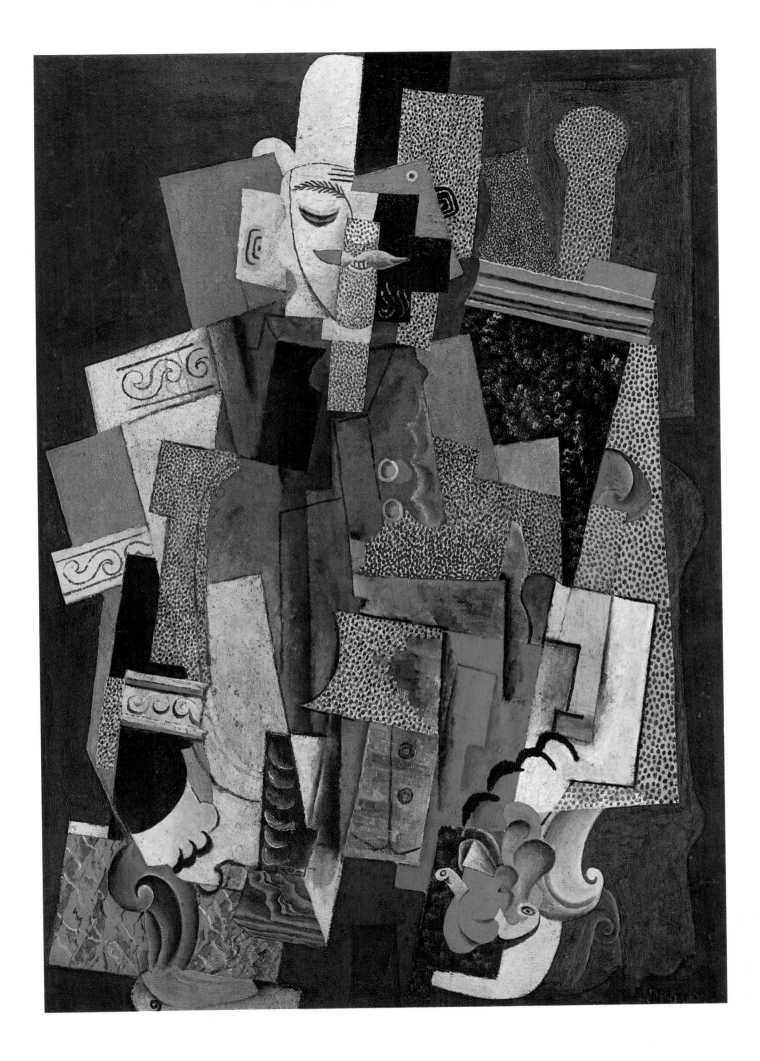

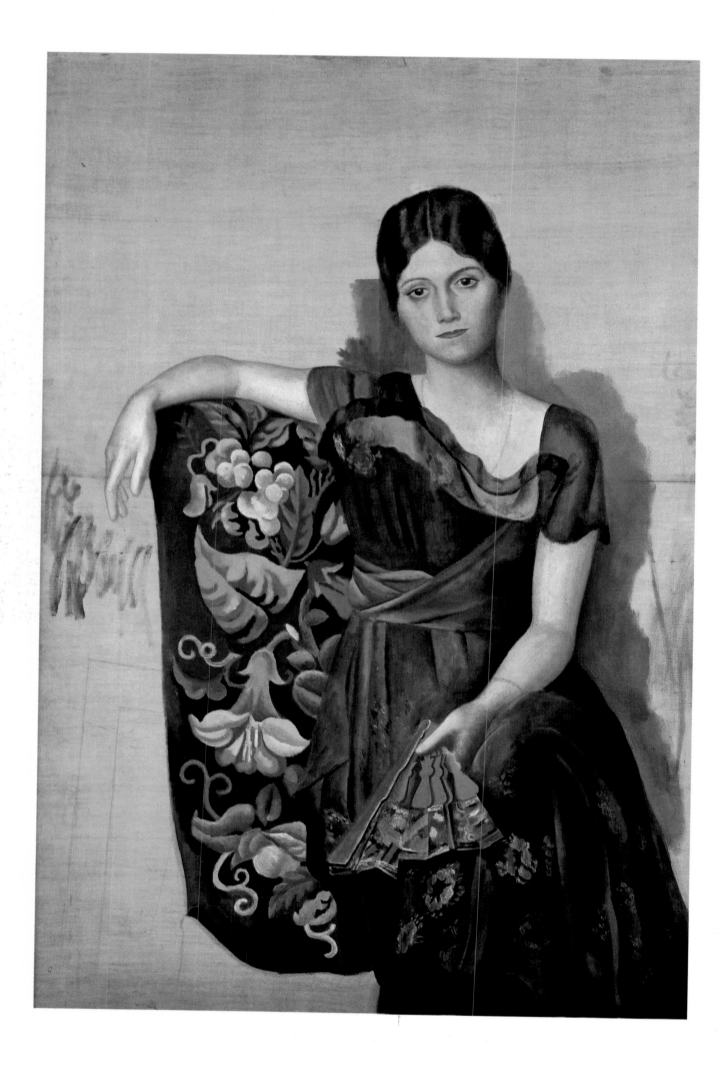

9 The Camera and the Classicist 1916–1924

The work Picasso did from 1916 to 1924 was among the most baffling in his entire output. The public, his critics, and fellow artists were now familiar with him as the founder of Cubism and indeed of modern art, the painter who was most radical and consistent in casting aside the conventional laws of art and putting new rules in their stead. Mimetic copying of the given world could be seen as superseded. But now the great iconoclast bewildered the experts and general public alike by returning to a representational art of a monumental, statuesque kind.

Once again, Picasso's pictures were figural. Wholly in the classical tradition, and in accord with European forms of classicism, they were built on the line as the definition of form, offering generously – fashioned outlines large in conception and volume. But this alone could not have accounted for the confusion of Picasso's contemporaries. His return to tradition could have been dismissed as a relapse.[228] It was not so simple: one and the same artist was painting classicist nudes, portraits, scenes, and works in the spirit of Synthetic Cubism – at first sight quite incompatible – all in the same period. Thus the years from 1916 to 1924 are marked by the coexistence of polar opposites. And yet Picasso's work matched the mood of the age, and pursued his own intentions as an artist.

In August 1914 the First World War began. Braque and Derain, Picasso's closest artist friends, were called up. His dealer Kahnweiler, now an abominated German alien, remained in Switzerland for the duration of the war, and did not return to Paris from his exile until 1920. Apollinaire applied for and was granted French citizenship, so that he could volunteer; both he and Braque were wounded at the front. The poet was allowed back to Paris in 1916 because of his wound; he died in the 1918 'flu epidemic. Meanwhile, Picasso's companion Eva died in 1915[229]. Picasso himself, an established artist, moved in theatre and ballet circles, and thus, from 1916, had an entrée into high society. He knew the aristocracy and did frescoes for the Chilean millionaire Eugenia Errazuriz. He spent bathing holidays at society resorts such as Biarritz and Antibes. He travelled widely throughout Europe. His bohemian days in Montmartre were at an end, for good. And in summer

Olga Picasso in the Studio
(photograph, about 1917)

Portrait of Olga in an Armchair
(after the above photograph)
Portrait d'Olga dans un fauteuil
Montrouge, late 1917
Oil on canvas, 130 x 88.8 cm
Zervos III, 83; MPP 55
Paris, Musée Picasso

Guitar
Guitare
Paris, 1916
Oil on canvas, 54 x 65 cm
Not in Zervos
Private collection

Harlequin and Woman with Necklace
Arlequin et femme au collier
Rome, 1917
Oil on canvas, 200 x 200 cm
Zervos III, 23
Paris, Musée National d'Art Moderne,
Centre Georges Pompidou

Right:
Man Leaning on a Table
Homme accoudé sur une table
Paris, 1916
Oil on canvas, 200 x 132 cm
Zervos II**, 550; DR 889
New York, Private collection

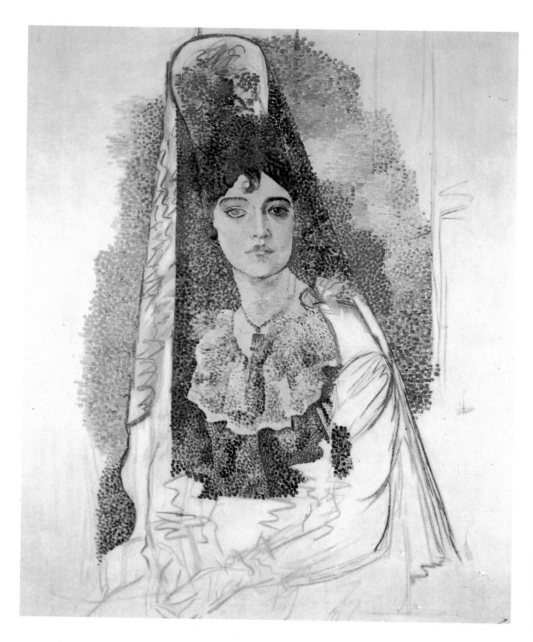

Woman in Spanish Costume (La Salchichona)
Femme en costume espagnol (La Salchichona)
Barcelona, 1917
Oil on canvas, 116 x 89 cm
Zervos III, 45; MPB 110.004
Barcelona, Museu Picasso

1918 he married. The previous year, working on a theatre project, he had met the Russian ballerina Olga Koklova.

Picasso followed her and the Ballets Russes to Rome, then to Madrid and Barcelona, and finally, in 1919, to London. These lengthy stays – eight weeks in Rome, three months in London – provided him with the chance to see more of Europe's heritage. He saw Naples and Pompeii; he saw the originals of the most important works of classical art; and in London he saw the Parthenon frieze, already familiar to him from plaster-cast copying exercises. He relished the masterpieces of the Renaissance in Rome, and took an interest in representations of Italian everyday life and lore which he bought in antique and junk shops.[230]

Changes in the art world accompanied those in his personal life, the current chauvinism influencing views of art too. Before the outbreak of war, in March 1914, Picasso's Rose Period masterpiece, "The Acrobats", had fetched a record price at a Paris auc-

The Peasants' Repast (after Le Nain)
Le retour du baptême (d'après Le Nain)
Paris, autumn 1917
Oil on canvas, 162 x 118 cm
Zervos III, 96; MPP 56
Paris, Musée Picasso

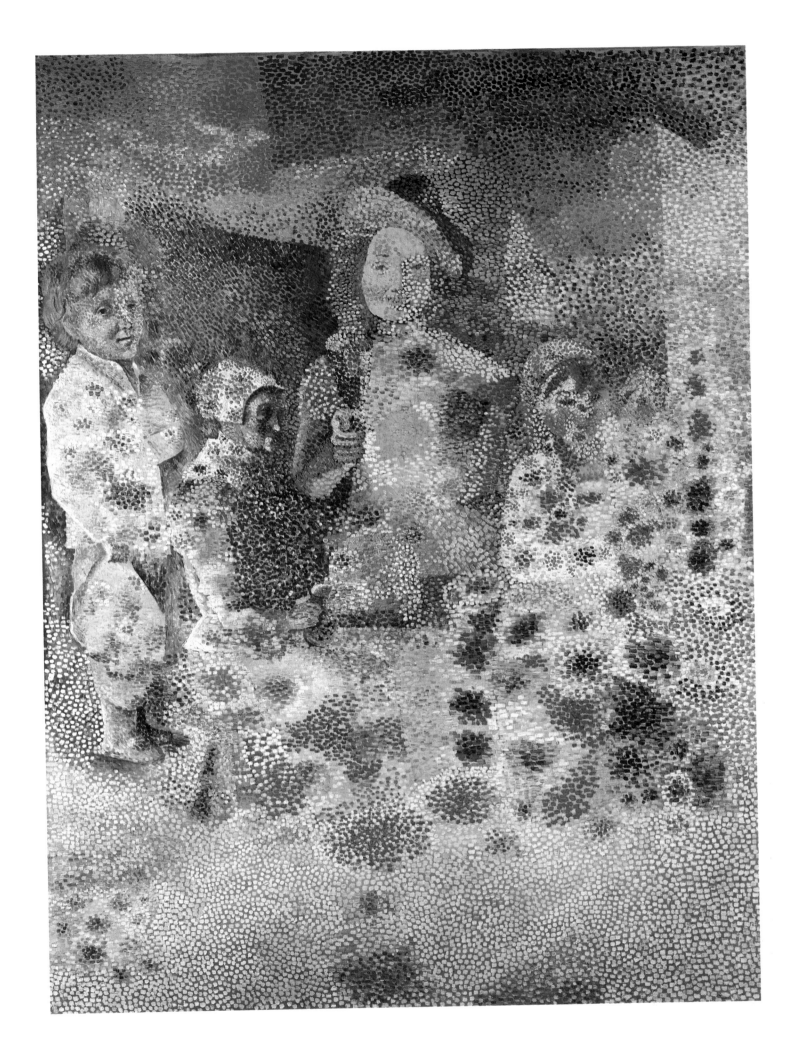

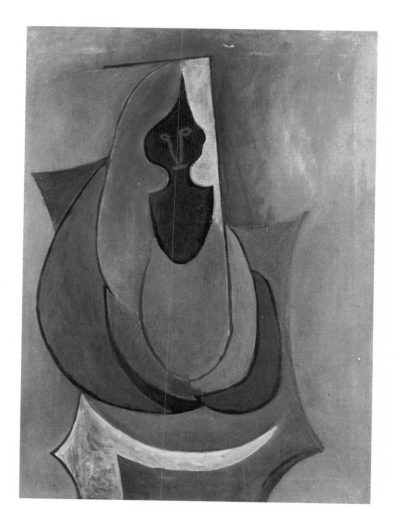

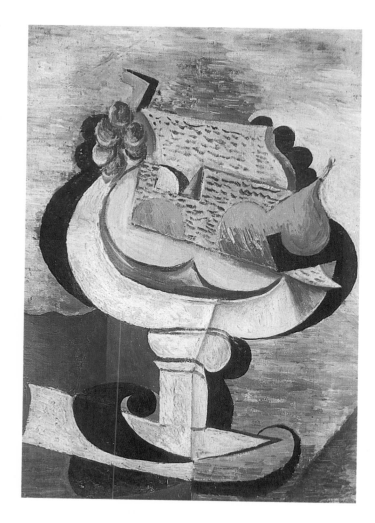

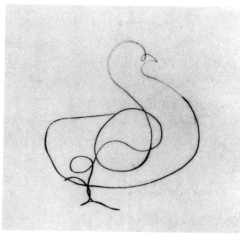

Study of a Cock
Etude d'un coq
Montrouge, 1917
Pencil on paper, 27.8 x 22.6 cm
Zervos III, 92

tion. The buyer was Munich's Thannhauser gallery, and the press spread the notion that the Germans were trying to use the absurd art of a few crazy foreigners to unsettle the art market.[231] Since then, sections of French public opinion had considered Cubism un-French, even an expression of things Teutonic and thus detested.

When the ballet "Parade" was first performed in Paris in 1917, with costumes and set design by Picasso, the audience called the performers "dirty boches".[232] During the war, political cartoons at times portrayed the German Kaiser and German militants as Cubists![233] This may well strike us as bizarre, since Kaiser Wilhelm II was hardly known for his avant-garde tastes, and none of the Cubist artists was German. But there was a tradition of detesting all things "boche", a tradition rooted in the Franco-Prussian War of 1870–71. It peaked in the First World War's victory over the German empire. It was connected with a French sense of classical tradition and an often crude rejection of the modern. France saw itself as the direct descendant of antiquity, the guardian of human values against the barbaric German enemy. Many factors and interests were interwoven with this image, among them campaigns for a restoration of the French monarchy. Not all of these factors were of real significance for the arts, but their effects were felt even among the cosmopolitan, internationalist Parisian avant-garde.[234]

A return to the classical tradition and a revival of classicism re-

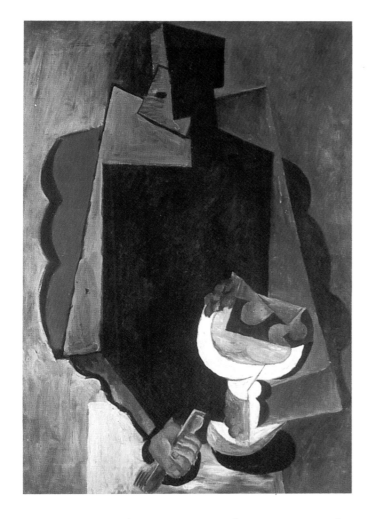
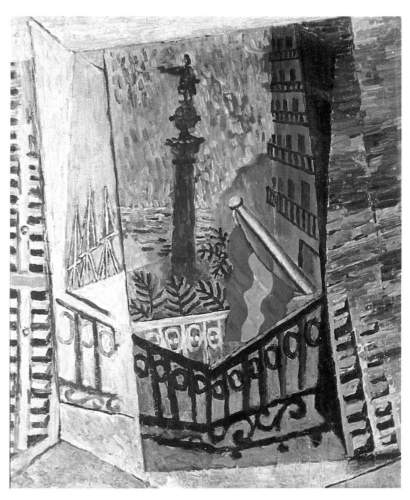

sulted, not only in France: the return to the values of the ancient world was common in all the Mediterranean countries. French Cubists such as Braque and Léger, but also the Italian Futurist Gino Severini, and Giorgio de Chirico, the foremost artist of "pittura metafisica", returned to the repertoire of classical styles and subjects.[235] Barcelona had its classicism too, "Noucentisme", as Picasso found when he went to Spain in 1917: "The Barcelona Harlequin" (p. 256), in the Museu Picasso, suggests as much.[236] Interestingly, Apollinaire's 1917 defence of Cubism in the "Mercure de France" is also of a classical bent, stressing the "Latin" side of Cubist art.[237]

It is certain that these years of Modernism were by no means of a piece. Léger, for instance, was trying to combine the achievements of Cubism with classical forms, in order to place art at the service of political aims and take the side of the workers in the debates of the day. He was not alone in this. It was one of the main international currents in art in the 1920s: we need only recall George Grosz in Germany or Diego Rivera in Mexico, or even the utopias of radically abstract art.[238] And then there was a further, strong move towards rendering the formal features of avant-garde art purely decorative and thus combining it with a continuation of *art nouveau*. This particular line of evolution peaked in the great Paris arts and crafts exhibition of 1925, the abbreviated title of which gave this form its name – "Art deco".[239]

Seated Woman in an Armchair
Femme assise dans un fauteuil
Barcelona, 1917
Oil on canvas, 116 x 89.2 cm
Zervos III, 49; MPB 110.003
Barcelona, Museu Picasso

Bowl of Fruit
Compotier
Barcelona, 1917
Oil on canvas, 40 x 28.1 cm
Zervos III, 46; MPB 110.029
Barcelona, Museu Picasso

Figure with Bowl of Fruit
Personnage avec compotier
Barcelona, 1917
Oil on canvas, 100 x 70.2 cm
Zervos III, 48; MPB 110.006
Barcelona, Museu Picasso

View of the Columbus Memorial
Vue sur le monument de Colomb
Barcelona, 1917
Oil on canvas, 40.1 x 32 cm
Zervos III, 47; MPB 110.028
Barcelona, Museu Picasso

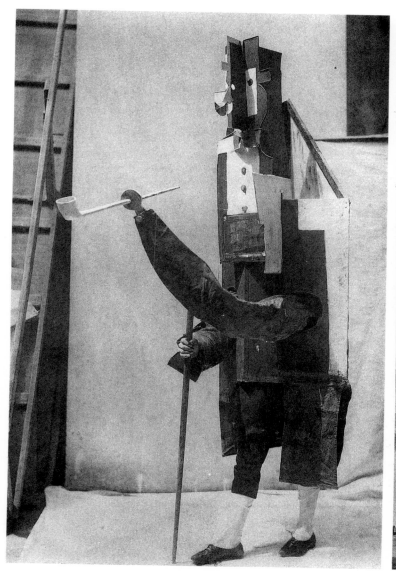

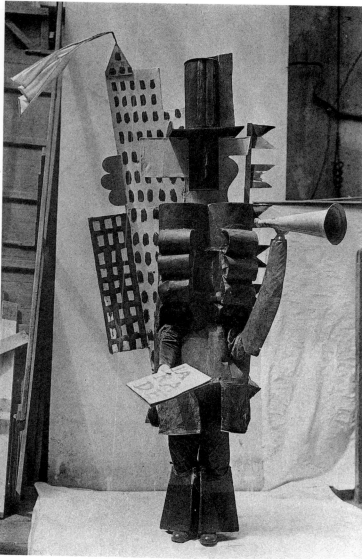

Remarkably enough, Picasso was very interested in the applied arts at that time, primarily in art design for the theatre. From 1916 to 1924 he was involved in no fewer than eight ballet or drama productions.[240] The first of these – designs for the curtain, set and costumes of the ballet "Parade" – was also the most important. In 1915 he had met the writer Jean Cocteau, who had an idea for a new ballet and had interested Sergei Diaghilev, the head of the Ballets Russes, in it. The avant-garde composer Erik Satie was engaged to write the music, and Picasso to design the ballet.

Though he had abandoned figural work in his Cubist phase, Picasso accepted the challenge. What decided him was Cocteau's concept, blending theatre, variety show and circus with technological features of modern city life. A travelling circus was to appear as a play within the play, accompanied by wailing sirens, clattering typewriters and public address voices. This idea derived from Futurist theatre but also from the tradition of circus images established since Toulouse-Lautrec, Seurat, and the Rose Period of Picasso.[241] He worked together with Cocteau, Satie and choreographer Léonide Massine, evolving an overall concept that adapted

"Parade": Costume of the French Manager
"Parade": Costume de manager français
Paris, 1917
Cardboard and cloth, painted,
approx. 200 x 100 x 80 cm
Spies 59; Zervos II**, 962
Original destroyed (photo dated 1917)

"Parade": Costume of the American Manager
"Parade": Costume de manager américain
Paris, 1917
Cardboard and cloth, painted,
approx. 200 x 100 x 80 cm
Spies 60; Zervos II**, 964
Original destroyed (photo dated 1917)

Cocteau's original idea somewhat. It was a chance for Picasso to marry Cubist style and figural representation in a novel way.

The curtain, an immense tableau, was such a marriage (cf. below and pp. 254–255). It shows a group of seven people in front of a theatre set; an eighth, a girl acrobat, is balancing on a white mare at left. The wings of the mythic Pegasus have been strapped onto the horse, who, licking her foal, seems unimpressed. The harlequin, torero, lovers, sailor and equilibrist are all familiar from Picasso's earlier work. They are presented two-dimensionally, with an emphasis on outline and in a manner plainly influenced by Picasso's collage work. Yet there is enough shadow and light in the scene to give an audience seated at some distance a distinctly evocative sense of spatial depth, combined with the Cubist effect of two-dimensionally flattened illusionist means of representation.

Plurality of styles remains a feature of Picasso's designs throughout. The costumes echo conventional clothing, as in the American girl's pleated skirt and sailor jacket. They use additive combinations of decorative items conceived in a two-dimensional spirit, but they also employ the means of Synthetic Cubism. This is particularly striking in the figures of the French and American managers (p. 252). Both figures are about three metres high, formed from various surfaces of painted papier maché, wood, cloth and even metal, slotted and notched into each other. The motifs – skyscrapers, Parisian boulevard trees – suggest the countries the managers come from, and underpin the Futurist principle of simultaneity. The managers are the formal idiom of Cubism in motion as they stomp their robotic way across the stage, personifying the mechanization and inhumanity of modern life.[242]

Self-portrait
Autoportrait
London, May to June 1919
Pencil and charcoal on paper, 64 x 49.5 cm
Zervos XXIX, 309; MPP 794
Paris, Musée Picasso

Design for the Curtain of "Parade"
Projet pour le rideau de "Parade"
Montrouge, 1917
Pencil on paper, 24.7 x 30 cm
Zervos II**, 949; MPP 1556
Paris, Musée Picasso

Pages 254/255:
Curtain for "Parade"
Le rideau de "Parade"
Paris, 1917
Tempera on cloth, 10.6 x 17.25 m
Zervos II**, 951
Paris, Musée National d'Art Moderne,
Centre Georges Pompidou

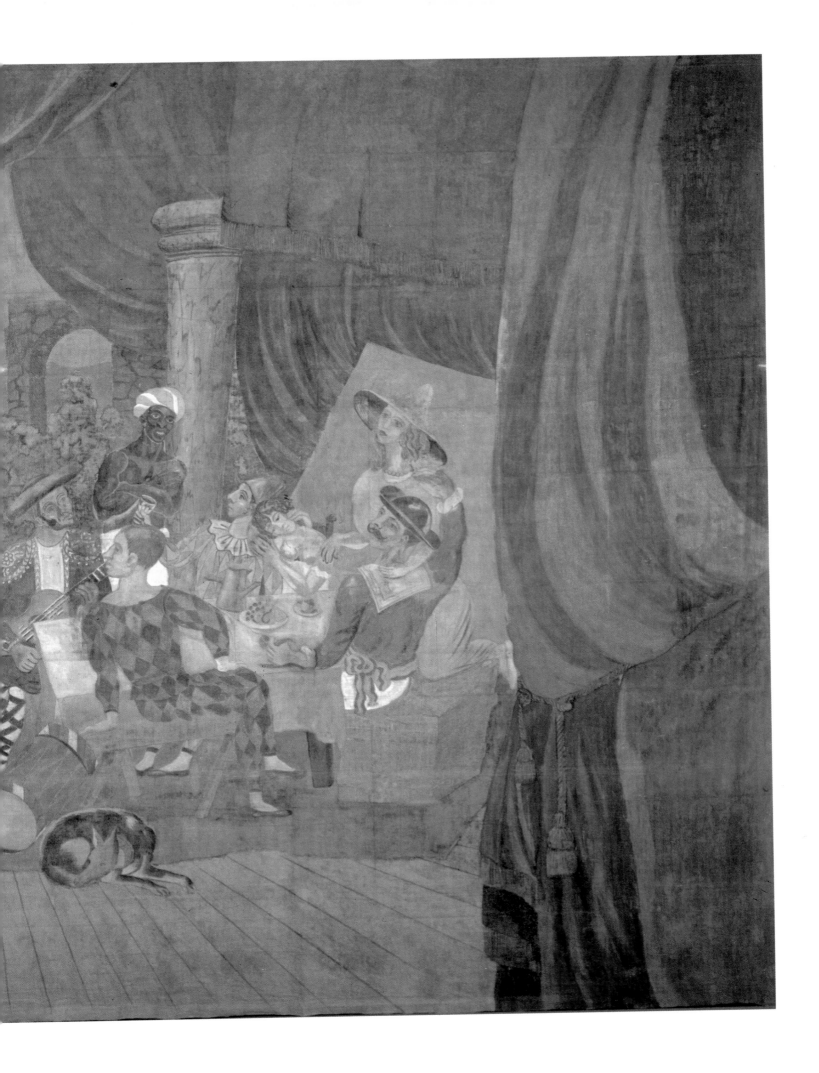

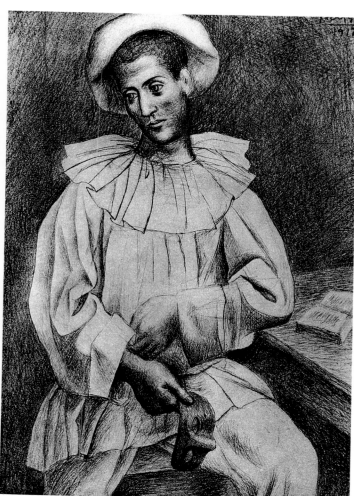

256 The Camera and the Classicist 1916 – 1924

Harlequin with Violin ("Si tu veux")
Arlequin au violon ("Si tu veux")
Paris, 1918
Oil on canvas, 142 x 100.3 cm
Zervos III, 160
Cleveland (OH), The Cleveland Museum
of Art

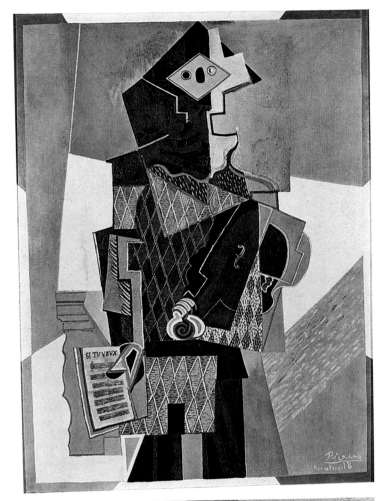

Pierrot with a Mask
Pierrot
Paris, 1918
Oil on canvas, 92.7 x 73 cm
Zervos III, 137
New York, The Museum of Modern Art

Harlequin Playing a Guitar
Arlequin à la guitare
Paris, 1918
Oil on panel, 35 x 27 cm
Zervos III, 158
Geneva, Heinz Berggruen Collection

Harlequin Playing a Guitar
Arlequin jouant de la guitare
Paris, 1918
Oil on canvas, 97 x 76 cm
Zervos II**, 518; DR 762
Basel, Private collection

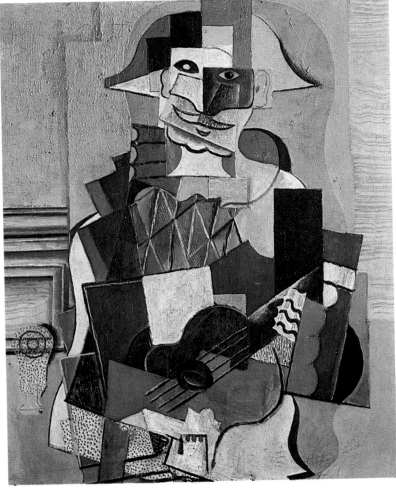

The Barcelona Harlequin
L'arlequin de Barcelone
Barcelona, 1917
Oil on canvas, 116 x 90 cm
Zervos III, 28; MPP 10.941
Barcelona, Museu Picasso

Pierrot with Mask
Pierrot au loup
Montrouge, 1918
Pencil on paper, 31 x 23 cm
Zervos III, 130

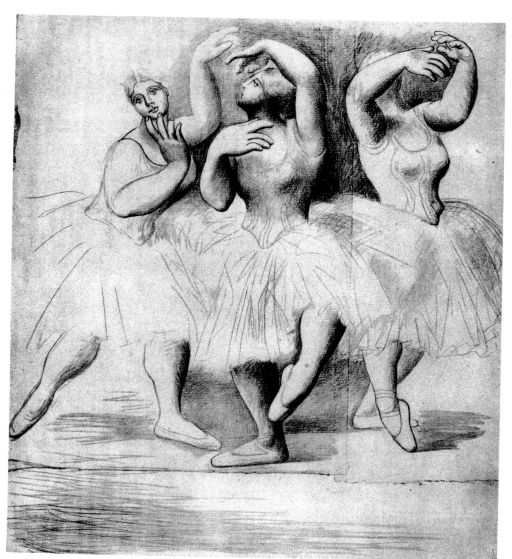

Three Dancers
Trois danseuses
London, 1919
Pencil on paper (three sheets glued together),
37 x 32.5 cm
Zervos XXIX, 432; MPP 840
Paris, Musée Picasso

Seven Dancers
(after a photograph; Olga in the foreground)
Sept danseuses
London, summer 1919
Ink on paper, 26.3 x 39.5 cm
Zervos III, 355
Estate of Jacqueline Picasso

Seven Dancers
(after a photograph; Olga in the foreground)
Sept danseuses
London, early 1919
Pencil on paper, 62.2 x 50 cm
Zervos III, 353; MPP 841
Paris, Musée Picasso

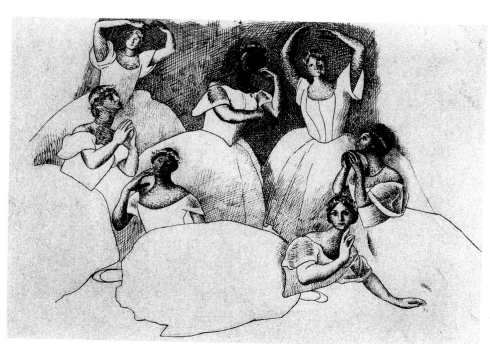

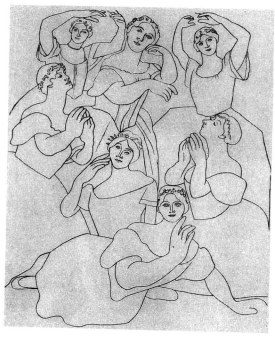

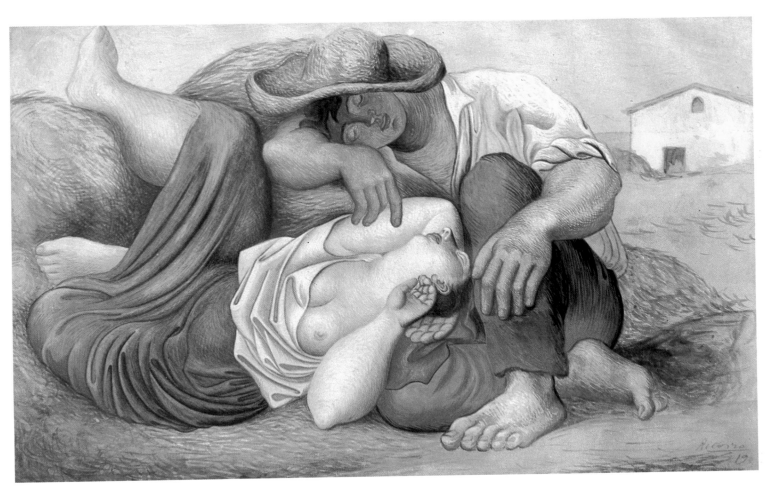

Sleeping Peasants
La sieste
Paris, 1919
Tempera, watercolour and pencil, 31.1 x 48.9 cm
Zervos III, 371
New York, The Museum of Modern Art,
Abby Aldrich Rockefeller Bequest

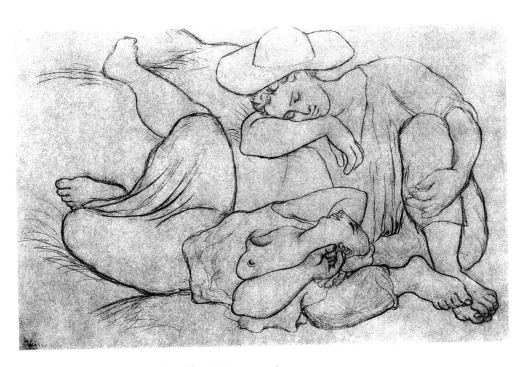

Study for "Sleeping Peasants"
Etude pour "La sieste"
Paris, 1919
Pencil on paper, 30 x 45.2 cm
Zervos III, 369

259 The Camera and the Classicist 1916 – 1924

Landscape with a Dead and a Living Tree
Paysage à l'arbre mort et vif
Paris, 1919
Oil on canvas, 49 x 64 cm
Zervos III, 364
Tokyo, Bridgestone Museum of Art

Picasso's designs for "Parade" were very complex. The classicist curtain can be read as a statement of the newly-awakened avant-garde interest in classical Latinate culture.[243] But the Cubist shapes, then widely detested, courted controversy. In the eyes of fellow artists, Picasso's "Parade" provided exemplary solutions to questions that were then interesting many artists throughout Europe, questions of how to create a new unity out of performance, choreography, music, set design and costumes. Robert and Sonia Delaunay, Marcel Duchamp, and Oskar Schlemmer did comparable work.[244]

This tenacious use of every possible stylistic option did not recur in Picasso's later stage designs. In 1919 he designed "Le Tricorne", a ballet set in 18th-century Spain. The curtain showed bullfight spectators, the stage set a stylized, two-dimensional landscape. The costumes (pp. 266–267) drew upon traditional Spanish costumes; though the combined frontal and upward angles of vision owe something to Cubism, the dominant note is superficial, decorative.[245] The same applies to "Pulcinella", a ballet with music by Stravinsky and choreography by Massine, produced in 1920. Picas-

so, in obedience to his commission, drew mainly on the Commedia dell'arte for his ideas. His stage set offered a view through the auditorium of a baroque theatre onto Naples by night.[246] In 1921 he used rejected "Pulcinella" designs for the ballet "Cuadro Flamenco".

During the work on "Pulcinella" disputes broke out between the artist and the theatre, and in 1922 they almost severed relations when Picasso came up with a near-abstract set design for "L'Après-midi d'une faune". This replaced designs by Léon Bakst which had been lost; Diaghilev turned it down.[247] Not until 1924 did they work together again, when Picasso designed the curtain for another ballet, "Le Train bleu" (p. 292). This in a sense marked the nadir of Picasso's involvement with the theatre, in that the design was merely an enlargement of "Women Running on the Beach", a watercolour he had done in summer 1922[248]. The same year, however, he successfully married choreography and plot in his designs for a production of "Mercure". Like "Parade", this production again used the talents of Satie and Massine – though its success was doubtless due also to the ballet itself, which viewed antiquity

Still Life with a Guitar on a Table
in Front of an Open Window
La table devant la fenêtre
Saint-Raphaël, summer 1919
Gouache on paper, 31 x 22.2 cm
Zervos III, 401
Galerie Rosengart

Still Life in Front of a Window at Saint-Raphaël
Nature morte devant une fenêtre à Saint-Raphaël
Saint-Raphaël, summer 1919
Gouache and pencil on paper, 35.5 x 24.8 cm
Zervos III, 396
Geneva, Heinz Berggruen Collection

Pages 262 and 263:
The Bathers
Les baigneuses
Biarritz, summer 1918
Oil on canvas, 26.3 x 21.7 cm
Zervos III, 237; MPP 61
Paris, Musée Picasso

The Family of Napoleon III
(after a photograph)
La famille de Napoléon III
Paris, 1919. Pastel on paper, 62 x 48 cm
Not in Zervos. Private collection

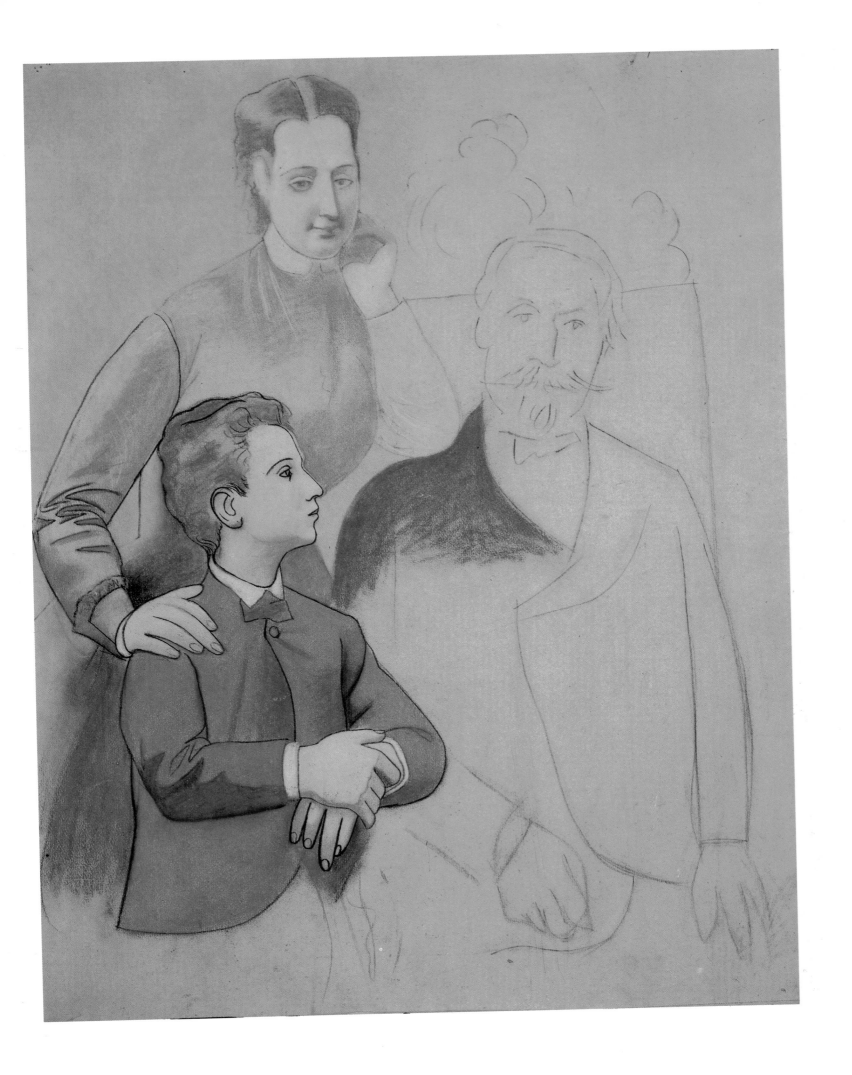

Still Life with Pitcher and Apples
Nature morte au pichet et aux pommes
Paris, 1919
Oil on canvas, 65 x 43 cm
Not in Zervos; MPP 64
Paris, Musée Picasso

Basket of Fruit
Corbeille de fruits
Paris, 1918
Oil on plywood, 47.5 x 61.5 cm
Not in Zervos
Estate of Jacqueline Picasso

Still Life with Pitcher and Bread
Nature morte avec pichet et pain
Fontainebleau, 1921
Oil on canvas, 101 x 128 cm
Zervos IV, 285
Paris, Baron E. de Rothschild Collection

The Camera and the Classicist 1916 – 1924 **264**

1

2

3

4

5

6

7

8

9

10

11

12

13

14

15

Costume Designs for the Ballet "Le Tricorne"
London, before 22 July 1919
Gouache, India ink and pencil on paper;
various formats
Paris, Musée Picasso

Ballet by Léonide Massine, after a novella
by Pedro de Alarcón. Music: Manuel de Falla.
Curtain, set and costumes: Pablo Picasso.
Performed by Sergei Diaghilev and his
"Ballets Russes".
Première: 22 July 1919,
Alhambra Theatre, London

1 "Le Tricorne": A Woman
Gouache and pencil on paper, 22.2 x 17.4 cm
Zervos XXIX, 401; MPP 1706

2 "Le Tricorne": A Woman
Pencil on paper, 25 x 16 cm
Zervos XXIX, 393; MPP 1700

3 "Le Tricorne": A Woman
Gouache, India ink and pencil, 22.5 x 17.5 cm
Zervos XXIX, 403; MPP 1705

4 "Le Tricorne": A Man
Gouache and pencil on paper, 22.5 x 17.5 cm
Zervos XXIX, 377; MPP 1695

5 "Le Tricorne": A Muleteer Carrying a
Sack of Flour
Gouache and pencil on paper, 26 x 19.7 cm
Zervos XXIX, 402; MPP 1688

6 "Le Tricorne": A Man from Aragon
Gouache and pencil on paper, 27 x 19.8 cm
Zervos III, 331; MPP 1685

7 "Le Tricorne": A Picador
Gouache and pencil on paper, 26.5 x 19.7 cm
Zervos III, 311; MPP 1691

8 "Le Tricorne": A Bailiff
Gouache, India ink and pencil on paper,
27 x 19.7 cm. Zervos III, 329; MPP 1682

9 "Le Tricorne": The Blue-Bearded Peasant
Gouache and pencil on paper, 27 x 19.5 cm
Zervos III, 332; MPP 1699

10 "Le Tricorne": An Old Man on Crutches
Gouache and pencil on paper, 26.5 x 19.7 cm
Zervos III, 335; MPP 1698

11 "Le Tricorne": A Lunatic
Gouache and pencil on paper, 26 x 19.8 cm
Zervos III, 317; MPP 1693

12 "Le Tricorne": The Miller
Gouache and pencil on paper, 26 x 19.5 cm
Zervos III, 320; MPP 1687

13 "Le Tricorne": The Partner of the Woman
from Seville
Gouache and pencil on paper, 27 x 20 cm
Zervos III, 313; MPP 1696

14 "Le Tricorne": The Mayor
Gouache, India ink and pencil on paper,
22,2 x 17.3 cm. Zervos XXIX, 380; MPP 1679

15 "Le Tricorne": The Chief Magistrate
Gouache and pencil on paper, 23.1 x 17.5 cm
Zervos XXIX, 379; MPP 1677

268 The Camera and the Classicist 1916 – 1924

Landscape near Juan-les-Pins
Paysage de Juan-les-Pins
Juan-les-Pins, summer 1920
Oil on canvas, 48 x 68 cm
Zervos IV, 107; MPP 68
Paris, Musée Picasso

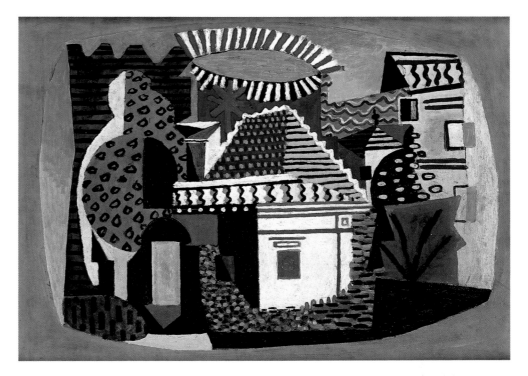

Studies
Etudes
Paris, 1920
Oil on canvas, 100 x 81 cm
Zervos IV, 226; MPP 65
Paris, Musée Picasso

Left:
Portrait of Léonide Massine
Portrait de Léonide Massine
London, May to June 1919
Pencil on paper, 38 x 29 cm
Zervos III, 297
Chicago (IL), The Art Institute of Chicago

Portrait of Sergei Diaghilev and Alfred Seligsberg
(after a photograph)
Portrait de Serge Diaghilev et d'Alfred Seligsberg
London, early 1919
Charcoal and pencil on paper, 63.5 x 49.6 cm
Zervos III, 301; MPP 839
Paris, Musée Picasso

Portrait of Pierre-Auguste Renoir
(after a photograph)
Portrait de Pierre-Auguste Renoir
Paris, winter 1919
Pencil and charcoal on paper, 61 x 49.3 cm
Zervos III, 413; MPP 913
Paris, Musée Picasso

Portrait of Igor Stravinsky
(after a photograph)
Portrait d'Igor Stravinsky
Paris, 24 May 1920
Pencil on paper, 61.5 x 48.5 cm
Zervos IV, 60; MPP 911
Paris, Musée Picasso

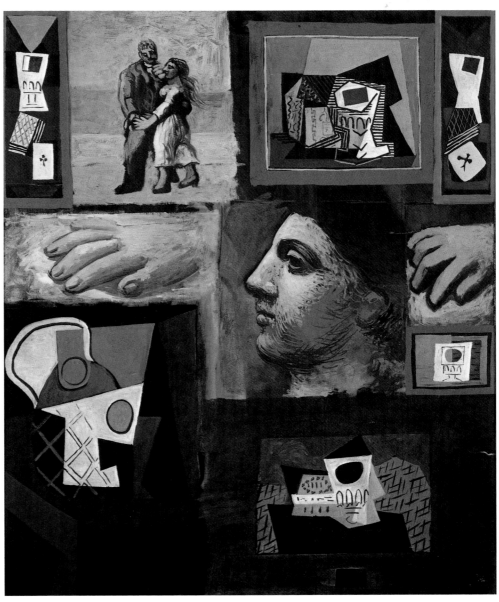

269 The Camera and the Classicist 1916–1924

through the caricaturist style of Dadaist farce and afforded ample leeway for formal experimentation.

Picasso's curtain showed a harlequin playing a guitar and a pierrot with a violin. The lines and colour areas were sharply at variance; the colour zones did not coincide with the outlines of the figures. For the stage action, Picasso devised similar constructions which were called "practicables". They consisted of various panels cut to size, with figures of a geometrical/constructivist or simply playfully representational nature attached to them with wire. These "practicables" were moved by actors who remained unseen, so that three-dimensional poses could be struck outside the parameters of conventional choreography.[249]

Picasso had already created the visual form of these line-and-surface figures in 1918 or 1919. His work on "Mercure" was as closely related to independent painting and drawing as his designs for "Parade". Evidently Picasso's theatre designs were aimed at establishing new directions in the art. But the limits that were set by functional necessity and prescription were more than he would gladly put up with. Only twice were his ideas even remotely successfully adopted in practice, and in the early 1920s his interest in theatrical collaboration faded. His contribution to Cocteau's 1922 adaptation of "Antigone" consisted solely of a pared-back set design: three sketchy Doric columns on white wooden panelling. This was in line with Cocteau's call for classical simplicity, and indeed with the prevailing ideas of the time; but "Parade" and "Mercure" show just how much greater was the range covered by Picasso's own ideas.

It would be wrong to see his interest in the applied arts and the influence of a classicizing mood in the arts in France as the main cause of Picasso's own classicism. His concern for original classical artworks was in fact a return to models that had always been sig-

Sisley and His Wife
(after a painting by Renoir)
Le ménage Sisley
Paris, late 1919
Pencil on paper, 31 x 21.8 cm
Zervos III, 429
Geneva, Heinz Berggruen Collection

Sisley and His Wife
(after a painting by Renoir)
Le ménage Sisley
Paris, late 1919
Pencil on paper, 31 x 23.8 cm
Zervos III, 428; MPP 868
Paris, Musée Picasso

Italian Peasants
(after a photograph)
Paysans italiens
Paris, 1919
Pencil and charcoal on paper, 59 x 46.5 cm
Zervos III, 431
Santa Barbara (CA),
The Santa Barbara Museum of Art

The Lovers
Les amoureux
Paris, 1919
Oil on canvas, 185 x 140.5 cm
Zervos III, 438; MPP 62
Paris, Musée Picasso

The Schoolgirl
L'écolière
Paris, 1919
Oil on canvas, 93 x 75 cm
Not in Zervos
Douglas Cooper Collection

Girl with a Hoop
Fillette au cerceau
Paris, 1919
Oil and sand on canvas, 142 x 79 cm
Zervos III, 289
Paris, Musée National d'Art Moderne,
Centre Georges Pompidou

nificant for him. And during his Cubist years, for instance, he had repeatedly painted variations on works by Ingres, the great classicist.[250] There were many sides to Picasso's classicism.

The inadequacy of any one-sided view can be readily seen if we grasp the irreconcilability of his own works with the European classical ideal in art. Historically, classicism pledged explicit allegiance to the aesthetics of ancient Greece, implying a style of representation best described as idealized naturalism, a style that fundamentally took its bearings in mimetic fashion but aimed to beautify the image through symmetry and balanced proportions. The human form was always at the heart of classical art.[251] This remark applies to Picasso's work from 1916 to 1924 as well, of course. The human image is central to his work, the tendency to monumentalize it unmistakable. But symmetry and balanced proportions, those determining features of an idealizing treatment of natural form, are conspicuous not merely by their absence but by Picasso's constant refutation of them. He paints scenes; he paints heavy, three-dimensionally modelled nudes; but in contrast to classical tradition his treatment ignores principles of balance and

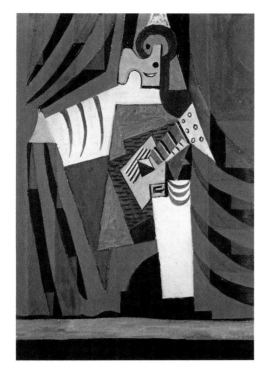

Pulcinella with a Guitar
Pulcinella à la guitare
Paris, 1920
Gouache and India ink on paper, 15.4 x 10.5 cm
Zervos IV, 66
France, Private collection

goes for monstrous and disproportioned physical mass. Classicist painters such as Ingres violated the natural physical proportions of the human body, it is true, but they were aiming at overall compositional harmony. That was quite manifestly not Picasso's goal.[252]

On the other hand, the dichotomies within his work are less gaping than might appear on a cursory first inspection. Back in 1914, his late Synthetic Cubism pictures were conventionally composed, plainly focussed on the centre. In pictures such as "Man with a Pipe (The Smoker)" (p. 237), a mixed-media work using oil and pasted paper, Picasso produced a figural image despite the use of various materials and an abstractive style. While the 1915 "Harlequin" (p. 235) transferred the appearance of collage and *papier collé* to work in oil, Picasso also reverted in that painting to the formal norms and techniques of representational art. The harlequin of the title is the main (if transfigured) subject, and thus central to the composition. The other zones of colour define the figure in a perfectly traditional manner, against a clear background.

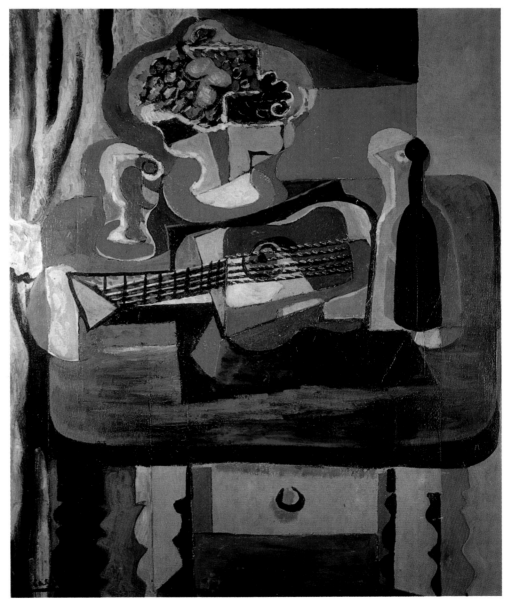

Guitar, Bottle, Fruit Dish and Glass on a Table
Guitare, bouteille, compotier et verre sur une table
Paris, 1919
Oil on canvas, 100 x 81 cm
Zervos III, 165
Geneva, Heinz Berggruen Collection

273 The Camera and the Classicist 1916 – 1924

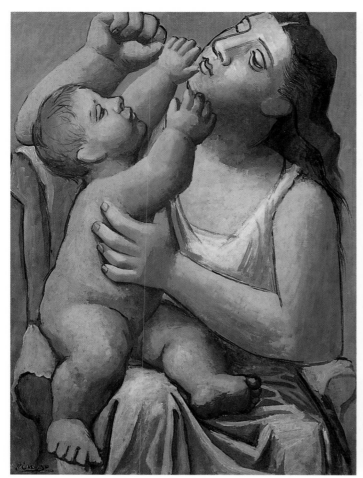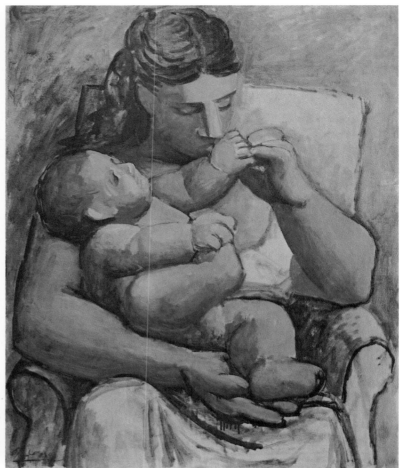

Mother and Child
Mère et enfant
Fontainebleau (?), 1921
Oil on canvas, 97 x 71 cm
Zervos IV, 289
Private collection

Mother and Child
Mère et enfant
Fontainebleau, 1921
Oil on canvas, 102.1 x 83.5 cm
Not in Zervos
Private collection

Picasso was exchanging the two poles of formal visual definition, the mimetic and the Cubist. This exchange was a return to first principles. A return seems logical since Cubism could go no further. To attempt to go on would have meant adopting total abstraction – a step that other artists did take at the time.

A new visual medium prompted Picasso's return: photography. Hitherto, this is a consideration that has been too little taken into account by Picasso's critics. Yet Picasso was an enthusiastic photographer as far back as Cubist days. He took a great many photographs of his studio, friends and fellow artists.[253] Though photography initially served merely to establish a documentary record, as pictures of paintings in different stages of completion suggest, Picasso will inevitably have noticed the distinctive features of the photographic image. The "Portrait of Olga in an Armchair" (p. 244) painted in 1917, the 1923 "Paul, the Artist's Son, on a Donkey" (p. 286), his studies of dancers (Olga among them: cf. p. 258) and of Diaghilev and Alfred Seligsberg or Renoir (p. 268), were all painted or drawn from photographs. Nor must we forget his many copies and variations of works of art seen in photographic reproduction, such as "Italian Peasants" or "Sisley and His Wife" (p. 270).[254] Line studies predominate among these works, reduced to essentials and almost completely disregarding shades of colours or indications of volume.

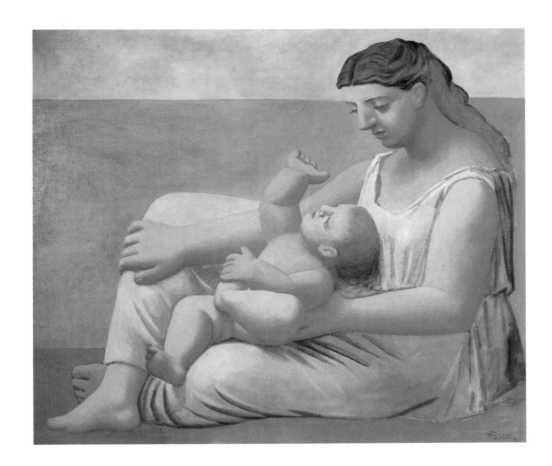

Woman and Child on the Seashore
Femme et enfant au bord de la mer
1921
Oil on canvas, 143 x 162 cm
Zervos IV, 311
Chicago (IL), The Art Institute of Chicago

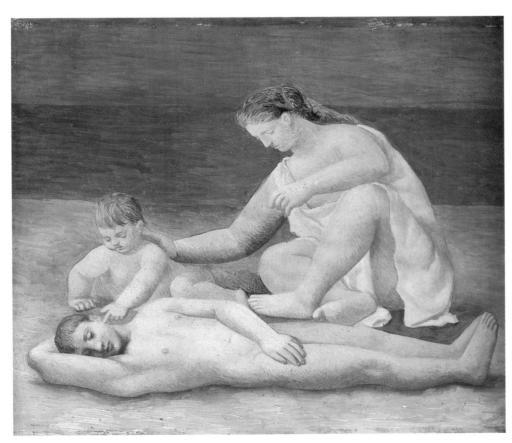

Family on the Seashore
Famille au bord de la mer
Dinard, summer 1922
Oil on panel, 17.6 x 20.2 cm
Not in Zervos; MPP 80
Paris, Musée Picasso

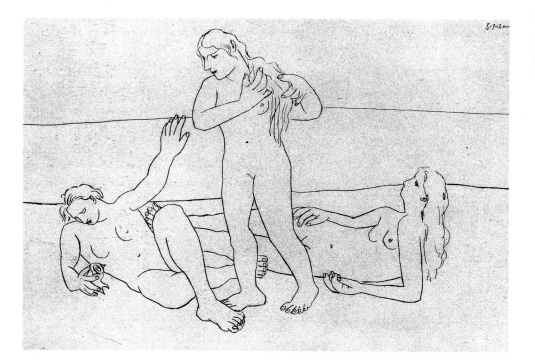

Three Bathers
Trois baigneuses
Juan-les-Pins, 3 September 1920
India ink on paper, 75 x 105 cm
Zervos IV, 182

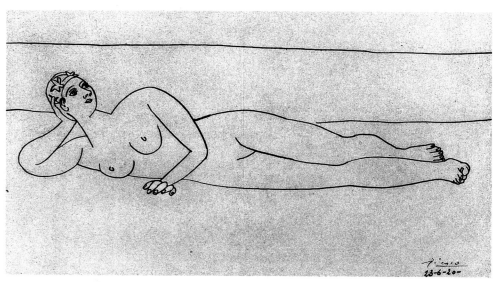

Reclining Bather
Baigneuse allongée
Juan-les-Pins, 23 June 1920
Pencil on paper, 26.5 x 42 cm
Zervos IV, 162

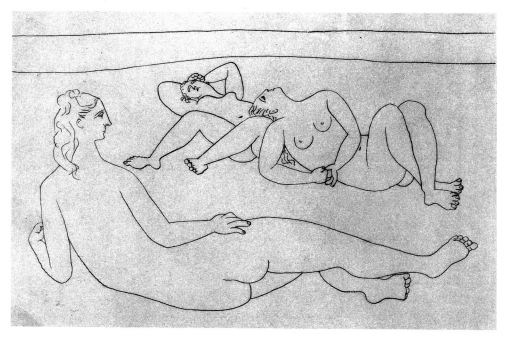

Three Bathers
Trois baigneuses
Juan-les-Pins, summer 1920
Pencil on paper, 48 x 63 cm
Zervos IV, 105

Right:
Seated Nude Drying Her Foot
Femme nue assise s'essuyant le pied
1921
Pastel on paper, 66 x 50.8 cm
Zervos IV, 330
Geneva, Heinz Berggruen Collection

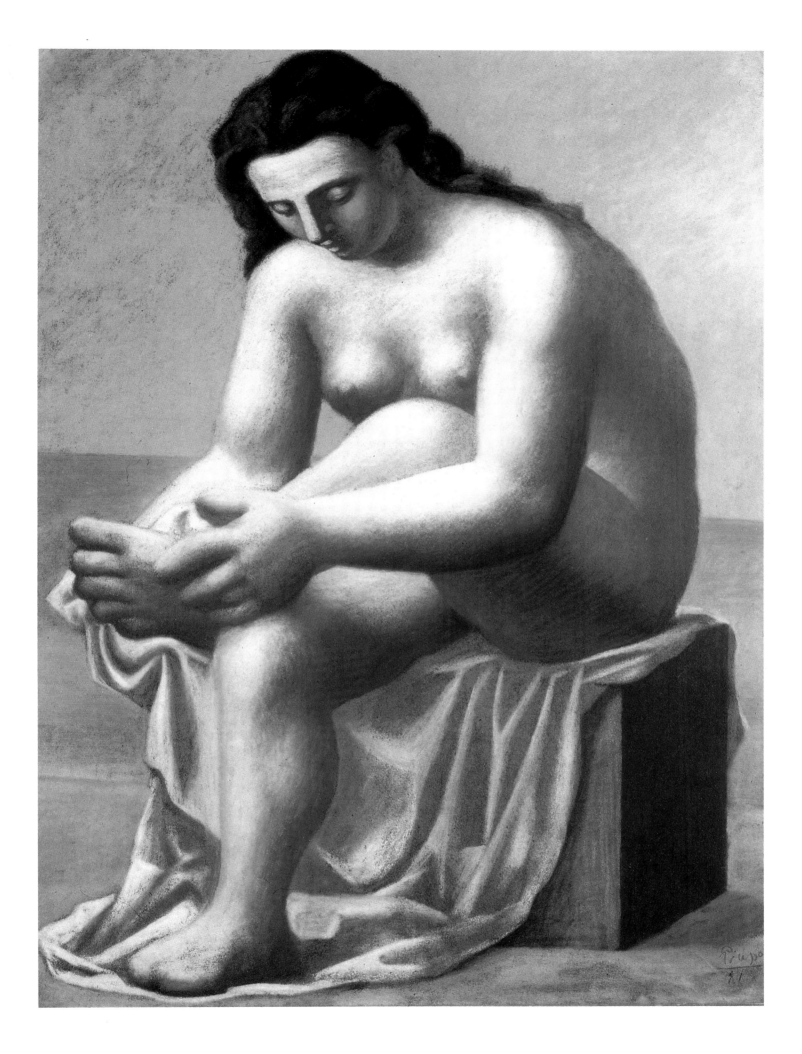

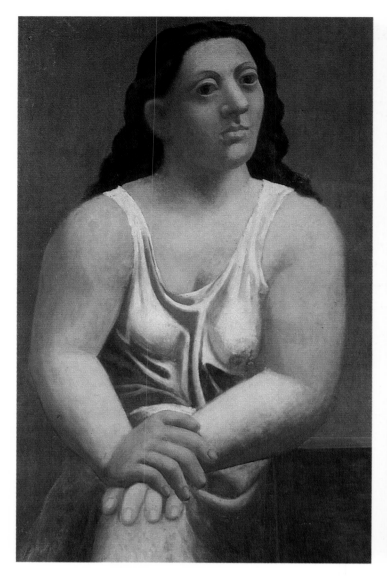

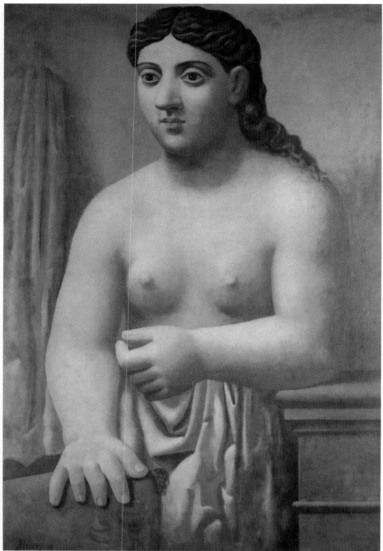

Seated Woman
Femme assise (Femme à la chemise)
1921
Oil on canvas, 116 x 73 cm
Zervos IV, 328
Stuttgart, Staatsgalerie Stuttgart

Standing Nude
Femme nue debout
1921
Oil on canvas, 132 x 91 cm
Zervos IV, 327
Prague, Národni Gallery

The Horseman
Le cavalier
Paris, 7 March 1921
Lithograph, 19.5 x 27 cm
Bloch 40; Geiser 228; Mourlot VIII; Rau 8

The Camera and the Classicist 1916 – 1924 **278**

Three Women at the Spring
Trois femmes à la fontaine (La source)
Fontainebleau, summer 1921
Oil on canvas, 203.9 x 174 cm
Zervos IV, 322
New York, The Museum of Modern Art

Study for "Three Women at the Spring"
Etude de main pour "Trois femmes à la fontaine"
Fontainebleau, summer 1921
Charcoal and red chalk on paper, 24.5 x 32.1 cm
Zervos IV, 326; MPP 967. Paris, Musée Picasso

Study for "Three Women at the Spring"
Etude pour "Trois femmes à la fontaine"
Fontainebleau, summer 1921
Pencil on panel, 21.5 x 27 cm
Not in Zervos; MPP 965
Paris, Musée Picasso

279 The Camera and the Classicist 1916 – 1924

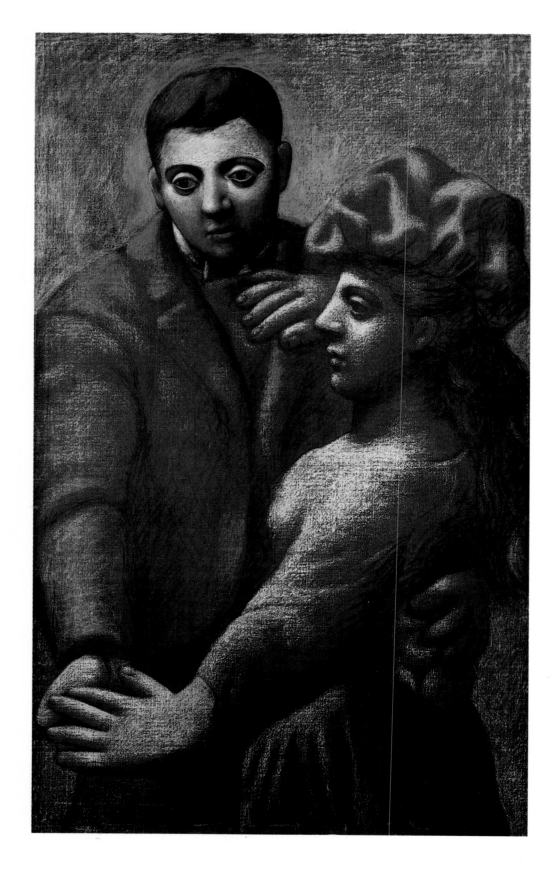

Country Dance (Dancing Couple)
La danse villageoise
Paris, 1921 (1922?)
Fixed pastel and oil on canvas,
139.5 x 85.5 cm
Zervos XXX, 270; MPP 73
Paris, Musée Picasso

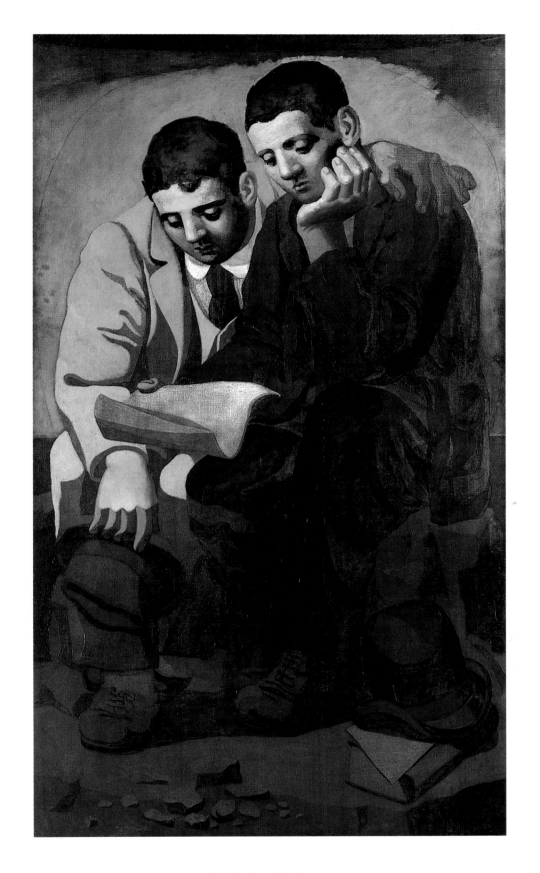

The Reading of the Letter
La lecture de la lettre
Paris, 1921
Oil on canvas, 184 x 105 cm
Not in Zervos; MPP 72
Paris, Musée Picasso

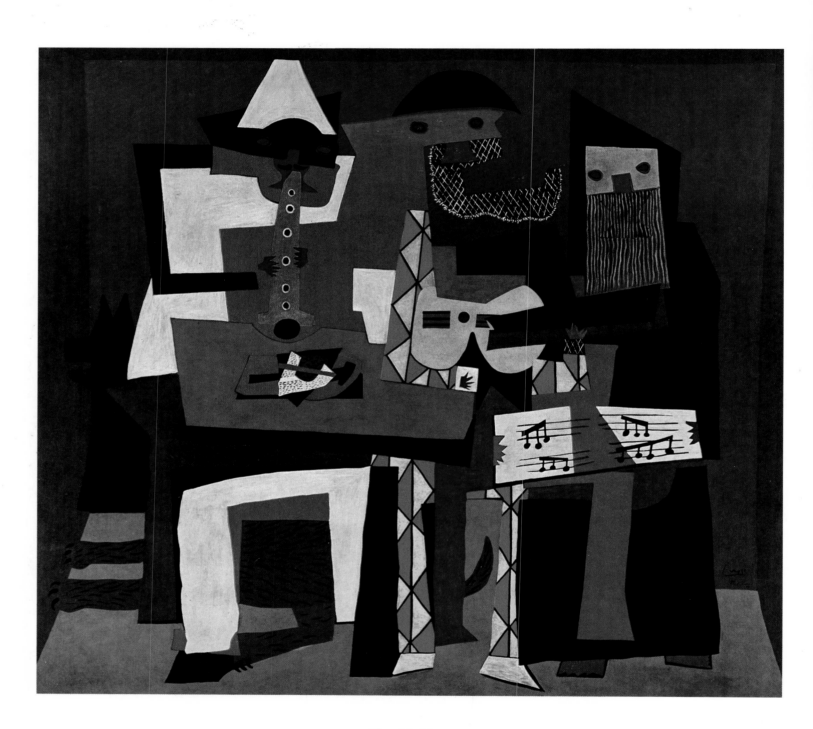

Three Musicians
Musiciens aux masques
Fontainebleau, summer 1921
Oil on canvas, 200.7 x 222.9 cm
Zervos IV, 331
New York, The Museum of Modern Art,
Mrs. Simon Guggenheim Fund

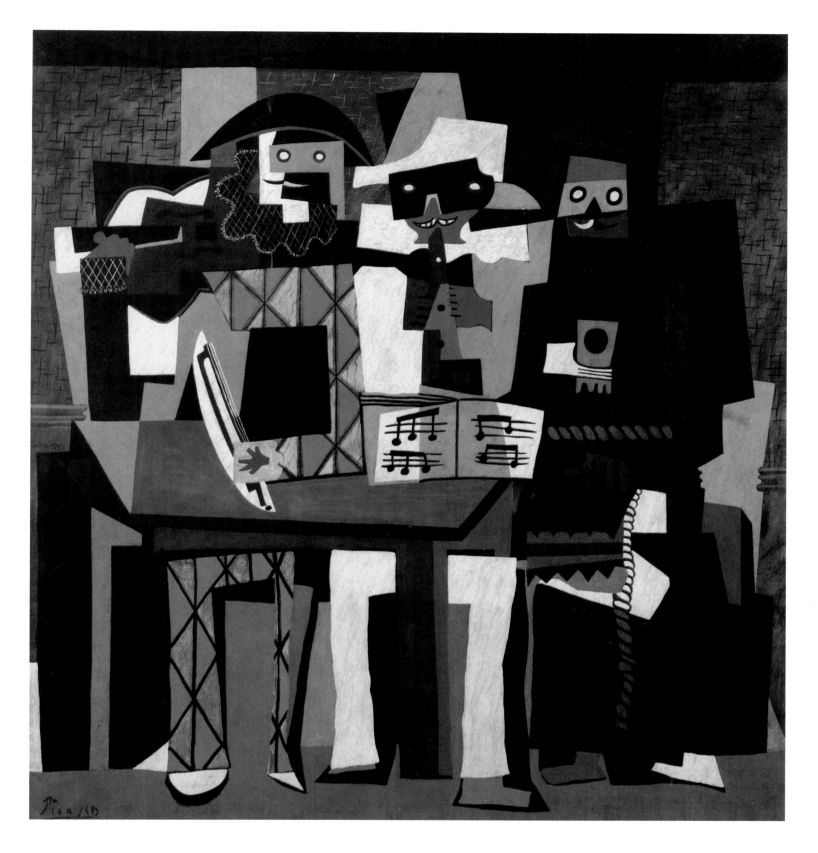

Three Musicians
Musiciens aux masques
Fontainebleau, summer 1921
Oil on canvas, 203 x 188 cm
Zervos IV, 332
Philadelphia (PA), Philadelphia Museum of Art

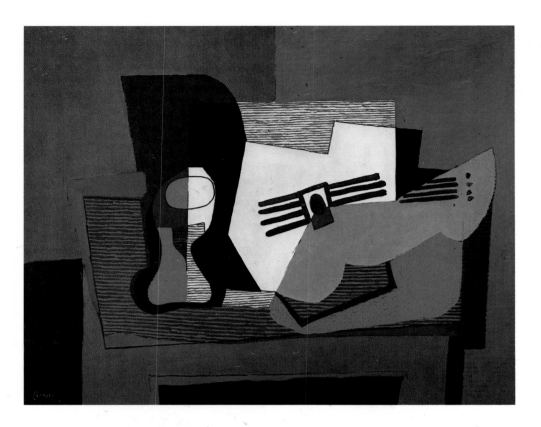

Still Life with Guitar
Nature morte à la guitare
Paris, 1922
Oil on canas, 83 x 102.5 cm
Zervos IV, 418
Galerie Rosengart

Packet of Tobacco and Glass
Paquet de tabac et verre
Paris, 1922
Oil on canvas, 33 x 41 cm
Zervos IV, 426
Switzerland, Private collection

The Bird Cage
La cage d'oiseaux
Paris, 1923
Oil and charcoal on canvas, 200.7 x 140.4 cm
Zervos V, 84
New York, Mrs. Victor W. Ganz Collection

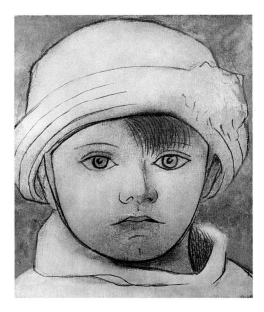

Paul, the Artist's Son, on a Donkey
(after the photograph: see right)
Paul, fils de l'artiste, à deux ans
Paris, 14 April 1923
Oil on canvas, 100 x 81 cm. Zervos VI, 1429
Paris, Bernard Ruiz-Picasso Collection

Paul, the Artist's Son, on a Donkey
Photograph, 1923

Paul, the Artist's Son, in a Round Hat
Paul, fils de l'artiste
Paris, 14 April 1923
Oil on canvas, 27 x 22 cm
Zervos V, 180. France, Private collection

Linear austerity, a predilection for a purely linear style, was a feature of late 18th-century classicist art. People therefore assumed a link between that period and Picasso. But the similarity is only superficial. Rather, Picasso was trying to apply the stylistic resources of photography to painting and drawing. Black and white photography translates natural colours into a tonal scale from white through grey to black, and renders subjects in varying degrees of clarity or unclarity according to the depth of field. An impression of documentary precision is conveyed; in reality, the recorded scene is defamiliarized. Photography either radically polarizes available contrasts or blurs them if the focus or light are not right. The distance from the photographed subject can reinforce or distort the sense of perspective. At all events, the picture that results has a character all its own. It may be more precise than hand-drawn likenesses, but it is not faithful. And it was these peculiar features of photography that attracted Picasso to the medium.

The nature of his concerns can readily be deduced from the study after a photo of ballet impresarios Diaghilev and Seligsberg (p. 268), drawn in outline, with only occasional charcoal accentuation to suggest volume. Picasso has accentuated the very features a photograph highlights: eyes, nose, mouth, folds in clothing. The seated man seems rather too bulky below the waist compared with his build above it, an impression caused by the slightly distorted perspective of the angle from which the original picture was taken.

Picasso approached the unfinished portrait of his wife Olga (p. 244) in similar fashion. The figure is cropped at the knee and placed vertically in the right-hand two-thirds of the composition. In her left hand, resting lightly on her crossed left leg, she is holding

Paul Drawing
Paul dessinant
Paris, 1923
Oil on canvas, 130 x 97.5 cm
Zervos V, 177; MPP 81
Paris, Musée Picasso

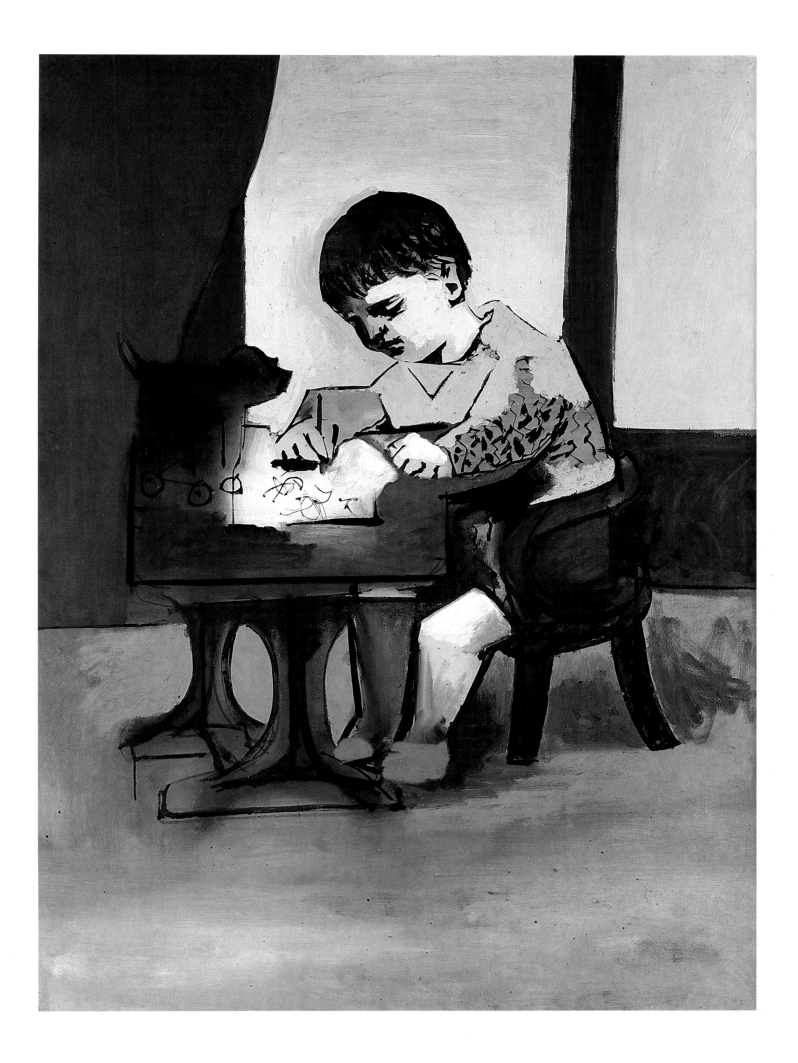

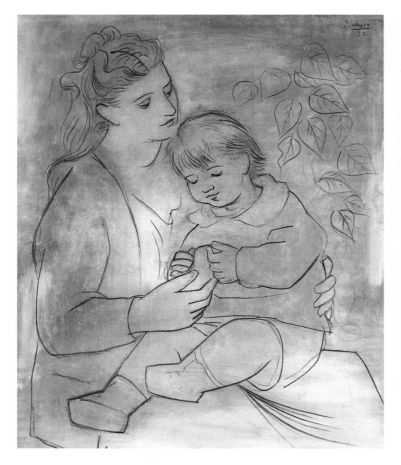

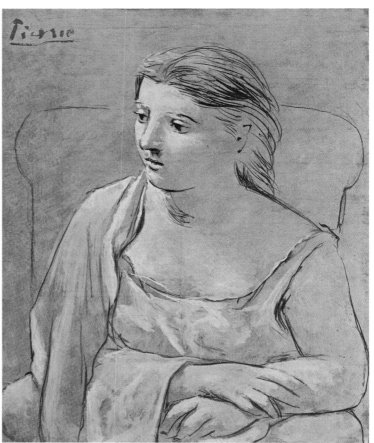

Mother and Child
Mère et enfant
Dinard, summer 1922
Oil on canvas, 100 x 81 cm. Zervos IV, 371
Baltimore (MD), The Baltimore Museum of Art,
Cone Collection

Seated Woman in an Armchair
Femme assise dans un fauteuil
Paris, winter 1922
Oil on canvas, 81 x 65 cm
Zervos IV, 450
Los Angeles (CA), Private collection

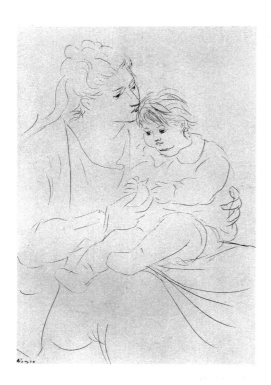

Mother and Child. Mère et enfant
Dinard, summer 1922
Pencil on paper, 41 x 29 cm. Zervos IV, 369

a half-open fan. Her right arm, crooked at the elbow, is out-stretched across the back of the armchair. Her wide-open eyes are gazing dreamily into nowhere, or within her own inner depths. The lustreless dark brown dress contrasts with her light flesh, the colour of which is also the colour of the canvas ground. The armchair is covered in a striking fabric of red and yellow flowers, purple grapes and green leaves – a floral pattern which makes the loudest visual impact but is somewhat muted by the patterning of the dress and fan. These agitated areas of the picture do not distract from the true subject, the portrait, but in fact lend emphasis to it. This highlighting is further assisted by Picasso's indifference to the textural, material qualities of the fabrics: Olga's face, by contrast, is painted with great sensitivity. And that was what Picasso was out to do in this painting. The canvas, however, was not yet filled.

Picasso clearly intended to finish the picture. But doing so posed a problem: he would have had to complete the composition – and the photo afforded him no help in his quest for the right counter-balance in what remained to be painted. Everything in the photo was of roughly equal clarity, and thus of roughly equal status. A photograph is like a sampler of forms, all of equal value; it is only

288 The Camera and the Classicist 1916 – 1924

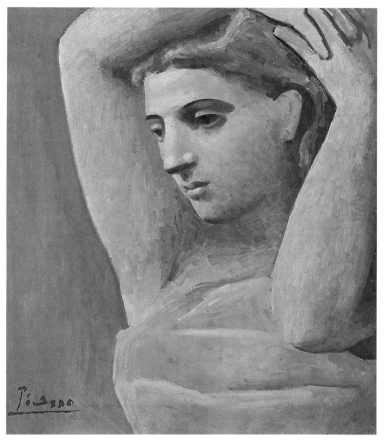

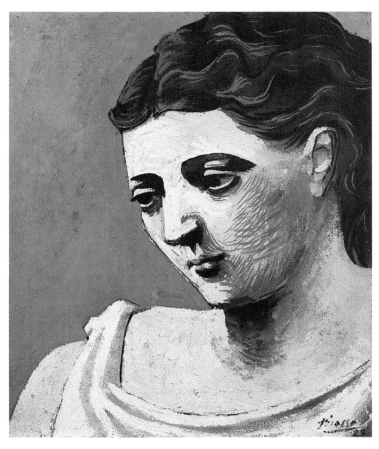

Bust of a Woman
Buste de femme
Paris, 1923
Oil on canvas, 65 x 54 cm
Not in Zervos
Chicago (IL), Private collection

Head of a Woman
Tête de femme
Paris, 1923
Oil and sand on canvas, 46 x 38 cm
Zervos V, 45
Tokyo, Bridgestone Museum of Art

the response in the beholder's eye that introduces differentiation. A painting, however, unlike a photo, is built on a hierarchical sense of forms – otherwise it cannot easily be grasped. The camera is impartial towards its subjects and therefore able to open up surprising perspectives or even, in extreme cases, convey almost Cubist visual experiences using purely representational means. So Picasso abandoned work on the painting at this point. It is all the more attractive for being unfinished; the neutral canvas counteracts the tension between the woman's figure and the colourful, rather loud pattern of the armchair. Had he continued painting, Picasso would probably have become entangled in a formal jungle.

Picasso viewed the photograph as a thoroughly artificial original, the formal principle of which resided in a curiously dialectical relationship of polarities to levelled-out uniformities. Every recognisable detail was distinct from every other; yet the sheer number of details defied the eye. Polarity and uniformity were inseparable. Thus, the formal constituents of the image – line, surface, depth modelling – were themselves distinct. And what was true of photographs in general was also true of reproductions of artworks, images constituting a twofold defamiliarization, as it were. When

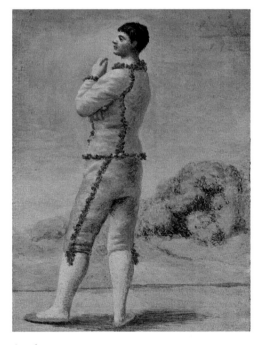

Acrobat
Saltimbanque
Paris, 1922
Gouache on paper, 16 x 11 cm
Not in Zervos. Private collection

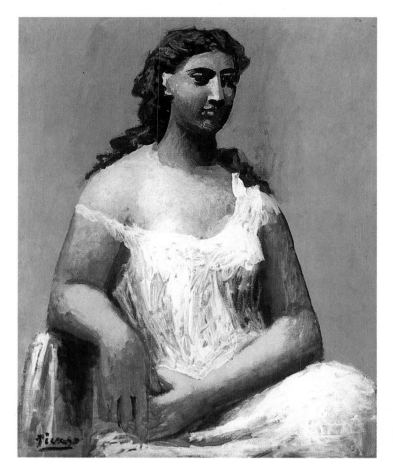 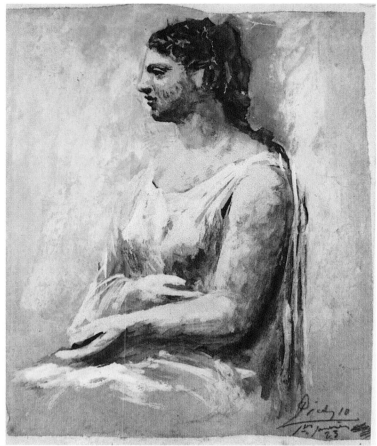

Seated Woman in a Chemise
Femme assise dans une chemise
1923
Oil on canvas, 92.1 x 73 cm
Zervos V, 3
London, Tate Gallery

Seated Woman
Femme assise
Paris, 1 January 1923
Gouache on cardboard, 20.9 x 17.4 cm
Zervos VI, 1401
Oberlin (OH), Allen Memorial Art Museum

Picasso, working with photography, returned to the mimetic image, it was by no means a step back. His work from 1916 to 1924 was every bit as avant-garde as his Cubist work. He was altogether progressive in his approach. He was simply trying something different. At that time, a great deal of thought was going into the nature and potential of photography, and it had achieved recognition as an art from which other visual artists could in fact learn.

Painters and draughtsmen have always sought ways to make the purely technical problems of visual mimesis easier to solve. First aids such as the camera obscura were important forerunners of photography. When photography was invented in the late 1830s, artists such as Delacroix immediately used the new medium for their work. But it was merely an auxiliary aid.[255] Its value lay in its unique documentary reliability. Even to Baudelaire, progressive though his aesthetic thinking was, photography was not an art.[256] Ambitious photographers therefore set out to rival painting on its own territory, with the result that artistic photography till the beginning of the 20th century looked like a caricature of fine art.[257]

Of course, open-minded artists had long been availing themselves of photography's particular representational strengths. Degas borrowed the photographic sense of a cropped section of seen reality to create completely innovative compositions. The photographic movement studies by Eadweard Muybridge and Etienne Jules Marey in the last decades of the 19th century were an important

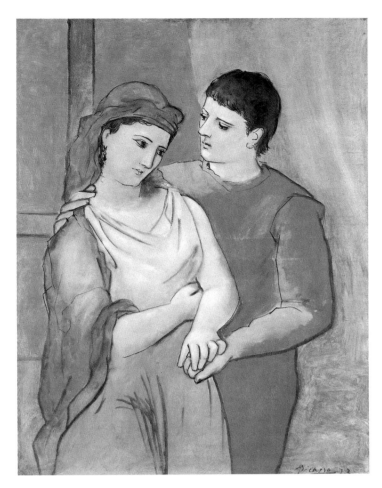 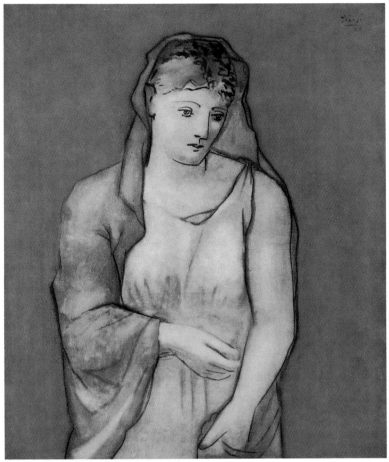

source of Futurism, and ultimately of abstract art too.[258] But not till the early 20th century did photographers strive for international recognition of their art on the basis of its distinctive features. Picasso was involved in these strivings almost from the outset. The American photographer Alfred Stieglitz was a major mover in the endeavour, founding the Photo Secession in New York in 1902, editing the journal "Camera Work" from 1903 on, and running the Little Galleries of the Photo Secession from 1905[259]. In 1907, the year Picasso painted "Les Demoiselles", Stieglitz took the photo he considered his best, "The Steerage", and was very pleased to find Picasso thought highly of it too. In 1911 Stieglitz organized the first American exhibition of Picasso's work at his gallery.[260]

In the USA, photography was soon an art form in its own right. The line of pure photography is linked with Edward Steichen, Walker Evans and Edward Weston. But painters such as Charles Sheeler also tried to use photographic forms in their art.[261] The nearest European equivalent was Germany's "Neue Sachlichkeit" (New Objectivity). From 1920 on, Dadaists, Surrealists, Soviet Constructivists and artists at the Bauhaus were all trying to bring new ideas to visual art with the help of experimental photography.[262]

And Picasso was trying to do the same. All of his figure drawings after 1916 were constructed according to the basic principles of photography – and for that reason they lack something we usually

The Lovers
Les amoureux
Paris, 1923
Oil on canvas, 130.2 x 97.2 cm
Zervos V, 14
Washington (DC), National Gallery of Art,
Chester Dale Collection

Woman with Blue Veil
La femme au voile bleu
Paris, 1923
Oil on canvas, 100.3 x 81.3 cm
Zervos V, 16
Los Angeles (CA), Los Angeles County Museum
of Art

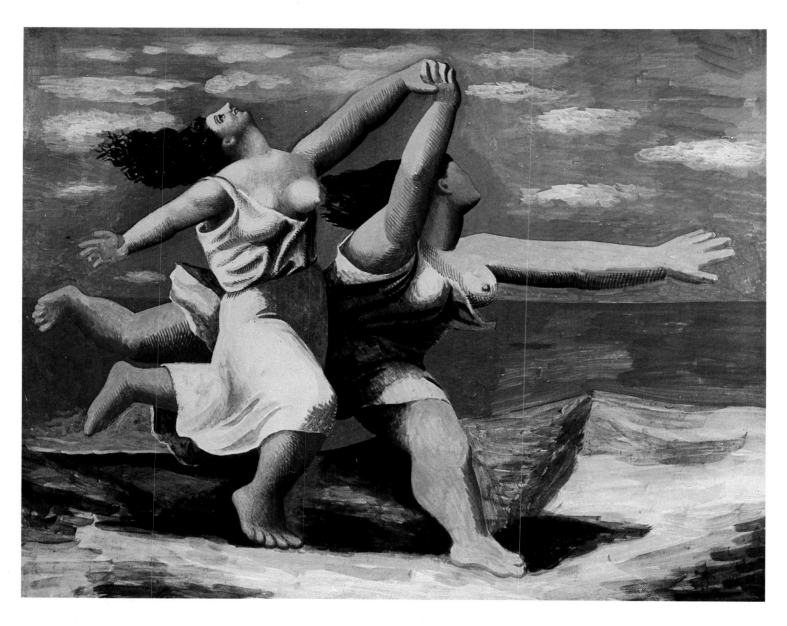

Women Running on the Beach
(Curtain for the ballet "Le train bleu", 1924)
Deux femmes courant sur la plage (La course)
Dinard, summer 1922
Gouache on plywood, 32.5 x 42.1 cm
Zervos IV, 380; MPP 78
Paris, Musée Picasso

find in an art drawing: variability of line. Lines can be thick or thin, deep black or pale grey, and the gradations chosen can make the visual rhythm of a picture by emphasizing certain portions and not others. Not so in Picasso. From his portraits of composers Satie and Stravinsky (p. 268) to his copy of Renoir's portrait of "Sisley and His Wife" (p. 270), the lines are almost mechanically even. It is an astonishing effect, at once cold and utterly stylish.

Picasso was not only adopting the photographic contour. His paintings and drawings also borrowed the characteristic overemphasis of light-dark contrasts in defining volume, the juxtaposition of the linear and the spatial, even the distortions of perspective. He still used the visual artist's conventional methods, thus often mixing forms. In the Stravinsky portrait, for example, the composer's limbs are outsize, combining photographic distortion with the cartoonist's technique. In such works as "The Reading of the Letter" (p. 281) or the great nudes of 1921–22 (cf. p. 277), photographic harshness in the contrast of light and shadow is combined with a sculpturally modelled three-dimensionality, adding a slight distor-

Standing Nude
Femme nue debout tenant une serviette
Cap d'Antibes, 1923
Pencil on paper, 35 x 26 cm
Zervos V, 50

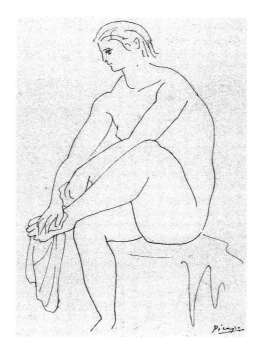

Seated Bather Drying Her Feet
Baigneuse assise s'essuyant les pieds
Cap d'Antibes, 1923
India ink on paper, 35 x 26 cm
Zervos V, 55

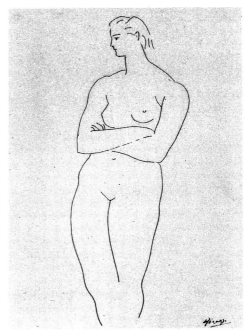

Standing Nude with Crossed Arms
Femme nue debout les bras croisés
Cap d'Antibes, 1923
Pencil on paper, 35 x 26 cm
Zervos V, 51. Private collection

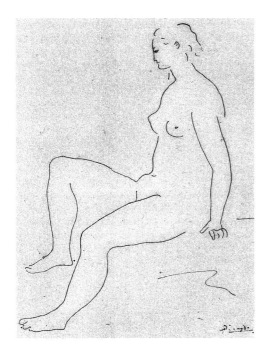

Seated Nude
Femme assise le bras gauche appuyé sur un rocher
Cap d'Antibes, 1923
Ink on paper, 35 x 26 cm. Zervos V, 56

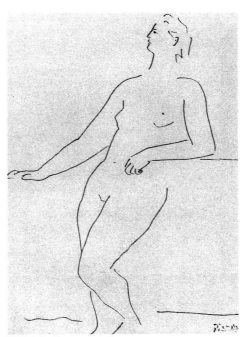

Standing Nude Resting on One Arm
Femme nue debout appuyée
Cap d'Antibes, 1923
Ink on paper, 36 x 25 cm. Zervos V, 59

Standing Nude
Femme nue tenant une serviette
Cap d'Antibes, 1923
Ink on paper, 108 x 72 cm
Zervos V, 58

tion of perspective. These massive figures with dark eye sockets and seemingly machine-made bodies are the result.

Other pictures present linear figures seen against neutral, non-representational areas of colour. In these, Picasso blended the techniques of Synthetic Cubism with the kind of mimesis he was borrowing from photography. The combinations produced new formal modes such as we see in "The Lovers" (1923; p. 291). Paintings such as this represent an intermediate position which the artist tested for its functional values by using it in his theatre designs – for instance, in his work for the 1924 ballet "Mercure". But Picasso was a man to test his results over and over again. This he did by copying from photographs once more. In 1923 he painted "Paul, the Artist's Son, on a Donkey" (p. 286). The accentuation of different textures in the photo prompted a delightful composition. Picasso runs the gamut of visual methods, opposing lines to surface areas, smooth surfaces to textured ones, spatial depth to depthless zones. The shaggy fell of the donkey is a continuous fabric of dark

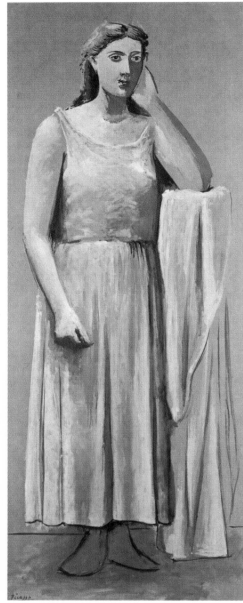

Greek Woman
La Grecque
Paris, 1924
Oil on canvas, 185 x 75 cm
Zervos V, 249
Private collection

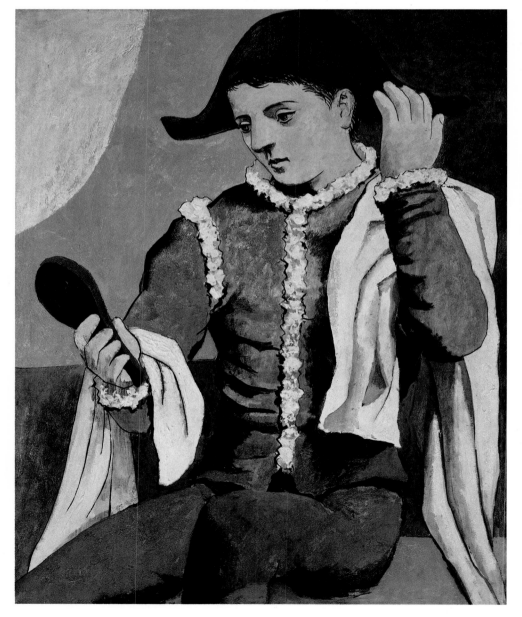

Harlequin with a Mirror
Arlequin avec un miroir
1923
Oil on canvas, 100 x 81 cm
Zervos V, 142
Lugano-Castagnola, Thyssen-Bornemisza
Foundation

and light greys with white and black brush-strokes too. The boy's clothes are an irregular linear outline that defines a patch of colour and is economically detailed with a few more lines for folds.

In 1919 Picasso had already used a 1916 Ballets Russes publicity photo in order to combine dancers' poses and various techniques of creating three-dimensionality (pp. 258 and 692). In the first of these works he rendered the photo's shadow areas as hatching of the kind commonly used in engravings and etchings. In others he changed the photo's horizontal format into a vertical, tightened up the composition, even cut the number of figures and changed their poses. A dreamy gaze, fingers to chin, or upraised arms to keep a balance – to Picasso the attitudes were interchangeable.

In 1923 Picasso returned to the use of emphatic linear outline together with hatching for his portraits of the painter Jacinto Salvado in a harlequin costume Cocteau had handed on (pp. 296 and 297). In the unfinished version we can see how Picasso was aiming to unite the linear elements and the colouring of areas in a new synthesis. It was an experimental phase in his work, as the range of subjects indicates. He was using almost exclusively motifs drawn from his stock repertoire: harlequins, mothers with children, nudes, still lifes, studies of bullfights, portraits. New motifs were the beach scenes and bathers. These gave Picasso the chance to test his nudes in contexts of action.

Portrait of Olga (Olga in Pensive Mood)
Portrait d'Olga (Olga pensive)
Paris, 1923
Pastel and pencil on paper, 104 x 71 cm
Zervos V, 38; MPP 993
Paris, Musée Picasso

Portrait of Olga
Portrait d'Olga
Paris, 1923
Pastel and pencil on paper, 100 x 81 cm
Zervos V, 29
Washington (DC), National Gallery of Art,
Chester Dale Collection

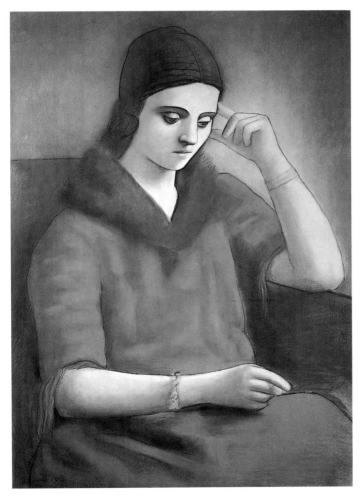
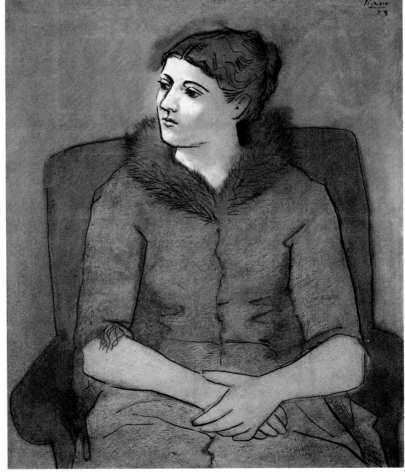

He was also looking back to art history. Since his youth Picasso had copied from other originals. This predilection now peaked in multi-layered visual quotations and variations, copies, and borrowings. In 1917 he painted "The Peasants' Repast" (p. 249), conspicuously using a stylistic device he had been highly interested in during his earliest real period of artistic identity: the multitudinous dots and dabs of pointillism. But "The Peasants' Repast" is a product of combination, of synthesis, the composition not the artist's own but taken from a painting by the French artist Louis Le Nain, done in 1642 and now in the Louvre. As in the variations on the Ballets Russes publicity photos, Picasso altered his original, transforming the wide format into a concentrated vertical and adapting the proportional relations of the figures as he chose.

Right:
Seated Harlequin (The Painter Jacinto Salvado)
Arlequin assis (Le peintre Jacinto Salvado)
Paris, 1923
Oil on canvas, 130 x 97 cm. Zervos V, 17
Paris, Musée National d'Art Moderne,
Centre Georges Pompidou

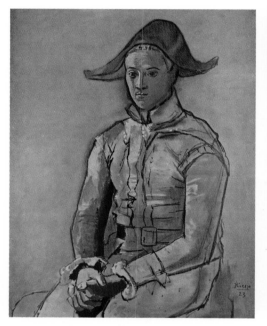 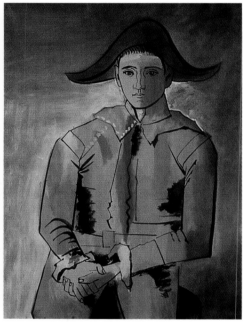 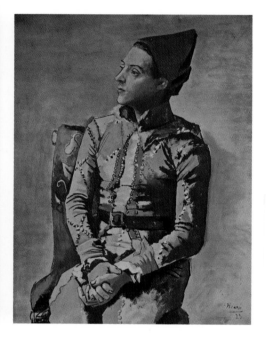

Similarly in "Three Women at the Spring" (p. 279) he has adopted the technique suggested by photographic three-dimensionality, as the preliminary studies plainly show. On the other hand, though, his composition of figures clad in the garb of ancient statues is a variation on a portion of a work by the French baroque artist Nicolas Poussin.[263] Picasso's arresting motion study, "Women Running on the Beach" (p. 292), uses motif details from Raphael's Vatican frescoes and from an ancient Medean sarcophagus in the National Museum in Rome, both works Picasso saw in 1917[264]. In "Three Dutch Girls" (p. 133), painted in 1906, Picasso had already done a variation on the ancient sculptural group of the Three Graces, and he now did a number of etchings based on the same famous original.[265] He stepped up his work in printed graphics because the medium suited his new linear style. As well as doing illustrations for books by his friend Max Jacob – "Le Cornet à Dés" in 1917 and "Le Phanérogame" the following year – which

Seated Harlequin (The Painter Jacinto Salvado)
Arlequin assis (Le peintre Jacinto Salvado)
Paris, 1923. Oil on canvas, 125 x 97 cm
Zervos V, 37. Stavros S. Niarchos Collection

Seated Harlequin (The Painter Jacinto Salvado?)
Arlequin assis (Le peintre Jacinto Salvado?)
Paris, 1923. Oil on canvas, 130 x 97 cm
Zervos V, 135. Private collection

Seated Harlequin (The Painter Jacinto Salvado)
Arlequin assis (Le peintre Jacinto Salvado)
Paris, 1923. Tempera on canvas, 130.5 x 97 cm
Zervos V, 23
Basel, Öffentliche Kunstsammlung Basel,
Kunstmuseum

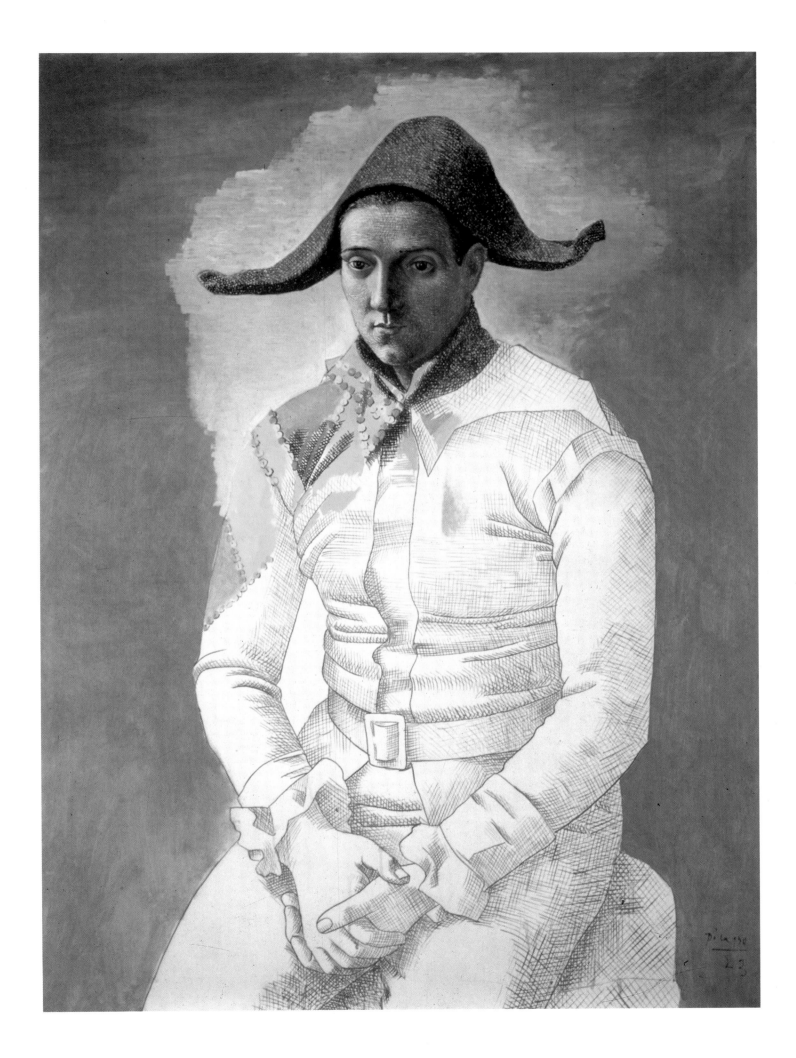

Female Nude and Pan-pipes Player
(Study for "The Pipes of Pan")
Etude pour "La flûte de Pan"
Antibes, summer 1923
India ink on paper, 23 x 31 cm. Zervos V, 109
USA, Private collection

Pan-pipes Player and Erotic Figures
(Study for "The Pipes of Pan")
Etude pour "La flûte de Pan"
Antibes, summer 1923
India ink on paper, 24.5 x 32 cm. Zervos V, 130

continued what he had begun in 1913 with three etchings for
Jacob's "Le Siège de Jérusalem", he mainly did variations of motifs
he had drawn or painted, such as "Three Women at the Spring".

The range of different techniques Picasso was using all shared a
concern with identity of craftsmanship and form. As well as paint-
ing in oil on canvas, he painted on wooden panels as in centuries
gone by. He even transferred pastel to canvas and combined it with
oils: the "Country Dance (Dancing Couple)" (p. 280) and "The
Reading of the Letter" (p. 281) are fine examples. The textural
effect of pastel chalk on a rough canvas ground curiously reinforces
tonal contrasts. As in earlier periods, the experiments were all sub-
sumed into one major work recapitulating his experience
throughout this period: "The Pipes of Pan" (1923; right).[266]

Over fifty studies in sketchbooks and on single sheets have sur-
vived, but the number of preliminary studies for the painting must
have been far greater, for Picasso also used his 1920–1921 pencil
and pastel drawings of bathers on the beach for his new purpose
(cf. pp. 276 and 277). The variously posed women, most of them
naked, were clearly originally meant to be part of an ambitious
composition using a merely hinted-at landscape setting. But the
artist broke off his work without managing to bring his ideas
together satisfactorily. However, he had settled on the idea of tight-
ly ordered groups of standing and seated figures. He returned to
this idea in 1923, linking it to bacchanalian motifs from antiquity.
The figure of a faun playing the Pan-pipes, in particular, was based
on ancient sculpture.[267] Little by little his physical posture evolved
– a kind of compromise between sitting, running and squatting (cf.
right). The youth is half-kneeling on his left leg while his right is
bent at the knee too. With both hands he is holding the pipes to his
lips. At an intermediate stage in his work on this composition,
Picasso added a woman to the scene, and a boyish Eros (cf. above),
doubtless with a historical picture of amorous content in mind. But
then he tautened the compositional concept, dropped the erotic
content, and again accentuated the motif of bathing, admittedly
not entirely jettisoning the erotic suggestiveness.

The result was the final big painting completed in summer 1923.
The Pan-pipes player is posed as in the preliminary studies. Beside

The Pipes of Pan
La flûte de Pan
Antibes, summer 1923
Oil on canvas, 205 x 174.5 cm
Zervos V, 141; MPP 79
Paris, Musée Picasso

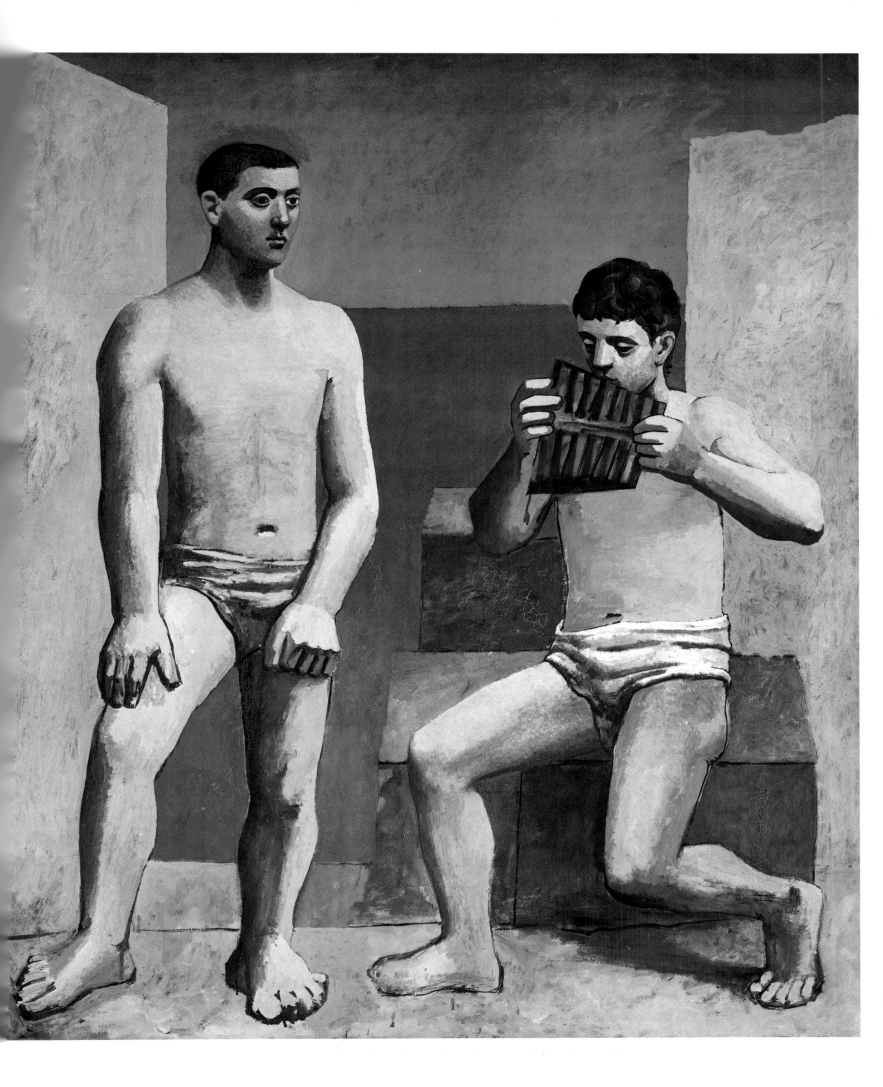

Still Life with Mandolin
Nature morte à la mandoline
Juan-les-Pins (?), 1924
Oil on canvas, 97.5 x 130 cm
Zervos V, 224
Amsterdam, Stedelijk Museum

him, in a frontal pose turned slightly to the right, also in bathing trunks, stands another youth. His right leg is casually bent at the knee. Between them we see the vast blues of sea and sky. The different shades emphasize the spatial depth. Rough brown, beige and sandy areas provide a backdrop to the youths, foregrounding them through the contrast, accentuating the spatiality, and rounding out the centripetal composition. The two figures illustrate Picasso's methods of three-dimensional modelling: darker and lighter shades, variously contrasting, to indicate a range of volume qualities from flat to round, together with the natural proportions of the bodies, heighten the picture's evocativeness.

Mandolin and Guitar
Mandoline et guitare
Juan-les-Pins, summer 1924
Oil and sand on canvas, 140.6 x 200.2 cm
Zervos V, 220
New York, The Solomon R. Guggenheim Museum

Book, Bowl of Fruit and Mandolin
Livre, compotier et mandoline
1924
Oil on canvas, 100 x 80.4 cm
Zervos V, 379
Munich, Staatsgalerie moderner Kunst

If Picasso seems to have eased off the violation of natural proportion seen in other nudes from this time, this is due to a more subtle approach to the problem. Like classically-minded 19th-century artists such as Ingres or Anselm Feuerbach, he combines an arbitrary elongation of bodily proportion with questions of posture and bearing, so that his figures balance each other out and establish a strong sense of harmony. The noticeable departures from ideals of beauty underline this; for in reality the violations are considerable – the pipes player, if he were to stand upright, would be taller than the other youth and would occupy the entire height of the canvas.

Like Picasso's entire output from 1916 to 1924, this picture was a variation on others, uniting in one place subject-matter with shades of antiquity, classical models, a classicist mode of composition, and a style derived from photography and blended with Synthetic Cubism.

Paul as Pierrot (The Artist's Son)
Paul en Pierrot (Le fils d'artiste)
Paris, 28 February 1925
Oil on canvas, 130 x 97 cm
Zervos V, 374; MPP 84
Paris, Musée Picasso

Paul as Harlequin
Paul en arlequin
Paris, 1924
Oil on canvas, 130 x 97.5 cm
Zervos V, 178; MPP 83
Paris, Musée Picasso

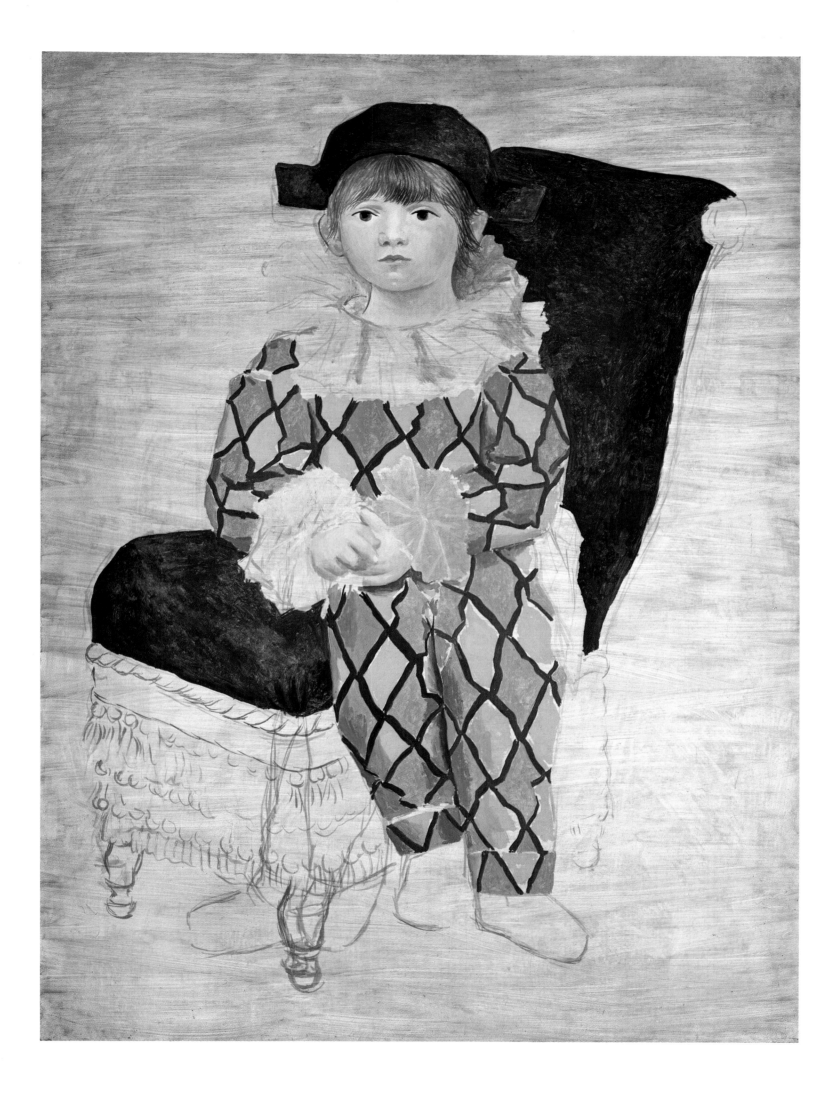

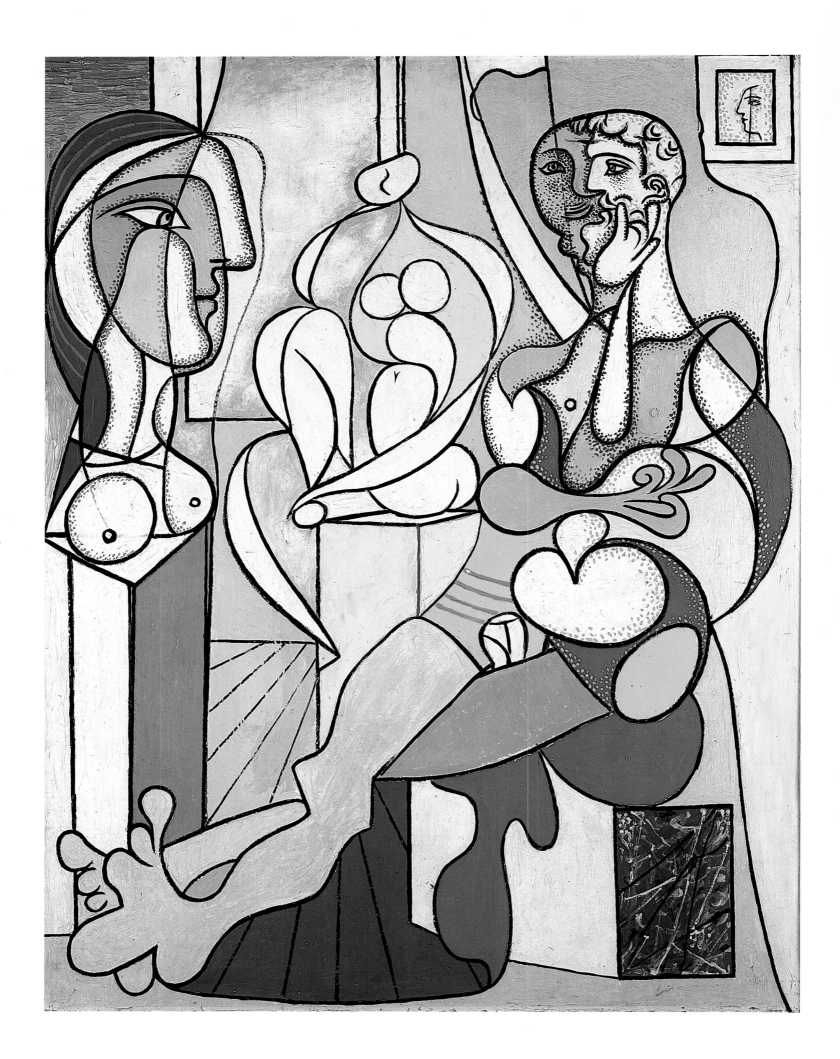

10 A Juggler with Form
1925–1936

In 1928, in the Paris studio of the Spanish sculptor Julio Gonzáles, Picasso made four constructions using iron wire and sheet metal, three of which have survived (pp. 324 and 325). Gonzáles had been familiarizing his countryman with soldering technique since that March, so that by October Picasso was able to play with some ideas he had for a sculpture. These pieces are models towards a large-scale work he was planning. They are thus fairly small, from 38 to 60 centimetres high, and economical in their use of iron wire of various thicknesses. The straight wires were arranged in long parallels or at acute or obtuse or right angles, and wires bent into arcs or ellipses were added, the whole soldered complex creating an intricate visual image. The impact draws as much upon the combination of linear and spatial elements as on the interplay of straight and curved forms and the varying thickness of the wire.[268]

At first glance these constructions look complicated and confusing. But on closer inspection we see two fundamental features. On the one hand, they present a juxtaposition of geometrical shapes, rectangles, triangles and ellipses grouped spatially into irregular stereometric configurations – extended pyramids, squashed cubes. These figures overlap and interpenetrate each other, so that we see new ones depending on where we stand. On the other hand, at points there are details – small spheres, discs, irregular tricorn ends – recalling, however remotely, the human figure. This encourages us to read the works entirely differently: what looked totally abstract at first now seems to be a stylized representational figure.

The works are like picture puzzles. Picasso's remarkable and noteworthy handling of the fundamentals of sculpture is striking. The use of wire translates form into an issue of linear definition. This is a principle of the draughtsman, not the sculptor. The work created in this way is on a sheet of metal, like a plinth, yet the shapes are in the open, challenging our sense of the tactile impressions that should be conveyed by sculpture. Our literally tactile "grasp" of the work is now transferred to the understanding eye. It is wholly a matter for the intellect, and depends on association. Picasso's approach has serious implications for three-dimensionality, which is fundamental to all sculpture. From any angle, these

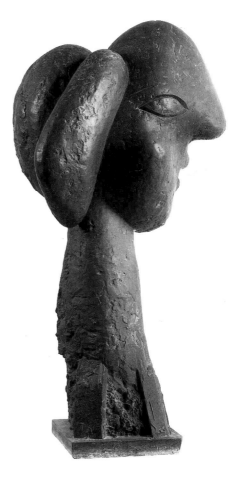

Head of a Woman
Tête de femme
Boisgeloup, 1931
Bronze, 128.5 x 54.5 x 62.5 cm
Spies 133 II; MPP 302
Paris, Musée Picasso

The Sculptor
Le sculpteur
Paris, 7 December 1931
Oil on plywood, 128.5 x 96 cm
Zervos VII, 346; MPP 135
Paris, Musée Picasso

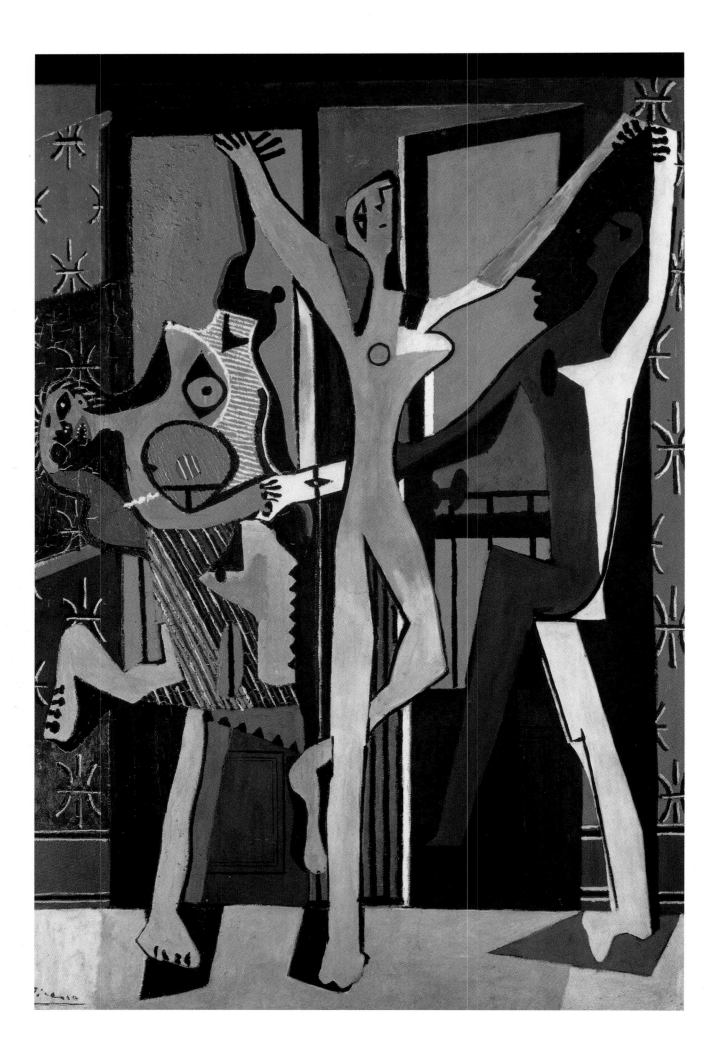

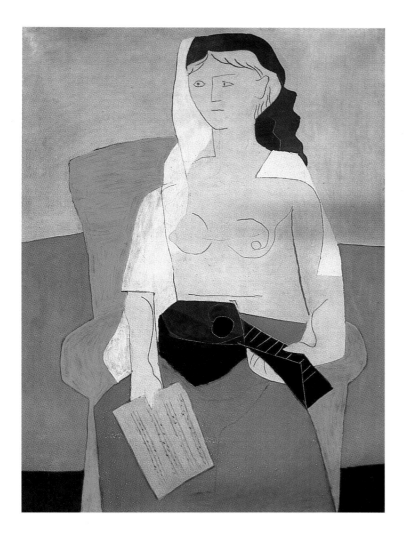

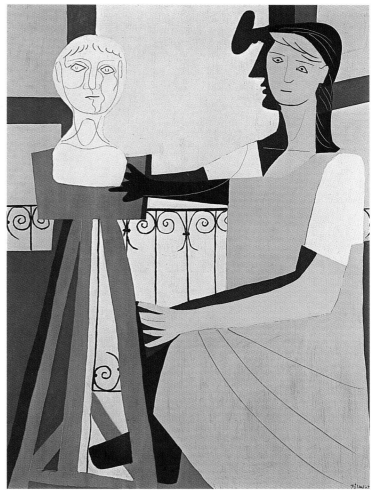

Woman with Mandolin
Femme à la mandoline
1925
Oil on canvas, 130 x 97 cm
Zervos V, 442
Los Angeles (CA), Walter Annenberg Collection

Woman with Sculpture (The Sculptress)
La statuaire (La femme sculpteur)
Juan-les-Pins, summer 1925
Oil on canvas, 131 x 97 cm
Zervos V, 451
New York, Mr. and Mrs. Daniel Saidenberg
Collection

The Dance
La danse
Monte Carlo, June 1925
Oil on canvas, 215 x 142 cm
Zervos V, 426
London, Tate Gallery

works become non-spatial patterns of lines. True, we can change our point of view by standing elsewhere, as with any genuinely volumed sculpture; but what we see is not a new spatial shape but a new pattern of lines. Unlike traditional sculpture, these works require an act of the intellect to complete the spatial transfer. The plinth helps us get our bearings. Strictly speaking, these works are three-dimensional transfers of two-dimensional graphics. They were given the label "spatial drawings" by Kahnweiler.[269]

It is an apt label, as Picasso's preliminary studies show (p. 325). These possess practically the same degree of three-dimensionality. The sculptures evolved from pure draughtsmanship. In 1924, Picasso did well over fifty linear ink drawings in a sketchbook, using curved and straight lines and adding solid circles at the bridge points (p. 324).[270] As we know from statements the artist made in 1926, maps of the night sky inspired these drawings. Picasso was fascinated by astronomical charts, which represented stars as thick dots and joined them up with thin lines to show constellations.[271] The representational and the abstract interacted. It was only an act of assertive recognition that gave significance to the meaningless figure. Picasso took the same approach. He used a technical method to craft concrete forms empty of content, and then imposed meaning on them in an arbitrary act of the maker's will.

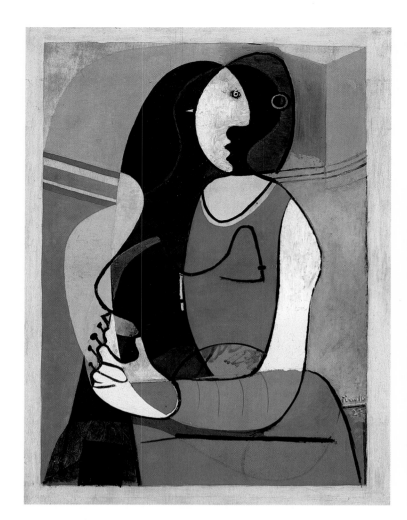 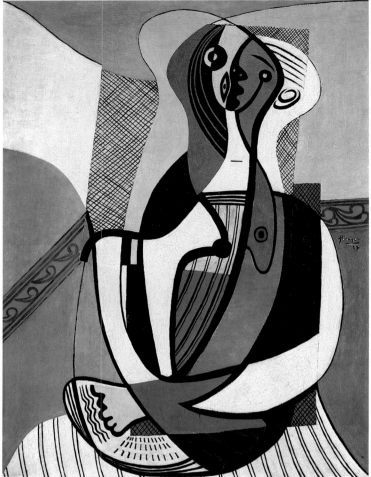

The ambiguity of formal meaning, the open expressive significance of an art object, the fundamental doubts concerning images conveyed by draughtsmanship – all these basic issues entered into Picasso's picture puzzles, on page and plinth alike. It was a new approach to something that had repeatedly concerned Picasso since his Rose Period: thinking about the nature of art became itself the occasion for an artwork and its meaning. But now, unlike in earlier periods, the principle was foregrounded and stood alone. The genre of artwork, its material form, was now primarily of a pragmatic nature. The nature of Picasso's work underwent a clear change, compared with the period immediately preceding this phase.

From 1916 to 1924, because he was testing the visual media, painting and drawing predominated. Autonomous art and applied art were as polarized as cause and effect. From 1925 to 1936, Picasso tackled sculpture, with an intense copiousness of production that can only be called explosive. He juxtaposed all the two- and three-dimensional forms of expression, or used them sequentially. The unceasing alternation of media was matched by an interplay of forms. In 1928, for instance, he did two small plaster figurines, later cast in bronze (p. 326). The restless shapes, shifting sharply from thick to thin, from open form to closed, have been made into figures largely abstract in character yet still reminiscent

Seated Woman
Femme assise
Paris, 1927
Oil on canvas, 130 x 97 cm
Zervos VII, 77
New York, The Museum of Modern Art

Seated Woman
Femme assise
Paris, 1926/27
Oil on canvas, 130 x 97 cm
Zervos VII, 81
Toronto, Art Gallery of Ontario

The Kiss (The Embrace)
Le baiser
Juan-les-Pins, summer 1925
Oil on canvas, 130.5 x 97.7 cm
Zervos V, 460; MPP 85
Paris, Musée Picasso

310 A Juggler with Form 1925 – 1936

The Bottle of Wine
La bouteille de vin
1925/26
Oil on canvas, 98.5 x 131 cm
Zervos VI, 1444
Basel, Beyeler Collection

Musical Instruments on a Table
Instruments de musique sur une table
1925
Oil on canvas, 162 x 204.5 cm
Zervos V, 416
Madrid, Centro de Arte Reina Sofía

Musical Instruments on a Table
Instruments de musique sur une table
Juan-les-Pins, summer 1926
Oil on canvas, 168 x 205 cm
Zervos VII, 3
Basel, Beyeler Collection

of human shapes. Everything is rounded; the flux of form seems fluid, as if a dynamic process were arrested and frozen. Legs, breasts, heads, eyes, noses protrude in a transitional smoothness from what seems an almost amorphous mass. These figures also took their origins from drawings, this time of an illusionist, three-dimensional nature rather than a purely linear character.

Sketchbooks dating from 1927 show endless variations of a basic figure (pp. 318 to 321). This is Picasso looking back; but he is doing so in pursuit of a decided transformation of form. The subject of bathers, of which he had already done numerous studies in 1920–1921, is now dealt with purely in terms of formal impact. The parts of the body are elongated or compressed or thinned out almost to lines in a process that seems mechanical, but are also conveyed in organic softness – the mechanical and organic loosely or tightly combined into a whole. At last, in 1928, Picasso rigorously dissected the structures, and on his drawing paper he worked on configurations geometrical in leaning. They are angular and straight, flat and solid, spheres and elliptical shapes that look

311 A Juggler with Form 1925 – 1936

The Artist and his Model
Le peintre et son modèle
Paris, 1926
Oil on canvas, 172 x 256 cm
Zervos VII, 30; MPP 96
Paris, Musée Picasso

as if they were made of stone (p. 326). The sculptures that resulted were organic in form – and that was how the "Metamorphoses" (p. 326) came about. In paintings, though, Picasso revised the thematic function of his abstraction, placing it in bathing scenes where the compositions feature a veritable ballet of amorphous shapes on the beach (pp. 320, 321, 330, 331).

Some years later, in 1932, this chain of variations culminated in the oil "Bather with Beach Ball" (p. 356). The visual opulence of this work at once proves it a peak achievement, a final point along a development, the sum of a long series of studies, experiments and insights. The composition, seemingly simple and yet subtle, is typical Picasso in its use of correspondences and contrasts. Angular forms are juxtaposed with rounded ones; naturalistic features appear alongside abstract. Spheres and shapes like clubs, thick, sweeping, dense, form a figure that has a distantly human appearance. Legs apart, arms crossed as she leaps, the bather has just caught a ball that makes a distinctly tiny impression beside her bulky body. The figure almost completely fills the canvas, this, with Picasso's use of a vertical diagonal, making the sense of movement all the more dynamic. Taken with the clumsiness of this body, the crass pattern of the bathing suit, the beach cabin and the blue sea, Picasso's view of life at the seaside is distinctly humorous.

But for Picasso form in itself was devoid of content; so he considered himself at liberty to interchange forms and substitute other contents. A 1931/1932 set of variations on a female portrait is almost programmatic in this respect. His starting point for a large number of drawings, graphic works, sculptures and paintings was the head of a woman with what is known as a Greek profile, an arc that might have been drawn with compasses tracing the line from brow to skull to a falling curtain of hair. The chin seems an exact reversal of the forehead. Picasso treats these two areas as equivalent in formal terms; he takes them apart and reassembles them into new, capricious forms. In one sculptured bust (p. 338, below right), for instance, he fashions the hair and brow into a solid, fleshy roll. He leaves this in the position where we would expect to see this kind of shape in a face, and simply scratches in a few parallel lines to indicate a hair-do and nose. The eyes and mouth, by contrast, are in an almost conventional albeit coarsely mimetic style. The head is a synthesis of the mimetic and the arbitrary.

In a work done on 2 January 1932 Picasso drew on the fruits of his sculptural work and transferred those insights, with slight variations of detail, to paint (p.345). This picture, "Reading", shows a seated woman, her body disassembled and reconstructed. Picasso proceeded to work variations on this process. One shows a woman

The Milliner's Workshop
Les modistes (L'atelier de la modiste)
Paris, January 1926
Oil on canvas, 172 x 256 cm
Zervos VII, 2
Paris, Musée National d'Art Moderne,
Centre Georges Pompidou

Still Life with Bust and Palette
Nature morte au buste et à la palette
1925
Oil on canvas, 97 x 130 cm
Zervos V, 380
Basel, Private collection

Still Life with a Cake
Nature morte à la galette
Paris, 16 May 1924
Oil on canvas, 98 x 130.7 cm
Zervos V, 185
Mexico City, Jacques and Natasha
Gelman Collection

314 A Juggler with Form 1925 – 1936

Still Life with Ancient Bust
Nature morte à la tête antique
1925
Oil on canvas, 97 x 130 cm
Zervos V, 377
Paris, Musée National d'Art Moderne,
Centre Georges Pompidou

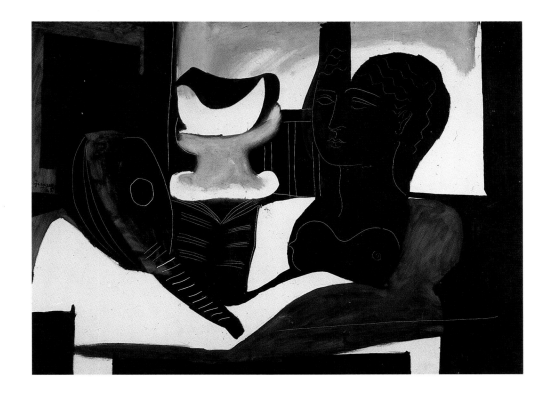

Studio with Plaster Head
Tête et bras de plâtre
Juan-les-Pins, summer 1925
Oil on canvas, 98.1 x 131.2 cm
Zervos V, 445
New York, The Museum of Modern Art

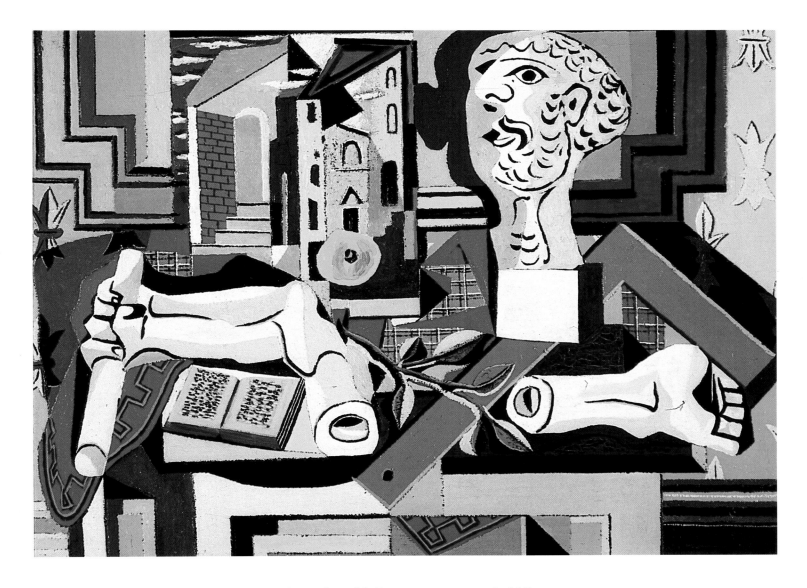

A Juggler with Form 1925 – 1936 **315**

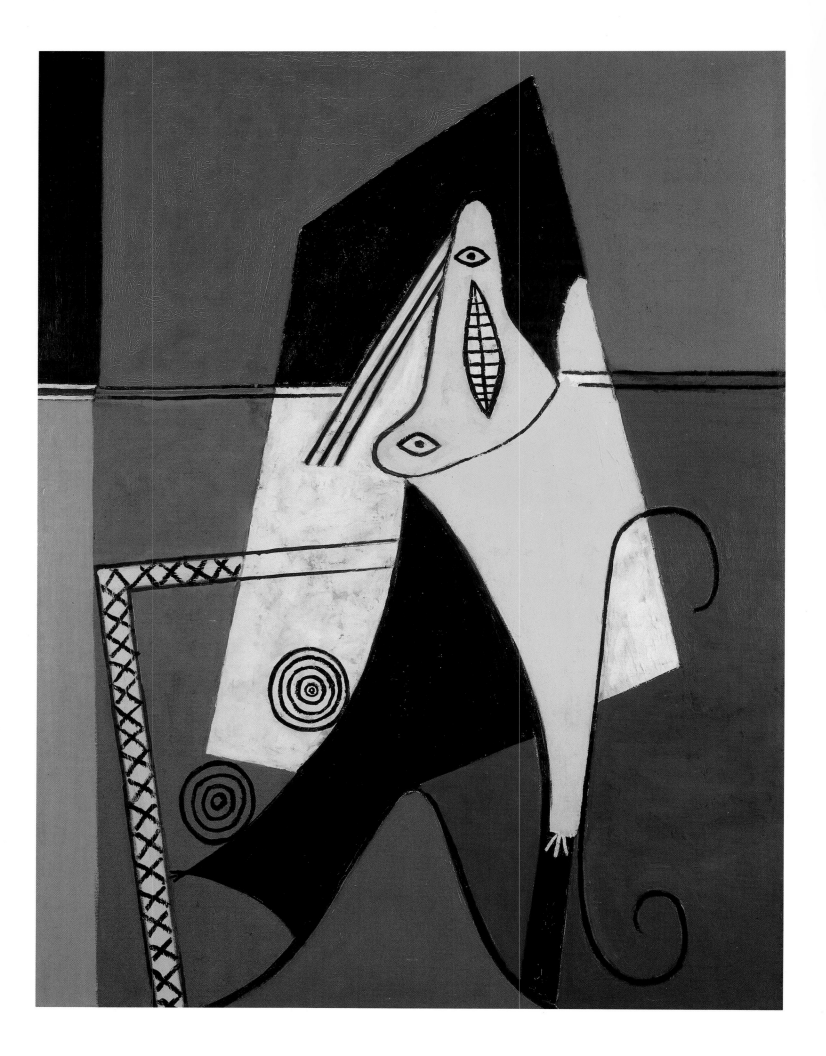

The Studio
L'atelier
Paris, winter 1927
Oil on canvas, 149.9 x 231.2 cm
Zervos VII, 142
New York, The Museum of Modern Art

The Artist and His Model
Le peintre et son modèle
Paris, 1928
Oil on canvas, 129.8 x 163 cm
Zervos VII, 143
New York, The Museum of Modern Art

Left:
Figure
Figure
Cannes, 1927
Oil on canvas, 128 x 98 cm
Zervos VII, 67
Estate of Jacqueline Picasso

Pages 318 and 319:
Sketchbook No. 95
Cannes, September 1927
Pencil on paper, 30.3 x 23 cm
Zervos VII, 90–107; Glimscher 95;
MPP 1990–107
Paris, Musée Picasso

318 A Juggler with Form 1925 – 1936

A Juggler with Form 1925 – 1936 **319**

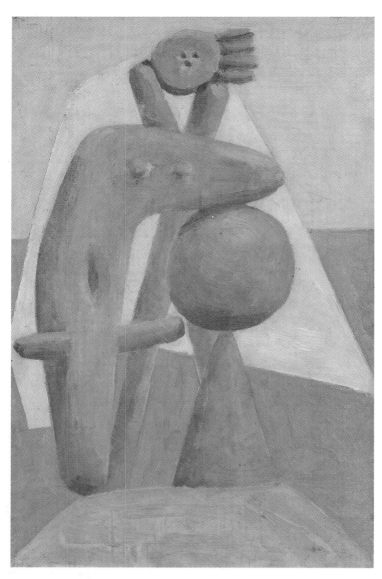

Sketchbook No. 95
Cannes, September 1927
Pencil on paper, 30.3 x 23 cm
Zervos VII, 108; Glimscher 95;
MPP 1990–107. Paris, Musée Picasso

Left:
Bather
Baigneuse
Dinard, 6 August 1928
Oil on canvas, 22 x 14 cm
Not in Zervos; MPP 106
Paris, Musée Picasso

Below:
Bathers on the Beach
Baigneuses sur la plage
Dinard, 12 August 1928
Oil on canvas, 21.5 x 40.4 cm
Zervos VII, 216; MPP 108
Paris, Musée Picasso

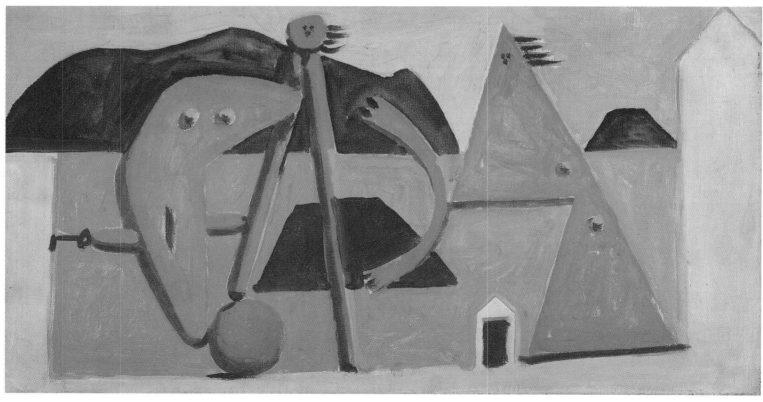

320 A Juggler with Form 1925 – 1936

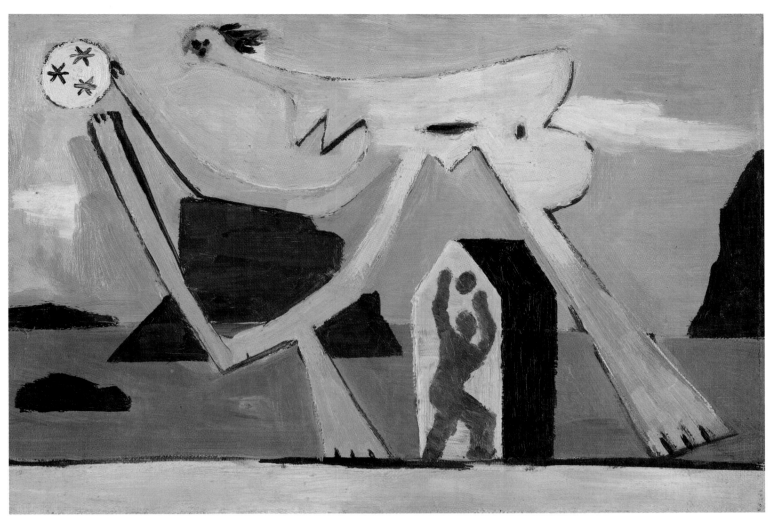

Ballplayers on the Beach
Joueurs de ballon sur la plage
Dinard, 15 August 1928
Oil on canvas, 24 x 34.9 cm
Zervos VII, 223; MPP 109
Paris, Musée Picasso

Right:
Bather Opening a Beach Cabin
Baigneuse ouvrant une cabine
Dinard, 9 August 1928
Oil on canvas, 32.8 x 22 cm
Zervos VII, 210; MPP 107
Paris, Musée Picasso

Left:
Sketchbook No. 95
Cannes, September 1927
Pencil on paper, 30.3 x 23 cm
Zervos VII, 109; Glimscher 95;
MPP 1990–107. Paris, Musée Picasso

A Juggler with Form 1925–1936 **321**

Head of a Woman
Tête de femme
Paris, 1929/30
Iron, sheet metal, colander and springs,
painted, 100 x 37 x 59 cm
Spies 81; MPP 270
Paris, Musée Picasso

Right:
Guitar
Guitare
Paris, spring 1926
String, newspaper, sackcloth and nails
on painted canvas, 96 x 130 cm
Zervos VII, 9; MPP 87
Paris, Musée Picasso

Guitar
Guitare
Paris, May 1926
Cardboard with India ink, string, tulle
and pencil on cardboard, 13.8 x 12.6 cm
Spies 65 E; MPP 92
Paris, Musée Picasso

Guitar
Guitare
Paris, 29 April 1926
Cardboard, tulle, string and pencil
on cardboard, 12.5 x 10.4 cm
Spies 65 A; MPP 88
Paris, Musée Picasso

Woman in a Garden
La femme au jardin
Paris, spring 1929
Iron, soldered and painted white,
206 x 117 x 85 cm
Spies 72 I; MPP 267
Paris, Musée Picasso

A Juggler with Form 1925 – 1936 **323**

Studies for Balzac's "Le Chef-d'œuvre inconnu"
Juan-les-Pins, 1924
Ink on paper, 10 x 11.5 cm
Zervos V, 281. Private collection

seated in a red armchair (p. 359), her arms, hands, torso, breasts and head spherical or club-like shapes, as if hewn from stone. Picasso was transferring the tactile qualities of sculpture into his painting. In the combination of semi-abstract, stylized forms with clear reminiscences of the human body, such paintings continue the 1927–1928 variations on the subject of bathers which Picasso had repeatedly drawn (pp. 318–321, 326).

This series peaked in April 1932 in the painting "Woman with a Flower" (p. 351). Two-dimensional areas of colour, boldly and sweepingly outlined, are juxtaposed with similar areas that bear witness to a modelling, three-dimensionalizing instinct. The head is like a kidney, with lines for mouth, nose and eyes. The picture is related to a sculpture done the previous year (p. 338) in which the long, irregular cylinder of the stand looks like an Alice in Wonderland neck and supports a head made of a number of smoothly interlocking heart-shaped solids. The eyes are scratched in as flat, pointed ovals. The mouth is a declivity walled about by a roll of flesh. And the nose has been displaced.

Picasso's juggling with form found support at that period in another new movement that had emerged from Dada: Surrealism. In summer 1923 Picasso met the leader of the movement, the writer André Breton, and did an etching of him. In 1924 Breton published the first Surrealist Manifesto. In it he proposed that the subconscious was a more valid mode of perceiving reality than rational thought and sense. He advocated dreams and the visions of madness as an alternative to reason. He was inspired by Sigmund Freud's psychoanalytic writings, and by the poetry of Rimbaud, Mallarmé, Lautréamont and Apollinaire, from whose work the label of the new movement was indirectly derived. Surrealism's aim was to reveal the subconscious realm of dreams by exploring avenues opened up by psychoanalysis. It disregarded the causal order of the perceptible world and set out to counter it with an unlimited use of the irrational. In this way, individual life would undergo a revolutionary transformation: feeling and expressive potential would be infinitely enhanced and extended.

The Surrealists were opposed to all artistic procedures based on

Figure (Maquette for a Memorial to Apollinaire)
Figure (Maquette pour un monument d'Apollinaire)
Paris, autumn 1928
Iron wire and sheet metal, 50.5 x 18.5 x 40.8 cm
Spies 68; MPP 264. Paris, Musée Picasso

Figure (Maquette for a Memorial to Apollinaire)
Figure (Maquette pour un monument d'Apollinaire)
Paris, autumn 1928
Iron wire and sheet metal, 60.5 x 15 x 34 cm
Spies 69; MPP 265. Paris, Musée Picasso

Figure
Figure
Paris, autumn 1928
Iron wire and sheet metal, 37.7 x 10 x 19.6 cm
Spies 71; MPP 266. Paris, Musée Picasso

Figure (Maquette for a Memorial to Apollinaire)
(Sketchbook No. 96, sheet 21)
Figure. Etude pour un monument d'Apollinaire
Dinard, 3 August 1928
India ink on paper, 30 x 22 cm
Zervos VII, 206
Geneva, Marina Picasso Foundation

326 A Juggler with Form 1925 – 1936

Woman with Veil
Femme au voile
1929
Oil on canvas, 40.9 x 26.5 cm
Zervos VII, 254. Private collection

Head
Tête
1929
Oil on canvas, 73 x 60 cm
Zervos VII, 273. Baltimore (MD), The Baltimore Museum of Art

Left:
Bather with Beach Ball
(Sketchbook No. 96, sheet 2)
Dinard, 27 July 1928
Pencil and India ink on paper, 38 x 31 cm
Zervos VII, 200
Geneva, Marina Picasso Foundation

Bather with Beach Ball
(Sketchbook No. 96, sheet 3)
Dinard, 27 July 1928
Pencil and India ink on paper, 38 x 31 cm
Zervos VII, 201
Geneva, Marina Picasso Foundation

Bather (Metamorphosis I)
Baigneuse (Métamorphose I)
Paris, 1928
Bronze, 22.8 x 18.3 x 11 cm
Spies 67 II; MPP 261
Paris, Musée Picasso

Bather (Metamorphosis II)
Baigneuse (Métamorphose II)
Paris, 1928
Plaster original, 23 x 18 x 11 cm
Spies 67 A II; MPP 262
Paris, Musée Picasso

conscious reason. In its place they put chance, trivia, and a revaluation of plain everyday sensation. Originally a literary movement, it quickly embraced the visual arts too, and a number of new techniques were developed. The most important of them were frottage, which (like brass rubbing) calls for the production of visual, textural effects by rubbing, and grattage, a kind of reverse frottage, in which paint is thickly applied and then scraped off revealing the layer underneath. Nor should we forget *Ecriture automatique*, the Surrealists' rediscovery of automatic writing and equivalent procedures in painting and drawing whereby what mattered was to suspend rational control and allow the subconscious to express itself directly via the text or image produced.[272]

One of their points of reference was also Picasso, as a pioneer of art and inventor of new methods. His playful approach to the meaning of form, his loose disdain for convention, made him appear a fellow spirit. A sculptural construction of Picasso's was reproduced in the first number of their periodical, "La Révolution surréaliste", in December 1924. In the second, in January 1925,

two pages of the sketchbook of "Constellations" (cf. p. 324) which he had done in summer 1924 at Juan-les-Pins were reproduced. The fourth issue used Picasso's painting "The Dance" (p. 306) and – reproduced for the first time in France – "Les Demoiselles d'Avignon". In 1925 Picasso exhibited at the first joint Surrealist show in the Galerie Pierre in Paris. He did portraits of Surrealist writers for their books, and in 1933 one of his collages was taken for the title page of the new magazine, "Minotaure" (p. 377).[273]

This contact, though continuing for several years, was not without conflict. When the ballet "Mercure" was first performed in 1924, with Picasso's set design and costume, several Surrealists protested at his involvement, claiming the event was merely a benefit show for the international aristocracy. It is true that Etienne Comte de Beaumont was involved in producing the ballet. But Breton, Louis Aragon and other Surrealists, impressed by the fertility of Picasso's imagination, published an apology in the "Paris Journal" headed "Hommage à Picasso".[274] Picasso, for his part, accused the Surrealists of not having understood him, in a lengthy statement on the aims and intentions of his art published in 1926. To prove his point, he referred to the interpretations the Surrealists had written to accompany the sketchbook drawings printed in their

Large Nude in a Red Armchair
Grand nu au fauteuil rouge
Paris, 5 May 1929
Oil on canvas, 195 x 129 cm
Zervos VII, 263; MPP 113
Paris, Musée Picasso

Reclining Woman
Femme couchée
Paris, April 1929
Oil on canvas, 46.3 x 61 cm
Zervos VII, 260
Paris, Musée National d'Art Moderne,
Centre Georges Pompidou

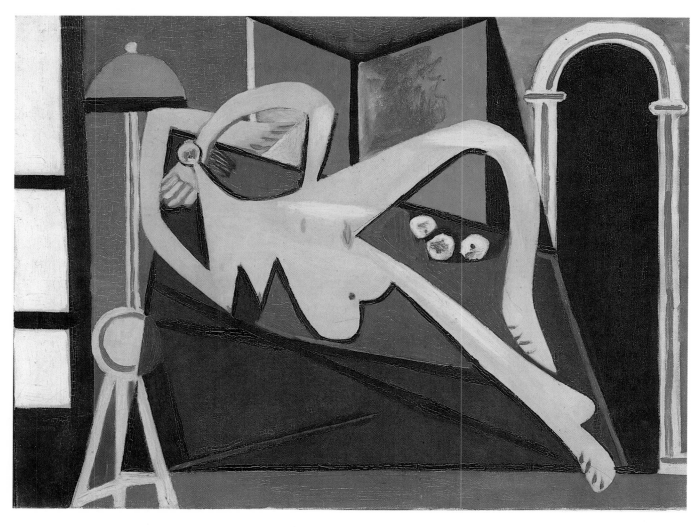

A Juggler with Form 1925 – 1936 **328**

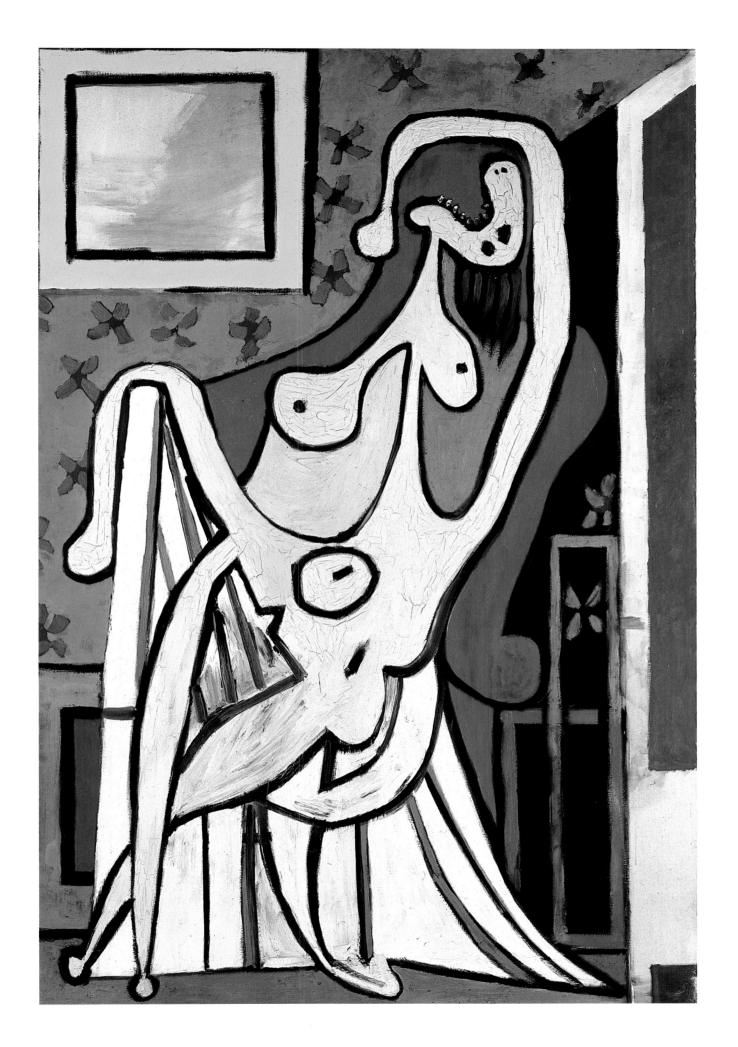

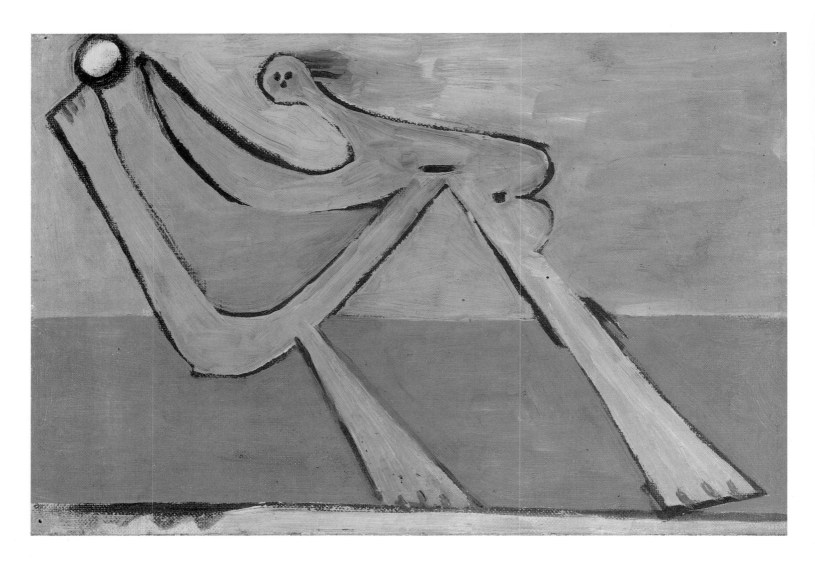

Bather
Baigneuse
Dinard, 15 August 1928
Oil on canvas, 24.5 x 35 cm
Zervos VII, 224; MPP 1900–14
Paris, Musée Picasso

magazine in 1924[275]. In the 1950s, he observed that his work before 1933 had been free of Surrealist influences.[276]

We might reply by pointing to the publication of his work in Surrealist periodicals, and to his close personal relations with certain members of the group, such as Paul Eluard, a lifelong friend. The fact is that Surrealist influences in his art are many and various. From de Chirico to Joan Miró, he registered Surrealist painting precisely, taking it as a model, and was particulary inspired by Surrealist sculpture, especially works by Alberto Giacometti.[277]

Not that the borrowings were ever isolated occurrences. Picasso adapted what he took to his own purposes, and combined it with borrowings from altogether different kinds of art. Thus his 1931/32 sculptures of women's heads are related to Matisse's bust "Jeannette V", made between 1910 and 1913, and also to the mask-like "Portrait of Professor Gosset" done by Raymond Duchamp-Villon in 1918, in which Cubist and Futurist elements are combined.[278] Picasso was also inspired by designs for female busts

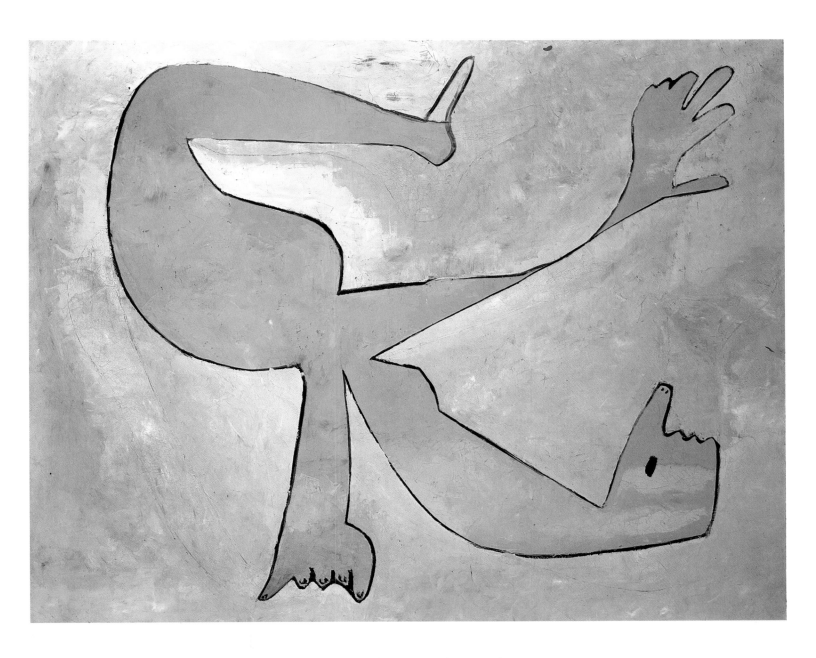

and full-length figures the sculptor Jacques Lipchitz was doing after 1930. The latter's broken-form sculptures, called "transparents", alongside Picasso's own sketches of "constellations", were the most important source for the wire constructions of 1928[279].

Like the Surrealists, Picasso too explored the visual potential of tactile qualities. There are a number of affinities in technical methods, the use of montage, and the further development of collage and assemblage. Yet still the tensions that existed between Picasso and the Surrealists were the product of deep-seated differences. It is no exaggeration to say that their respective aims and intentions were in fact diametrically opposed. For that very reason there were superficial overlaps in the approach to artistic experiment and the transformation of conventional techniques and modes of expression. The assemblages Picasso did in spring 1926, which were published that summer in "La Révolution surréaliste", point up the differences of creative method nicely. The assemblages consist of just a few, simple, everyday things. Scraps of linen and tulle, nails,

The Swimmer
La nageuse
Paris, November 1929
Oil on canvas, 130 x 162 cm
Zervos VII, 419; MPP 119
Paris, Musée Picasso

Pages 332 and 333:
The Blue Acrobat
L'acrobate bleu
Paris, November 1929
Charcoal and oil on canvas, 162 x 130 cm
Not in Zervos; MPP 1990–15
Paris, Musée Picasso

The Acrobat
L'acrobate
Paris, 18 January 1930
Oil on canvas, 162 x 130 cm
Zervos VII, 310; MPP 120
Paris, Musée Picasso

Seated Woman (Figure)
Femme assise (Figure)
Paris, 1930
Oil on panel, 66 x 49 cm
Zervos VII, 314
Basel, Beyeler Collection

334

Bust of a Woman with Self-portrait
Buste de femme et autoportrait
Paris, February 1929
Oil on canvas, 71 x 60.5 cm
Zervos VII, 248
Private collection

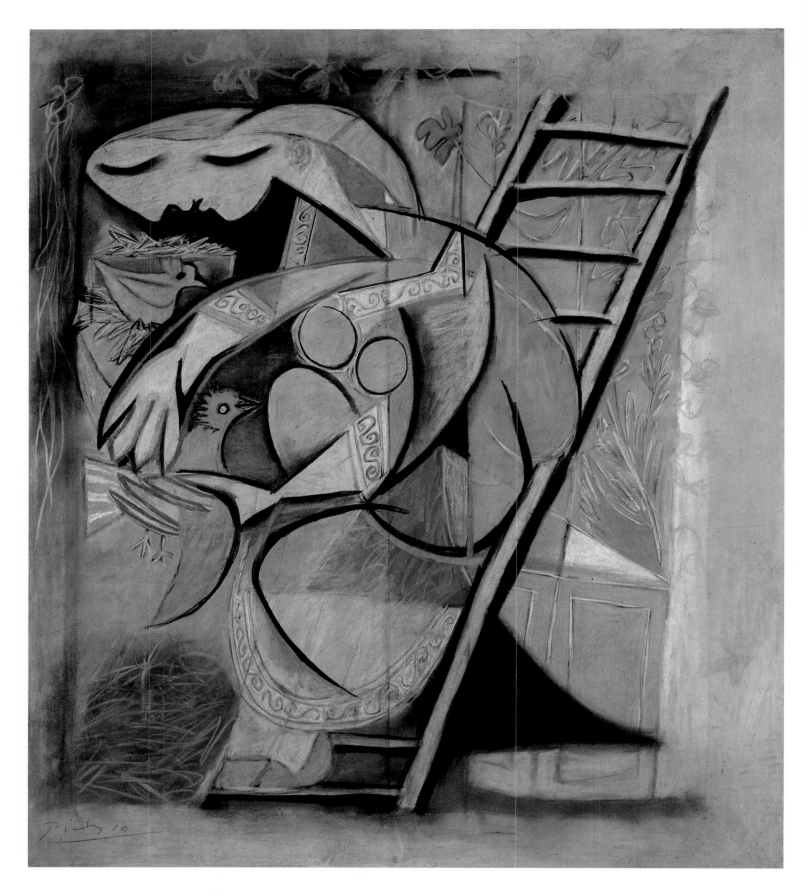

Woman with Doves
La femme aux pigeons
Paris, 1930
Oil on canvas, 200 x 185 cm
Not in Zervos
Paris, Musée National d'Art Moderne,
Centre Georges Pompidou

The Crucifixion (after Grünewald)
La crucifixion (d'après Grünewald)
Boisgeloup, 19 September 1932
Ink and India ink on paper,
34.5 x 51.5 cm
Zervos VII, 55; MPP 1075
Paris, Musée Picasso

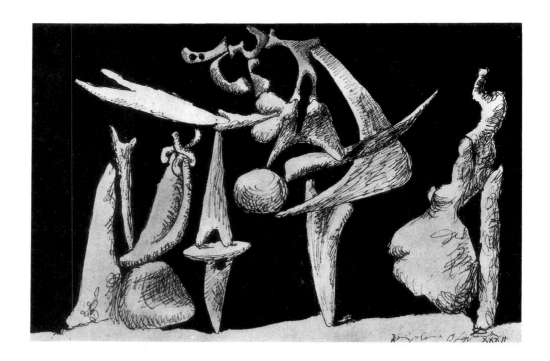

The Crucifixion
La crucifixion
Paris, 7 February 1930
Oil on plywood, 51.5 x 66.5 cm
Zervos VII, 287; MPP 122
Paris, Musée Picasso

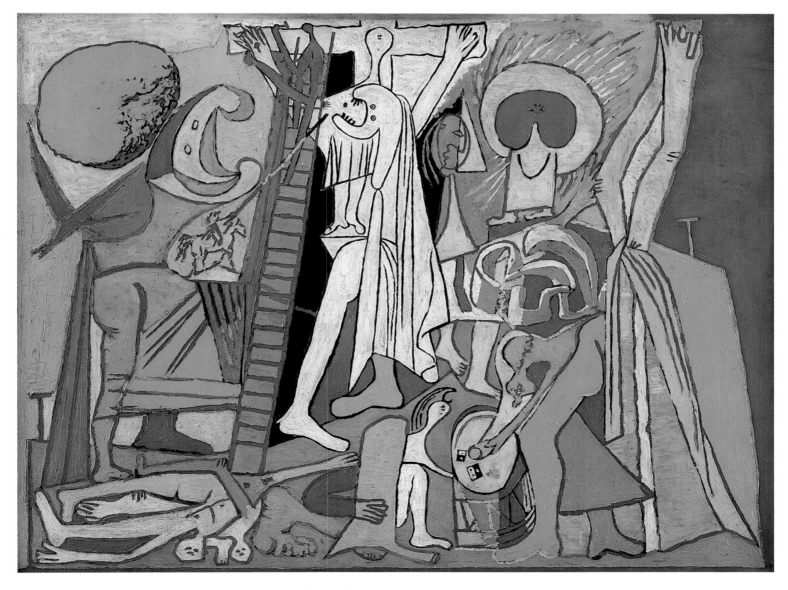

A Juggler with Form 1925 – 1936 **337**

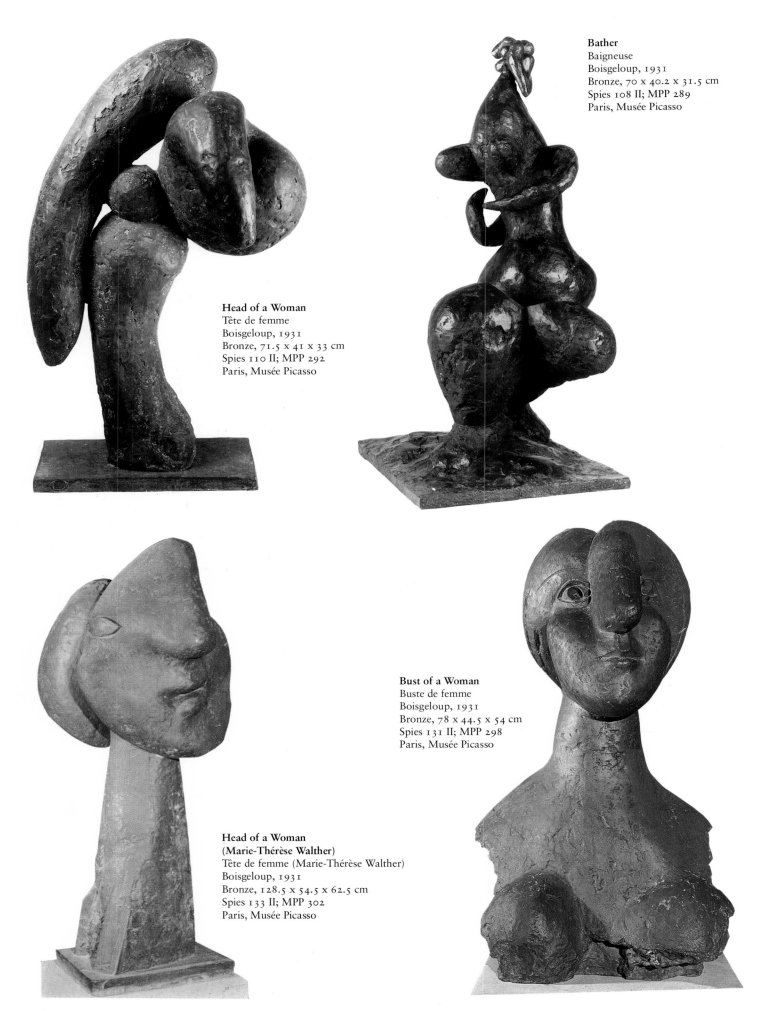

Head of a Woman
Tête de femme
Boisgeloup, 1931
Bronze, 71.5 x 41 x 33 cm
Spies 110 II; MPP 292
Paris, Musée Picasso

Bather
Baigneuse
Boisgeloup, 1931
Bronze, 70 x 40.2 x 31.5 cm
Spies 108 II; MPP 289
Paris, Musée Picasso

Bust of a Woman
Buste de femme
Boisgeloup, 1931
Bronze, 78 x 44.5 x 54 cm
Spies 131 II; MPP 298
Paris, Musée Picasso

Head of a Woman
(Marie-Thérèse Walther)
Tête de femme (Marie-Thérèse Walther)
Boisgeloup, 1931
Bronze, 128.5 x 54.5 x 62.5 cm
Spies 133 II; MPP 302
Paris, Musée Picasso

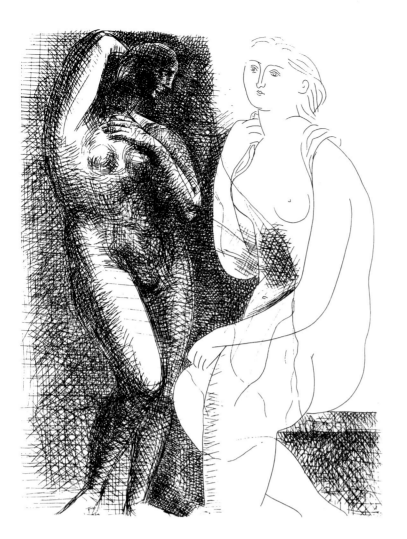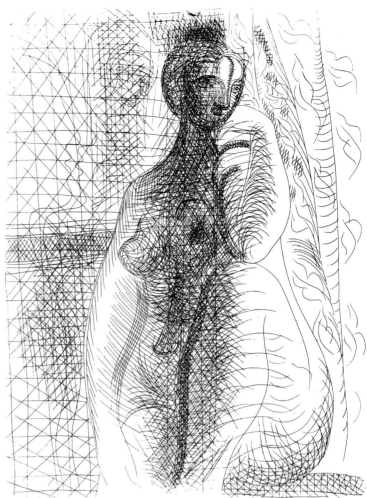

string, buttons and newspaper are put together to make almost abstract images.[280]

In "Guitar" (p. 323, top), for instance, Picasso has arranged a piece of sackcloth, a scrap of newspaper, two long nails and some string in such a way that what looks like a random collection of objects takes on the appearance of a "picture". By referring to the title we can read this picture as representational. The cut-out circle in the middle of the cloth echoes the hole in a guitar's soundboard, and the two nails loosely suggest the strings. The yellowed newspaper denotes the side and bottom of the instrument, and the string must presumably represent the (oddly angled) neck. The image is wholly non-naturalistic, and the form contrasts with that of an actual guitar. But in its details there are enough similarities to establish the concept of a guitar. Picasso is continuing the line of Synthetic Cubism here, seeing the picture as a system of signs, the arbitrary nature of which leaves the imagination leeway for untrammelled invention. The possibility of recognition is anchored in concepts and definitions, and happens entirely in the intellect.

Surrealism does exactly the opposite. It too primarily operates with a conceptual system, but its techniques and aims alike depend on the irrational. Scarcely controlled creative acts may produce random results, or logical and meticulous labour may produce im-

Nude in Front of a Statue
Femme nue devant une statue
4 July 1931
Etching, 31.2 x 22.1 cm
Bloch 139; Geiser 205

Nude with Raised Knee
Femme nue à la jambe pliée
9 July 1931
Etching, 31.2 x 22.1 cm
Bloch 141; Geiser 208

ages beyond rational interpretation; that is not the point. In the former case, form expresses the artist's subconscious and appeals to the beholder's emotions. In the latter, the beholder's subconscious is activated via feeling even though he has no rational access to the work. In terms of form and the meaning of form, however, emotion plays no part at all in Picasso's work.

This is not to say that no feeling is involved in the impact of his work. But it is different. For the Surrealists, form is the trigger of a chain of associations which are suggestive of emotional states and linked to the spiritual condition of instinctual mankind. In Picasso, form is free, autonomous. He appeals to the emotions to prompt conflict or even shock, starting an intellectual process in the course of which we reflect not on ourselves but on art. That was the aim of the picture-puzzle line-and-point sketches of summer 1924 which led to the wire sculptures of autumn 1928 (cf. pp. 324 and

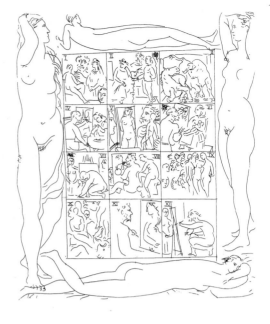

Table of Etchings
Table des eaux-fortes
Paris, 4 July 1931
Etching, 37.5 x 29.8 cm
Bloch 94; Geiser 135 I b

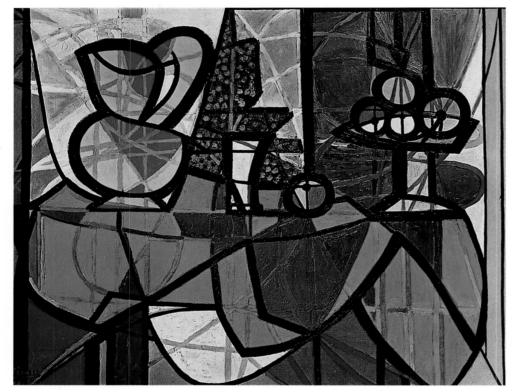

Pitcher and Bowl of Fruit
Pichet et coupe de fruits
Paris, 22 February 1931
Oil on canvas, 130 x 162 cm
Zervos VII, 322
New York, The Museum of Modern Art

325). These works avowedly play off the abstract against the representational, the spatial against the graphic. But Picasso had a particular reason, drawn from the theory of art, for using linear studies to make constructions. Their form reveals his purpose.

Linearity and space are dialectically juxtaposed. The iron rods stand for tactile, material volume. But they also look like lines, and seem two-dimensional. Since we interpret them as denoting outlines, they establish figures. But the material they outline is air – neither visible nor palpable. Paradoxically, these sculptures use a substance the spatial content of which is literally *immaterial*. What Picasso has sculpted is *nothing-ness*. This was what he was after.

Large Still Life on a Pedestal Table
Grande nature morte au guéridon
Paris, 11 March 1931
Oil on canvas, 195 x 130.5 cm
Zervos VII, 317; MPP 134
Paris, Musée Picasso

Figures at the Seashore
Figures au bord de la mer
Paris, 12 January 1931
Oil on canvas, 130 x 195 cm
Zervos VII, 328; MPP 131
Paris, Musée Picasso

The maquettes were done in response to a commission. The Association of Friends of Apollinaire planned to erect a memorial to the poet on the tenth anniversary of his death, and approached Picasso, who aptly tackled the project in the spirit of a phrase Apollinaire had written: "the statue made of nothing, of vacancy". Apollinaire was thinking of a monument to a poet; so it seemed doubly appropriate to Picasso to borrow this thought from his friend. The evident relation to the human figure derives its meaning from this consideration too: Picasso evolved his idea in order to put the 19th century's outmoded notions of memorials aside, for good. The representational, figural echo alludes to the tradition of monuments, but in a radical form that departs conspicuously from the tradition. Unfortunately Picasso's idea was too daring and progressive for his contemporaries. The committee turned it down.[281]

Not till much later did the artist have the chance to realize his ideas, at least in part. In 1962 he himself had two large-scale versions of the four maquettes made, one 115 centimetres high, the other 200, intended as intermediate stages towards a finished version on a monumental scale. In 1973, shortly before his death, one version over four metres high was put up in the Museum of Modern Art, New York. No longer able to see it for himself, Picasso followed the progress of the work through reports and photo-

graphs. Finally, in 1985, when the Picasso Museum was opened in Paris, another version almost five metres high was put up there.[282]

The basic idea remained alive in Picasso's œuvre. In 1931 he used 16 of the 1924 sketches to illustrate a bibliophile edition of Honoré de Balzac's tale "Le Chef-d'œuvre inconnu". Again the line-and-point constructs, neutral in themselves, were placed in a theoretical context. Balzac's story of the unknown masterpiece is about translating the absolute into art. It tells of a 17th-century painter whose ambition is to express an ideal, perfect illusion of life, beyond all specifics of form, colour and perspective. When he has been at work on his masterpiece for ten years, friends – among them the French painter Poussin – persuade him to let them see it. What the shocked group see, instead of the portrait of a lady they have been led to expect, is a chaotic jumble of colours and lines.[283]

At that time, Picasso was particularly interested in the applied art of book illustration. The subjects he searched out were closely connected with his own work towards self-reflexive art. He employed a variety of etching processes (cold needle, line etching and aquatint) for this work, which included thirteen classicist etchings also for Balzac's novella, thirty etchings done in 1930 for publisher Albert Skira for an edition of Ovid's "Metamorphoses" which appeared the following year, and one hundred plates done between

Woman Throwing a Stone
Femme lançant une pierre
Paris, 8 March 1931
Oil on canvas, 130.5 x 195.5 cm
Zervos VII, 329; MPP 133
Paris, Musée Picasso

1930 and 1937 which became the "Suite Vollard" in 1939. The same familiar repertoire of subjects recurred: painter and model, bullfight, bathers, nudes, acrobats. The works have titles such as "Sculptor Resting with Model in his Arms" or "Sculptor with Model at a Window". Sculptors or painters with models account for the greatest part of these works. Painters and sculptors, themselves drawn naturalistically, can make abstract figures from real originals, Picasso is saying – or naturalistic images from abstract models. These sequences of graphics, deconstructed twofold, bring home the work of the artist. This applies to the return to antiquity too, a constant in Picasso's work since his youth. It was not only the classical style that provided a point of reference for formal matters, but also the subject matter of myths illustrated.

Ovid's "Metamorphoses", the most illustrated of all books after the Bible, deals with the entirety of the ancient world's mythology. Its presence in European art has been a long and signal one. On a political level, it moves from the beginning of the world to the new Golden Age under Emperor Augustus (Ovid's contemporary). In a

Reading
La lecture
Boisgeloup, 2 January 1932
Oil on canvas, 130 x 97.5 cm
Zervos VII, 358; MPP 137
Paris, Musée Picasso

Reclining Nude
Femme nue couchée
Boisgeloup, 4 April 1932
Oil on canvas, 130 x 161.7 cm
Zervos VII, 332; MPP 142
Paris, Musée Picasso

A Juggler with Form 1925 – 1936 **344**

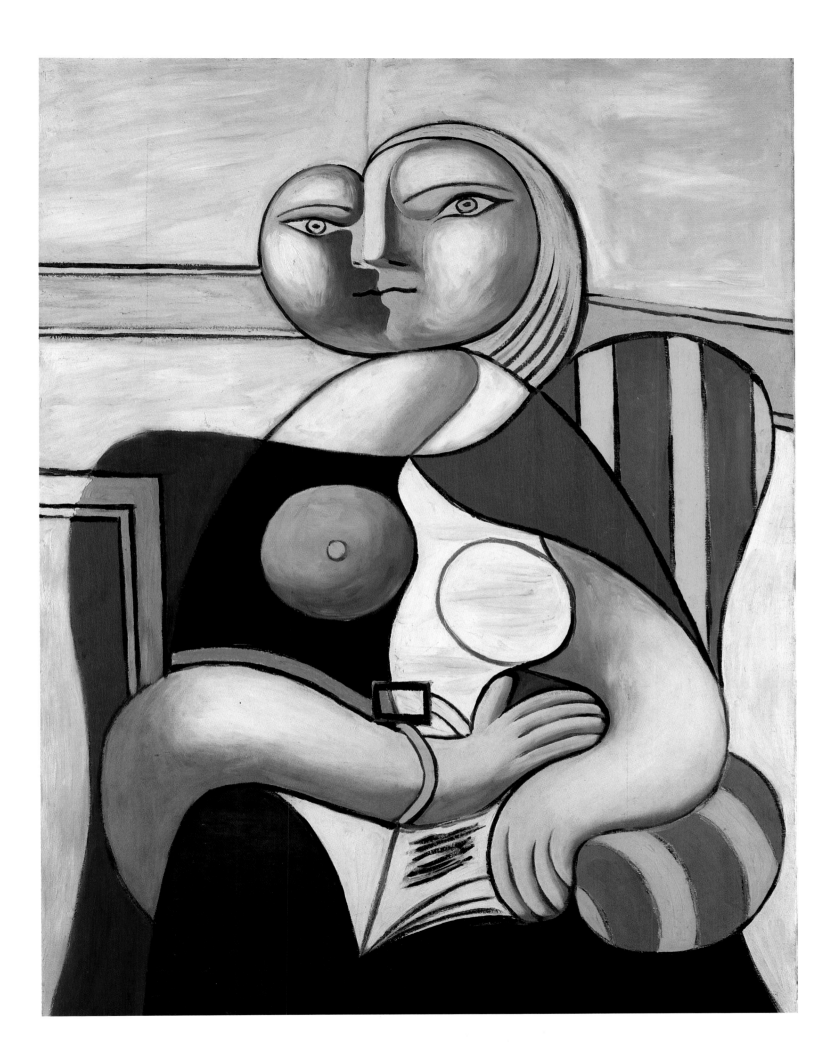

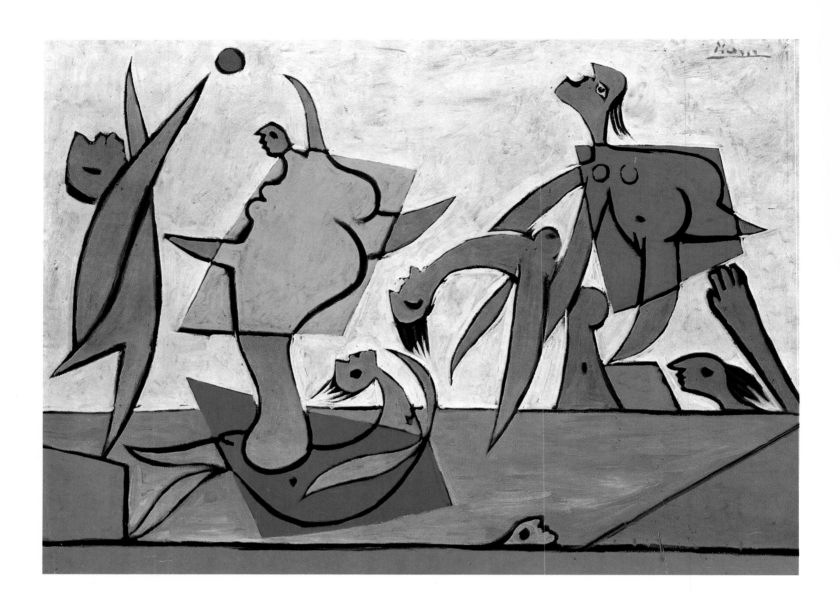

Beach Game and Rescue
Jeu de plage et sauvetage
Paris, November 1932
Oil on canvas, 97 x 130 cm
Zervos VIII, 64
Switzerland, Private collection

sense the "Metamorphoses" are sublime propaganda. The book, true to its title, tells of heroes and heroines transformed into animals, plants, streams, stars and so forth.[284] Metamorphoses of this order are the proper province of the creative artist. If he wishes he can use the aesthetic norms and subjects of antiquity; but he can also make a faun into an artist, transform a stone into organic substance, and then metamorphose it back to a stone.

As always, Picasso did not observe the bounds of one artistic genre. He combined elements from various sources, and transferred his figurations and motifs from drawings to printed graphics, from etchings to paintings. Thus in the 1933 "Silenus Dancing in Company" (p. 365) we have a gouache and India ink variation on a baroque theme.[285] In late 1931, in "The Sculptor" (p. 304), Picasso transferred to an oil painting the 1931/32 female busts from the painter-and-model theme, and transposed the formal puzzle component to both figures, the artist and the statue created by him. The motifs are repeated in a distinctly different 1933 treatment in ink, India ink, watercolour and gouache which again shows the sculptor and his work (p. 364).

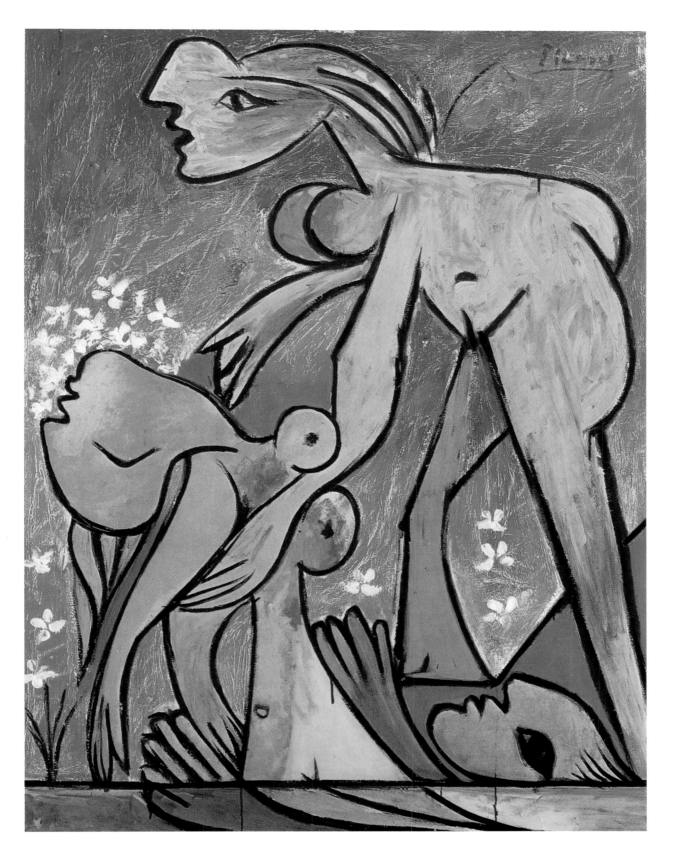

The Rescue
Le sauvetage
Paris, December 1932
Oil on canvas, 130 x 97 cm
Zervos VIII, 66
Basel, Beyeler Collection

347

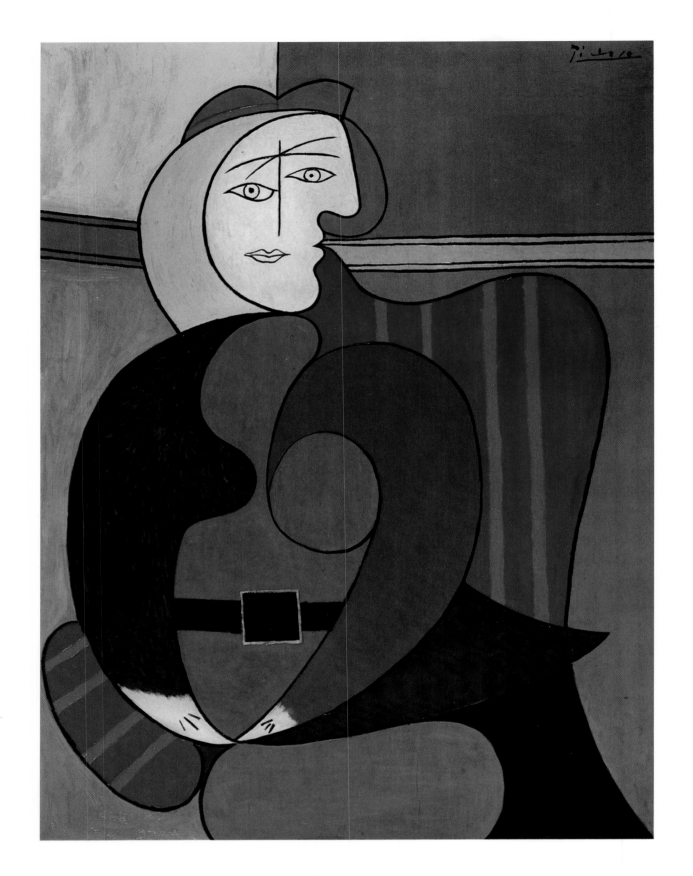

The Red Armchair
Femme assise dans un fauteuil rouge
Paris, 16 December 1931
Oil and enamel paint on plywood,
130.8 x 99 cm
Zervos VII, 334
Chicago (IL), The Art Institute of Chicago

348

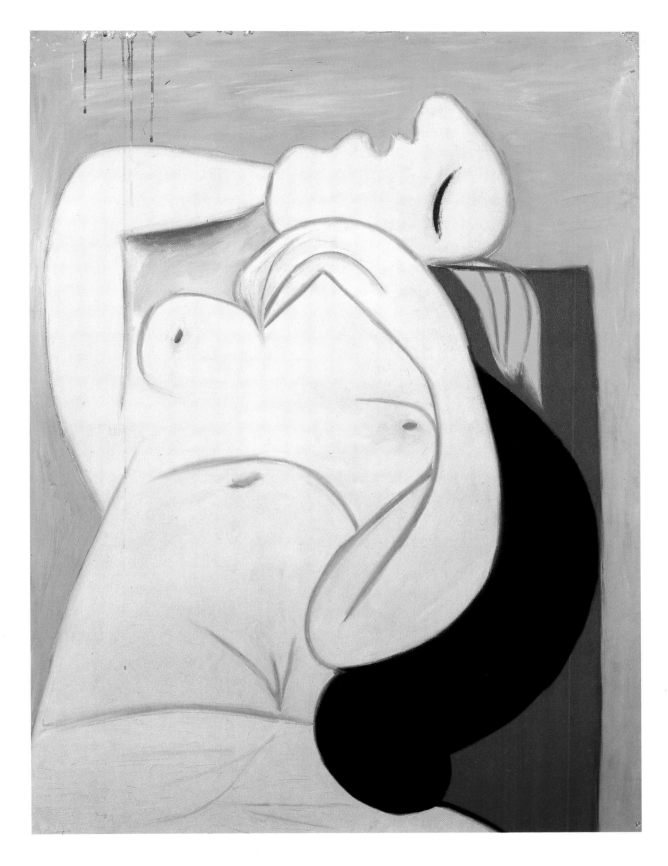

Sleep
Le sommeil
Paris, 23 January 1932
Oil on canvas, 130 x 97 cm
Zervos VII, 362
Estate of Jacqueline Picasso

349

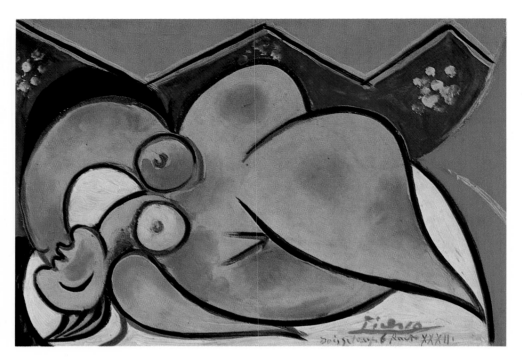

Reclining Nude
Femme nue couchée
Boisgeloup, 6 August 1932
Oil on canvas, 24 x 35 cm
Not in Zervos
Rome, Private collection

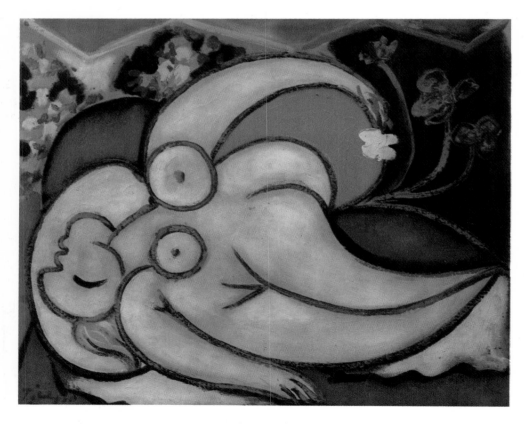

Reclining Nude
Femme nue couchée
Boisgeloup, 19 June 1932
Oil on canvas, 38 x 46 cm
Not in Zervos
Paris, Musée National d'Art Modern,
Centre Georges Pompidou

Woman with a Flower
Femme à la fleur
Boisgeloup, 10 April 1932
Oil on canvas, 162 x 130 cm
Zervos VII, 381
New York, Mr. and Mrs. Nathan
Cummings Collection

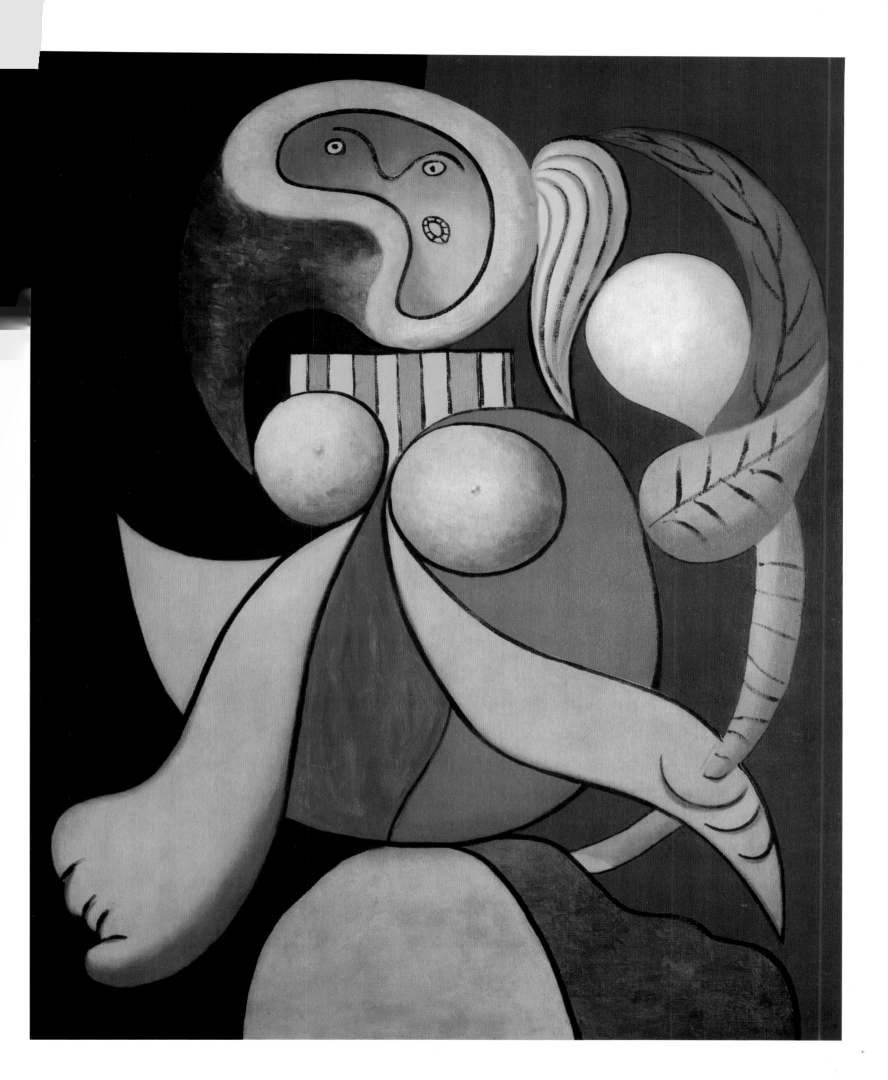

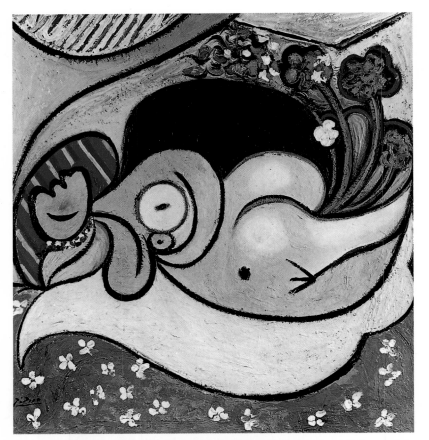

Reclining Nude with Flowers
Femme nue couchée aux fleurs
Boisgeloup, July 1932
Oil on canvas, 101.6 x 92.7 cm
Zervos VII, 407
New York, Peter A. Rübel Collection

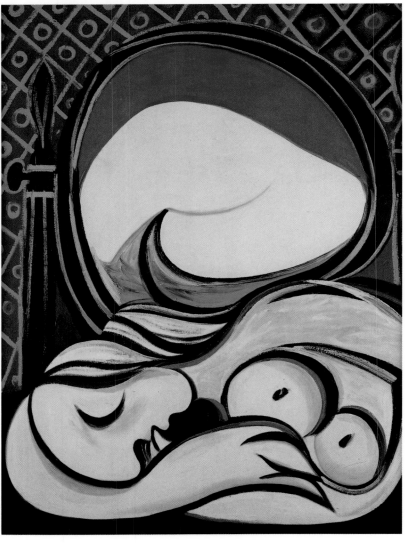

The Mirror
Le miroir
Boisgeloup, 12 March 1932
Oil on canvas, 130.7 x 97 cm
Zervos VII, 378
Private collection

Girl Before a Mirror
Jeune fille devant un miroir
Boisgeloup, 14 March 1932
Oil on canvas, 162.3 x 130.2 cm
Zervos VII, 379
New York, The Museum of Modern Art,
Gift of Mrs. Simon Guggenheim

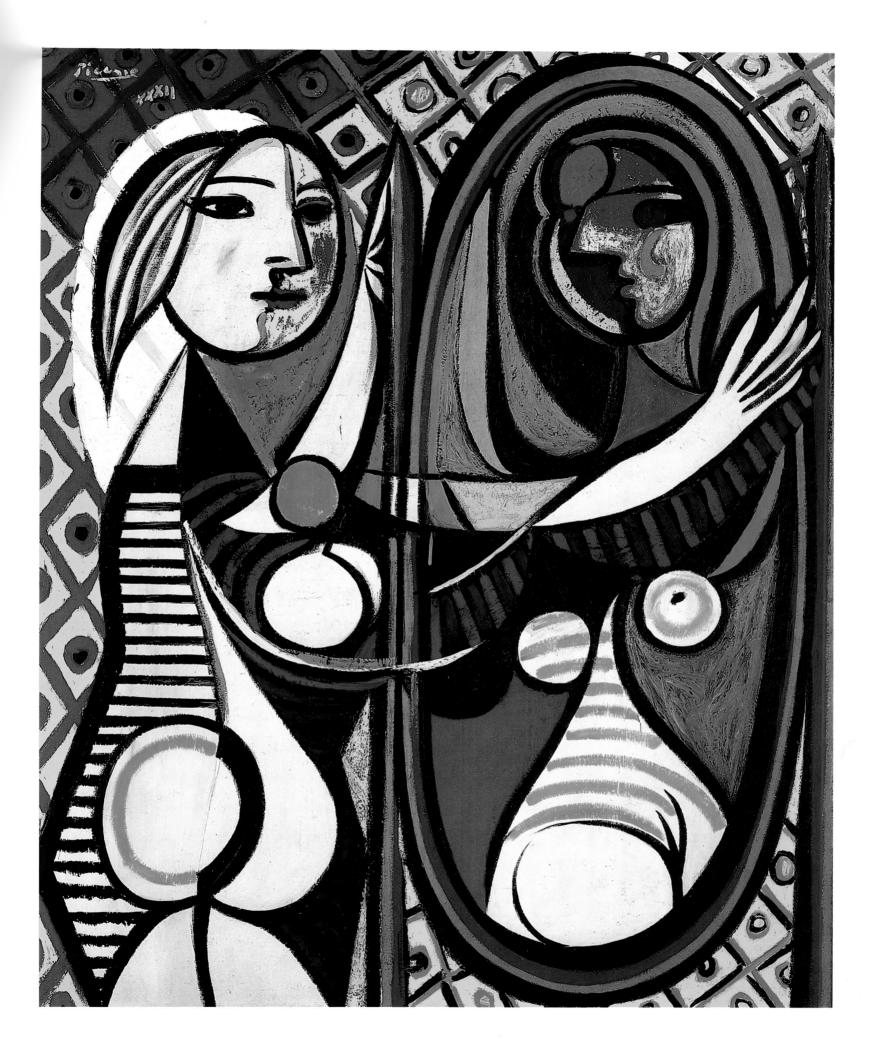

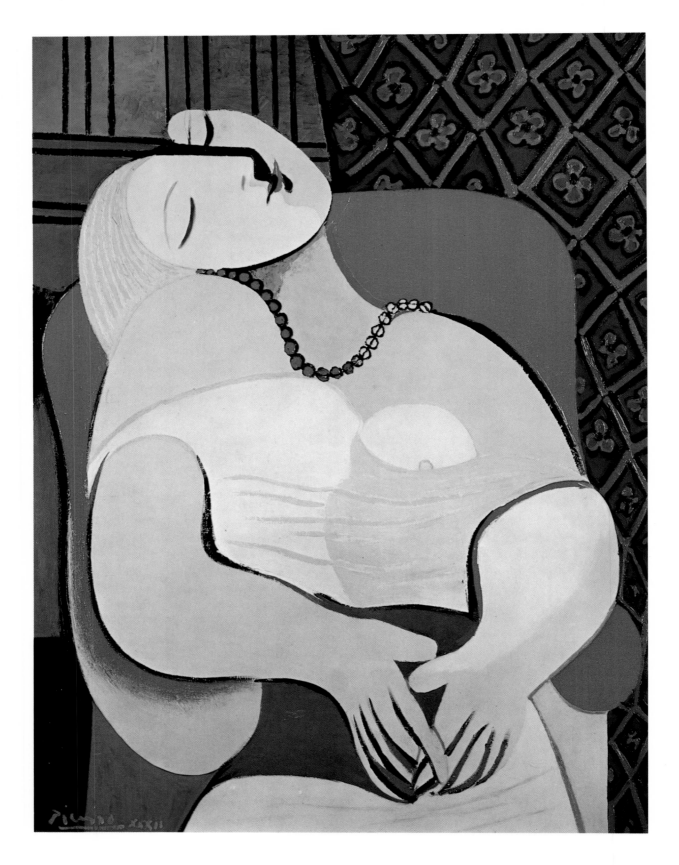

The Dream
Le rêve
Boisgeloup, 24 January 1932
Oil on canvas, 130 x 98 cm
Zervos VII, 364
New York, Mrs. Victor W. Ganz Collection

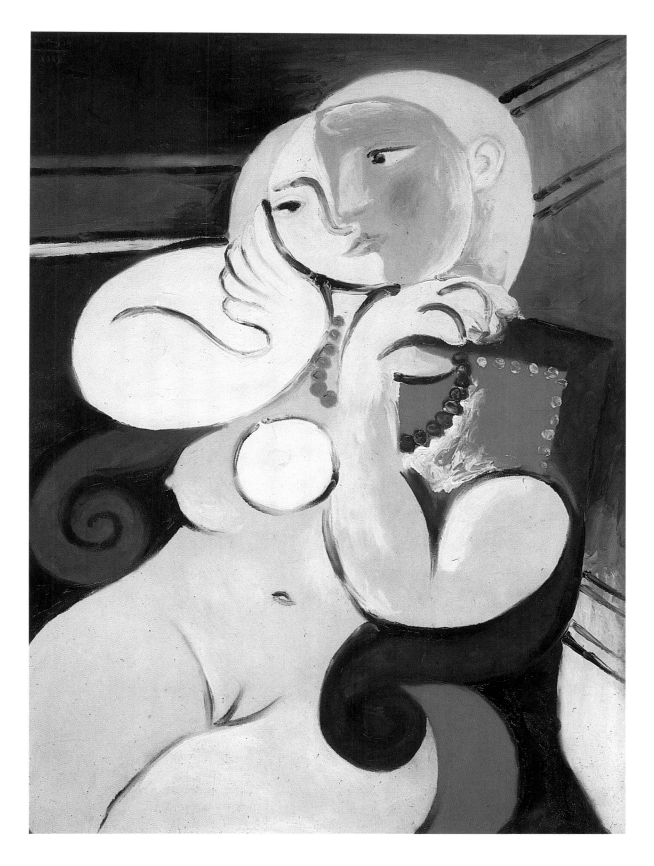

Nude in a Red Armchair
Femme nue dans un fauteuil rouge
1932
Oil on canvas, 130 x 97 cm
Zervos VII, 395
London, Tate Gallery

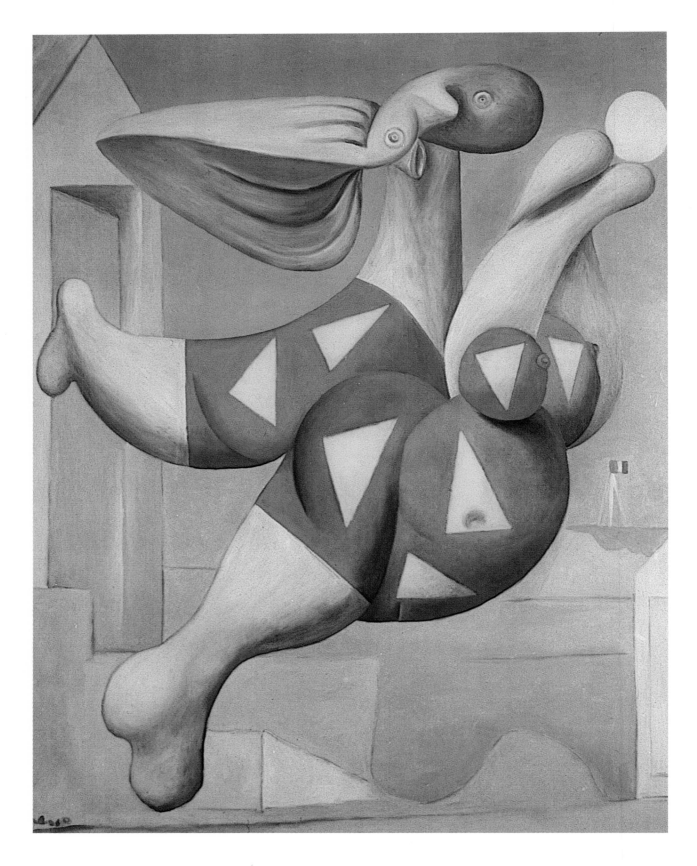

Bather with Beach Ball
Baigneuse au bord de la mer
Boisgeloup, 30 August 1932
Oil on canvas, 146.2 x 114.6 cm
Zervos VIII, 147
New York, The Museum of Modern Art

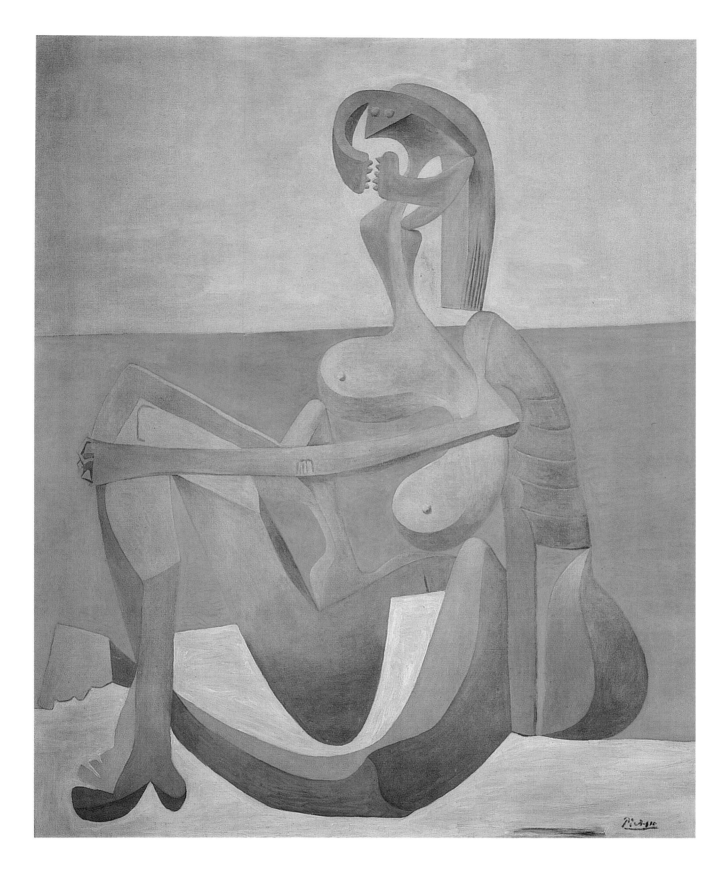

Seated Bather
Baigneuse assise au bord de la mer
Paris, early 1930
Oil on canvas, 163.2 x 129.5 cm
Zervos VII, 306
New York, The Museum of Modern Art,
Mrs. Simon Guggenheim Fund

357

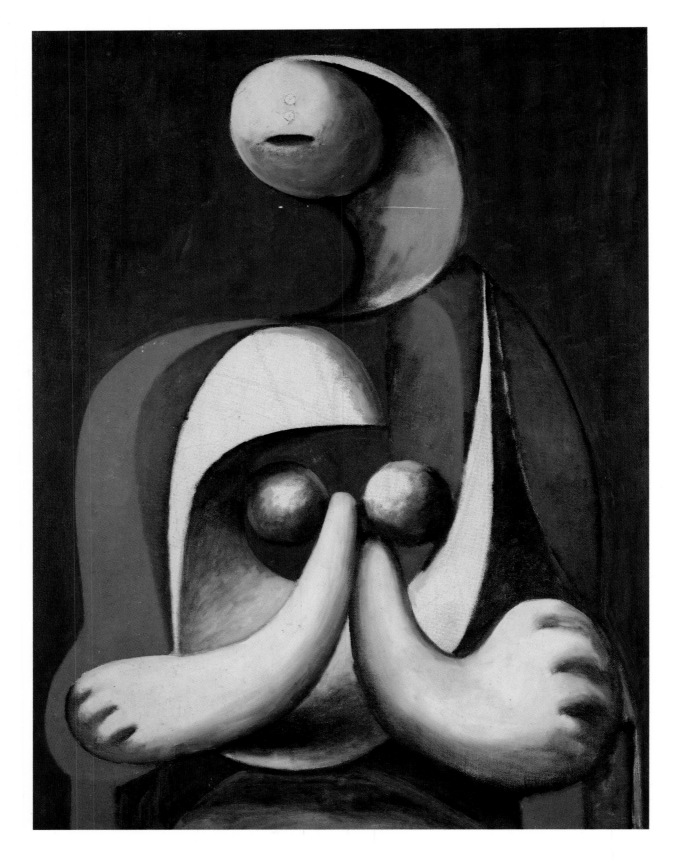

Seated Woman in a Red Armchair
Femme assise dans un fauteuil rouge
Boisgeloup, 1932
Oil on canvas, 130 x 97.5 cm
Not in Zervos; MPP 139
Paris, Musée Picasso

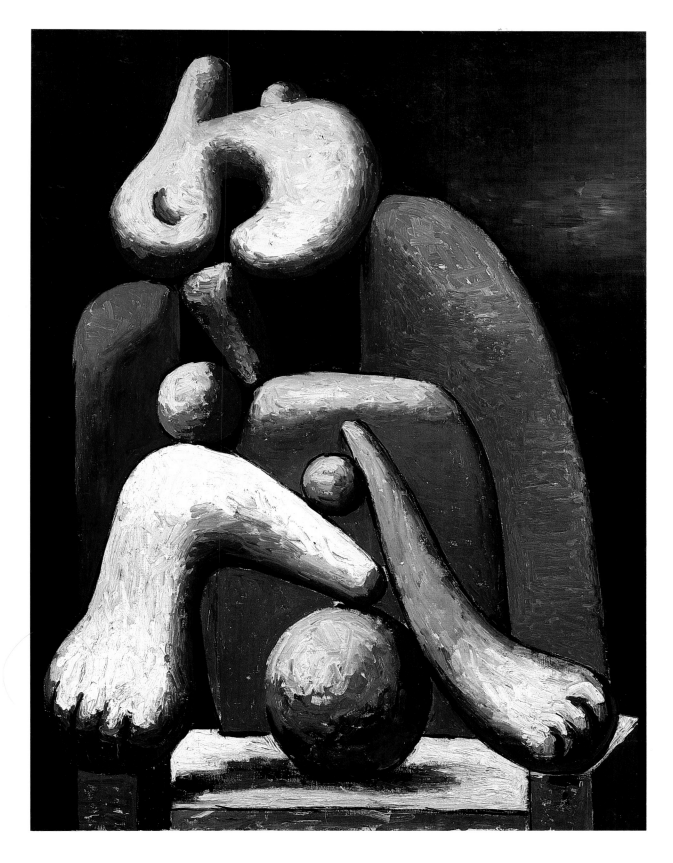

Woman in a Red Armchair
Femme au fauteuil rouge
Boisgeloup, 27 January 1932
Oil on canvas, 130.2 x 97 cm
Zervos VII, 330; MPP 138
Paris, Musée Picasso

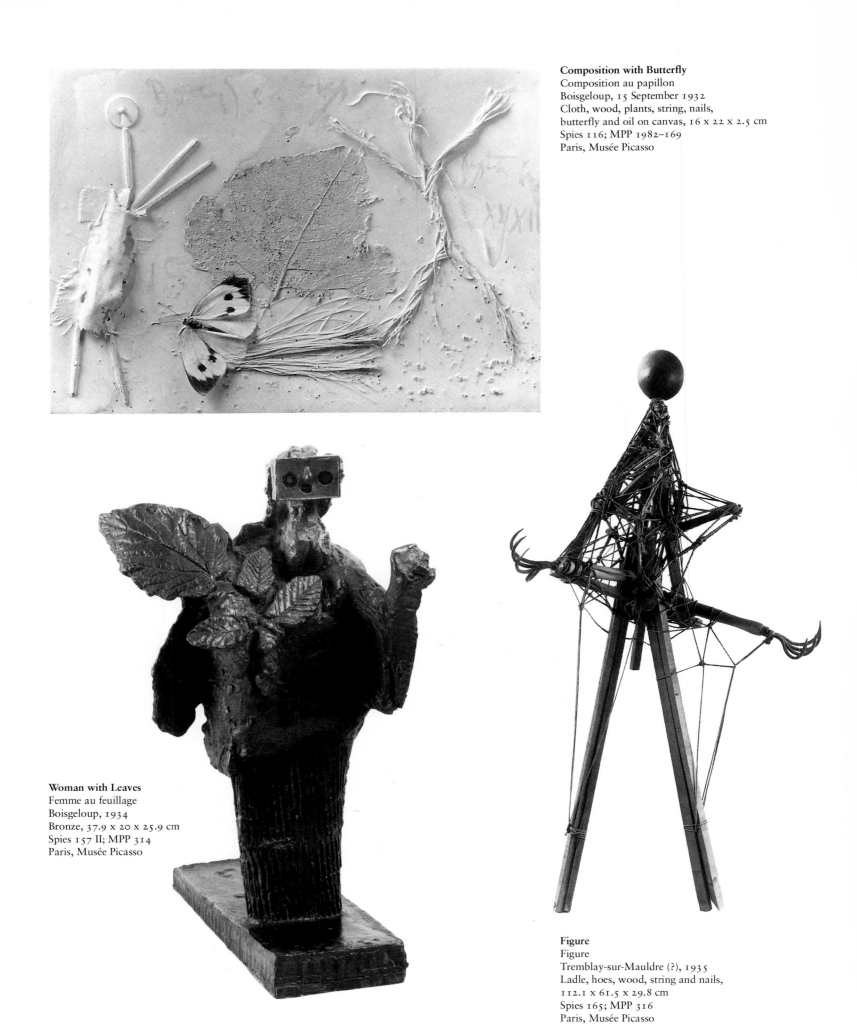

Composition with Butterfly
Composition au papillon
Boisgeloup, 15 September 1932
Cloth, wood, plants, string, nails,
butterfly and oil on canvas, 16 x 22 x 2.5 cm
Spies 116; MPP 1982–169
Paris, Musée Picasso

Woman with Leaves
Femme au feuillage
Boisgeloup, 1934
Bronze, 37.9 x 20 x 25.9 cm
Spies 157 II; MPP 314
Paris, Musée Picasso

Figure
Figure
Tremblay-sur-Mauldre (?), 1935
Ladle, hoes, wood, string and nails,
112.1 x 61.5 x 29.8 cm
Spies 165; MPP 316
Paris, Musée Picasso

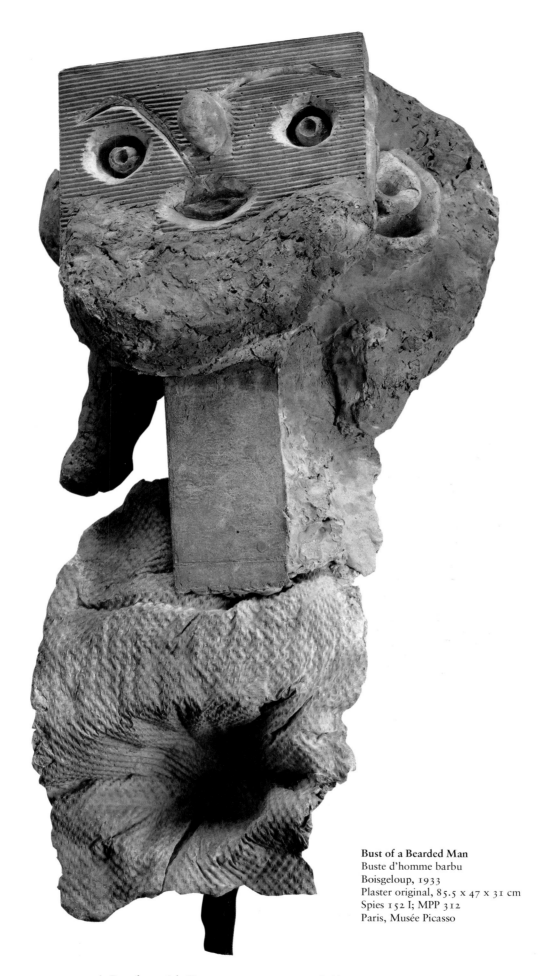

Bust of a Bearded Man
Buste d'homme barbu
Boisgeloup, 1933
Plaster original, 85.5 x 47 x 31 cm
Spies 152 I; MPP 312
Paris, Musée Picasso

A Juggler with Form 1925 – 1936 **361**

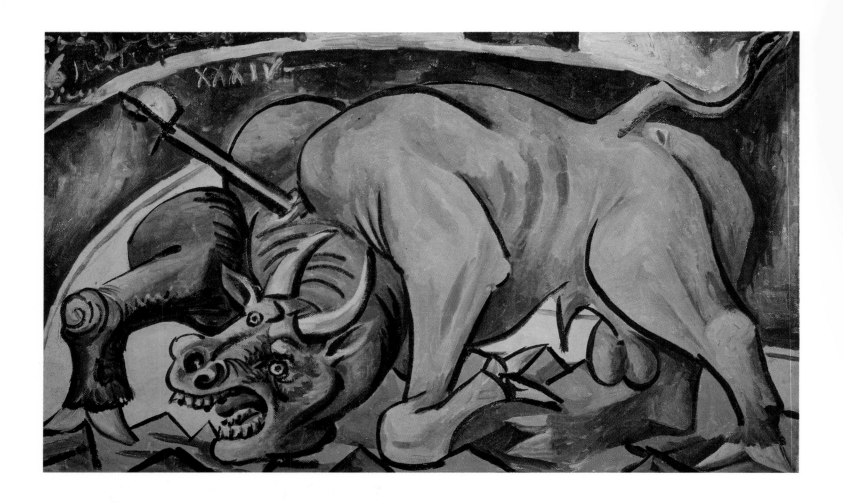

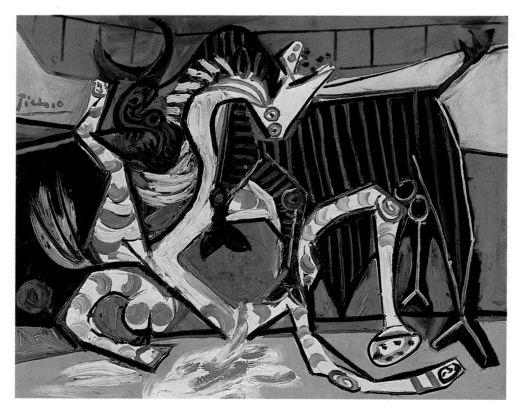

Dying Bull
Taureau mourant
Boisgeloup, 16 July 1934
Oil on canvas, 33.3 x 55.2 cm
Zervos VIII, 228
Mexico City, Jacques and Natasha
Gelman Collection

Bullfight (Corrida)
Course de taureaux (Corrida)
Boisgeloup, 27 July 1934
Oil on canvas, 50 x 61 cm
Not in Zervos
Private collection

A Juggler with Form 1925 – 1936 **362**

Bullfight (Corrida)
Course de taureaux (Corrida)
Boisgeloup, 22 July 1934
Oil on canvas, 54.3 x 73 cm
Zervos VIII, 219
Private collection

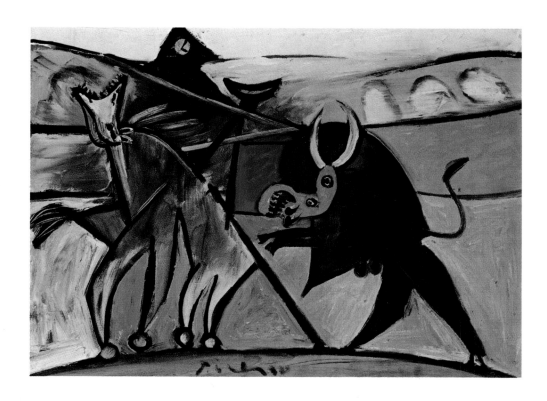

Bullfight (Corrida)
Course de taureaux (Corrida)
Boisgeloup, 22 July 1934
Oil on canvas, 97 x 130 cm
Zervos VIII, 229
Private collection

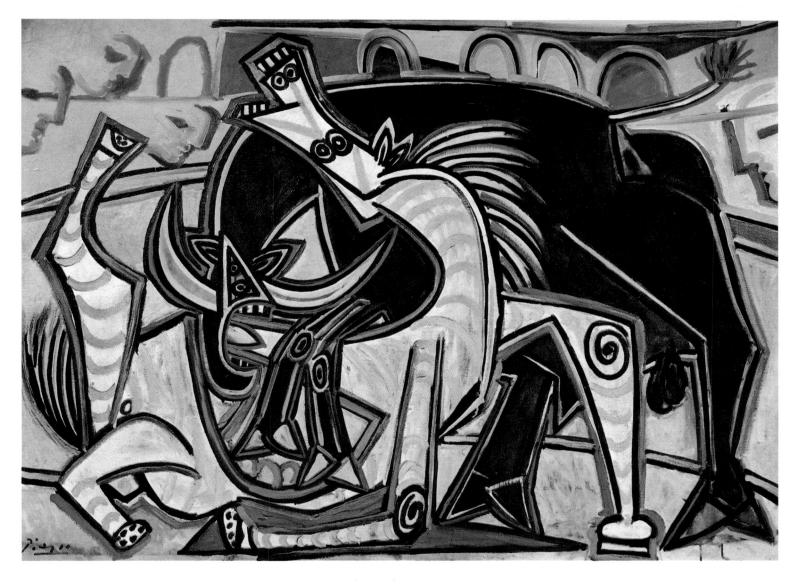

363 A Juggler with Form 1925 – 1936

The Sculptor and His Statue
Le sculpteur et sa statue
Cannes, 20 July 1933
Ink, India ink, watercolour and gouache
on paper, 39 x 49.5 cm
Zervos VIII, 120
Geneva, Heinz Berggruen Collection

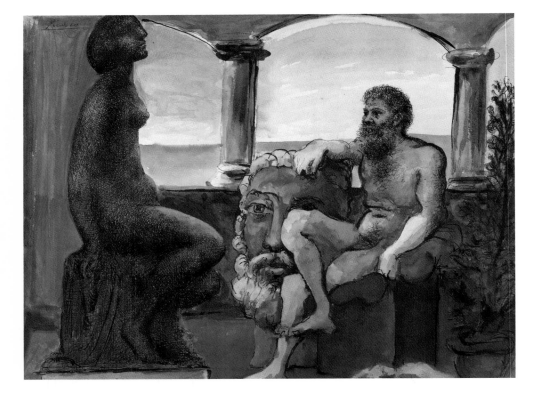

Bullfight: Death of the Toreador
Course de taureaux: la mort du torero
Boisgeloup, 19 September 1933
Oil on panel, 31.2 x 40.3 cm
Zervos VIII, 214; MPP 145
Paris, Musée Picasso

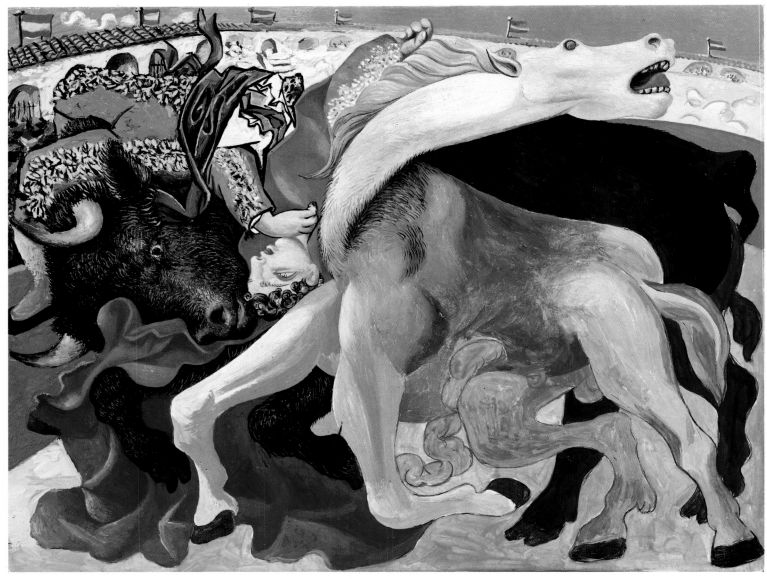

364 A Juggler with Form 1925 – 1936

Silenus Dancing in Company
Silène en compagnie dansante
Cannes, 6 July 1933
Gouache and India ink on paper,
34 x 45 cm
Not in Zervos
Geneva, Heinz Berggruen Collection

A large number of Picasso's etchings are responses to Rembrandt. In three, the Dutch baroque painter appears with his model, but many other plates in the "Suite Vollard" document Picasso's approach to Rembrandt. One unfinished Rembrandt etching shows the artist and his model. Picasso not only played numerous variations on the theme of a female nude seen from the rear together with an artist seen frontally. He was also interested in formal aspects of the Rembrandt work. He adopted the contrast of richly cross-hatched areas with plain outline drawing, using it elsewhere with different subjects.[286] Both types of quotation – of form and of motif – acted as an analysis of the artist himself. Picasso was placing himself on a par with Rembrandt – a high ambition indeed, for Rembrandt is widely seen as *the* master of etching, and in Picasso's time was considered the greatest artist of all time. Picasso was asserting that he himself was Rembrandt's legitimate successor, that he himself was the most important 20th-century artist.

There is a contrast to Surrealist intentions and techniques. Picasso transfers a clearly definable content to his pictures, his system of signs directly related to the message to be conveyed. In Surrealism, the visual sign is an enigma, an instrument of encodement; deep and inward meditation is required to decode the image. For Picasso, form and content are mutually determinant, in a way that is ultimately perfectly traditional. They serve either the exploration of visual problems or the analysis of a subject. Picasso's titles define the content; Surrealist titles add a layer of obfuscation.

In summer 1925, in his painting "The Dance" (p. 306), Picasso reworked studies drawn that spring when visiting the Ballets Russes in Monte Carlo, purely representational ones playing off

Woman Facing to the Right
Femme de 3/4 gauche
Boisgeloup, 12 July 1934
Oil on canvas, 55 x 33 cm
Zervos VIII, 243
Basel, Galerie Beyeler

Woman with Cap
Femme au béret
Boisgeloup, 12 July 1934
Oil on canvas, 55 x 38 cm
Not in Zervos
Paris, Maya Ruiz-Picasso Collection

linear effects against economical three-dimensionality. He now combined this interplay with what he had learnt from the papiers collés, finding a way of heightening the ecstatic dynamism of the action in the most evocative of styles. But there is far more to the picture. In a gap towards the top right, silhouetted against the blue sky, we see the profile of Ramón Pichot, a friend of Picasso's who had recently died. The painting is dedicated to him. What looks like a pure celebration of *joie de vivre* turns out to portray the old Spanish custom of dancing around the dead when they are laid out.[287] This redefinition of the subject is perfectly matched to the redefinition of form; as in the later maquettes for the Apollinaire memorial, the picture-puzzle component has a distinct function.

That year, Picasso created another masterpiece of formal metamorphosis, "The Kiss" (p. 309), a truly awful picture – but wonderful too! A manifesto of new ways of expression, it presents the aggressive, violent and primitive aspects of the act of love with a brutality scarcely ever attempted before. It makes demands on us. We have to disentangle what we see, gradually discovering at the

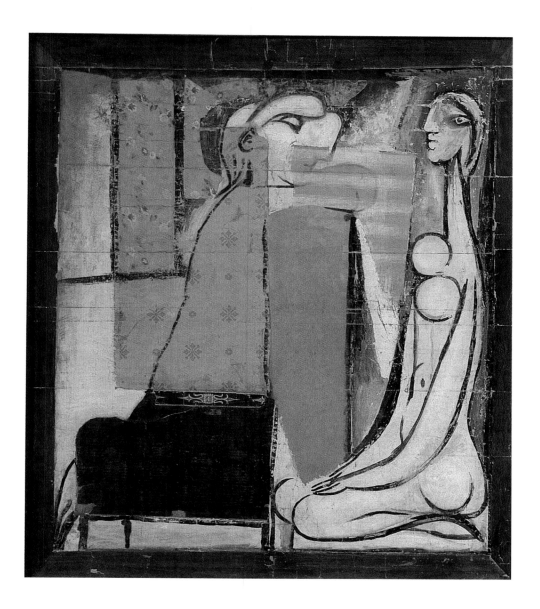

Confidences
Confidences
1934
Oil, papiers collés and gouache
on canvas, 194 x 170 cm
Zervos VIII, 268
Paris, Musée National d'Art Moderne,
Centre Georges Pompidou

top, amidst the seeming chaos of loud colours and contrasts, mouths locked in a devouring kiss; a figure at left, holding another in an embrace; an exploded backbone atop straddled legs. But what looks like a mouth or eye, soulfully intimate, is in fact a vagina about to be "eaten", and at the bottom of the picture we are provocatively confronted with an anus – balancing the composition in ribald parody of classical laws of composition. Not until late work done in the 1960s did Picasso again treat sexuality thus.

A picture as aggressive as "The Kiss" was of course not merely the articulation of an artistic programme. It came out of personal experience. Picasso's marriage to Olga was not a happy one. They shared few interests, neither communicating nor enriching each other's lives. Art here mirrors reality, expresses it vividly.

A similar process is at work in the female bust that recurs frequently in the sculptures, drawings, graphics and paintings from 1931 on. The features are those of Marie-Thérèse Walter, Picasso's young lover. In January 1927, aged 45, he had met the girl, then aged just 17, outside Lafayette's, a Paris department store. The

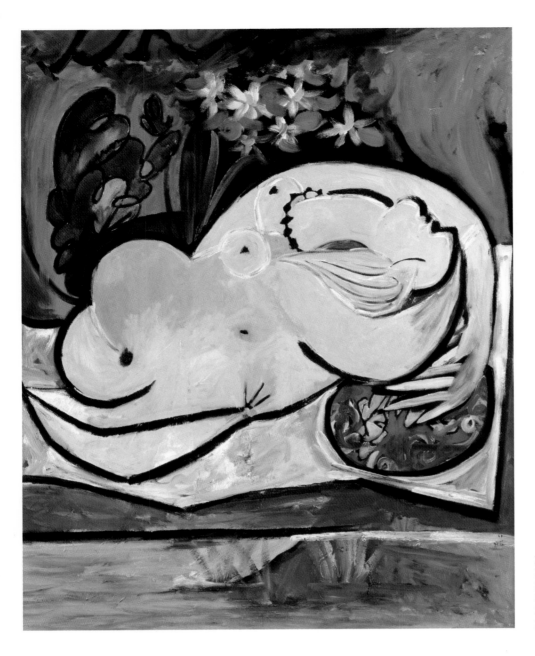

Nude in a Garden
Femme nue dans un jardin
Boisgeloup, 4 August 1934
Oil on canvas, 162 x 130 cm
Not in Zervos; MPP 148
Paris, Musée Picasso

story goes that he used the corniest approach in the book: "You have an interesting face, Mademoiselle. I should like to paint you. My name is Picasso." The name meant nothing to her, but she agreed. Within months she was his lover. But he was still married, and had to keep the relationship secret. In the years that followed there was many an undignified scene and incident. It was not till 1935 that Picasso finally left his wife, when Marie-Thérèse gave birth to their daughter Maja.[288] The artist called it the worst time of his life. But it was also the climax of a fraught situation that had been affecting the subjects and formal approaches of his art for years. We need only look at the 1932 painting "Girl Before a Mirror" (p. 353). The girl is Marie-Thérèse. Picasso preferred this picture of his lover to all the others. In the paradoxical tension between the motif of tranquil contemplation and the agitated style in which it is painted, Picasso has conveyed far more than an everyday moment. Marie Thérèse is studying her reflected image closely; but

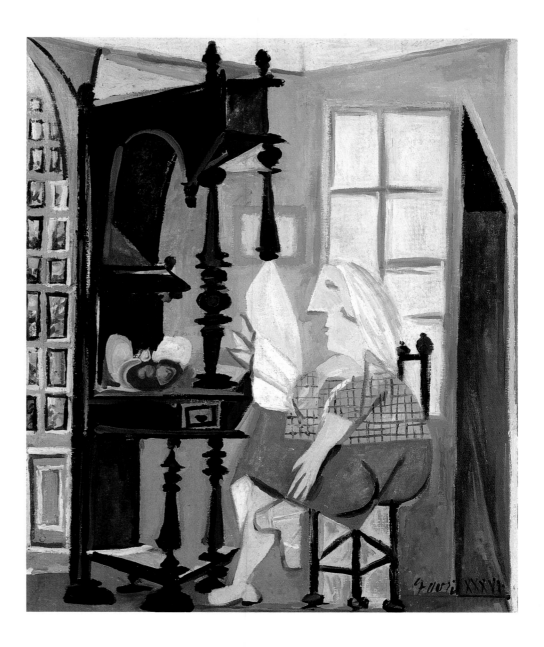

Woman at the Sideboard
Femme au buffet
Juan-les-Pins, 9 April 1936
Oil on canvas, 55 x 46 cm
Not in Zervos; MPP 151
Paris, Musée Picasso

this simple attitude is transformed by the wild colours and assertive lines. It is as if we were seeing her at once clothed, naked, and revealed in X-ray image. The picture is full of sexual symbolism.[289]

In other works of the period, distress and violent feeling are apparent in the visible tension. From 1930 on, we frequently find the Christian motif of the crucifixion, partly using historical originals such as Matthias Grünewald's Isenheim altarpiece, of which Picasso did a small painting (p. 337) and a 1932 series of India-ink variations. Above all, he dealt with relations between the sexes, in numerous variations on his artist-and-model subject but also in a new version of his bullfight pictures: the motif of the Minotaur. Picasso approached the mythical subject in characteristic fashion. In Greek myth, the Minotaur was the son of Pasiphaë – wife of Minos, King of Crete – by a white bull. The king had the half-human, half-animal creature confined to a labyrinth, and every ninth year (at the close of every Great Year) seven Athenian youths

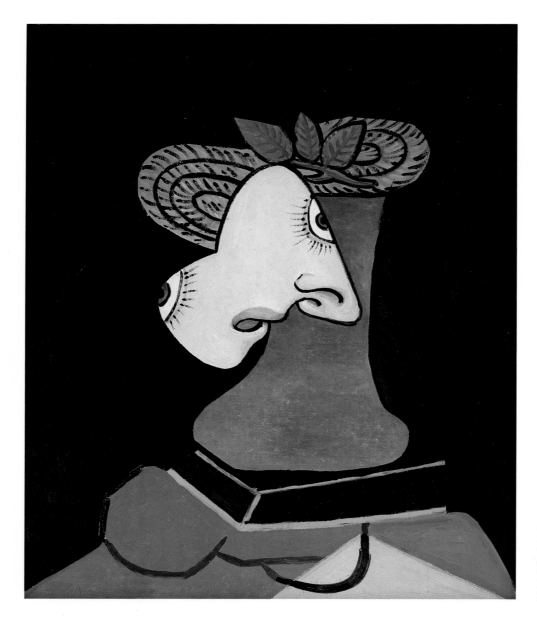

Lady in a Straw Hat
Le chapeau de paille au feuillage bleu
Juan-les-Pins, 1 May 1936
Oil on canvas, 61 x 50 cm
Not in Zervos; MPP 155
Paris, Musée Picasso

and seven Athenian maidens were offered up to the Minotaur – till finally Theseus, with Ariadne's help, slew the beast. In the 19th century the Minotaur was increasingly divorced from its mythic context, and the Surrealists took it as a symbolic figure. André Masson portrayed it, and a Surrealist magazine started in 1933, to which Picasso contributed, had its name for a title.[290] Picasso used the subject as a vehicle for personal and historical material.

The various states of the "Minotauromachy" etching, and the India-ink and gouache studies of 1936 (pp. 376 to 379), allude both to the ancient tradition and to the modern. The Minotaur invades the sculptor's studio. He is also seen dragging the dead mare, a symbol of female sexuality, from his lair. He is plagued by demons, and is vanquished by Theseus. But the creature can always be identified with the dual nature of the artist. This owes something to Nietzsche's "The Birth of Tragedy", in which Nietzsche saw art as essentially a duality, possessing Apollonian and Dionysian features. His view was an un-historical one, projected upon Greek

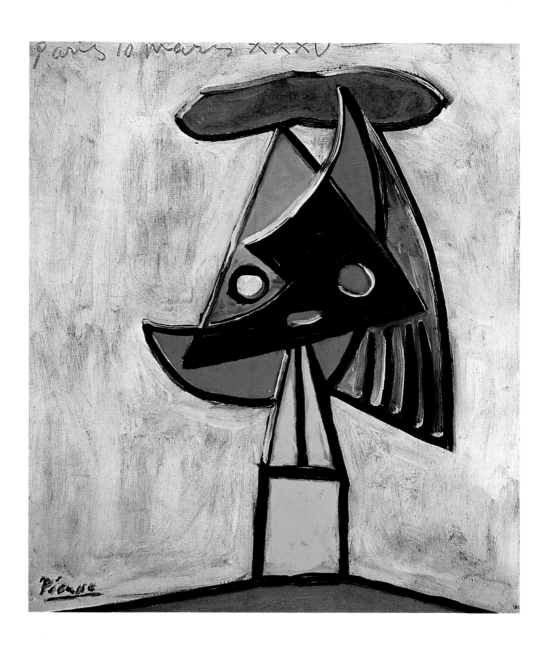

Head of a Woman (Olga Picasso)
Tête de femme (Olga Picasso)
Paris, 10 March 1935
Oil on canvas, 61 x 50.5 cm
Not in Zervos
Buffalo (NY), Albright-Knox Art Gallery

antiquity; but the interpretative structure it provided has proved widely useful. Picasso equated his sculptor with the Apollonian spirit, but all things intoxicated and impassioned were Dionysian. Both aspects of the creative duality appeared in his work.[291]

Of course we must remember that the violence in many of these works also reflected contemporary politics. France and indeed all of Europe was radically unstable at the time, and Fascism was on the rise. Spain had been in the hands of a military dictatorship since 1923, and it was not till 1931 that an elected government replaced it. Since 1930, the Surrealists had been increasingly committed to the Communist Party, but Picasso refused to be directly involved in politics. This does not mean that he took no interest in political events or was ignorant of social conditions, though it is true that his purchase in 1932 of Boisgeloup, a château 60 kilometres north of Paris, and his employment of a private secretary and a chauffeur, can be taken as indications of his middle-class established status.[292]

The key picture in political terms is the composition showing the

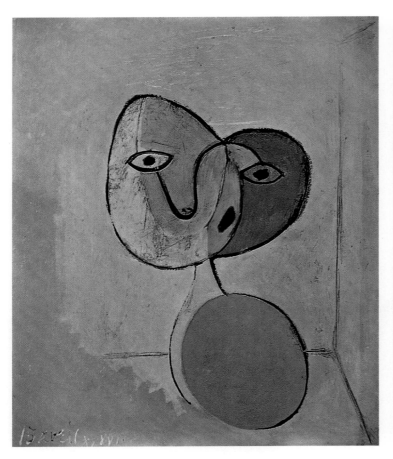
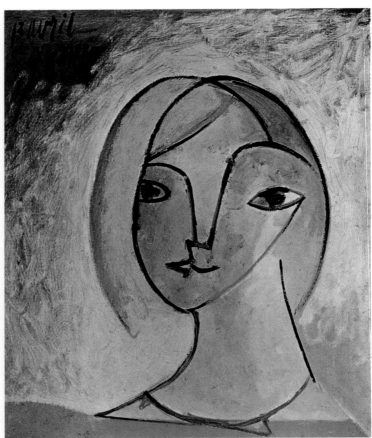
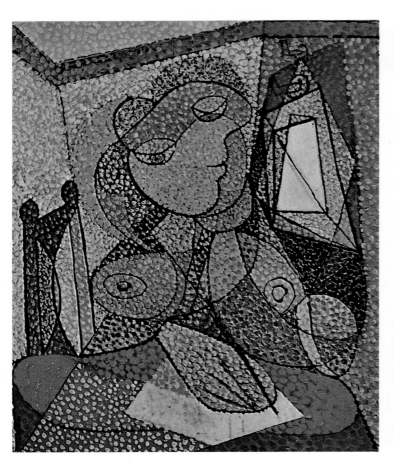
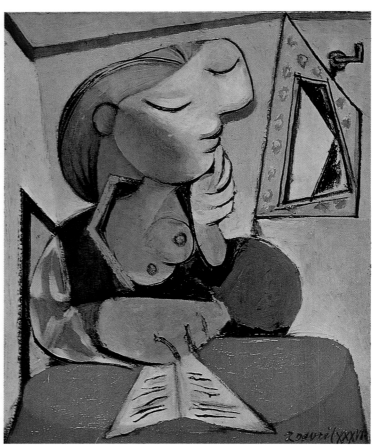

372 A Juggler with Form 1925 – 1936

Right:
Woman with Bouquet of Flowers
Femme au bouquet
Paris (?), 17 April 1936
Oil on canvas, 73 x 60 cm
Not in Zervos
Estate of Jacqueline Picasso

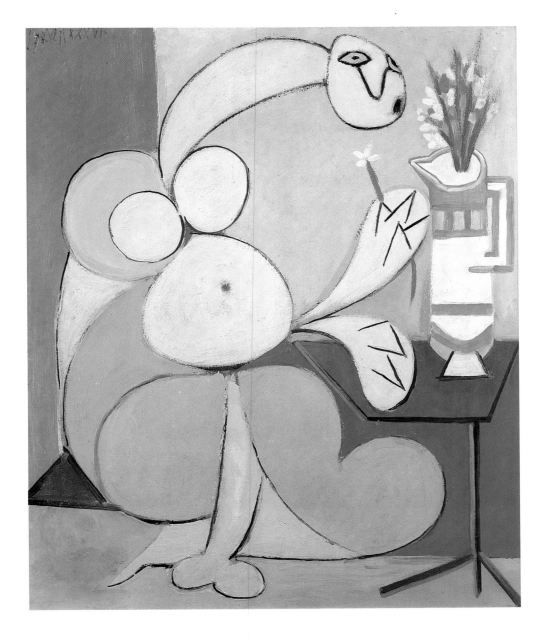

Left:
Portrait of a Woman
Portrait de femme
Juan-les-Pins, 15 April 1936
Oil on canvas, 61 x 50 cm
Not in Zervos

Bust of a Woman
Buste de femme
Juan-les-Pins, 13 April 1936
Oil on canvas, 55 x 46 cm
Not in Zervos

Portrait of a Woman
Portrait de femme
Juan-les-Pins, 22 April 1936
Oil on canvas, 46 x 38 cm
Not in Zervos
Estate of the artist

Portrait of a Woman
Portrait de femme
Juan-les-Pins, 20 April 1936
Oil on canvas, 41 x 33 cm
Not in Zervos

Minotaur in the clutches of a gryphon figure (p. 378, bottom), Picasso's variation on a famous ancient model, the Hellenistic Pasquino group, showing the dead Patroclus in the arms of Menelaus.[293] It was done as a study for the curtain for Romain Rolland's play "14 juillet", performed in Paris in summer 1936 in honour of the election victory of the French People's Front. Like the bullfight, the use of the Minotaur motif shows the subject's symbolic value in Picasso's eyes, as an expression of social concern. The parallels with the increasingly critical political situation, and Picasso's preoccupation with the Minotaur and bullfight complex, eloquently suggest the multitude of meanings these themes can convey.[294] From 1925 to 1936, Picasso used a stock of formal and thematic approaches that could be used for a great variety of purposes. It was an art of transfer. Unlike the previous period, this one did not end in a single work gathering all the strands together in one great synthesis, but in the end the times compelled him to create such a work. In 1937 he painted his great masterpiece "Guernica".

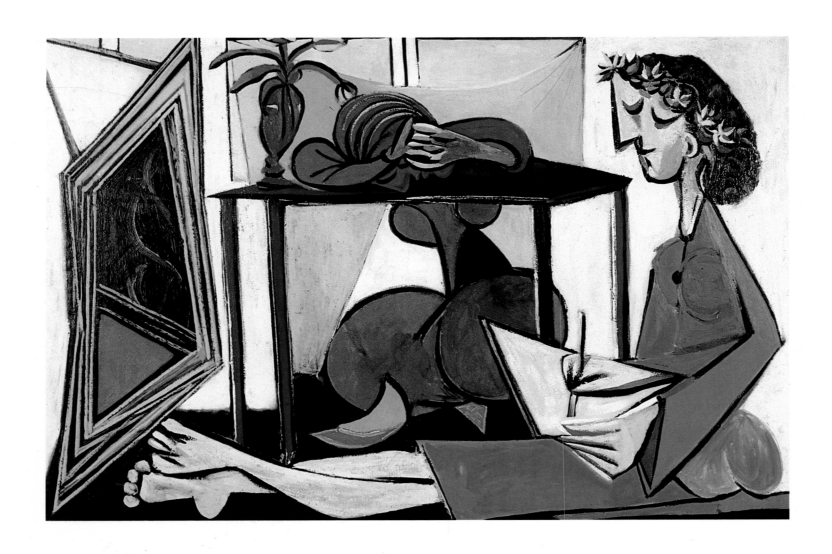

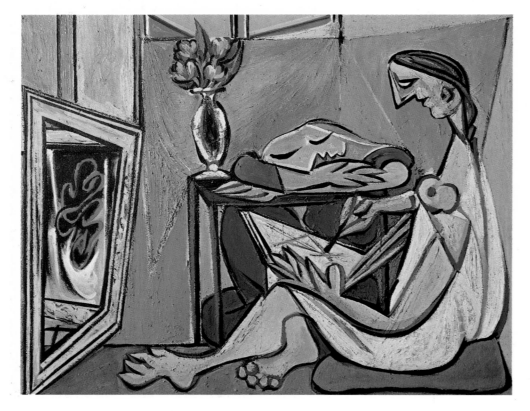

Interior with a Girl Drawing
Deux femmes
Paris, 12 February 1935
Oil on canvas, 130 x 195 cm
Zervos VIII, 263
New York, The Museum of Modern Art,
Nelson A. Rockefeller Bequest

Young Woman Drawing (The Muse)
La muse
1935
Oil on canvas, 130 x 162 cm
Zervos VIII, 256
Paris, Musée National d'Art Moderne,
Centre Georges Pompidou

Right:
Woman Reading
Femme lisant
Paris, 9 January 1935
Oil on canvas, 161.5 x 129.5 cm
Zervos VIII, 260; MPP 149
Paris, Musée Picasso

374 A Juggler with Form 1925–1936

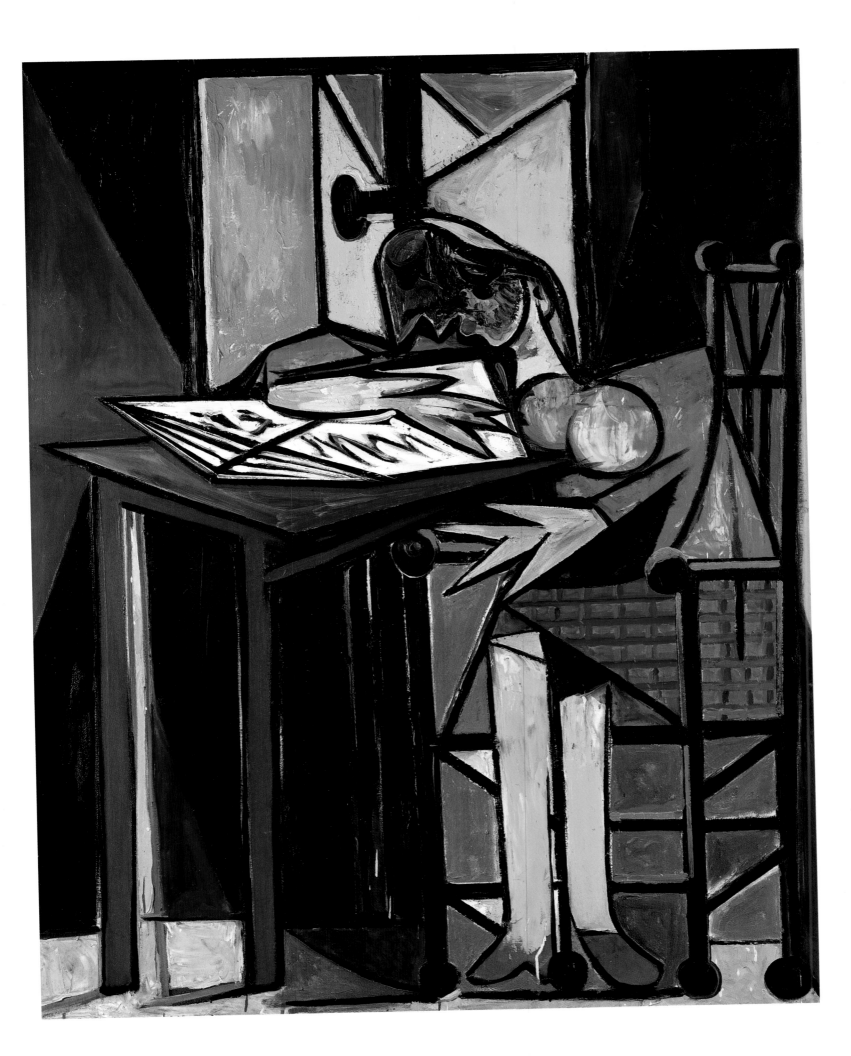

Woman with a Candle, Fight Between Bull and Horse
Femme à la bougie, combat entre taureau et cheval
Boisgeloup, 24 July 1934
Ink, India ink and pencil on canvas
on panel, 31.5 x 40.5 cm
Zervos VIII, 215; MPP 1136
Paris, Musée Picasso

Minotauromachy
La minotauromachie
Paris, begun 23 March 1935
Etching and grattoir, 49.8 x 69.3 cm
Bloch 288, V; Baer 373, VII
Paris, Musée Picasso

376 A Juggler with Form 1925 – 1936

Minotaur and Horse
Minotaure et cheval
Boisgeloup, 15 April 1935
Pencil on paper, 17.5 x 25.5 cm
Zervos VIII, 244; MPP 1144
Paris, Musée Picasso

Design for the Cover of "Minotaure"
Maquette pour la couverture de "Minotaure"
Paris, May 1933
Collage: Pencil on paper, corrugated cardboard,
silver foil, silk ribbon, wallpaper overpainted
with gold and gouache, doilies, browned canvas
leaves, drawing pins and charcoal on wooden
board, 48.5 x 41 cm. Not in Zervos
New York, The Museum of Modern Art

Pages 378 and 379:
Wounded Minotaur, Horse and Figures
Minotaure blessé, cheval et personnages
Paris, 10 May 1936
Gouache, ink and India ink on paper,
50 x 65 cm. Zervos VIII, 288; MPP 1165
Paris, Musée Picasso

**Study for the Curtain for "14 juillet"
by Romain Rolland**
Etude pour le rideau de scène du "14 juillet"
de Romain Rolland
Paris, 28 May 1936
Gouache and India ink, 44.5 x 54.5 cm
Zervos VIII, 287; MPP 1166
Paris, Musée Picasso

**Minotaur and Dead Mare Outside a Cave,
with Young Veiled Girl**
Minotaure et jument morte devant une grotte
face à une jeune fille au voile
Juan-les-Pins, 6 May 1936
Gouache and India ink on paper, 50 x 65.5 cm
Not in Zervos; MPP 1163
Paris, Musée Picasso

Faun, Horse and Bird
Faune, cheval et oiseau
Paris, 5 August 1936
Gouache and India ink on paper, 44.2 x 54.4 cm
Not in Zervos; MPP 1170
Paris, Musée Picasso

378 A Juggler with Form 1925 – 1936

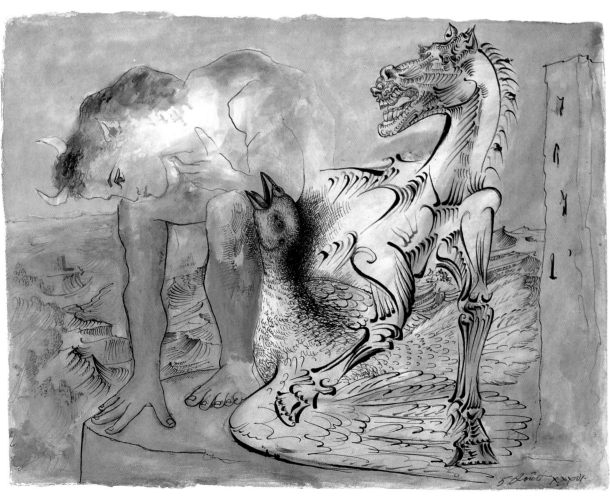

A Juggler with Form 1925 – 1936 379

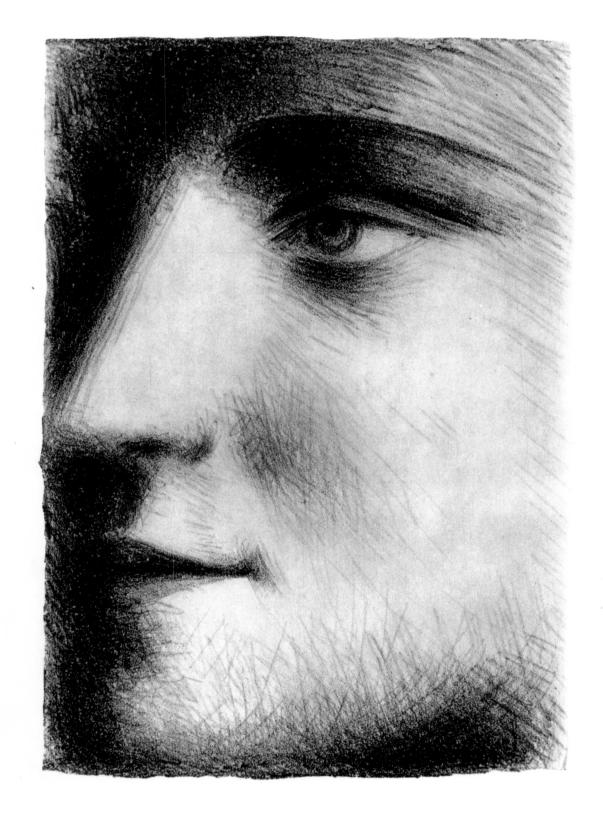

Face
Visage
1928
Lithograph, 20.4 x 14.2 cm
Bloch 95; Geiser 243;
Mourlot XXIII; Rau 23
Alling, Walther Collection